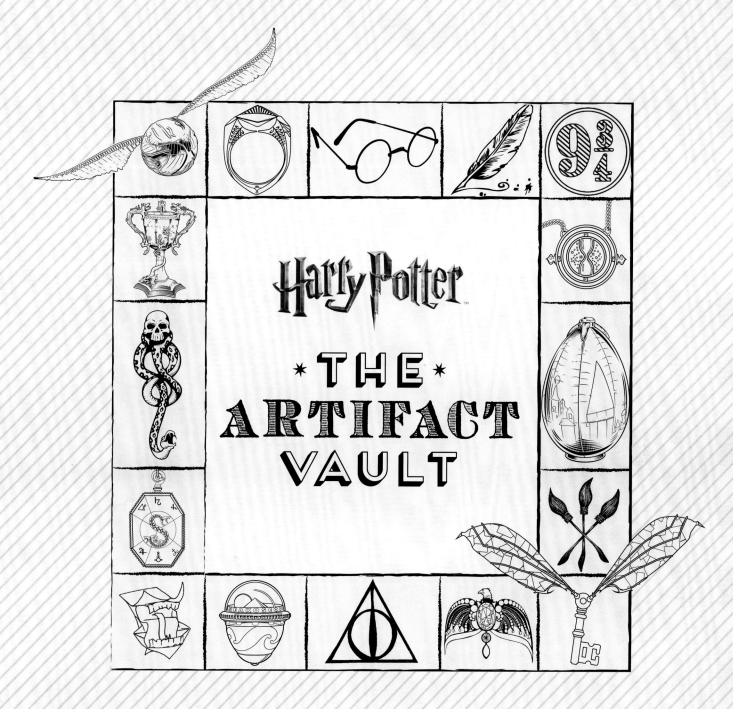

Harry Potter

✷ THE ✷
ARTIFACT
VAULT

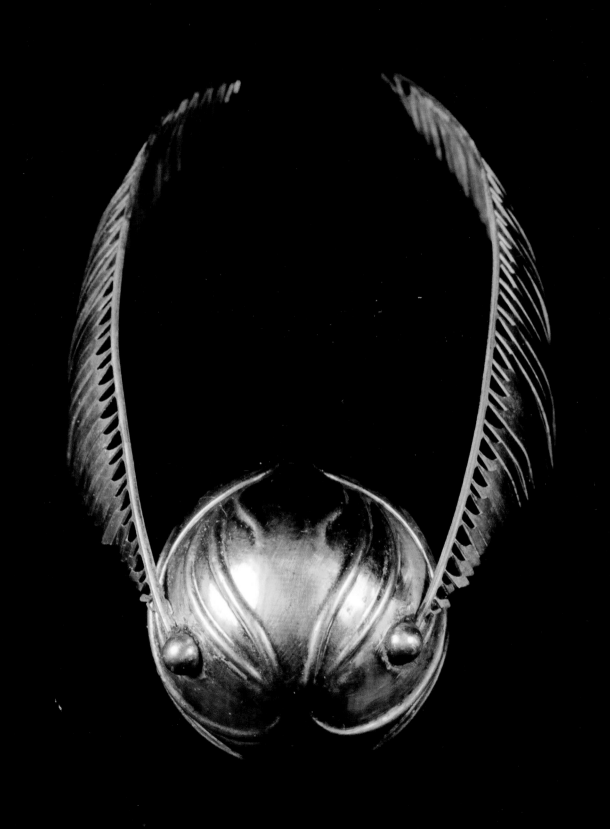

Harry Potter

✦ THE ✦ ARTIFACT VAULT

WRITTEN BY

JODY REVENSON

HARPER DESIGN

An Imprint of HarperCollinsPublishers

An Insight Editions Book

CONTENTS

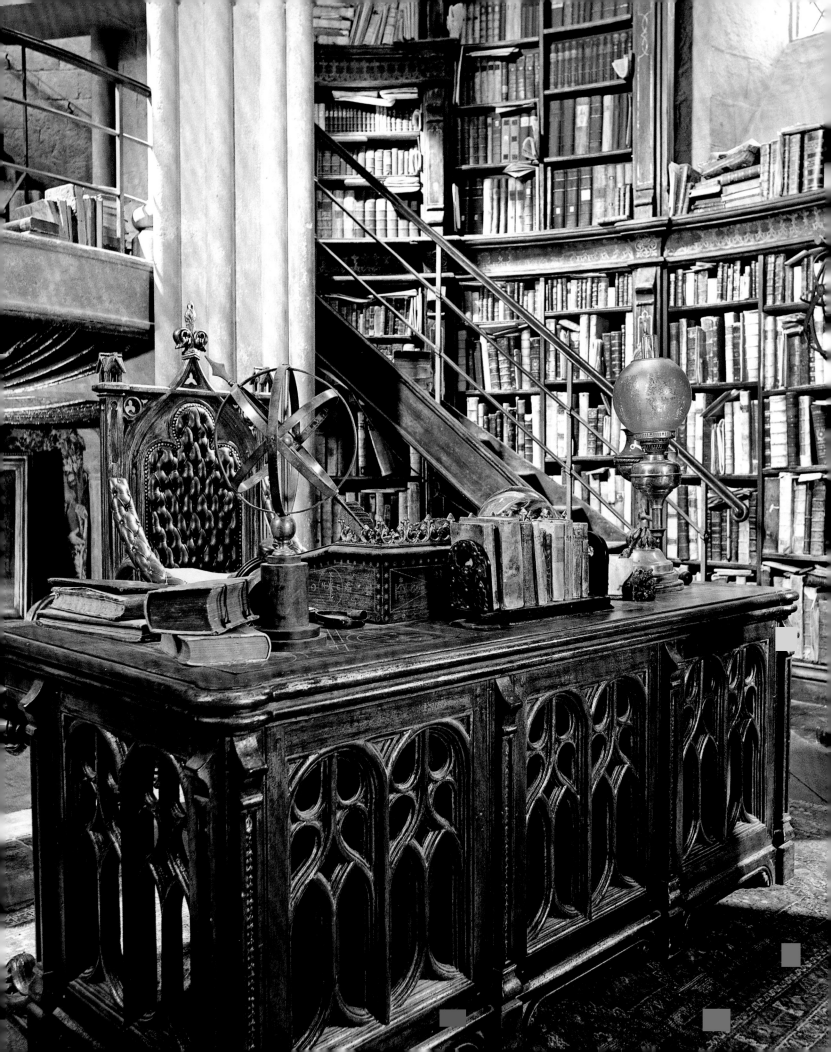

INTRODUCTION

An artifact, according to the dictionary, is "an object created by a human being for a practical purpose, especially: an object remaining from a particular period, trend, or individual, typically an item of cultural or historical importance." The artifacts that populated the wizarding world of the Harry Potter films, which in filmmaking terms we'd call *props*—from books and clocks to mirrors and trunks—served many purposes, the least of which was as props and set dressing. Many of these would be considered "hero props," another film term that refers to those special things handled by the heroes, and which are, in fact, important to the character and the story. These ranged from a map with endless layers that showed a rat (both in physical form and traitorous actions) walking around Hogwarts School of Witchcraft and Wizardry, to a small piece of jewelry that could turn back time, and in

that turn, save two lives. A piece of paper covered with names represented the commitment of many inexperienced young wizards to fighting the Dark forces that threatened their way of life. A bowl of liquid divulged memories that offered evidence of a tragic mistake and proof it could be rectified. The artifacts created by J.K. Rowling in the Harry Potter book series offered clues to a character's personality, enriched the world that she built, and were integral to the plot of the story.

LEFT: The office of Professor Albus Dumbledore, filled with books, paintings, cabinets, and astrological equipment; ABOVE: Draft work for the sign at Platform 9 3/4; BELOW: Harry Potter's bedside table in the Gryffindor dorm during the events of *Harry Potter and the Half-Blood Prince* includes some of the most iconic artifacts in the story: his wand and glasses, the Marauder's Map, and his copy of *Advanced Potion-Making*.

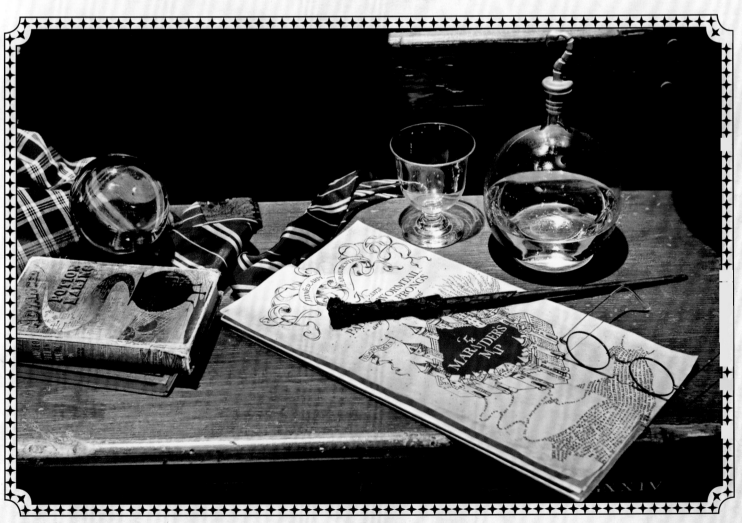

FORD ANGLIA 105E

WIZARD BUTTON

3/4"

Top view

Side view

PUSH IN

Shiny silver finish

3/4 View (X 4)

F/S Details
NOTE : Push button has to be practical.

HARRY POTTER "THE CHAMBER OF SECRETS"	DRW TITLE : WIZARD BUTTON/ FORD ANGLIA	
DRAWN BY: CN 02	DATE DRAWN: 20/09/01	DATE APPROVED

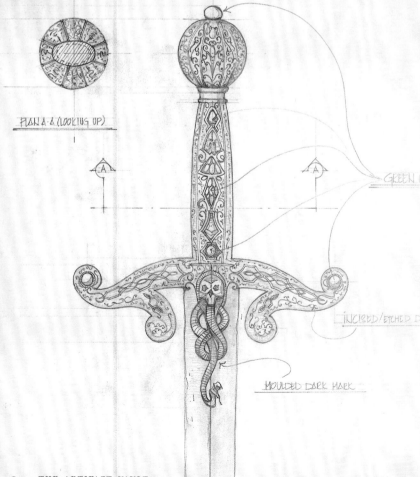

PLAN A-A (LOOKING UP)

A

A

GREEN (JADE

INCISED/ETCHED D

MOULDED DARK MARK

Crafting the artifacts for the Harry Potter films began with production designer Stuart Craig, who oversaw all the creative departments involved in the filmmaking process. The scripts dictated which objects were necessary to a character or a location, but there was an entire magical society to fill that also required everyday items for the students and professors at a thousand-year-old school and their families in wizard homes, bureaucratic paperwork for a government in transition, products for long rows of shops, and food for feasts. Craig consulted ceaselessly with producers David Heyman and David Barron; directors Chris Columbus, Alfonso Cuarón, Mike Newell, and David Yates; and the author herself, J.K. Rowling, to bring a credible and believable world to the screen. "The modelers and the props department created most everything," says producer David Heyman, "because most everything was specific to this world." Hattie Storey was one of many key players on the artistic team. "When trying to describe the job I had, of props art director," she says, "I often just said it's all 'wands and broomsticks.'" It is rare for a film to have an art director whose job it is to specifically take care of the props, but the requirements of the Harry Potter films necessitated that they be made from scratch, and so the position was created for *Harry Potter and the Sorcerer's Stone* and continued through the end of the series. Lucinda Thomson and Alex Walker preceded Storey in the job, which was coordinating the design, drawing, and fabrication of all things wizard. "For this," Storey continues,

LEFT: Blueprint of the false Sword of Gryffindor placed in the Lestrange Vault at Gringotts in *Harry Potter and the Deathly Hallows – Part 2*, draft work by Julia Dehoff; TOP: Visual development artwork for the button used to turn on the invisibility booster in Arthur Weasley's Flying Ford Anglia; OPPOSITE: The necklace that cursed Katie Bell in *Harry Potter and the Half-Blood Prince*, designed by Miraphora Mina.

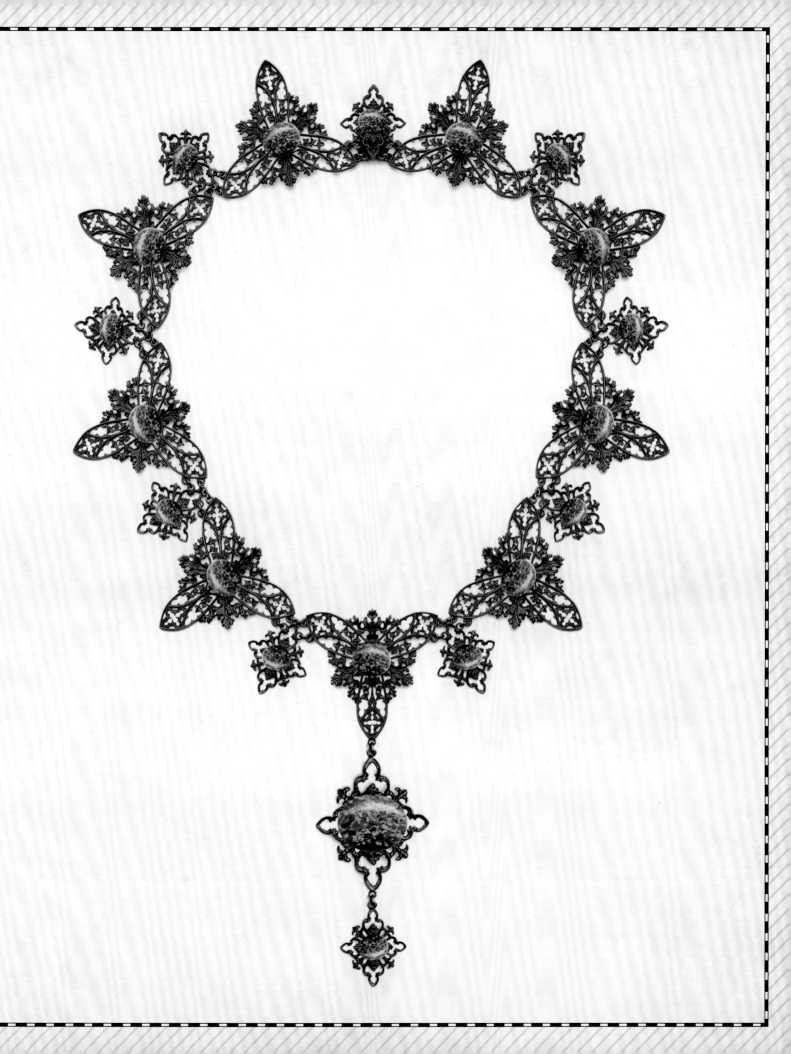

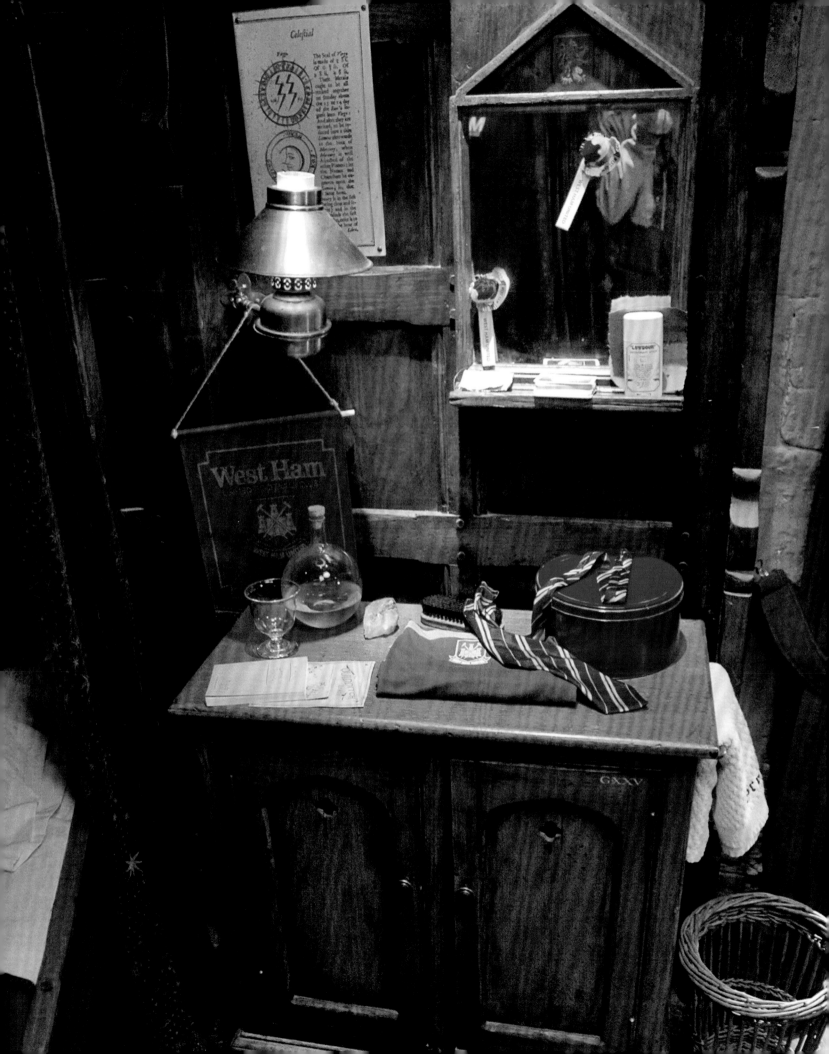

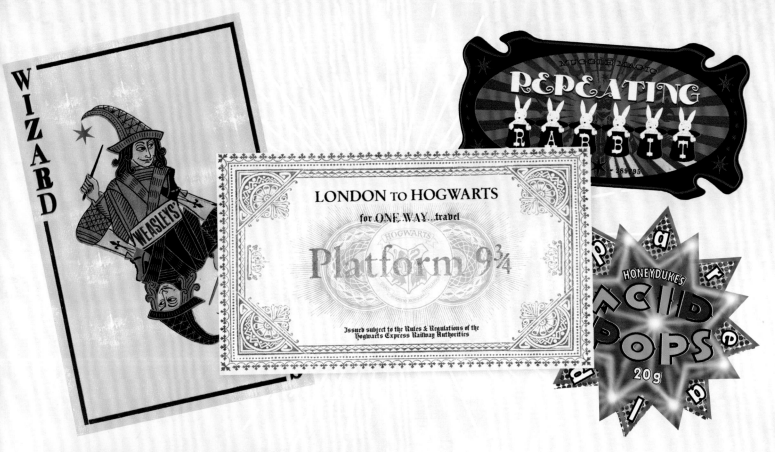

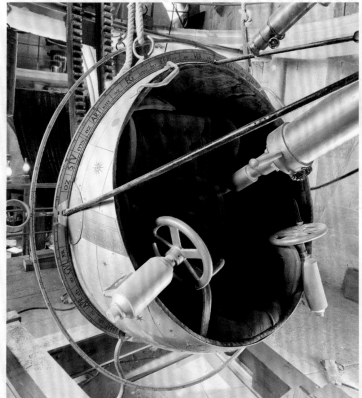

"I relied on our team of superbly talented prop manufacturers, led by Pierre Bohanna, which included sculptors, carpenters, painters, and the many other talented craftsmen at Leavesden Studios." The design process would start with meetings with Stuart Craig. Then, in addition to culling through the books for descriptions, Storey's team of draftsmen would combine their research and references into technical drawings. Other props were designed by concept artists including Adam Brockbank, who stocked nearly every shelf of Weasleys' Wizard Wheezes with jokes, toys, and candy. Since the book series hadn't been finished when the films were being made, there were often times when the graphic artists and prop designers would have no idea that a hero prop in one film would be found out to be something else in a later part of story, and they would have to quickly rethink it. Once approved, the designs would go to Bohanna's prop makers and utilize carpenters, plasterers, and metal workers, as well as seamstresses from the costume department and painters from the art department. Barry Wilkinson was the property master who made sure the finished props went into their right places and were taken care of on and off the sets.

Two artists led the graphics department, and designed and created everything from the Howler that Ron Weasley receives in *Harry Potter and the Chamber of Secrets* to most of Lord Voldemort's Horcruxes: Miraphora Mina and Eduardo Lima. Although they worked on many big ticket items, both Mina and Lima felt that background objects should never be given any less detail or attention than those seen significantly on screen. "Although some objects may only flash by in a second," says Mina, "the audience will feel the effects of an immersive experience, and the actors have more to work with in the scene to create their character." Mina and Lima drew on myriad sources for their research, from Boy Scout membership cards, to novels of the thirties and forties, to Soviet propaganda from the Cold War. "One of the best things about working on the Harry Potter films was being able to try out so many different styles, from Victorian letterpress to modern design," says Lima.

OPPOSITE: The production design and set decoration departments personalized each student's bedside nightstand. For *Harry Potter and the Half-Blood Prince*, Gryffindor Dean Thomas proclaims his support for the West Ham United football team; TOP: (left to right) The graphics department crafted myriad artifacts that ranged from Weasleys' Wizard Wheezes playing cards to Harry Potter's ticket for the Hogwarts Express to packaging for Honeydukes candy products; ABOVE: An elaborate astrology chair crafted for the upper level of Professor Dumbledore's office in *Half-Blood Prince*.

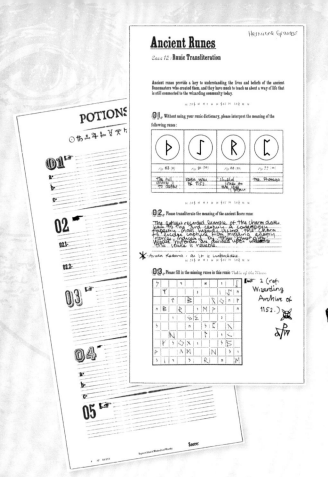

Ancient Runes

Case 12 : Runic Transliteration

Ancient runes provide a key to understanding the lives and beliefs of the ancient Runemasters who created them, and they have much to teach us about a way of life that is still connected to the wizarding community today.

01. Without using your runic dictionary, please interpret the meaning of the following runes:

02. Please transliterate the meaning of the ancient Boore runes:

03. Please fill in the missing runes in this runic Table of the Moon.

POTIONS

01
a:
b:

02
02.1:
02.2:

03

04
a:
b:

05

Score:

BROOMSTICK SERVICING KIT

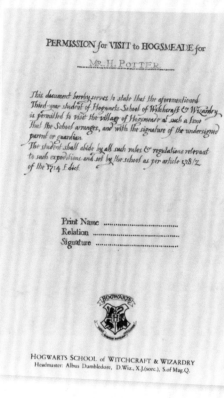

SERRATED EDGE

SLOT FOR TAPE

PERMISSION for VISIT to HOGSMEADE for

MR. H. POTTER

This document hereby serves to state that the aforementioned Third-year student of Hogwarts School of Witchcraft & Wizardry is permitted to visit the village of Hogsmeade at such a time that the School arranges, and with the signature of the undersigned parent or guardian.

The student shall abide by all such rules & regulations relevant to such expeditions and set by the school as per article 528/z of the 1714 F dict.

Print Name
Relation
Signature

HOGWARTS SCHOOL of WITCHCRAFT & WIZARDRY
Headmaster: Albus Dumbledore, D.Wiz., X.J.(sorc.), S.of Mag.Q.

At all times, however, the designers were aware they were working in an as-yet-unseen magical world. "On the whole," Mina continues, "our design style was to take the reality we knew and shift it by a few degrees instead of creating a completely new world. And hopefully that way we created an environment that was believable." One of their more unique approaches used when designing a character's hero prop was to "try to get into the character's head," Mina explains. They would ask themselves, "How would four teenage wizards creating a map want it to function?" "What is Gilderoy Lockhart trying to achieve in the design of his books?" "What would an ancient cup that is the prize in a wizard school competition look like?" Mina adds, "For us, for every single design job we were given on the films, we had to enter the character of that person or the environment of that place or the history behind that moment, and it was our duty to try and help tell the story in that one moment with that one piece of graphic." Lima describes the bottom line: "You always have to think of the storytelling," he says. "You need to tell that story with that prop."

Actor David Thewlis, who played Professor Lupin, is among the many who starred in the Harry Potter films impressed with the hero props. "For me," says Thewlis, "at the end of *Harry Potter and the Prisoner of Azkaban*, when I say good-bye to Harry, I do two things: I fold up the Marauder's Map, and I put my stuff in my closet. And they weren't special effects. They were shot in camera." The Marauder's Map folded up by a series of invisible threads that took only a few takes to capture. "And I thought the genius of that

summed up to me the creative aspects of the designers on the film. They hadn't relied on computer effects, but actually worked out a way of folding a map invisibly eight ways, just by pulling little threads."

The number of artifacts required for the Harry Potter films is astounding—and not simply the result of being spread over eight films, but rather that some locations needed to be filled up wall to wall! There were twenty thousand goods and products in the windows of Diagon Alley alone; add to that a relatively similar number in Hogsmeade. Weasleys' Wizard Wheezes was stocked with forty thousand items. Twelve thousand handmade books filled up classrooms, offices, and libraries. No matter the number or the size, the artifacts in Harry Potter's world inform and delight us. We are entranced by the ethereal quality of the Mirror of Erised, can't wait to play chess on a life-size board with exploding pieces, and know that an hourglass that runs faster or slower according to the quality of conversation would be absolutely sluggish when discussing Horcruxes.

The following is a collection of plans, sketches, visual development art, behind-the-scenes information, screen captures, and commentary from the incredible artists who filled the Great Halls and tiny nooks on-screen in the Harry Potter films.

ABOVE: (left to right) A Potions answer sheet and Runes homework assignment from Hermione Granger; Harry Potter's Broomstick Servicing Kit, and a possible idea for a hand-carved Spellotape dispenser to be used by Ron Weasley in *Harry Potter and the Chamber of Secrets*; Harry Potter's unsigned permission slip from *Harry Potter and the Prisoner of Azkaban*; INSET: Hermione's mirror from *Harry Potter and the Chamber of Secrets*; OPPOSITE: Visual development art for the Sorting Ceremony stool in *Harry Potter and the Sorcerer's Stone*.

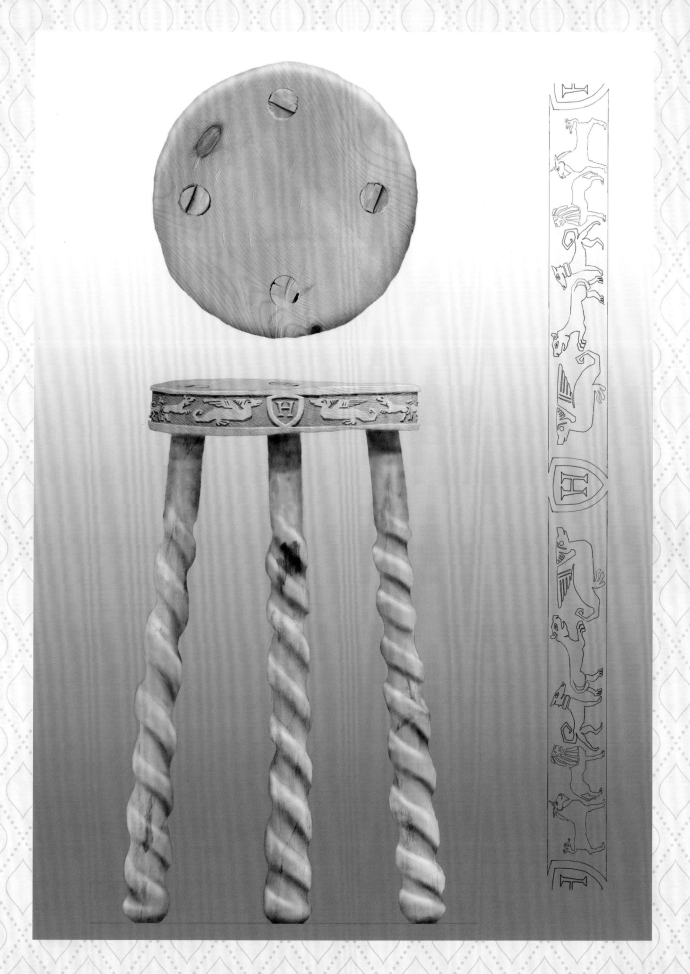

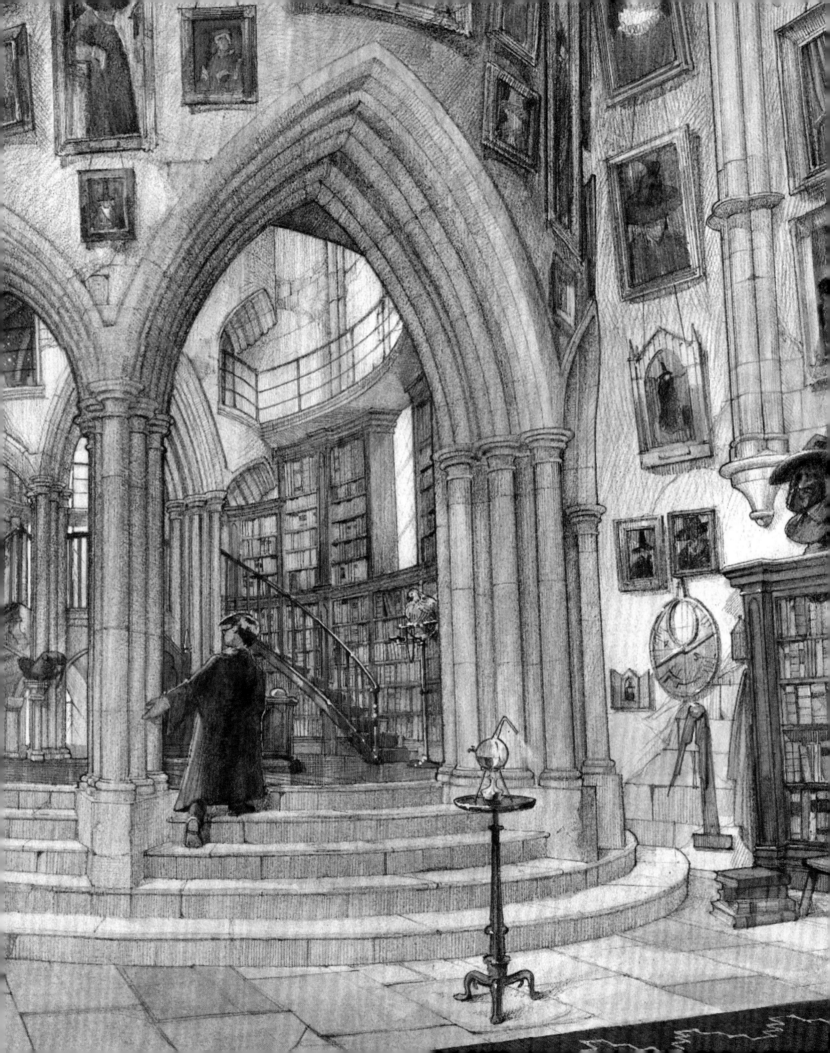

CHAPTER 1

AT HOGWARTS

"All students must be equipped
with one standard size two pewter
cauldron and may bring if they desire
either an owl, a cat or a toad."

—Harry Potter, *Harry Potter and the Sorcerer's Stone*

HOGWARTS ACCEPTANCE LETTER

"We are pleased to inform you that you have been accepted at Hogwarts School of Witchcraft and Wizardry."

—letter from Minerva McGonagall, *Harry Potter and the Sorcerer's Stone*

It's a proud day for new students when Hogwarts School of Witchcraft and Wizardry sends them their acceptance letter. In Harry Potter's case, however, it takes not just one letter but ten thousand before he is able to read the invitation to the school, as his uncle, Vernon Dursley, makes every effort to quash its receipt in *Harry Potter and the Sorcerer's Stone*. When the Dursleys' living room needed to be filled with thousands of duplicates of Harry's letter, director Chris Columbus assumed this would be accomplished digitally. But John Richardson, visual effects supervisor for the Harry Potter films, assured him that his crew could do this as a practical effect. "And Chris looked at me as if I was slightly loopy," Richardson recalls. "But I said no, we can do it. We'll build rigs that will fire the letters into the room and down the chimney." Columbus was doubtful and requested a test run before agreeing to this. "So we built machines that would fling the envelopes out at a very rapid but controlled speed," he explains. "These were built into the top of the set. We had another mechanism that fired them down the chimney using an air device." Richardson's crew rigged these up one night after shooting to show the director, who Richardson recalls exclaiming, "Gosh, it works! That's great!"

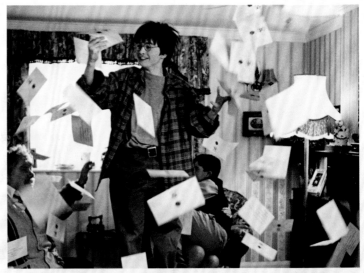

There were several types of envelopes created for different uses. As they needed to be light enough to fly around the room, ten thousand single sheets of paper were printed with the envelope's graphics, including the Hogwarts seal on the back. There were also several letters that had a real wax stamp on the back so they could be seen in close-ups. These contained the actual letter sent by Professor Minerva McGonagall, handwritten by graphic artist Miraphora Mina, who wrote many other documents for the film series. The owls that brought the acceptance letter to number four, Privet Drive, did "carry" real envelopes, in a way. A plastic harness with a release mechanism and a long, undetectable cord that was held by a trainer was placed over the bird's body. At the proper time, the trainer would open the release mechanism and the owl would "drop" the envelope.

MR H POTTER
The Cupboard under the Stairs,
4 Privet Drive,
Little Whinging
SURREY.

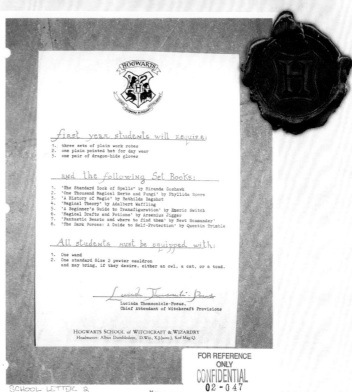

first year students will require:

1. three sets of plain work robes
2. one plain pointed hat for day wear
3. one pair of dragon-hide gloves

and the following Set Books:

1. 'The Standard Book of Spells' by Miranda Goshawk
2. 'One Thousand Magical Herbs and Fungi' by Phyllida Spore
3. 'A History of Magic' by Bathilda Bagshot
4. 'Magical Theory' by Adalbert Waffling
5. 'A Beginner's Guide to Transfiguration' by Emeric Switch
6. 'Magical Drafts and Potions' by Arsenius Jigger
7. 'Fantastic Beasts and where to find them' by Newt Scamander
8. 'The Dark Forces: A Guide to Self-Protection' by Quentin Trimble

All students must be equipped with:

1. One wand
2. One standard Size 2 pewter cauldron
 and may bring, if they desire, either an owl, a cat, or a toad.

Lucinda Thomsonicle-Pocus,
Chief Attendant of Witchcraft Provisions

HOGWARTS SCHOOL of WITCHCRAFT & WIZARDRY
Headmaster: Albus Dumbledore, D.Wiz., X.J.(sorc.), S.of Mag.Q.

SCHOOL LETTER 2 XX 1040

FOR REFERENCE
ONLY
CONFIDENTIAL
02-047

PAGE 14: Harry Potter's first visit to Albus Dumbledore's office, as drawn by concept artist Andrew Williamson for *Harry Potter and the Chamber of Secrets*, shows walls covered with paintings; RIGHT AND OPPOSITE: Harry Potter's Hogwarts acceptance letter and list of school supplies, among the first documents created by the graphics department; TOP RIGHT: In the Dursley house, Harry (Daniel Radcliffe) is enveloped in a tornado of owl-delivered letters as his uncle, Vernon (Richard Griffiths), and cousin, Dudley (Harry Melling), try to swat them away in *Harry Potter and the Sorcerer's Stone*; LEFT: A close-up of the single-sheet envelope.

To: Mr Harry Potter
The Cupboard Under the Stairs,
4 Privet Drive,
Little Whinging,
SURREY.

Dear ...Mr. Potter.,

We are pleased to inform you that you have been accepted at Hogwarts School of Witchcraft and Wizardry.

Students shall be required to report to the Chamber of Reception upon arrival, the dates for which shall be duly advised.

Please ensure that the utmost attention be made to the list of requirements attached herewith.

We very much look forward to receiving you as part of the new generation of Hogwarts' heritage.

Yours sincerely,

Prof. McGonagall

Professor McGonagall

HOGWARTS SCHOOL of WITCHCRAFT & WIZARDRY
Headmaster: Albus Dumbledore, D.Wiz., X.J.(sorc.), S.of Mag.Q.

GILDEROY LOCKHART'S CLASSROOM QUESTIONNAIRE

"Look at these questions. They're all about him."

—Ron Weasley, *Harry Potter and the Chamber of Secrets*, deleted scene

In a scene deleted from *Harry Potter and the Chamber of Secrets*, new Defense Against the Dark Arts professor Gilderoy Lockhart tests the students' knowledge of . . . himself! The questionnaire, hand-drawn by the graphics department overseen by Miraphora Mina and Eduardo Lima, would have been another opportunity to showcase Hermione Granger's outstanding wizarding knowledge and Harry Potter and Ron Weasley's indifference toward reading.

DEFENCE against the DARK ARTS
Second Year Essential Knowledge Test

1. What is Gilderoy Lockhart's colour? Lilac.
2. What is Gilderoy Lockhart ambition? to rid the world of evil & to range of hair-care potions
3. What, in your opinion, is Gilderoy Lockhart's greatest achievement to banish the bogle-handler in t
4. When is Gilderoy Lockhart and what would his ideal gift be? magic and non-magic peoples. 2
5. How many times has Gilderoy L won Witch Weekly's Most-Charming five times.
6. In his book "Break with a Banshee" Gilderoy Lockhart br Broan Banshee knocked
7. Which is Gilderoy Lockhart for photographs? Left side.
8. Has Gilderoy Lockhart Dunstable Duelling Championship been ripped at the post? Always
9. Which product does Gilderoy clean his teeth with to achieve hi white smile? Gentleman's

10. Mention some of Gilderoy Lockhart's pet hates and personal vices He hates bally-butter stuff His special treat is Ogden's Old Firewhiskey
11. Suggest in less than twenty words some top grooming tips for Gilderoy Lockhart Always condition from root to tip with Egg-Shine-for-Wizards
12. What, in your opinion, is the bravest encounter Gilderoy Lockhart has ever had? With the hungarian hairy hippogriff
13. How many fans are in the Gilderoy Lockhart fan club? Uncountable
14. To which side does Gilderoy Lockhart part his hair? Left.
15. Name three key time defying spells that have contributed to Gilderoy Lockhart's ageless features 1. The twinkle-wrestler 2. Honeydew eyeglazing spell 3. The follow-fortifier
16. What does Gilderoy Lockhart absolutely never travel the world without? Tooth-flossing string mints.
17. Which wizard-coutier makes Gilderoy Lockhart's magnificent robes? Plumblewick's.
18. If Gilderoy Lockhart launched his own range of hair products, what would they be called? "Gilda-goo hair-care".
19. What is the personal name which Gilderoy Lockhart has given to his broomstick? The swash buckler.

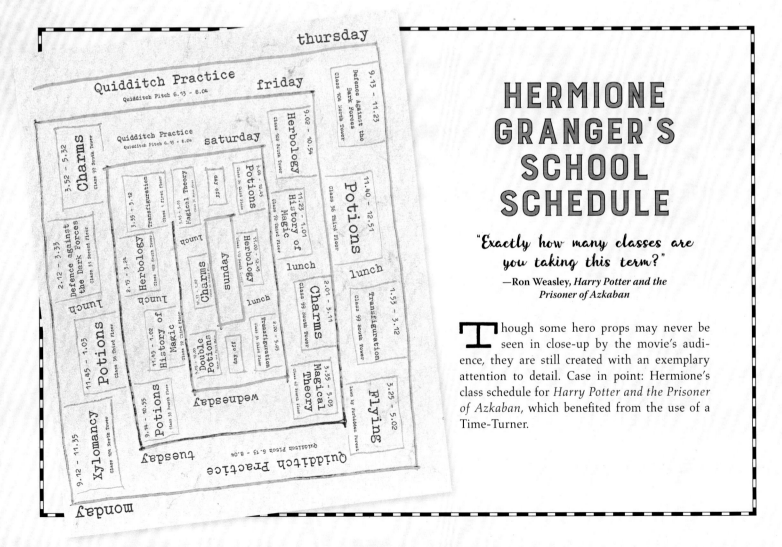

HERMIONE GRANGER'S SCHOOL SCHEDULE

"Exactly how many classes are you taking this term?"

—Ron Weasley, *Harry Potter and the Prisoner of Azkaban*

Though some hero props may never be seen in close-up by the movie's audience, they are still created with an exemplary attention to detail. Case in point: Hermione's class schedule for *Harry Potter and the Prisoner of Azkaban*, which benefited from the use of a Time-Turner.

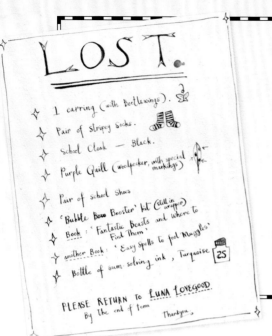

L.O.S.T.

✦ 1 earring (with Beetlewings).
✦ Pair of stripey socks.
✦ School Cloak — Black.
✦ Purple Quill (woodpecker, with special markings)
✦ Pair of school Shoes
✦ 'Bubble Bow Booster' hat (still in wrapper)
✦ Book: 'Fantastic Beasts and Where to Find Them'
✦ another Book: 'Easy Spells to fool Muggles'
✦ Bottle of sum-solving ink, Turquoise 25

PLEASE RETURN TO LUNA LOVEGOOD
By the end of term Thankyou.

LUNA LOVEGOOD'S LOST SIGN

"Are you sure you don't want any help looking?"
"...things we lose have a way of coming back to us in the end."

—Harry Potter and Luna Lovegood,
Harry Potter and the Order of the Phoenix

In *Harry Potter and the Order of the Phoenix*, Luna's list of lost items to be returned includes books, quills, and clothing. This is another creation of the graphics department, who came up with individual handwriting styles for the characters.

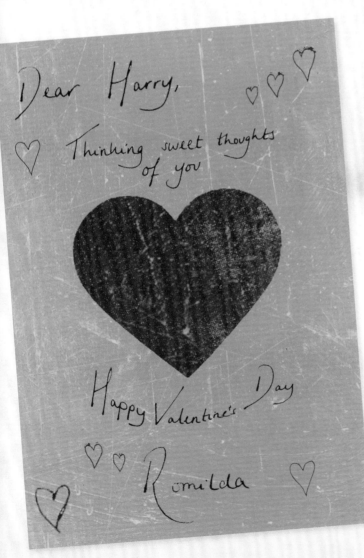

Dear Harry,

Thinking sweet thoughts of you

Happy Valentine's Day

Romilda

VALENTINE'S DAY CARD

"Alright, fine! You're in love with her! Have you ever actually met her?"

—**Harry Potter,** *Harry Potter and the Half-Blood Prince*

In *Harry Potter and the Half-Blood Prince*, Romilda Vane sends a card to Harry Potter on Valentine's Day accompanied by love potion–enhanced chocolates that get intercepted by Ron Weasley.

OPPOSITE TOP: In a scene deleted from *Harry Potter and the Chamber of Secrets*, Professor Gilderoy Lockhart handed out a quiz about . . . himself. Hermione Granger's completed test contains all the correct answers; OPPOSITE BOTTOM: Hermione Granger's Time-Turner–influenced schedule for classes in *Harry Potter and the Prisoner of Azkaban* was constructed by graphic designer Ruth Winick; TOP, ABOVE, AND LEFT: The graphic design artists created the handwriting for many Hogwarts students, including Luna Lovegood and Romilda Vane.

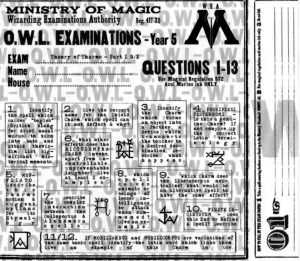

CRAM IT! REVIEW GUIDE AND O.W.L. EXAM

"Ordinary Wizarding Level Examinations, O.W.Ls. More commonly known as OWLS."
—Dolores Umbridge, *Harry Potter and the Order of the Phoenix*

Throughout the films, the graphics and props department paid much attention to dressing the sets with props that would enhance the story because they related to the characters. Mina and Lima populated the Gryffindor Common Room with artifacts typical of student life, including a guide to passing the O.W.L exam taken in *Harry Potter and the Order of the Phoenix*.

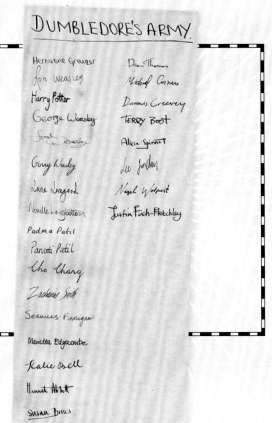

DUMBLEDORE'S ARMY PARCHMENT

A length of parchment paper holds the names of Dumbledore's Army, who first meet during a trip to Hogsmeade in *Harry Potter and the Order of the Phoenix*. This scrap of paper defines the pivotal moment when Harry Potter accepts a leadership role in the fight against the Dark forces. The majority of signatures were inscribed by the actors themselves.

ABOVE AND OPPOSITE: When the Ordinary Wizarding Level exams are given to fifth years, a Cram It! Review Guide can be spotted in the Gryffindor Common Room in *Harry Potter and the Order of the Phoenix*, offering the wizardly version of spell check; RIGHT: Signatures of the members of Dumbledore's Army, who found a way to learn Defense Against the Dark Arts in *Harry Potter and the Order of the Phoenix* when Professor Umbridge would not teach it to them.

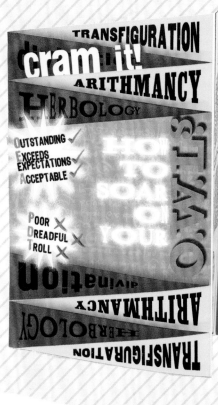

TRANSFIGURATION

cram it!

ARITHMANCY

HERBOLOGY

OUTSTANDING ✓
EXCEEDS
EXPECTATIONS ✓
ACCEPTABLE ✓

POOR ✗
DREADFUL ✗
TROLL ✗

HOW TO SOAK IN YOUR

divination

ARITHMANCY

HERBOLOGY

TRANSFIGURATION

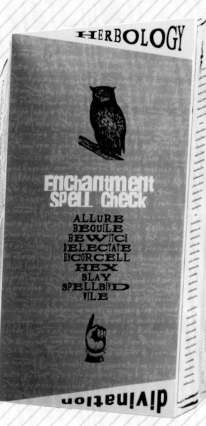

HERBOLOGY

Enchantment Spell Check

ALLURE
BEGUILE
BEWITCH
DELECTATE
ENCORCELL
HEX
SLAY
SPELLBIND
VILE

divination

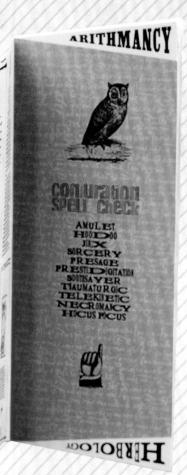

ARITHMANCY

conjuration Spell Check

AMULET
HOODOO
JINX
SORCERY
PRESAGE
PRESTIDIGITATION
SOOTHSAYER
THAUMATURGIC
TELEKINETIC
NECROMANCY
HOCUS POCUS

HERBOLOGY

SPACE for note taking
& TOP REVISION tips

HERBOLOGY

Enchantment Spell Check

AMULET
HOODOO
JINX
SORCERY
PRESAGE
PRESTIDIGITATION
SOOTHSAYER
THAUMATURGIC
TELEKINETIC
NECROMANCY
HOCUS POCUS

divination

conjuration Spell Check

ALLURE
BEGUILE
BEWITCH
DELECTATE
ENCORCELL
HEX
SLAY
SPELLBIND
VILE

ARITHMANCY

HERBOLOGY

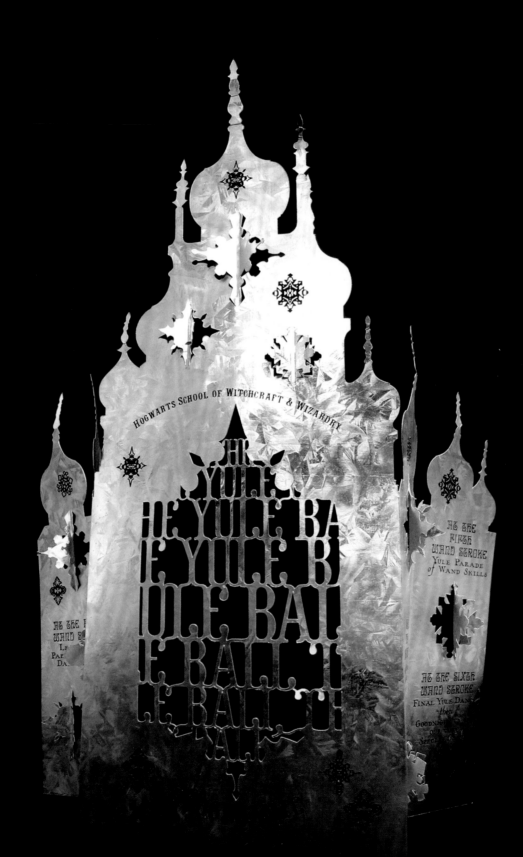

YULE BALL EMPHEMERA

*"On Christmas Eve night, we and our guests gather
in the Great Hall for well-mannered frivolity."*
—Minerva McGonagall, *Harry Potter and the Goblet of Fire*

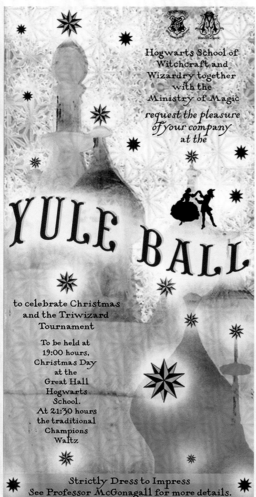

Hogwarts School of
Witchcraft and
Wizardry together
with the
Ministry of Magic

request the pleasure
of your company
at the

YULE BALL

to celebrate Christmas
and the Triwizard
Tournament

To be held at
19:00 hours,
Christmas Day
at the
Great Hall
Hogwarts
School.
At 21:30 hours
the traditional
Champions
Waltz

Strictly Dress to Impress
See Professor McGonagall for more details.

As mementoes are often collected as remembrances for those important events in a student's life, Mina and Lima created a programme for the Yule Ball that listed the events and the times they would occur during the evening. At the first wand stroke, students would lead their partners to the dance floor, which hopefully would have been helped by the dance lesson card distributed to them previously. At the second, beverages would be served, and at the third, the feast. Similar to a Muggle prom dance, the fourth wand stroke brought the announcement of the witch and wizard of the ball, which was followed by a parade of wand skills at the fifth. The final stroke was for the final dance, and "then goodnight to all our very special guests."

ABOVE AND OPPOSITE: The Yule Ball Programme, created by Miraphora Mina and Eduardo Lima for *Harry Potter and the Goblet of Fire*, was crafted with delicate cutout lettering and pop-out snowflakes. The architectural outline echoes the elaborate ice sculptures that decorated the Great Hall for the ball; LEFT: A poster for the Yule Ball encouraged students to "dress to impress," and, thankfully, dance instructions were distributed for the Wizard Waltz.

UMBRELLAS

As Hogwarts is situated in a cold and often rainy geography, the prop makers tasked themselves with creating umbrellas for several characters.

TOP LEFT: A cat with an arched back forms the handle of an umbrella created for Professor McGonagall that echoes her Animagus form; LEFT: Two umbrellas that are clearly for Ravenclaw house, carrying their namesake bird on the handle, featuring visual development art by Dermot Power; ABOVE: For the Pensieve memory of Dumbledore's first meeting with Tom Riddle in *Harry Potter and the Half-Blood Prince*, concept artist Rob Bliss sketched out his concept for what he called the "Dumbrella," which matched the extremely stylish purple paisley suit worn by the professor.

WALKING STICKS

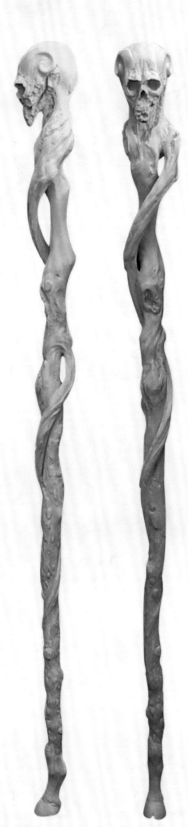

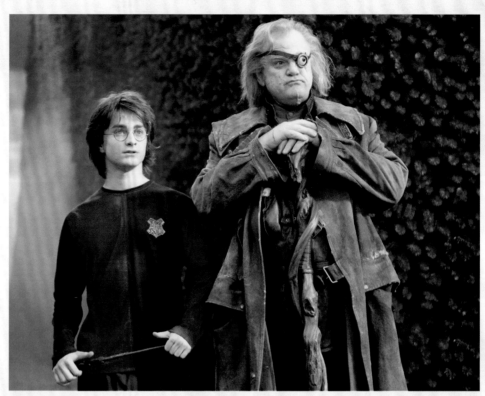

ABOVE AND LEFT: Harry Potter and Professor Alastor "Mad-Eye" Moody (Brendan Gleeson) await the final task in *Harry Potter and the Goblet of Fire*. Moody's staff complemented his shillelagh-style wand. It has a very stylized head, originally conceived as skeletal but eventually becoming an abstract ram's head, which matches the hooved foot at its bottom end; BELOW LEFT: Professor Remus Lupin took over the Defense Against the Dark Arts position at Hogwarts in *Harry Potter and the Prisoner of Azkaban*. As a symbol of the toll being a werewolf takes on him—in the manner of a chronic illness—Lupin uses a walking stick. There are astronomical and zodiac symbols on the collar of the cane, and a handle that resembles a wolf's claw; BELOW RIGHT: Lucius Malfoy's walking stick sheaths his wand in its handle, as conceived by the actor who played him, Jason Isaacs. The emerald-eyed snake handle reflected his school house of Slytherin. The fangs on the snake had removable false teeth so they would not scratch the actors, especially as the elder Malfoy would occasionally clout his son, Draco, in a scene.

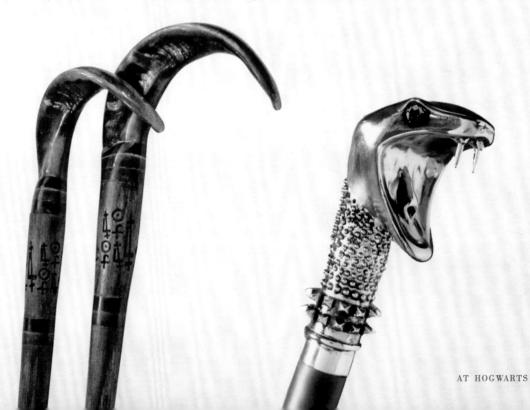

TRUNKS

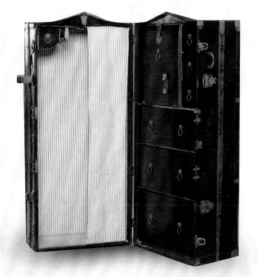

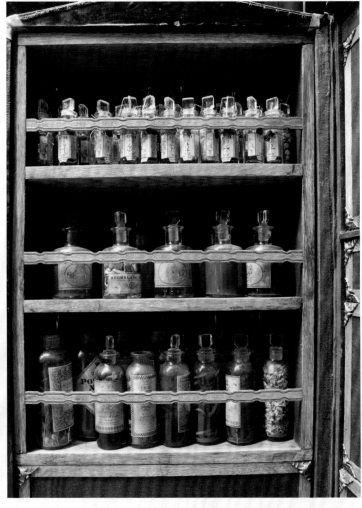

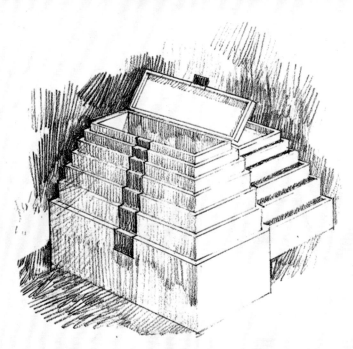

Just as every student brings a trunk to Hogwarts filled with school supplies, so do the professors: TOP LEFT: The financially poor Professor Remus Lupin wears clothes that are shabby and of pitiable quality, and his trunk follows form. It's a simple construction, a drab brown, and definitely threadbare. Practical effects were used to "pack" the trunk when Lupin tells Harry he's resigned at the end of the school year; LEFT AND ABOVE LEFT: The seven-tiered multi-lock leather trunk, which Bartemius Crouch Jr. uses to hold the real Alastor "Mad-Eye" Moody prisoner during the events of *Harry Potter and the Goblet of Fire*, was a real prop built by the special effects department. Each stage of the trunk opened mechanically to reveal the smaller level above in the fully working prop seen in a sketch by Stuart Craig (left), and visual development artwork by Rob Bliss (above left); ABOVE AND OPPOSITE: Although the trunk Professor Horace Slughorn brings with him when he returns to the post of Potions Master in *Harry Potter and the Half-Blood Prince* shows years of use, its velvety purple color and gold trim are a nod to the fashion-conscious professor. On one side of the case are rows and rows of potion bottles and ingredients, which graphic artist Eduardo Lima describes as "having been around for years and years."

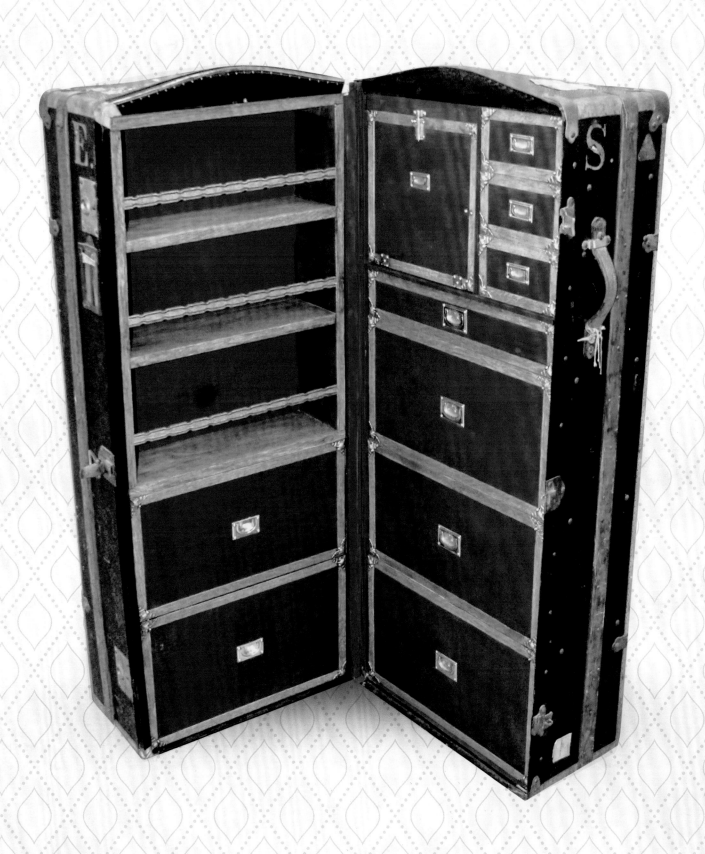

SEVERUS SNAPE'S AND HORACE SLUGHORN'S POTIONS BOTTLES

"I've never seen a more complicated potion."

—Hermione Granger, *Harry Potter and the Chamber of Secrets*

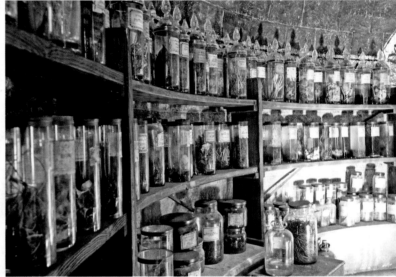

Essence of Dittany. Skinned Shrivelfig. Pepperup Elixir. The potions and potion ingredients seen throughout the Harry Potter films were held in everything from vials of several inches to jars of several feet. The original five hundred bottles for Professor Severus Snape's classroom in *Harry Potter and the Sorcerer's Stone* were filled with dried herbs and other plants, baked animal bones from a butcher, and plastic animal toys from the London Zoo gift shop. Then the graphics design team would make the labels, each one handwritten and handcrafted, which included serial numbers, lists of the ingredients, and stains and splashes of liquid. The number of potion bottles increased as Snape gained an office in *Harry Potter and the Chamber of Secrets*, and in *Harry Potter and the Goblet of Fire*, the audience is offered a glance of Snape's fully stocked storeroom. By the time Professor Slughorn took over the position as Potions Master and moved into a larger classroom in *Harry Potter and the Half-Blood Prince*, the potion bottles numbered over one thousand. The smallest ones were created by prop maker Pierre Bohanna, who sourced test tubes and cast differently shaped tops and bottoms onto them for interesting looks. A specially designed vial was created for the Felix Felicis potion, complemented by a miniature cauldron and elaborate holding clamp. And what was in the bottles when the characters needed to drink a potion? Soup! Favorite flavors included carrot and coriander.

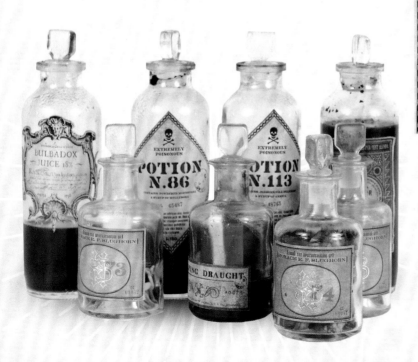

BOTTOM LEFT AND TOP RIGHT: The hundreds of potions bottles seen in the Harry Potter films, crafted in a collaboration of the props and graphic design departments, were individually labeled, and contained liquids, plant matter, and plastic toys; THESE PAGES: Though most potions came from the stores of Hogwarts as collected by Severus Snape and other Potions professors, Horace Slughorn's potions were notably labeled as being from his personal apothecarium, and so featured a specific handwriting and label style created by the graphic artists.

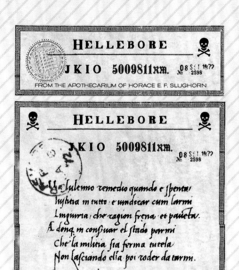

HELLEBORE

JKIO 5009811xm.

FROM THE APOTHECARIUM OF HORACE E. F. SLUGHORN

HELLEBORE

JKIO 5009811xm.

Ut Iulemo remedio quando e spentu
lustria m tutte e undscar cum larmi
Imgurra, che ragion frena et pauetu.
A dena m confuar el stado parmi
Che la milma sia ferma tutela
Non lasciando ella por roder da turm.

FROM THE APOTHECARIUM OF HORACE E. F. SLUGHORN

ACONITE
"Wolfsbane"
(TYPE 2)

EXTREMELY POISONOUS

Nº 99800

Reg.13-03/Poisons

Honey, ℔ ii. Tartar, ℥ i. ſs. Aquavita, gal. iii.

N.10
Graphorn Powder

Mummy, Maſtick, Red Myrrh,
Olibanum, Ammoniacum, Copra

A little Peece of our Ladie in
Chriſt upon her right hand By
Haniball Caratts

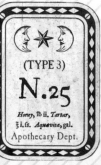

(TYPE 3)

N.25

Honey, ℔ ii. Tartar,
℥ i. ſs. Aquavita, gal.

Apothecary Dept.

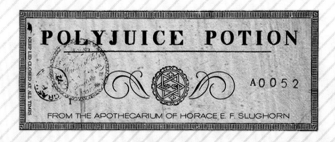

POLYJUICE POTION

A0052

FROM THE APOTHECARIUM OF HORACE E. F. SLUGHORN

Hogwarts Apothecary

Essence

of

Dittany

ℇ8483

Please handle this essence with care.
Keep lid close at all times.

Nº 0127

Mg23/1

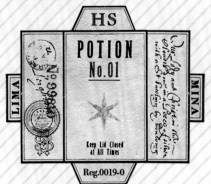

HS

POTION
No.01

Keep Lid Closed
at All Times

Reg.0019-0

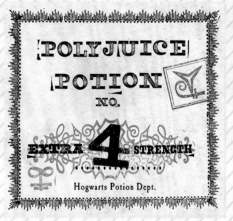

POLYJUICE POTION
NO.

EXTRA **4** STRENGTH

Hogwarts Potion Dept.

N. XXI

Purest Extraction of
SNAKEWEED

*The Dragon Dispensary
since 226*

Nº S1
Potio Nimbus

EXTREMELY POISONOUS

POTION
N.113

CONTAINS: JOBBERKNOLL FEATHERS
& SYRUP OF ARNICA

Nº 48765

L.151

FROM THE APOTHECARIUM OF
HORACE E. F. SLUGHORN

CC 61042

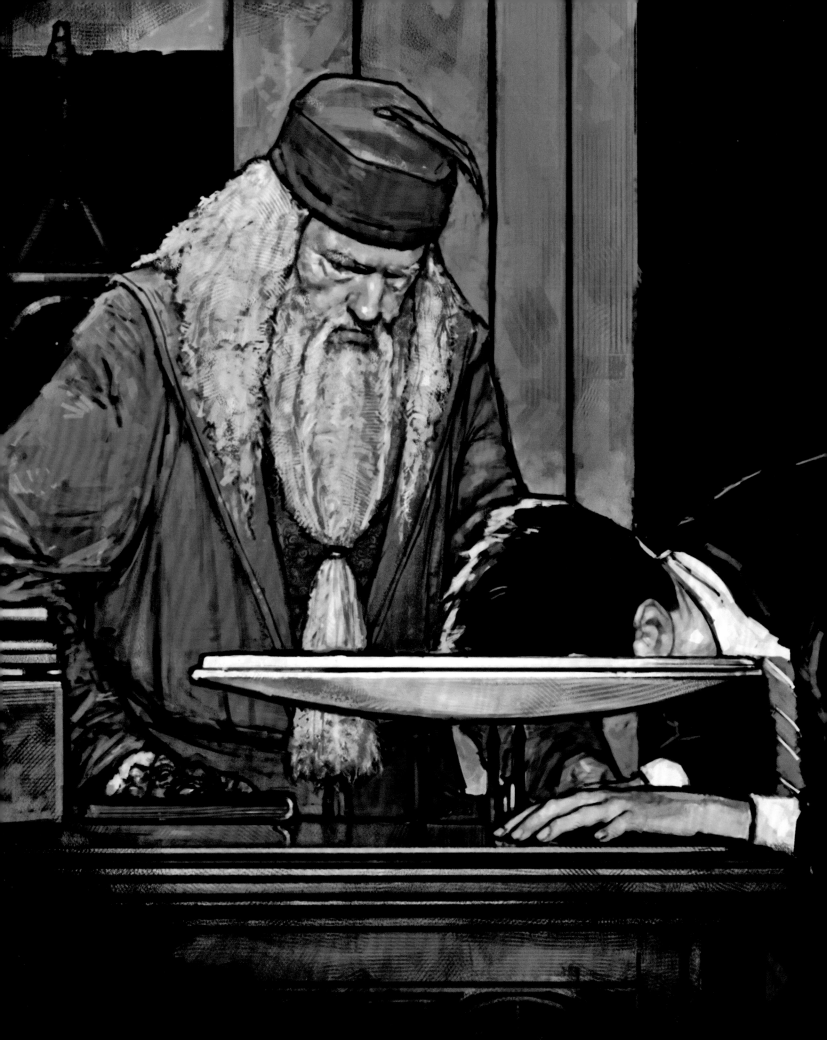

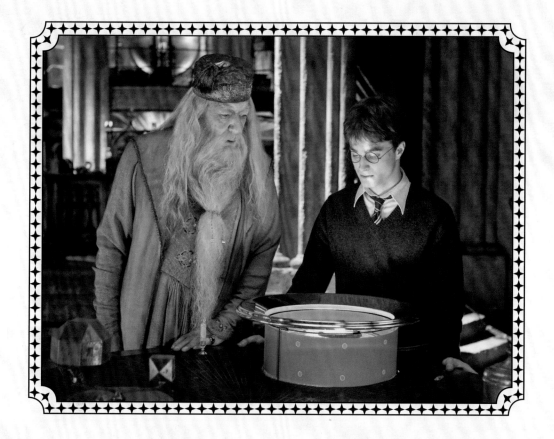

ALBUS DUMBLEDORE'S PENSIEVE AND MEMORY CABINET

"It's a Pensieve, very useful if, like me, you find your mind a wee bit stretched."

—**Albus Dumbledore**, *Harry Potter and the Goblet of Fire*

A Pensieve allows the user to view memories that have been taken from a wizard's mind. Harry Potter accidentally discovers its use when he "falls" into it in *Harry Potter and the Goblet of Fire*, into a memory of Dumbledore's where he sees Karkaroff and Barty Crouch Jr. at the Death Eater trials. Digital artists created a complex liquid surface for the Pensieve that included not only realistic "wave generations" but also threads of silver fluid eddying in the shallow basin and Harry's reflection before all dissolve into the memory.

The Pensieve bowl in *Harry Potter and the Half-Blood Prince* was no longer sunken in a tabletop but rather suspended in midair in a computer-generated version. As the memories were poured into the receptacle, they turned into inky black threads that shot downward. Once Harry's face was immersed in the liquid, the swirls formed into the memory. The Pensieve was crucial to viewing the conversation between Horace Slughorn and Tom Riddle about Horcruxes, and in *Harry Potter and the Deathly Hallows – Part 2* for

Harry to learn about Severus Snape's connection to his mother, as well as his own destiny in defeating Voldemort.

The memories used in the Pensieve are preserved in vials crafted by Pierre Bohanna in the same way he created the small vials that held potions. Their labels were designed by Miraphora Mina; each label was written by a member of the props department who then stuck them on the vials by hand. There were somewhere between eight and nine hundred vials placed very carefully into the Gothic-style memory cabinet. Meticulous attention was paid to lighting the memories from within the freestanding cylindrical cabinet, which complemented the circular design of Dumbledore's office.

OPPOSITE: Harry submerges his face in the Pensieve to view Professor Dumbledore's memory of his first meeting with Tom Riddle in artwork by Rob Bliss for *Harry Potter and the Half-Blood Prince*; ABOVE: Michael Gambon (Dumbledore, left) and Daniel Radcliffe (Harry Potter) film the same scene. The physical prop of the Pensieve is marked with VFX reference points that will be used by the visual effects crew as they create the artifact in post-production; INSET: Tom Riddle's memory vial.

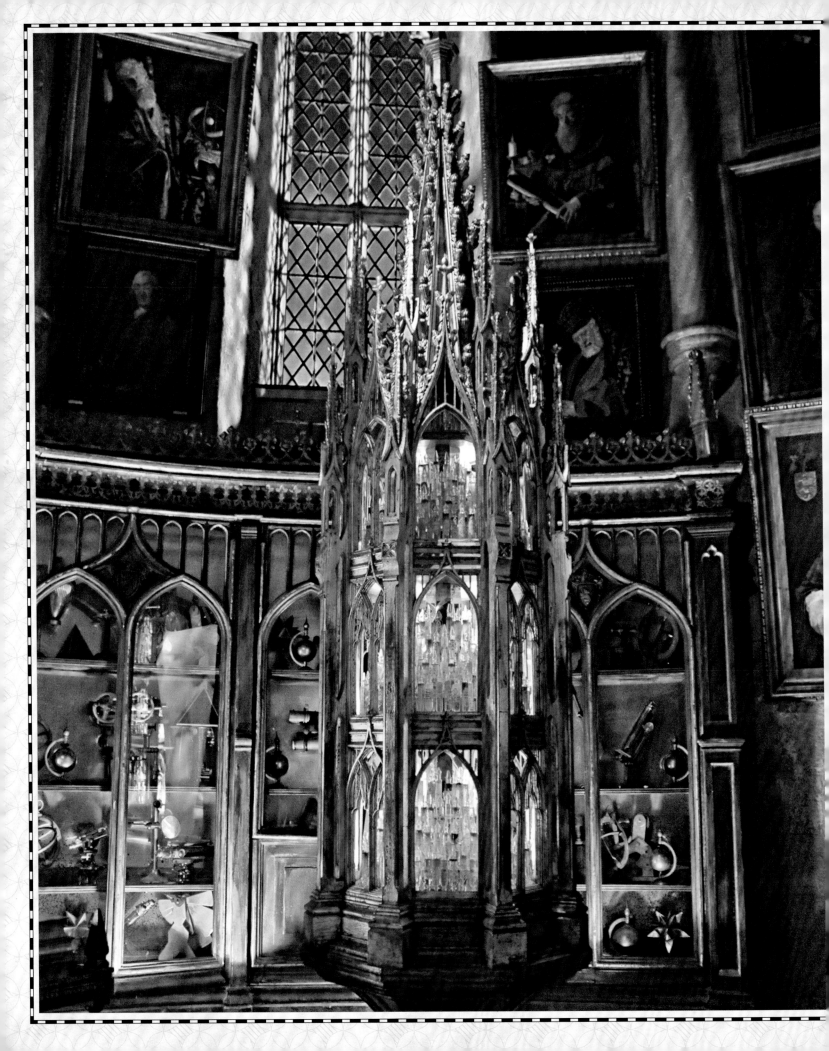

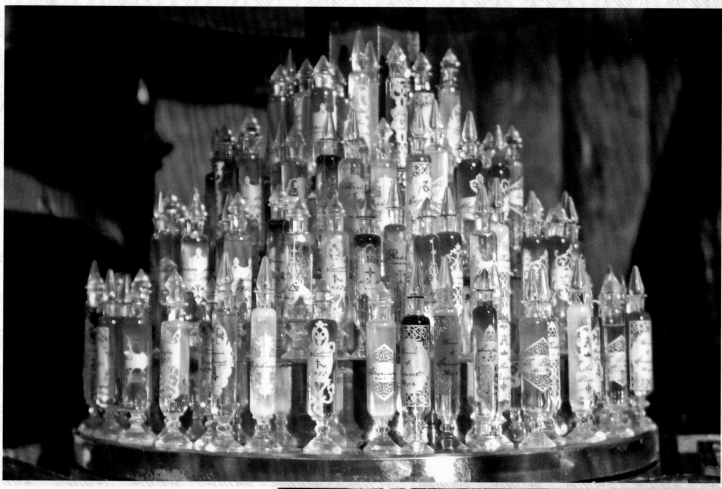

Sc.249 Int.Shrieking Shack

11

A — C.U.
SNAPE —
SILVERY
BLUE
LIQUID
SEEPS
FROM HIS
EYES ..

CUT

B — WIDER —
HERMIONE
CONJURES
FLASK &
GIVES IT
TO HARRY ..

CUT

C — EX.C.U.
THE
TEARS
FLOW
INTO
THE
FLASK.

CUT

D — LOW ANGLE —
HERMIONE
& HARRY
LOOK DOWN
TO CAM. —
RON
APPEARS
IN B.G.
'HE'S GONE.'

CUT

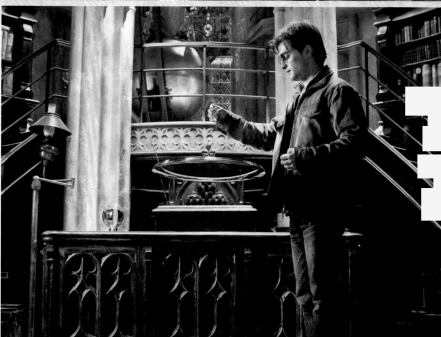

OPPOSITE: The memory cabinet in Dumbledore's office, *Harry Potter and the Half-Blood Prince*. Its door and walls were removable—the vials were placed on its shelves first, so that props personnel could work from all sides, then the door and walls were reattached; TOP: Each shelf contained several levels of individually hand-lettered memory vials; LEFT: Storyboard art for *Harry Potter and the Deathly Hallows – Part 2* plots out how Harry Potter will capture Severus Snape's memory-filled tears in a flask for viewing in the Pensieve, originally set in the Shrieking Shack; ABOVE: Harry Potter prepares to view Professor Snape's memory in *Harry Potter and the Deathly Hallows – Part 2*.

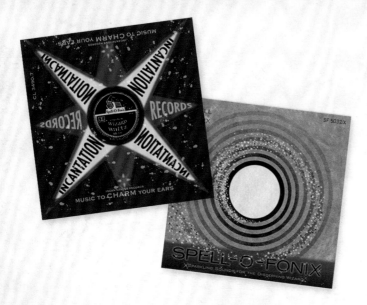

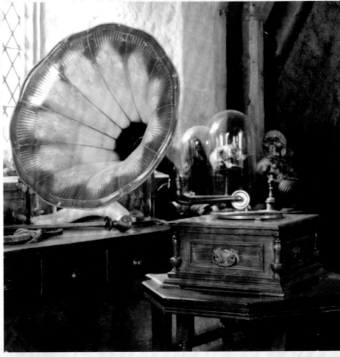

REMUS LUPIN'S GRAMOPHONE AND RECORDS

"Riddikulus!"

—Remus Lupin, *Harry Potter and the Prisoner of Azkaban*

Professor Lupin accompanies his lesson on how to perform a simple charm to repel a Boggart in *Harry Potter and the Prisoner of Azkaban* with a snappy jazz number played on a gramophone, a way to portray him as the most playful and beloved of Defense Against the Dark Arts teachers. The real working record player was manufactured by C. Gilbert & Co. under its economic "Geisha" brand in the 1920s and has a morning glory–style horn attached to the cabinet. The name of the song Lupin plays is "Witchita Banana."

Professor McGonagall also uses a gramophone in *Harry Potter and the Goblet of Fire* for her dance lesson before the Yule Ball. Its gigantic cygnet-style horn was created by the props department, but again, the cabinet supported a real working model. The music here was the "Wizard Waltz" on the Spell-O-Fonix label.

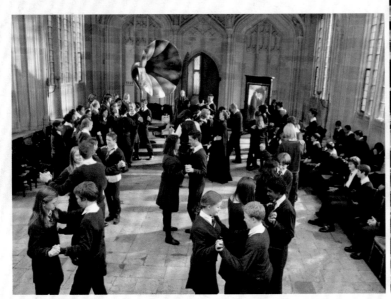

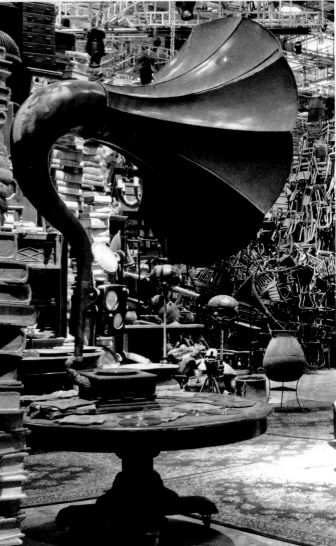

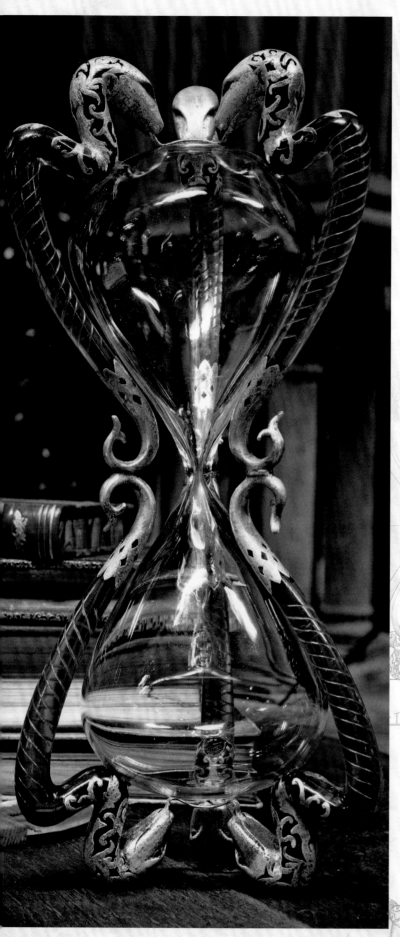

HORACE SLUGHORN'S HOURGLASS

"A most intriguing object. The sands run in accordance with the quality of the conversation. When it is stimulating, the sands run slowly..."

—Horace Slughorn, *Harry Potter and the Half-Blood Prince*

The hourglass admired by Harry Potter when he visits Professor Slughorn's office in *Harry Potter and the Half-Blood Prince* in order to persuade him to disclose his untampered memory of Tom Riddle was a creation for the film. Three silver-headed snakes meet at each end of the green-tinted hourglass in tribute to Slughorn's Slytherin House.

OPPOSITE TOP LEFT: Popular selections from the Spell-O-Fonix label; OPPOSITE TOP RIGHT: Professor Lupin's gramophone, seen in *Harry Potter and the Prisoner of Azkaban*; OPPOSITE BOTTOM LEFT AND RIGHT: The gramophone used for the dance lessons in *Harry Potter and the Goblet of Fire* was among myriad artifacts placed on the set of the Room of Requirement for *Harry Potter and the Half-Blood Prince* and *Harry Potter and the Deathly Hallows – Part 2*; LEFT: An empty version of Slughorn's hourglass featuring the black and green of Slytherin's house colors. The snakes' tongues extend and unite to cradle the glass; BELOW: Visual development art of the hourglass by Miraphora Mina; BACKGROUND: A detailed blueprint for the hourglass by Amanda Leggatt.

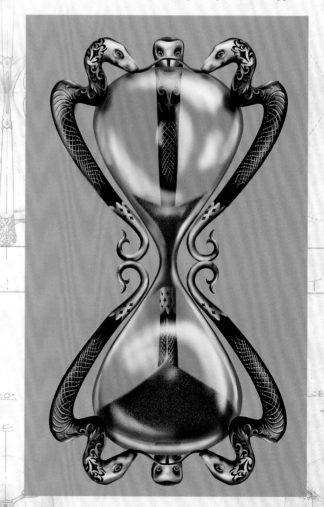

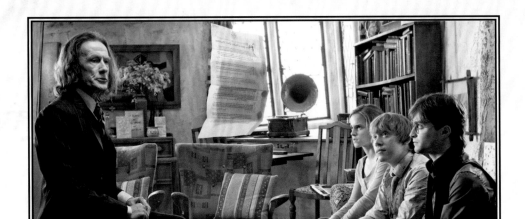

ALBUS DUMBLEDORE'S WILL

"Herein is set forth the Last Will and Testament of Albus Percival Wulfric Brian Dumbledore ..."

—Rufus Scrimgeour, *Harry Potter and the Deathly Hallows – Part 1*

One key theme that Miraphora Mina liked to employ in her designs was a sense of discovery. The layers of Albus Dumbledore's will, read to Harry Potter, Ron Weasley, and Hermione Granger by Minister for Magic Rufus Scrimgeour in *Harry Potter and the Deathly Hallows – Part 1*, satisfy this aim. To Mina, "the layers came from the thought that maybe, at the last minute, he added in the stuff for the three kids." After the paper was stained and aged by the graphics department, their hardest task was placing on a wax seal. "With certain papers," Mina explains, "the wax can bleed through the paper or leave a greasy mark. This paper was very resistant, and it kept falling off." Finally, she switched to a type of wax used by the Bank of England and the seal stuck.

TOP: The Minister for Magic, Rufus Scrimgeour (Bill Nighy), reads the bequests from Dumbledore's will to Hermione Granger (Emma Watson), Ron Weasley, and Harry Potter in *Harry Potter and the Deathly Hallows – Part 1*; RIGHT: Dumbledore's will. As paper artifacts in the Harry Potter series needed to be produced in duplicate for filming, the fonts were digitally produced for consistency.

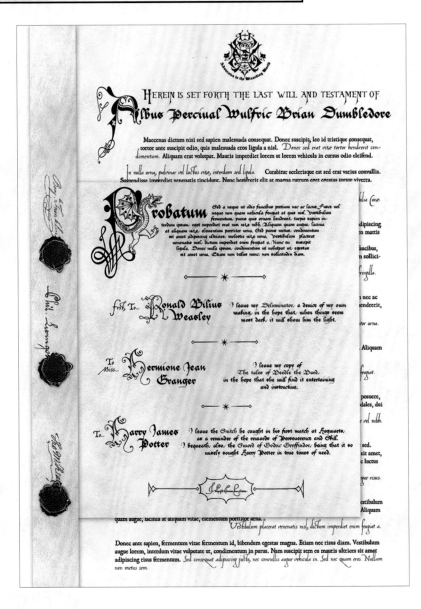

TIME-TURNER

"Don't be silly. How could anyone be in two classes at once?"

—Hermione Granger, *Harry Potter and the Prisoner of Azkaban*

When graphic artist Miraphora Mina was briefed on creating the Time-Turner that Hermione Granger uses in *Harry Potter and the Prisoner of Azkaban* to follow a seemingly grueling class schedule, she knew she wanted the piece to be inconspicuous but also have an element that moved in it. In addition to clocks and watches, Mina investigated astrological instruments as a source of inspiration. "I looked at astrolabes and what was nice about them was they were flat instruments, which to me felt discrete," she recalls. The Time-Turner couldn't be that obvious when Hermione was wearing it until she showed it to Harry. "But when she uses it, it comes alive, it becomes 3-D because it's really a ring within a ring that opens up to allow part of it to spin." Mina also needed to take into account the way the Time-Turner's chain was

used. "The script described an action where Hermione extends the chain to circle her and Harry," Mina continues, "so it was created with a double catch that allowed the chain to widen to fit around them both. But normally it wouldn't hang really long around her neck." The final touches to the piece of golden jewelry were two mottos about time Mina had engraved upon it. The outside ring reads, "I mark the hours every one, nor have I yet outrun the sun" and, on the inside ring: "My use and value unto you depends on what you have to do."

BELOW: Development art by Dermot Power for *Harry Potter and the Prisoner of Azkaban* imagined the Time-Turner in various forms, placing an hourglass-shaped turning element within clocks, vials, and pendants; ABOVE: The final Time-Turner, designed by Miraphora Mina.

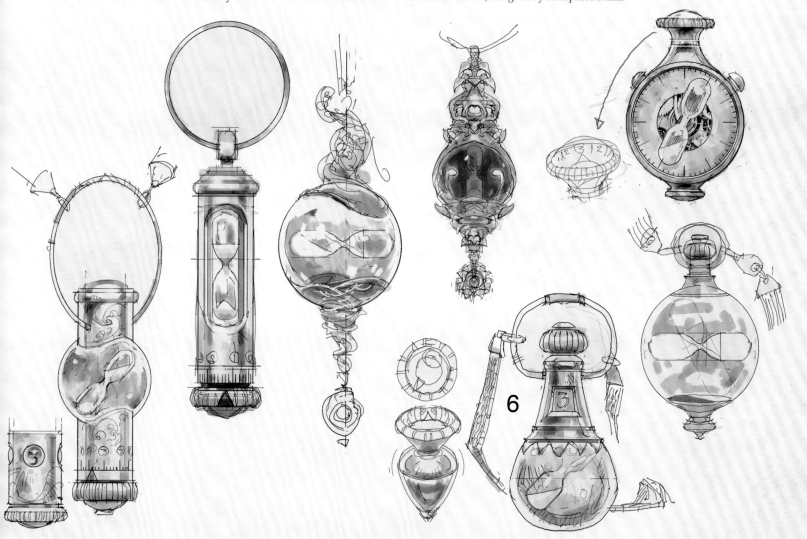

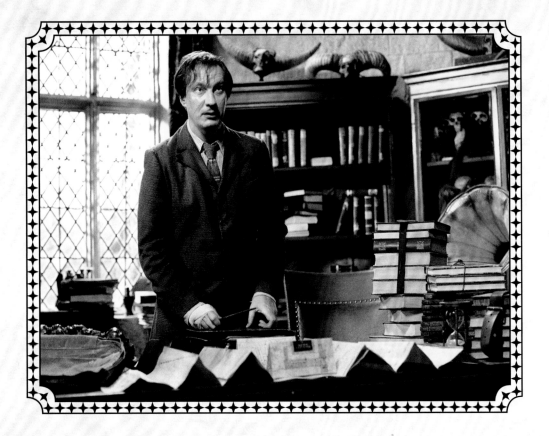

THE MARAUDER'S MAP

"Messrs. Moony, Wormtail, Padfoot & Prongs are proud to present the Marauder's Map."

—James Potter, Sirius Black, Remus Lupin, Peter Pettigrew, *Harry Potter and the Prisoner of Azkaban*

Throughout the Harry Potter films, Harry acquires tools that will help him in his journey toward defeating Voldemort. One such artifact is the Marauder's Map, which is a catalyst to a chain of plot points that define the story of *Harry Potter and the Prisoner of Azkaban*. Getting the map gets him to Hogsmeade, where he overhears devastating information about Sirius Black. The map then reveals the presence of Peter Pettigrew in Hogwarts, and Harry alerts Remus Lupin to this fact, setting up the confrontation of the remaining Marauders where new truths are learned about the death of Harry's parents.

When briefed with the task of creating the Marauder's Map given to Harry Potter by the Weasley twins in *Harry Potter and the Prisoner of Azkaban*, Miraphora Mina knew she needed to keep in mind the students who created the map in the story. "It was designed by four cunning kids," she explains, "who were smart and knew what they were doing. We definitely didn't want it to be a treasure island–type map with burnt edges that rolled up." Mina and Eduardo Lima decided that the map needed to fold and have multiple layers, "because Hogwarts does feel like it just goes on and on. That was the impression I got from descriptions of the school, that it was kind of boundless. We felt the map had to have a three-dimensional form to give it the sense

that every time you unfolded it, you could be going down to another layer of the school and there could always be another layer that you hadn't discovered yet." Mina was also influenced by the moving staircases in *Harry Potter and the Sorcerer's Stone*, and thought a folded map would give the feeling of three-dimensional steps. And finally, the film series' production designer, Stuart Craig, "was always very keen on maintaining the relationship between the architecture of the school and anything that came near it." So to design the map, Mina used the architectural drawings for the sets and traced over them. "So the Marauder's Map is architecturally correct," she affirms. "We tried to show the complicated layers of the map, but in spite of all the work and research we did, we still made mistakes. For a long time, the Room of Requirement was part of the design until somebody spotted it!" The Room was quickly covered over so it could not be found (unless you know where to look). As most props and especially hero props need to be made multiple times, Mina and Lima ensured that the structure

ABOVE: Professor Remus Lupin returns the Marauder's Map to Harry Potter at the end of *Harry Potter and the Prisoner of Azkaban*. The map folded back up in a simple practical effect utilizing thread; OPPOSITE: A detail of the first version of the Marauder's Map showcases the three levels of Dumbledore's circular office. The map's design evolved though the films, as did Hogwarts castle.

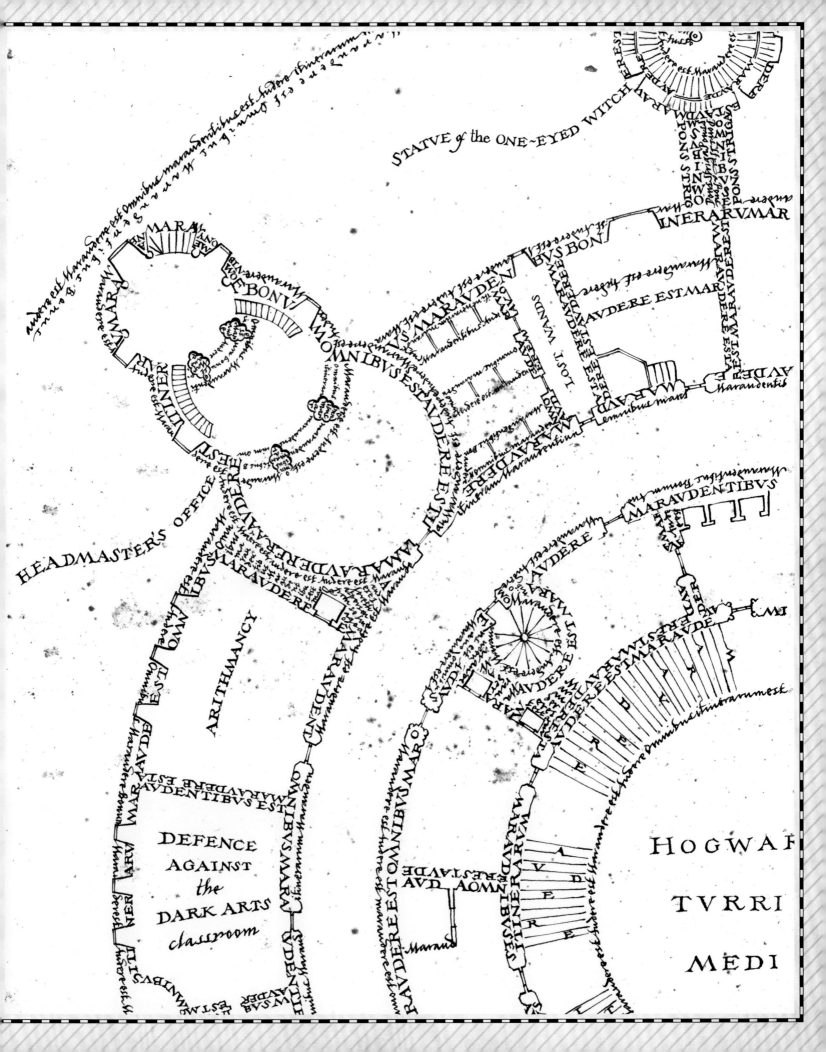

STATVE of the ONE~EYED WITCH

HEADMASTER'S OFFICE

ARITHMANCY

DEFENCE
AGAINST
the
DARK ARTS
classroom

LOST WANDS

INERARVMAR

AVDERE EST MAR

HOGWAR

TVRRI

MEDI

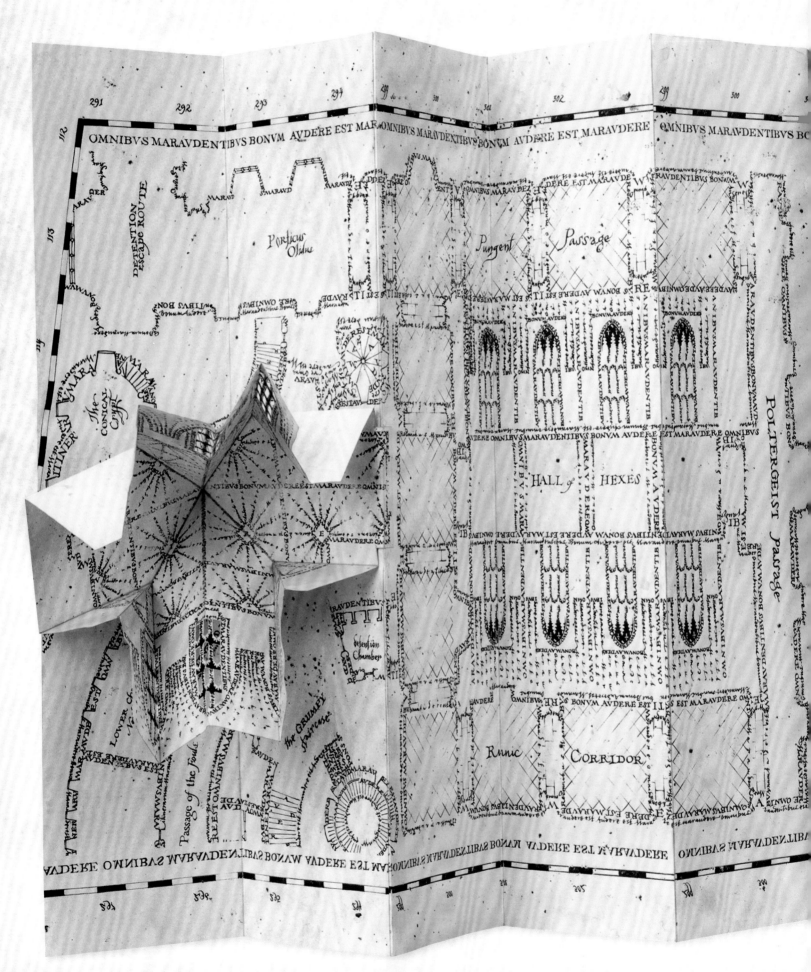

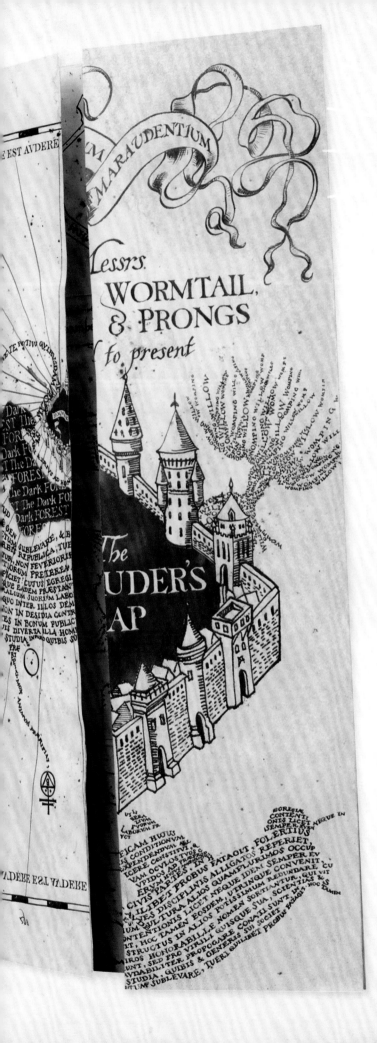

of the map could be easily photocopied. The map also needed to fold magically at one point in *Harry Potter and the Prisoner of Azkaban*, accomplished by a practical effect using thread. The only digital effects were the footsteps and the rippling words when it is seen in close-up.

Obviously, the Marauder's Map wasn't entirely finished when it premiered in the third film. "When we started designing the map," says Lima, "we didn't know how the map was going to come back in the other films, so we needed to design it in a way that we could keep adding the other parts of the castle." It was revised for *Harry Potter and the Order of the Phoenix*, when Dumbledore's office, the courtyard, and some new corridors were layered in, as well as for *Harry Potter and the Half-Blood Prince* and *Harry Potter and the Deathly Hallows – Part 1* and *Part 2*.

One of the most striking features of the map is its aged, sepia-colored appearance. "You can't really print aging," explains Mina. "Sometimes we print a color on the inside pages of a book that will read as old, but generally, each piece of paper must go through a process." "We have a secret formula," adds Lima. "Basically, it is a combination of coffee, sandpaper, and love," he says with a laugh. (The coffee in the secret formula was Nescafé Gold.) Some stains and spots were printed on the paper in the interest of consistency, but each page was individually "dunked" in a solution of water and coffee and dried before assembly. Mina and Lima would fill the art department's hallways with these coffee-scented pages.

From her research, Mina developed another idea for the map: to use words and letters instead of lines to delineate the areas. "It's in Latin," she explains. "Eduardo and I put in things about marauders and other sneaky concepts." The designers also found a phrase that they had translated and used to demarcate as room and tower walls and as a border that includes the concepts of daring (*audere*) and goodness (*bonum*). English phrases (if not written by the Marauders, then by Fred and George) include "Undercover route to the kitchens" and "Detention escape route." "Again, it was the idea that the people who created this were cheeky," explains Mina. "But they were also intellectually advanced enough to want to do something that was clever and visual." For example, the two words "Whomping Willow" (spelled "womping willow") are written repeatedly to form the branches and trunk of the tree. The lettering was turned into a font to save production time of the map. Runic symbols appear in places without any rhyme or reason, which, Mina says, "was frequently a type of visual shorthand for us to make things looks interesting."

THESE PAGES: Another layer of the Marauder's Map, created by Miraphora Mina and Eduardo Lima, seen in *Harry Potter and the Order of the Phoenix*. Actor Daniel Radcliffe (Harry Potter) had to ensure that necessary story elements were visible when he folded or unfolded the map.

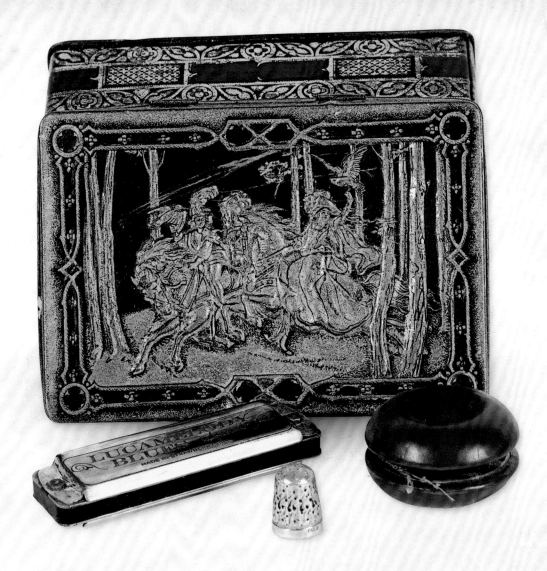

TOM RIDDLE'S TREASURES

"Thievery is not tolerated at Hogwarts, Tom."

—Albus Dumbledore, *Harry Potter and the Half-Blood Prince*

In *Harry Potter and the Half-Blood Prince*, Harry Potter is shown the saved memory of Albus Dumbledore's first meeting with Tom Riddle, in Wool's Orphanage. There, Dumbledore becomes aware of Tom's habit of taking items—in this case, from others in the orphanage. A small tin box belonging to Tom contains, among other artifacts, a thimble, a harmonica, and a yo-yo. Throughout the Harry Potter films, when tasked with branding something that was not specified in the books, the graphic artists would cleverly construct these from their research or, depending on the artifact, their surroundings and their friends and families. The harmonica is manufactured by "Lucamelody," more than likely a reference to Miraphora Mina's son, Luca. Strawberry Hill, the place of the harmonica's manufacture, is the name of an estate previously owned by Horace Walpole, son of Britain's first prime minister and a compulsive collector, which is located only one hour from where the films were shot at Leavesden Studios.

VANISHING CABINET

"I think from what you described … the object Draco is so interested in, is a Vanishing Cabinet."

—Arthur Weasley, *Harry Potter and the Half-Blood Prince*

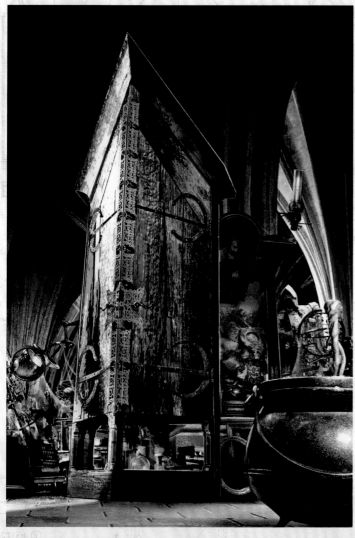

In a plan to allow Death Eaters to gain entry into Hogwarts Castle in *Harry Potter and the Half-Blood Prince*, a Vanishing Cabinet is concealed in the Room of Requirement by Draco Malfoy. Two such cabinets will allow passage between them, and Draco needs to make sure that the cabinets will work properly before their invasion. Director David Yates wanted the cabinet to look both mysterious and threatening, as it was an article of Dark magic. "Stuart Craig saw that a simple and strong silhouette was the best way to convey this feeling," explains props art director Hattie Storey, "especially in a set that overflowed with an eclectic array of other props and furniture." The imposing, obelisk-shaped cabinet has a dark finish overlaid with the effect of an ancient flaking lacquer. It boasts an intricate locking mechanism of fretted bronze that was devised and engineered by Mark Bullimore, the special effects technician who also created the locks for the Gringotts Bank vaults and the Chamber of Secrets.

OPPOSITE: Tom Riddle kept his "treasures"—taken from other students—in a blue and silver metal box in *Harry Potter and the Half-Blood Prince*. The box features a scene of wizards and witches holding birds of prey as they ride through a forest; LEFT: The Vanishing Cabinet in Andrew Williamson's concept art for *Harry Potter and the Half-Blood Prince* towers over other artifacts stored in the Room of Requirement; BELOW: Digitally composited visual development art created by Williamson features Draco Malfoy next to the cabinet, almost lost in the vastness of the room; BACKGROUND: Draft work of the cabinet by Hattie Storey.

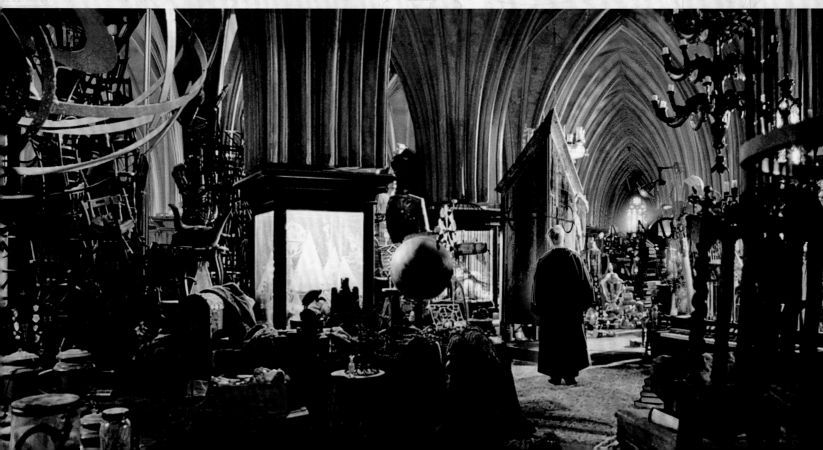

"Quidditch is great. Best game there is!"
—Ron Weasley, *Harry Potter and the Sorcerer's Stone* film

The popular wizarding sport of Quidditch plays an important role in Harry Potter's story. The game's object is to score the most points by shooting a Quaffle through one of three hoops, or by catching the Golden Snitch. In each team of seven players, there are three Chasers who try to score goals with the Quaffle, two Beaters who hit two Bludger balls at the opposing team or keep the other team's Bludgers away from their own team, a Keeper who guards the goal posts, and a Seeker, whose job it is to catch the Golden Snitch. Harry's natural skill at riding a broom—first seen when he retrieves a Remembrall tossed into the air by Draco Malfoy in *Harry Potter and the Sorcerer's Stone*—leads him to become, as Ron Weasley informs him, "the youngest Seeker in a century" in the school's history of the sport. Harry's talent is brilliant, even though he catches his first Golden Snitch with his mouth, an important story point that doesn't pay off until the last film.

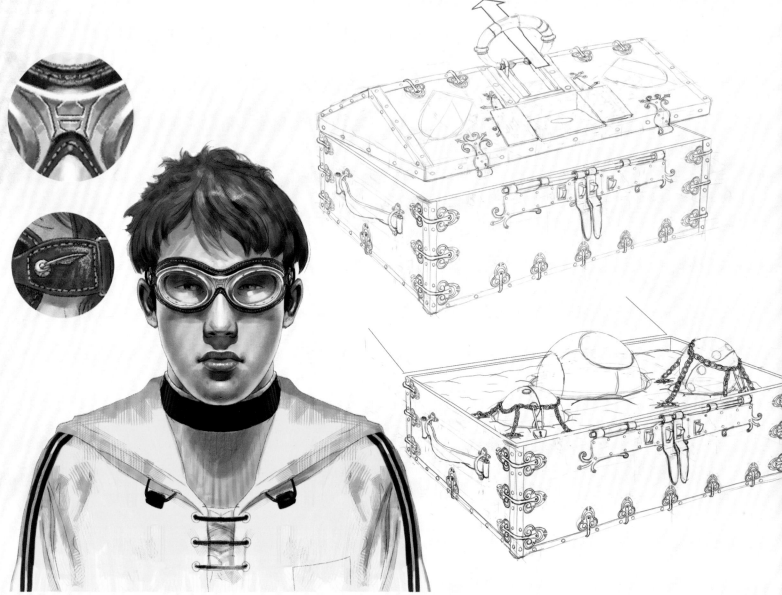

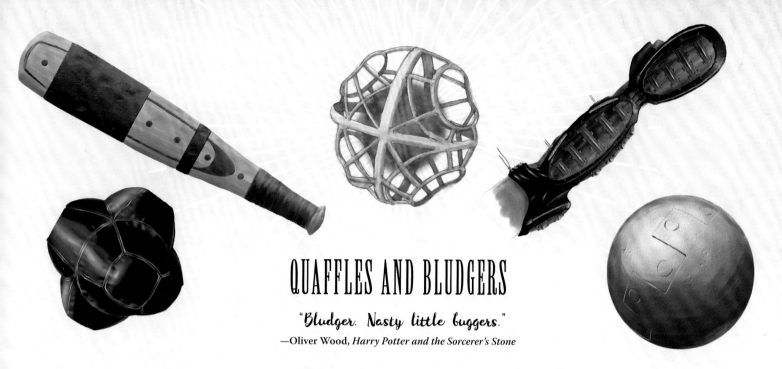

QUAFFLES AND BLUDGERS

"Bludger. Nasty little buggers."

—Oliver Wood, *Harry Potter and the Sorcerer's Stone*

In the real world, a Quaffle would appear to be sort of a cross between a basketball and a soccer ball. Production designer Stuart Craig sketched out concept art for all the Quidditch equipment, including size (a nine-inch diameter for the Quaffle) and texture ideas, and then the prop makers took the approved designs and turned them into working sports equipment. The four Quaffles that were created for the films had a red-colored leather cover wrapped over a core of foam. The stitching is concealed, and a Hogwarts crest logo is debossed on the opposite sides of the ball, faded and scratched up from years of use.

Bludgers are intended to be much heavier than Quaffles. The small black spheres are quick, dense, and very dangerous, as they are whacked by the Beaters with short wooden hand bats. "Bays," which are special arm guards used in cricket matches, were an important safety feature of the players' uniforms. The bays start at the shoulder and went down to the wrist. As play became more aggressive through the years, more and more uniform padding and even a helmet were added.

Each ball used in Quidditch needed to have its own sound as it flew through the air. Since the Quaffle is the biggest ball in the game, it makes a loud thunk when captured or hit by a player. The sound designers decided that since Bludgers were "nasty little buggers," as Gryffindor captain Oliver Wood calls them, they should sound like an angry animal when struck.

OPPOSITE TOP: Harry Potter flees a rogue Bludger in *Harry Potter and the Chamber of Secrets*; OPPOSITE BOTTOM RIGHT: Concept sketches for a trunk that holds the Quidditch equipment with chains that hold impatient Bludgers in place; OPPOSITE LEFT: Adam Brockbank's concept art for a pair of goggles to be worn when inclement weather impeded the Quidditch matches; ABOVE LEFT TO RIGHT: Concept designs for a Bludger, a Bludger bat, a Quaffle, a protective arm guard, and another Bludger; BELOW RIGHT: Design for a hand bat, all by Stuart Craig and drawn by Gert Stevens; BELOW LEFT: Detailed visual development art for the final iteration of the Quaffle indicates placement of the Hogwarts crest on the ball.

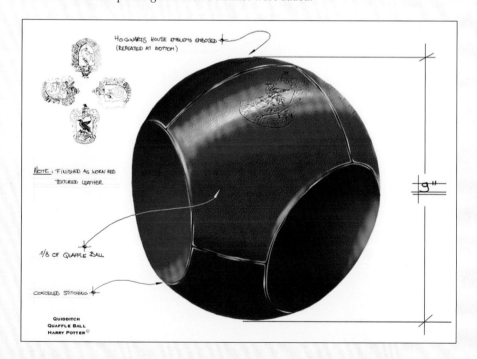

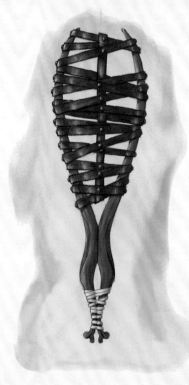

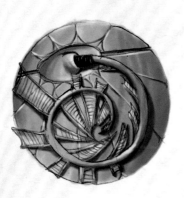

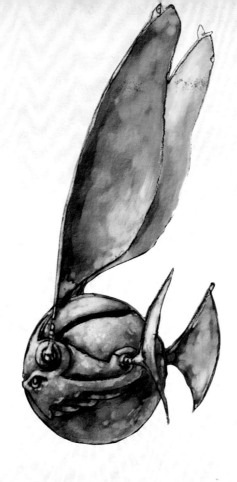

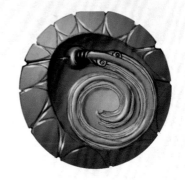

THE GOLDEN SNITCH

"The only ball I want you to worry about is this ... the Golden Snitch."

—Oliver Wood, *Harry Potter and the Sorcerer's Stone*

The Golden Snitch flies around the Quidditch pitch with amazing speed, wings fluttering furiously as it darts up and down, and side to side, eluding and teasing each team's Seeker. Various designs were considered for both the wings and the body of the Golden Snitch in order to give it credible aerodynamics; some wings were moth-shaped while others were sail-shaped, with ribs that went either horizontally or vertically across them. One Golden Snitch had rudders resembling fish fins. The walnut-sized ball of the Golden Snitch also went through several design iterations, but eventually the final prop included thin, ribbed wings in an abbreviated sail shape attached to an Art Nouveau–style body. The actual mechanics of the wings retracting and expanding were also important to the design. "In theory," says Stuart Craig, "the wings retract into the grooves on the sphere so that it reverts back to being just a ball." The multiple versions of the Golden Snitch prop were electroformed in copper and then plated with gold. However, it was the special effects team that made the Golden Snitch fly and the sound design team that gave the small, elegant ball a hummingbird-like sound. When needed, the computer artists also created a reflection of the Golden Snitch in Harry's glasses to make the illusion complete.

TOP AND ABOVE RIGHT: A hero prop for a true hero. Visual development art by Gert Stevens of the Golden Snitch for *Harry Potter and the Sorcerer's Stone* offered different possibilities for wing and rudder designs, and positions for how the wings would wrap back onto the ball; RIGHT: The Golden Snitch as seen in *Sorcerer's Stone*; OPPOSITE: The final Golden Snitch.

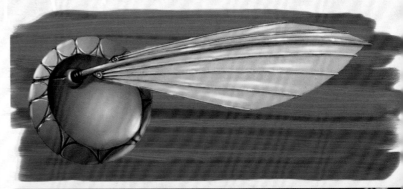

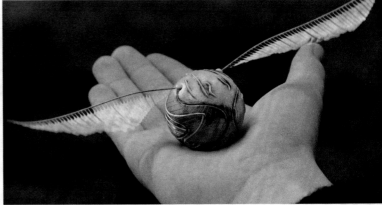

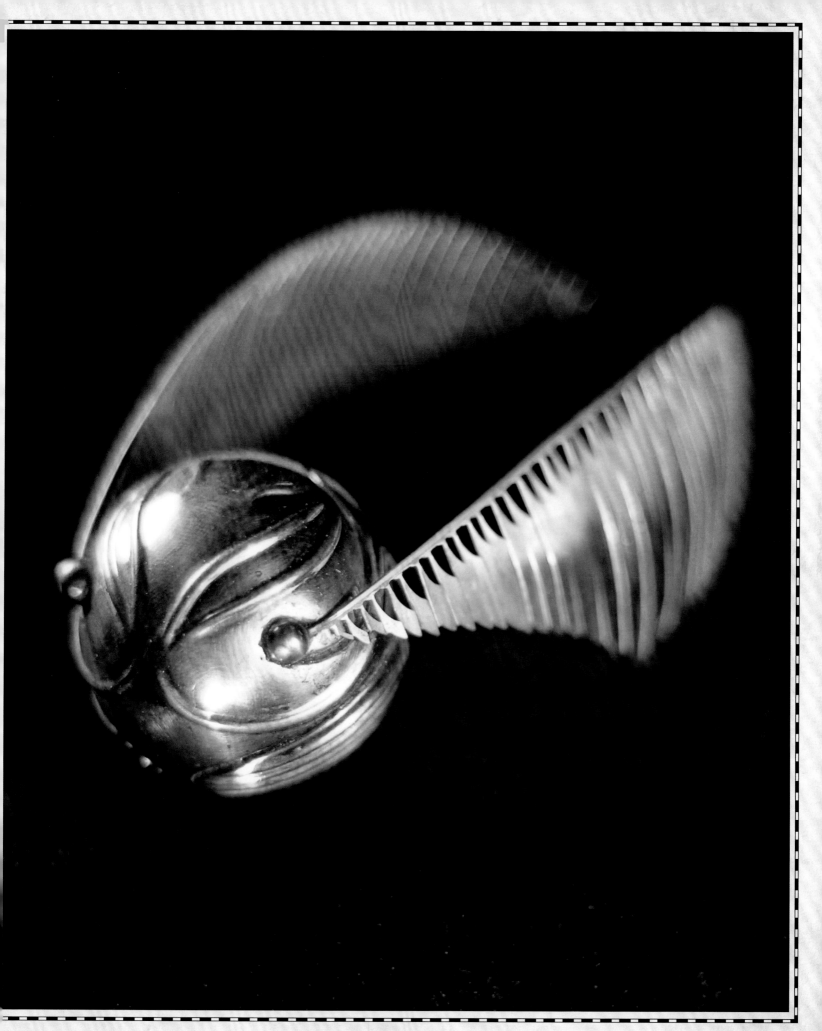

HOUSE POINTS HOURGLASSES

"Your triumphs will earn you points. Any rule breaking, and you will lose points. At the end of the year, the House with the most points is awarded the House Cup."

—Minerva McGonagall, *Harry Potter and the Sorcerer's Stone*

Mounted on the wall to the right of the Great Hall's High Table are four large hourglass-shaped cylinders representing the Houses of the school, respectively in the order of Slytherin, Hufflepuff, Gryffindor, and Ravenclaw. Filled with precious "gems" (emeralds, yellow diamonds, rubies, and sapphires), the hourglasses release these down or back up to indicate points won and lost by the students in each House. Instead of jewels, production designer Stuart Craig loaded the hourglasses with tens of thousands of glass beads, which caused a national shortage of these in England. The hourglasses were fully functional; attention was paid at the beginning of each school year to having the beads occupy only the shorter top portion of the glasses until classes started.

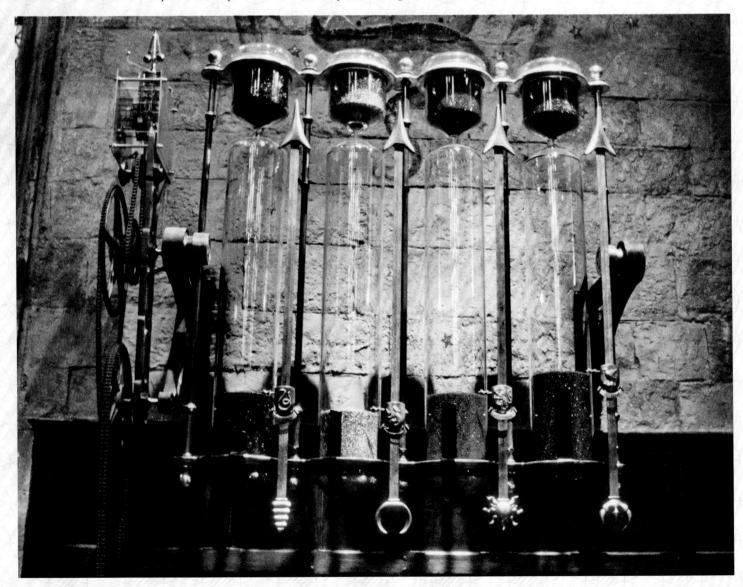

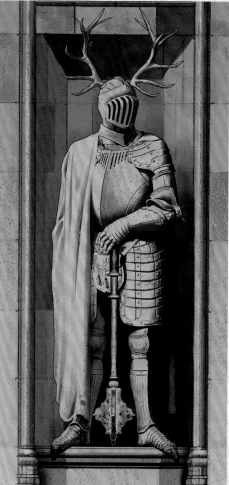
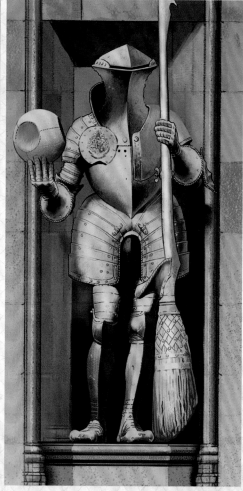

THE FIGHTING KNIGHTS OF HOGWARTS

"Piertotum Locomotor!"

—Minerva McGonagall, *Harry Potter and the Deathly Hallows – Part 2*

In *Harry Potter and the Deathly Hallows – Part 2*, the final battle between good and Dark forces—and the final confrontation between Harry Potter and Lord Voldemort—is fought on the grounds and in the hallways of Hogwarts. Teachers, students, and other school personnel are involved, including defenders as yet unseen to this point: the statues of armor-suited knights that are brought to life to protect the school. Jumping down from their perches, they march to battle at the command of Professor McGonagall (who always wanted to use the spell to do that). Concept artists Adam Brockbank and Andrew Williamson drafted knights equipped with chain mail, maces, battleaxes, and shields, several of which show clear allegiance to one of the four Hogwarts houses. One sports a sporran, the leather pouch that is part of traditional Scottish Highland attire, typically worn over a kilt, and another seems better suited to play in a Quidditch match. The knights came to life thanks to a combination of practical and digital effects. Fiberglass models of the knights were cast and then painted to look like stone. These models were then cyberscanned into the computer for their knightly locomotion.

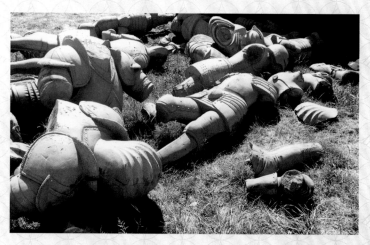

OPPOSITE: The House Points Hourglasses with Ravenclaw right then in the lead for the House Cup; TOP: Visual development art of the Fighting Knights by Adam Brockbank featuring individualized weapons and shields; ABOVE: Post-battle, the fiberglass versions of the knights lie in pieces on the field.

ELF AND
TROLL ARMOR

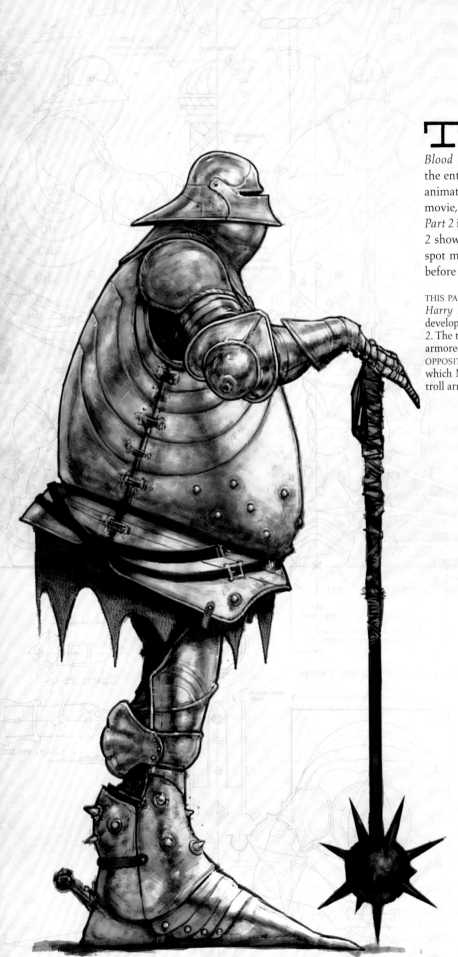

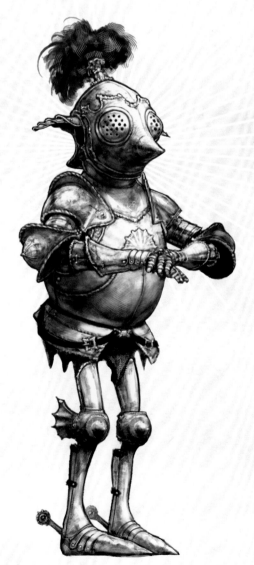

The filmmakers constantly explored ideas that might enhance locations or action sequences. For *Harry Potter and the Half-Blood Prince* it was proposed that armored troll and elf statues in the entrance hall stairway of Hogwarts would come to life via digital animation. This particular concept didn't end up making it into that movie, but was realized in *Harry Potter and the Deathly Hallows – Part 2* in the Fighting Knights. Concept art for *Deathly Hallows – Part 2* shows that armored elves might have joined them. Sharp eyes can spot manufactured troll and elf armor in the Room of Requirement before it is destroyed by Fiendfyre.

THIS PAGE: Concept artist Rob Bliss's visual development for troll armor for *Harry Potter and the Half-Blood Prince* stands next to Adam Brockbank's development art of elf armor for *Harry Potter and the Deathly Hallows – Part 2*. The two suits of armor are not to scale—the elf would barely top the troll's armored shoe; BACKGROUND: Draft work by Emma Vane of the troll armor; OPPOSITE: Storyboard art plots out a possible scene for *Half-Blood Prince* in which Mr. Filch and Mrs. Norris are distracted by a mouse scurrying within troll armor as Harry Potter walks by unseen.

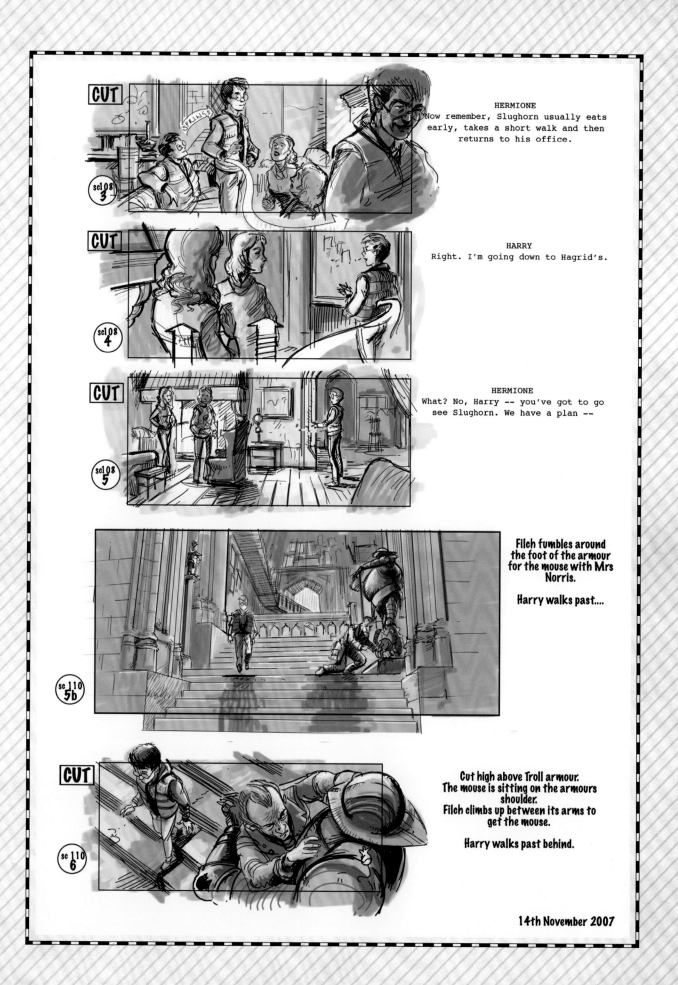

CUT
scl08 3

HERMIONE
Now remember, Slughorn usually eats early, takes a short walk and then returns to his office.

CUT
scl08 4

HARRY
Right. I'm going down to Hagrid's.

CUT
scl08 5

HERMIONE
What? No, Harry -- you've got to go see Slughorn. We have a plan --

sc110 5b

Filch fumbles around the foot of the armour for the mouse with Mrs Norris.

Harry walks past....

CUT
sc110 6

Cut high above Troll armour. The mouse is sitting on the armours shoulder. Filch climbs up between its arms to get the mouse.

Harry walks past behind.

14th November 2007

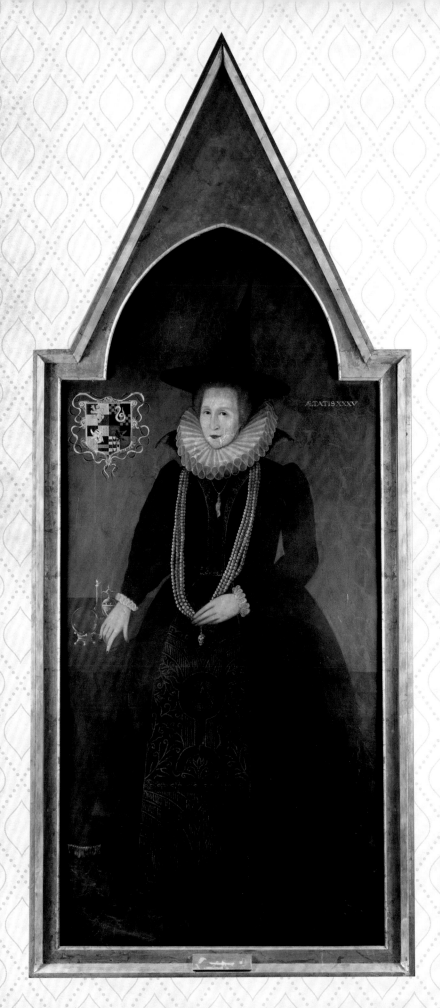

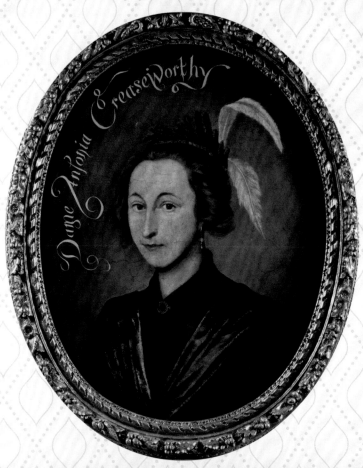

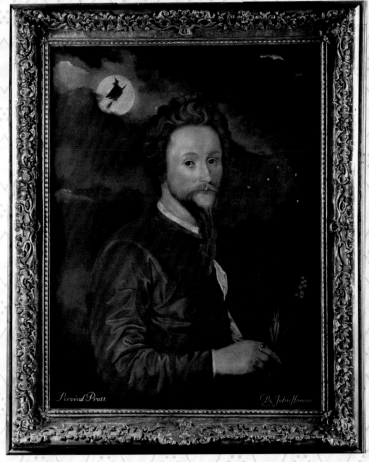

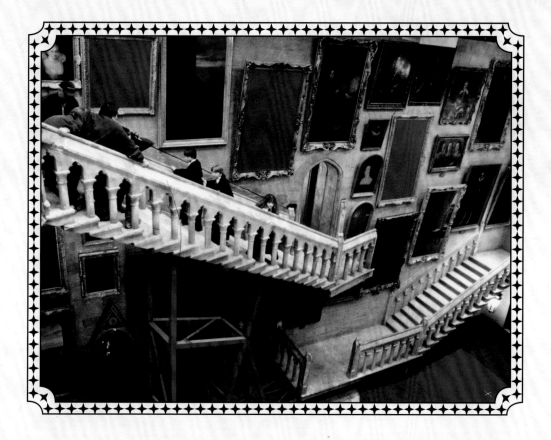

THE PAINTINGS OF HOGWARTS CASTLE

"Seamus, that picture's moving!"

—Neville Longbottom, *Harry Potter and the Sorcerer's Stone*

One of the most magical moments on Harry Potter's first day at Hogwarts in *Harry Potter and the Sorcerer's Stone* that unequivocally signifies an immersion into the wizarding world is the students' encounter with the moving paintings and portraits on the walls of the grand staircase. Modern technology may have given us video and "live photos," but there's nothing yet that will top a painting with which you can have an actual conversation. "One of the major tasks of the art director in charge of props," explains set decorator Stephenie McMillan, "was to research and commission the portraits and get them painted." Over the course of the series, Lucinda Thomson, Alex Walker, and Hattie Storey had this responsibility. Their research covered every time period and style. "We looked at the whole history of painting, really," says production designer Stuart Craig, "from classical Egyptian to the twentieth century." Many of the unmoving paintings were based on well-known portraits of royalty or celebrities from literature, art, and society. Cre-

Paintings seen on the walls of Hogwarts Great Hall include: OPPOSITE LEFT: Elizabeth Burke, who may be a relative of Caractacus Burke, co-founder of Borgin & Burke's; OPPOSITE TOP RIGHT: Dame Antonia Creaseworthy; OPPOSITE BOTTOM RIGHT: Percival Pratt, who was a well-regarded poet; ABOVE: Filming on a moving staircase for *Harry Potter and the Sorcerer's Stone*. In post-production, the scaffolding and floor is digitally removed or replaced for the final shot, and the paintings are composited with their moving elements; LEFT: "White card" models were created for consistency of portrait placement and for the blocking (choreography) of scenes.

ating the artwork involved various processes. "One of our artists, Sally Dray, preferred to paint on a clean white canvas. Very intimating, I think," Craig says. "We would give her the subject, and she would create it from scratch." Others were "cheats." "We would start with a photograph, and the artist would give it a painterly texture including the appearance of aged varnish, so it would look exactly like an oil painting." Ten artists painted an estimated two hundred portraits for the first film; more were added throughout the series to address story points.

For the moving portraits, the same process was followed with a few extra steps. Once the painting was sketched out in concept, the background would be painted and filmed. The moving subjects would then be cast—actors and very often crew members were recruited for the roles. The costume department would create their clothing, set design would coordinate with the props department to put together a setting if needed, and the action would be filmed by the second unit in front of a green screen. Jany Temime, costume designer from *Harry Potter and the Prisoner of Azkaban* through the end of the series, considered this a fun task. "I enjoyed doing the portraits, creating little tableaus of a sixteenth-century wizard or an eighteenth-century wizard. Or we would take a classic painting and wizard up the people in it."

In order to ensure that the portrait's subject had the correct eye line to the actors or action, the scene would be filmed first with a green-screen canvas inside the frame. Then the visual effects team would be able to film the actor or actors "in" the painting with the knowledge of where they should be looking. Once all the elements were composited together by the visual effects team, "the moving portrait would be given a texture digitally," explains visual effects producer Emma Nor-

TOP LEFT: Storyboard artwork by Stephen Forrest-Smith for *Harry Potter and the Half-Blood Prince* depicts an unfilmed scene where Harry Potter sneaks out of Hogwarts undetected after having imbibed Felix Felicis; TOP RIGHT AND OPPOSITE BOTTOM RIGHT: An unidentified Headmaster; RIGHT: Visual development art of Sir Cadogan by Olga Dugina and Andrej Dugin for a moving portrait to be seen in *Harry Potter and the Prisoner of Azkaban*. Sadly, this brave knight's scenes were left on the cutting room floor; OPPOSITE TOP RIGHT: Professor Armando Dippet, Headmaster when Tom Riddle attended Hogwarts and the Chamber of Secrets was first opened; OPPOSITE TOP AND BOTTOM LEFT: Newt Scamander, author of the book *Fantastic Beasts and Where to Find Them*, a standard work in the Care of Magical Creatures curriculum.

ton, "a source of light for shadow or reflection, and often that crackling effect that you get on old oil paintings." The final portrait might also be duplicated in a nonmoving form if the painting needed to be in its position on the wall in the background of a scene. As it would be too far away to tell, it wouldn't warrant any motion in it. For scenes on the staircases where there was no interaction between the characters and the portraits, the walls would still be filled with paintings but with only a few that were animated. "You're watching the characters," Norton continues. "You're not looking at the portraits, and you wouldn't want too many moving ones because it would be distracting. There should be a few that could show a reaction to the conversation or the action, but only if they were there to enhance the story, not to be there just because you could put them there."

Lighting the portraits was of extreme importance. For example, the anteroom to Dumbledore's office featured walls filled with portraits of the previous headmasters and headmistresses of Hogwarts, and many of these paintings had been hung on the upper portion of the walls between windows, so the light source needed to be considered very carefully. Due to height of the room, cinematographer Roger Pratt had to create several distinct lighting sources. "I didn't want to use candles for lighting," he explains, "because I always feel that candles are distracting. So we opted for oil lamps, which would be on and around the tables and would allow me to create a certain amount of warmth and softness." Higher up, the anteroom would be lit by cool moonlight, softly coming through the windows.

Another task for the art, props, and costume departments was the classroom for Defense Against the Dark Arts professor Gilderoy Lockhart in *Harry Potter and the Chamber of Secrets*, which featured a large painting of Lockhart painting a portrait of . . . himself. The static inset portrait is reminiscent of a 1638 painting by Anthony van Dyck; the larger Lockhart was filmed in the same way as all other moving portraits. Initially, Stuart Craig and Stephenie McMillan proposed that, in a visual effect, Lockhart would walk out of the portrait into

TOP: An unidentified Headmaster; ABOVE RIGHT: Actress Elizabeth Spriggs poses for her portrait as the Fat Lady in full costume and with some set dressing for *Harry Potter and the Sorcerer's Stone*; RIGHT: Professor Gilderoy Lockhart paints his own portrait, *Harry Potter and the Chamber of Secrets*; OPPOSITE: The portrait of Professor Albus Dumbledore (Michael Gambon) was placed in the Headmaster's Office after the events of *Harry Potter and the Half-Blood Prince*.

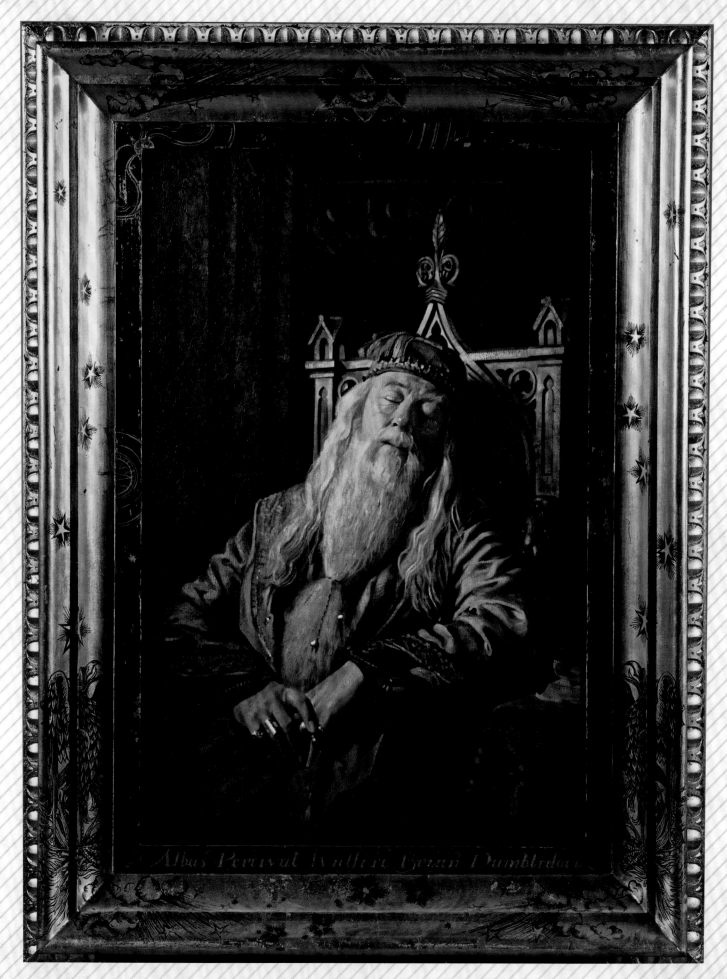

Albus Percival Wulfric Brian Dumbledore

the classroom, but eventually it became simply that Lockhart descends down the staircase from his office in a dramatic entrance and only exchanges a wink with his painted double.

In two of the films, many subjects of the paintings leave their frames: in *Harry Potter and the Prisoner of Azkaban* in fear of the possibility of Sirius Black being in the castle, and in *Harry Potter and the Deathly Hallows – Part 2* in fear during the Battle of Hogwarts. "The inspiration for these was a combination of what was in the script and the director's ideas," says McMillan. For *Harry Potter and the Prisoner of Azkaban*, "Director Alfonso Cuarón very carefully choreographed all the small ridiculous situations and people running away," she continues. "Then art director Hattie Storey worked with a concept artist to create a master plan for the choreography, according to which various subjects traveled from one portrait to the next." Perspective needed to be attended to carefully. "The movements were very complex," says Emma Norton, "because you were also changing scale. The subjects would be moving through different aspect ratios, and so we'd have to work out all those cues."

In addition to the actors and crew members used as portrait subjects, some of the people "wizarded up" included the films' producers and department heads, as recounted by Stuart Craig: "In Dumbledore's office, prop master Barry Wilkinson's there. Producer David Heyman is on the marble staircase, very prominently, as well as producer David Barron. I'm there. *Harry Potter and the Prisoner of Azkaban* director Alfonso Cuarón's wife and baby are in one, and another features art director Alex Walker. *Harry Potter and the Sorcerer's Stone* director Chris Columbus had his portrait painted, but it didn't make the film. Very good portrait, I have to say." There is a Columbus on the wall of Hogwarts, however. Violet Columbus, the director's daughter, portrays the girl holding flowers who curtseys to the first years in *Harry Potter and the Sorcerer's Stone*.

OPPOSITE TOP RIGHT: A wizard chess match set on the walls of the Gryffindor Common Room viewed in a deleted scene from *Harry Potter and the Prisoner of Azkaban* demonstrates the coordination of the production design, set decoration, and art departments: The paintings on the wall of this painting are also visible on the walls of Hogwarts including OPPOSITE TOP LEFT: An unidentified witch; OPPOSITE BOTTOM LEFT AND RIGHT: Two unidentified Headmasters; ABOVE LEFT: Cottismore Croyne, better known as David Heyman, the producer of the Harry Potter films; ABOVE RIGHT: Stuart Craig, production designer for the Harry Potter films, is immortalized on the Grand Staircase as Henry Bumblepuft; FAR LEFT: The Girl with Flowers was portrayed by Violet Columbus, daughter of director Chris Columbus; LEFT: Barry Wilkinson, property master for the Harry Potter films, was the model for Tobias Misslethorpe, founder of *Witch Weekly*.

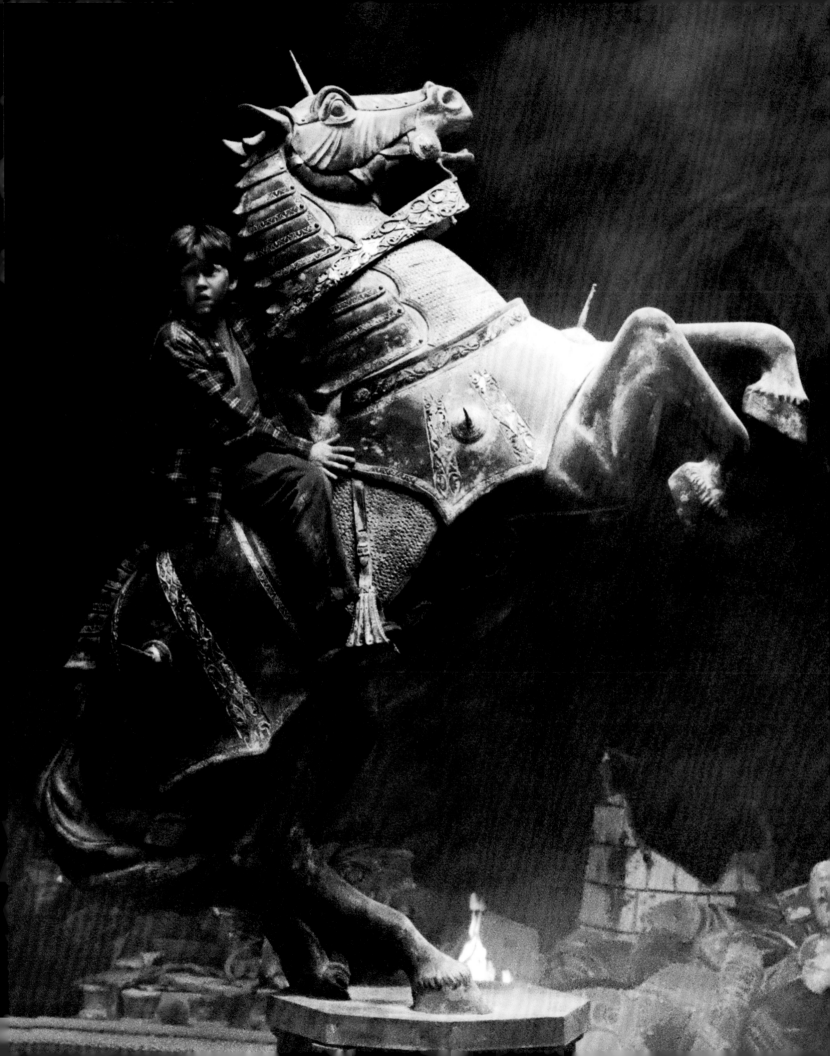

CHAPTER 2

THE SORCERER'S STONE

"Of course! There are
other things defending the
Stone, aren't there? Spells
...enchantments."

—Hermione Granger, *Harry Potter and
the Sorcerer's Stone*

As the book and movie title suggest, the story of *Harry Potter and the Sorcerer's Stone* is the pursuit by Harry Potter, Ron Weasley, and Hermione Granger of a magical object that is, as Hermione describes, "a legendary substance with astonishing powers. It will turn any metal into pure gold and produces the Elixir of Life, which will make the drinker immortal." In order to prevent Voldemort from acquiring the stone, the staff of Hogwarts have hidden it and created four security obstacles: the three-headed dog, Fluffy; a temperamental plant; a door that can only be opened by a winged key; and a life-size game of chess that must be won. Voldemort, who is still noncorporeal and so shares Professor Quirinus Quirrell's body, has passed them all. These tests will call upon each hero to contribute a skill that delineates their character: Hermione for her knowledge of spells, Harry for his broomstick-flying talents, and Ron for his proficiency at wizard's chess.

The nearly 100-percent-digital Fluffy (his drool was a practical effect) could be subdued by music. Getting through Devil's Snare involved relaxation (impossible for Harry and Ron when wrapped in the Snare's tentacles) or a source of light, created by Hermione. Devil's Snare was surprisingly a practical effect (as a digital one would have proved incredibly costly). Puppeteers positioned below the plant slowly pulled off vines that had been wrapped around the actors. Then the film was played backward so it appeared that the plant was entangling them instead of the other way around.

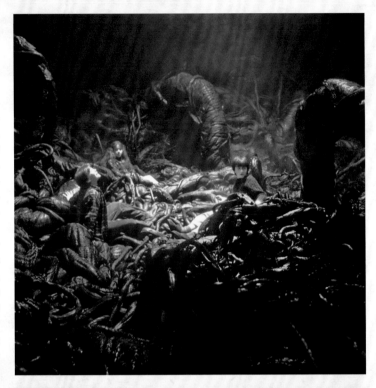

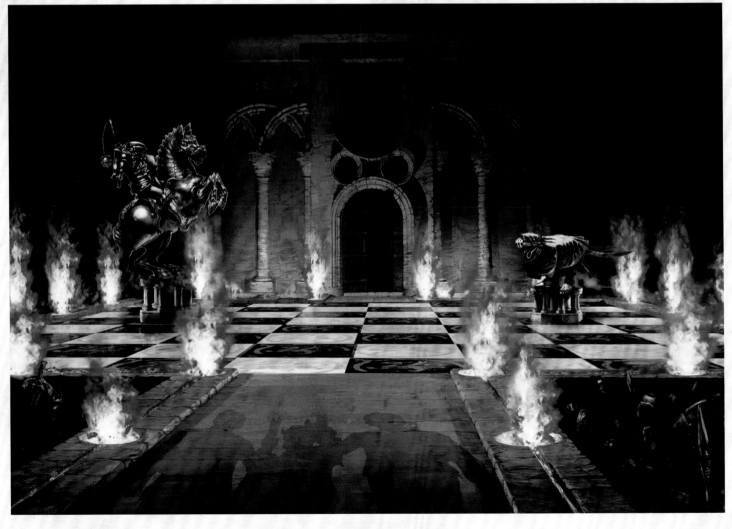

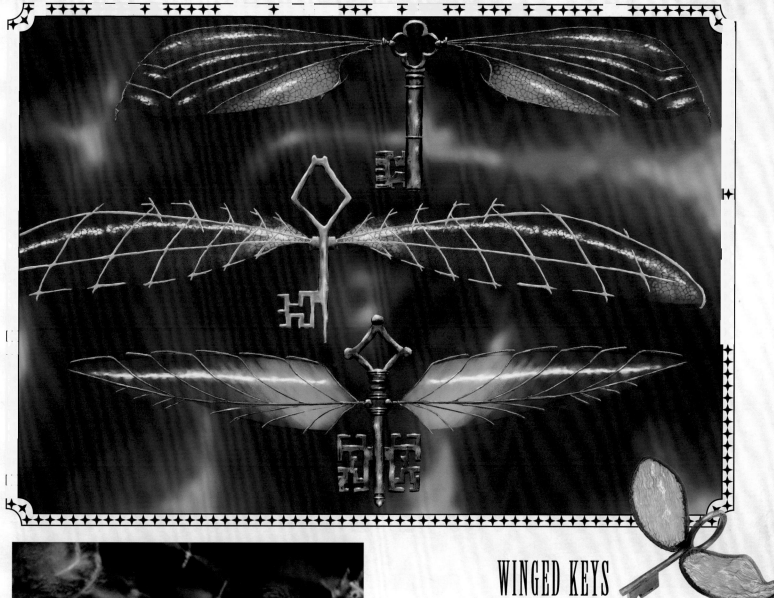

PAGE 60: Ron Weasley directs the life-sized wizard chess game from atop his knight's horse. Ron sacrifices his piece so that Harry Potter can win and retrieve the Sorcerer's Stone in the first Harry Potter film; OPPOSITE TOP: A film still of Ron, Hermione, and Harry after landing in Devil's Snare; OPPOSITE BELOW: Visual development artwork by Cyrille Nomberg illustrates the arrival of Harry, Hermione, and Ron into the room of their chess game challenge; TOP: Concept art for the winged keys by Gert Stevens; ABOVE: Harry Potter flies among a swarm of winged keys; ABOVE RIGHT: The winged key prop used to open the locked door.

WINGED KEYS

"Curious. I've never seen birds like these."
"They're not birds, they're keys."

—Hermione Granger and Harry Potter, *Harry Potter and the Sorcerer's Stone*

After sidestepping Fluffy and dropping through Devil's Snare, the next challenge to get closer to the Sorcerer's Stone is to get through a locked door. After Hermione tries the charm *Alohamora*, which, to her frustration, does not work, Ron and Harry realize that they must find and catch the right key in a swarm of winged keys flying through the room. While the design of the keys was relatively simple, they "had to be scary and wild, but not *too* scary or *too* wild," explains visual effects supervisor Robert Legato. "The more beautiful you make something, the more nonthreatening it becomes." Legato knew it was a fine line between the keys being frightening and being intimidating. Another consideration was their movement: "They are in essence tied together, the way they move, which affects the way they'll look and the way they're lit on-screen," he says. After the final design was tested and approved in a digital animatic, the many keys were made to move in concert like a flock of birds. The wings of the key that opens the door were crafted in an iridescent shot silk.

CHESS PIECES

"It's obvious, isn't it? We've got to play our way across the room. All right. Harry, you take the empty Bishop's square. Hermione, you'll be the queenside castle. As for me, I'll be a knight."

—Ron Weasley, *Harry Potter and the Sorcerer's Stone*

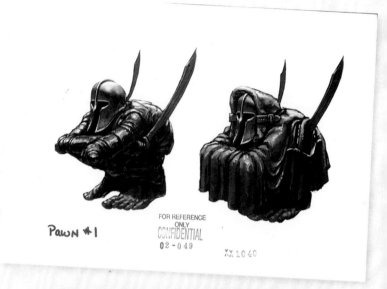

The final challenge before Harry Potter's confrontation with Voldemort is to win a game of wizard's chess. Director Chris Columbus's preference was always to see if the action could be created practically instead of digitally, and the special effects and props departments were glad to comply. Full-size models of the thirty-two chess pieces, some of them twelve feet high and weighing up to five hundred pounds, were sculpted in clay and cast in various materials according to their use. The prop makers produced the swords, maces, armor, and even the bishop's staffs that were their armaments. "Then we had to make the chess pieces move," says special effects supervisor John Richardson, "which was a challenge because of their size and weight, and the fact that their bases were very small." Richardson and his team rigged the pieces that needed to move with radio controls. "We could drive a horse forward and then stop, and then move it sideways and stop very cleanly."

"While the pieces on the set were fully built and could shift across the board," says visual effects producer Emma Norton, "they weren't articulated. So when you see one of those pieces do more than just

BELOW AND TOP RIGHT: Visual development art of the black side's pawn and queenside castle chess pieces by Cyrille Nomberg and Ravi Bansal; BELOW RIGHT: Finishing touches are added to one of the chess set's kings; OPPOSITE: A close-up reference photo of the white side's chess pieces features the rook, knight, bishop, and pawns, some of which moved via radio controls.

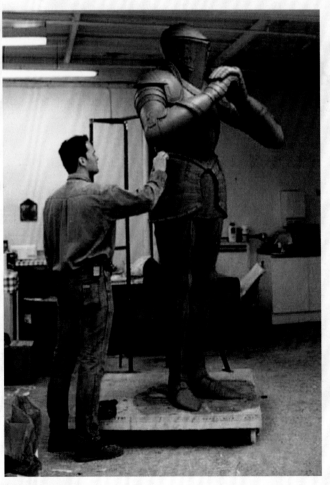

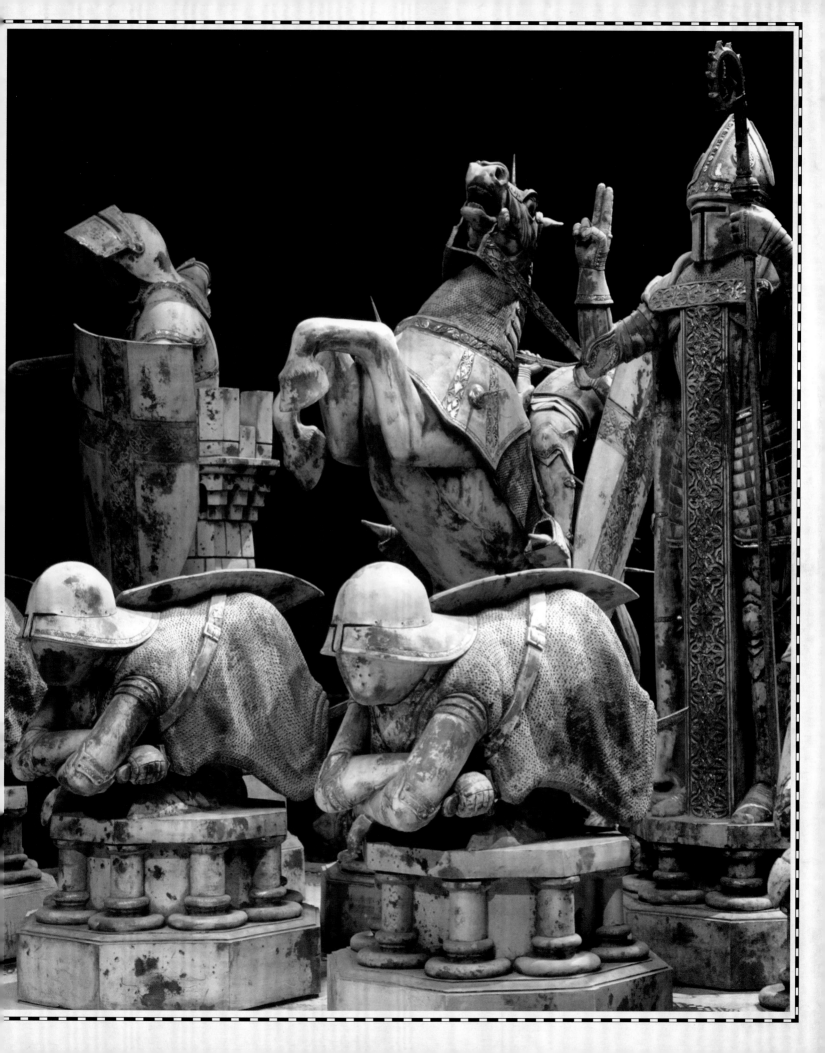

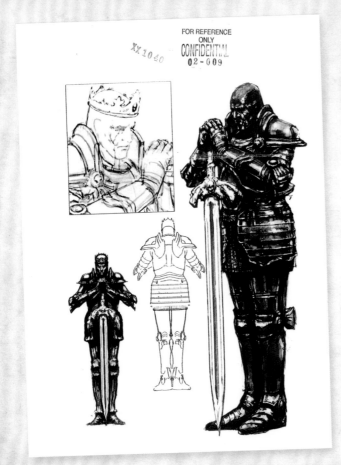

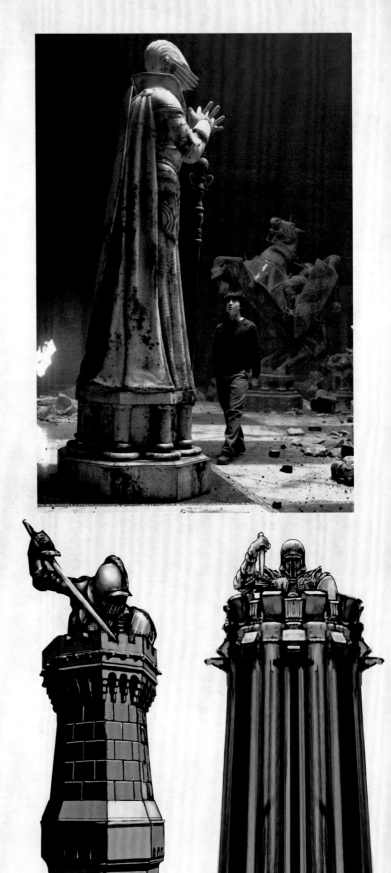

move forward, they're computer-generated versions. But when we create something in CG, we will borrow as much as we can from the model, which has been painted to be photographed on-screen. So we photograph it, cyberscan it, take textures from the prop and from whatever the art department has provided and treat it like skin, the texture skin. Then we build a CG model and wrap that texture around it. So for all intents and purposes, you're looking at the real thing."

The most important consideration of the scene was that when a piece was taken by the opposite side, it would explode, meaning the young actors would be involved in a scene with blasts and bursts and flying rubble. Instead of pyrotechnics, Richardson and his team used compressed air devices activated via remotes to blow the pieces up in a very controlled way. "There was some flame on the set, and smoke, so we had air and fire and bangs and pretty much a little bit of everything else we come across in effects," Richardson explains. The "broken" pieces seen after the explosions were individually sculpted and cast, and not just smashed originals. Digital dust and debris were added after the scene was shot. The "marble" of the chessboard's squares was created using a well-known art technique of squirting oil paint into a vat of water—in this case, a six-foot-square tank—and then placing paper on top to absorb the swirling colors. The best versions were scanned, enhanced digitally, and then laid down on the set. "That was an incredible set," actor Rupert Grint (Ron Weasley) recalls. "And such a cool scene, with pieces being smashed and exploding around us. I've still a broken piece of the horse I was riding!"

TOP, RIGHT, AND OPPOSITE TOP: Concept art by Cyrille Nomberg and Ravi Bansal of the wizard chess pieces, experimenting with different weaponry, postures, and girths; ABOVE RIGHT: Harry Potter approaches the twelve-foot-high white queen in a reference photograph taken on the set of *Harry Potter and the Sorcerer's Stone*; OPPOSITE BOTTOM: Behind each side of the chess board were pits where the exploded and taken pieces were piled up.

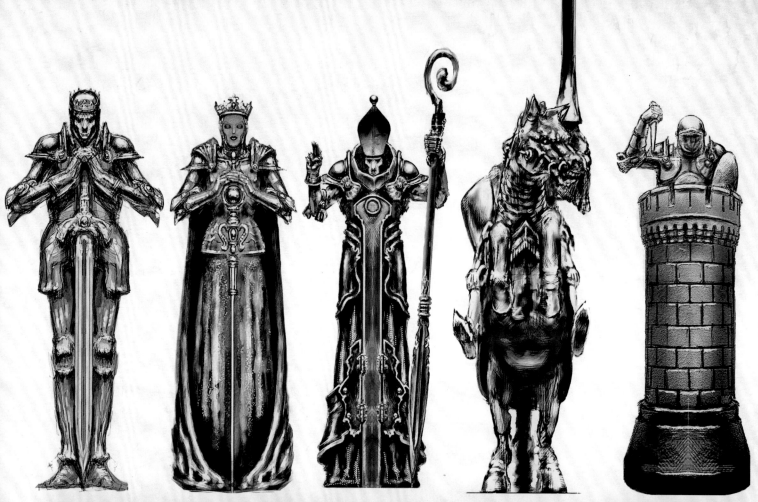

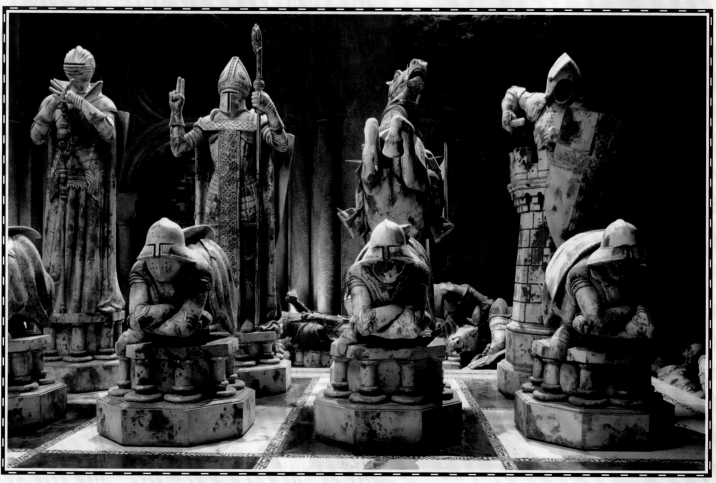

THE SORCERER'S STONE

*"I see myself holding the stone.
But how do I get it?"*

—Quirinus Quirrell, *Harry Potter and the Sorcerer's Stone*

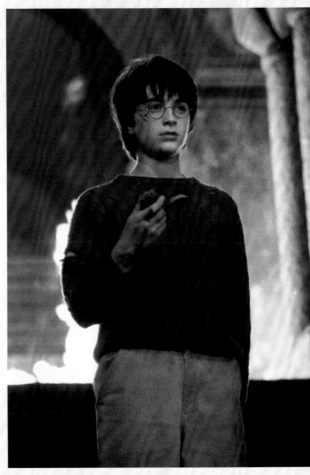

What prop could be more important in the first film than the titular Sorcerer's Stone? When the design department asked J.K. Rowling what the stone should look like, she described it as an uncut ruby. Several prop stones were created out of plastic, which has the tendency to look more like a big piece of candy than a ruby. So in order to give it the shimmering, flickering appearance of a real gem, filmmakers turned to the basics from Lighting 101. The reflection of light seen in the stone was from a small flame placed on top of the camera as it was filmed.

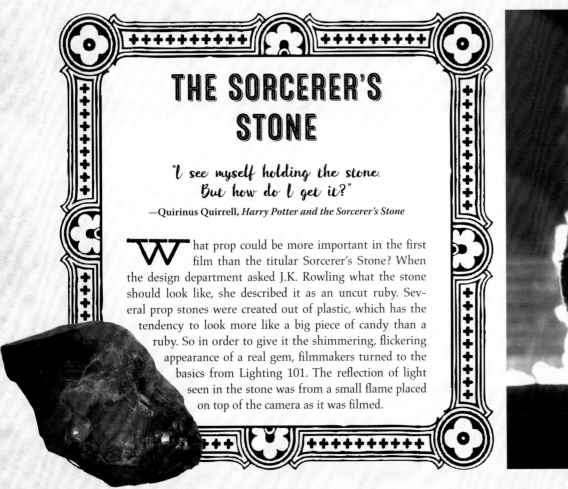

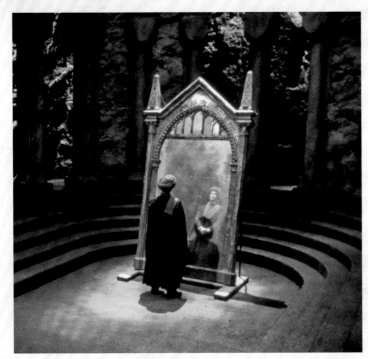

TOP RIGHT: In a movie still from *Harry Potter and the Sorcerer's Stone*, Harry holds the Sorcerer's Stone, which shows up, to his surprise, in his pants pocket; TOP LEFT: A close-up of the Sorcerer's Stone; ABOVE: Professor Quirrell (Ian Hart) sees his reflection in the Mirror of Erised; OPPOSITE: A props reference shot of the Mirror of Erised.

THE MIRROR OF ERISED

*"It shows us nothing more or less than the deepest,
most desperate desires of our hearts."*

—Albus Dumbledore, *Harry Potter and the Sorcerer's Stone*

Though the Mirror of Erised plays an important part in Harry Potter's defeat of the combined Professor Quirrell/Lord Voldemort, he first encounters the mirror during his escape from the Restricted Section of the library after an interrupted search for information on Nicholas Flamel, the owner of the Sorcerer's Stone. The mirror is a mashup of different architectural styles: the outer sides are Corinthian columns that bracket an inner set of smaller Doric columns embellished with a knot pattern. The principal style is Gothic; seven graduated lancet-style arches are framed by a larger one. (The number seven appears frequently within the wizarding world.) Above this is a triangular arch adorned with palmettes that supports the final toppers—two obelisks. The writing that appears over the biggest arch of the mirror reads: *Erised stra ehru oyt ube cafru oyt on wohsi.* It's not a magical language, but rather the mirror image of the sentence, "I show not your face but your heart's desire," with the letters arranged in unique combinations. Unlike most props, which are duplicated for different uses and in case of breakage during filming, only one Mirror of Erised was ever created.

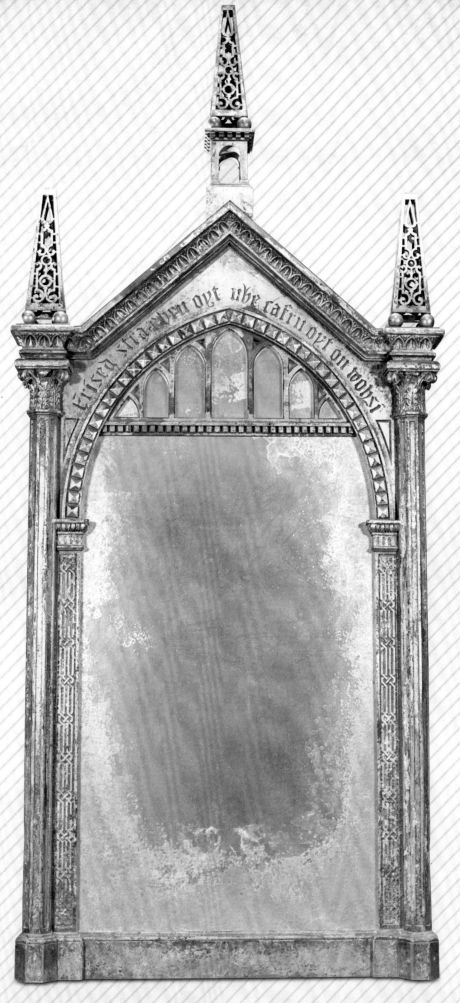

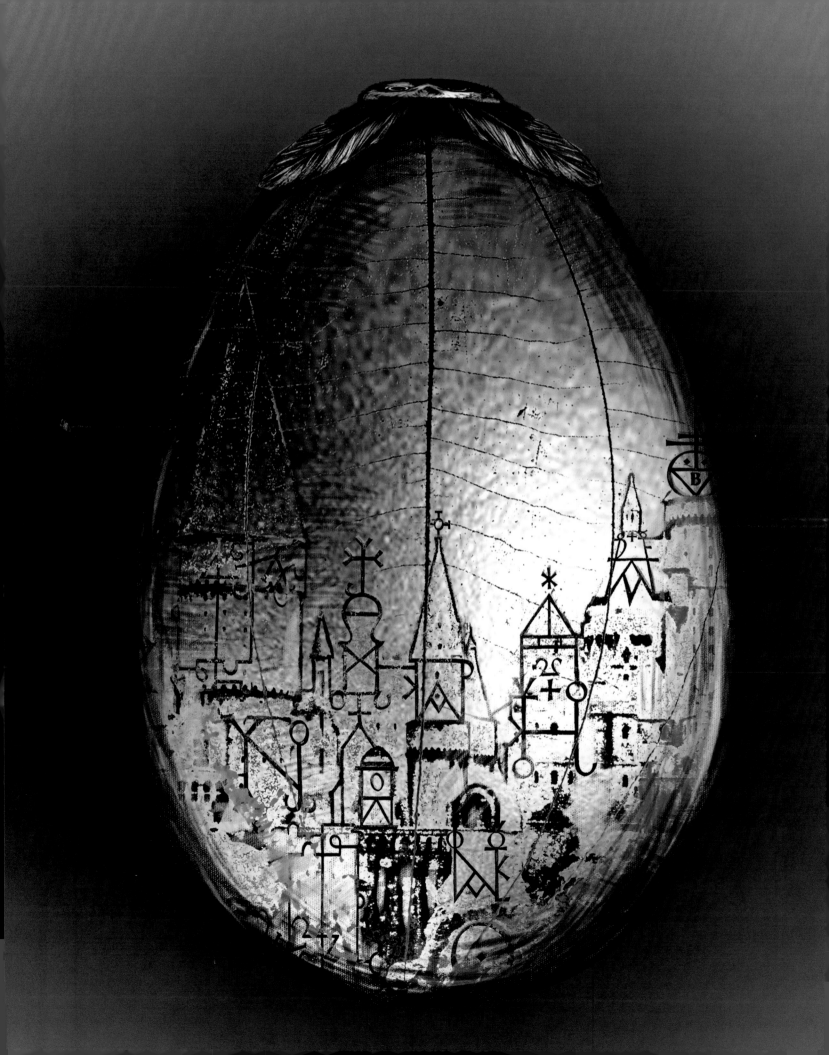

CHAPTER 3
THE TRIWIZARD TOURNAMENT

"Hogwarts has been chosen to host a legendary event: the Triwizard Tournament."

—Albus Dumbledore, *Harry Potter and the Goblet of Fire*

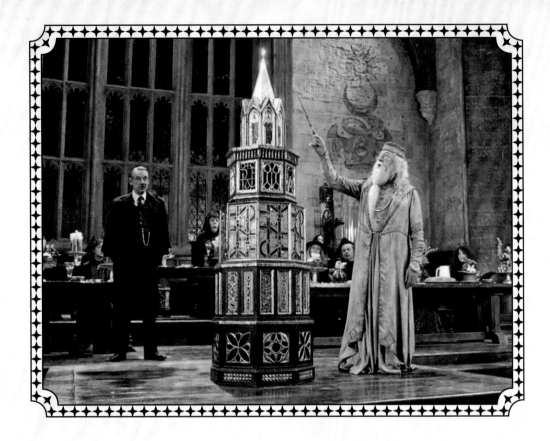

THE GOBLET OF FIRE

"Anyone wishing to submit themselves for the tournament merely write their name upon a piece of parchment and throw it in the flame. . . . Do not do so lightly. If chosen, there's no turning back."

—Albus Dumbledore, *Harry Potter and the Goblet of Fire*

For hundreds of years, the three largest wizarding schools in Europe—Hogwarts School of Witchcraft and Wizardry, Beauxbatons Academy of Magic, and Durmstrang Institute—have held a dangerous competition, the Triwizard Tournament. A champion from each school competes in three tasks that test their courage, cunning, and magical talents. The tournament begins with the reveal of the Goblet of Fire, into which prospective champions from each of the three schools will place their names. The Goblet of Fire is first presented encased in a gilded and bejeweled casket. For the design, production designer Stuart Craig and graphic artist Miraphora Mina blended their research on medieval architecture and the decoration of English and Orthodox Russian churches. "From these inspirations," says Mina, "I had the idea of a stacked construction of arches, one on top of the other. I also wanted it to be heavily jeweled, like church mosaics, as that would be affected by the light around it." Prop maker Pierre Bohanna cast the different sections inscribed with runic or alchemic symbols, and they were variously inlaid with gold leaf and painted jewels, or other light-catching materials. "It's almost like a religious reliquary," says Craig, "but of a type that's never been seen before." The casket is visible for only a short time, and then "melts" away

to reveal the goblet. Mina remembers being asked if that could be a practical effect, but it was quickly decided that it was easier done digitally. "But the casket is a real physical object, no doubt," Mina proclaims. "I had to carry it into the Great Hall!"

Craig's original intention was for the cup to be small, metal, and encrusted with tiny jewels. But after their research, the Goblet of Fire became "basically a huge Gothic cup decorated with a Gothic motif that's been created from wood," he explains. "We found the best bit of timber we possibly could, with burrs and twists and knots and splits in it. So this creates a quality that it's incredibly ancient, but at the same time organic." Pierre Bohanna and his team sculpted the five-foot-tall goblet out of an English elm tree trunk, with the addition of some plastic castings. Mina's idea behind the goblet was that because the lower half is wood, which creeps up to meet the curve of the goblet's base, one couldn't be sure whether it was still growing. "The impression to me is that it's half complete," says Craig. "Half architectural and half natural, as if the carving of it hasn't been finished. And I think it's as great in silhouette as it's great in detail when you examine it closely."

THE TRIWIZARD TOURNAMENT CUP

"Only one will hoist this chalice of champions, this vessel of victory, the Triwizard Cup!"

—Albus Dumbledore, *Harry Potter and the Goblet of Fire*

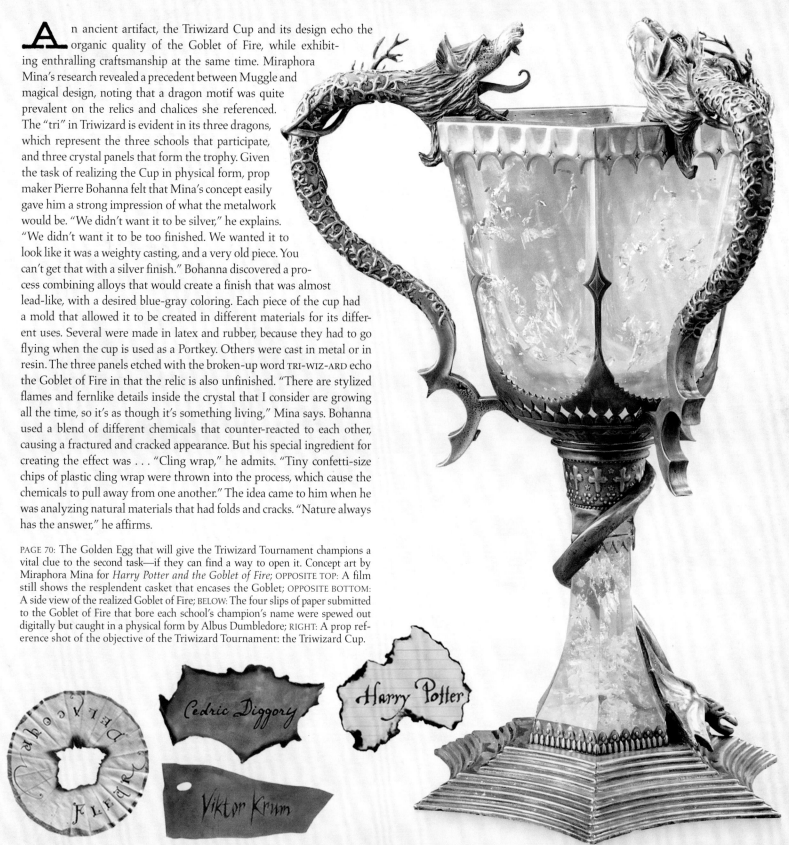

An ancient artifact, the Triwizard Cup and its design echo the organic quality of the Goblet of Fire, while exhibiting enthralling craftsmanship at the same time. Miraphora Mina's research revealed a precedent between Muggle and magical design, noting that a dragon motif was quite prevalent on the relics and chalices she referenced. The "tri" in Triwizard is evident in its three dragons, which represent the three schools that participate, and three crystal panels that form the trophy. Given the task of realizing the Cup in physical form, prop maker Pierre Bohanna felt that Mina's concept easily gave him a strong impression of what the metalwork would be. "We didn't want it to be silver," he explains. "We didn't want it to be too finished. We wanted it to look like it was a weighty casting, and a very old piece. You can't get that with a silver finish." Bohanna discovered a process combining alloys that would create a finish that was almost lead-like, with a desired blue-gray coloring. Each piece of the cup had a mold that allowed it to be created in different materials for its different uses. Several were made in latex and rubber, because they had to go flying when the cup is used as a Portkey. Others were cast in metal or in resin. The three panels etched with the broken-up word TRI-WIZ-ARD echo the Goblet of Fire in that the relic is also unfinished. "There are stylized flames and fernlike details inside the crystal that I consider are growing all the time, so it's as though it's something living," Mina says. Bohanna used a blend of different chemicals that counter-reacted to each other, causing a fractured and cracked appearance. But his special ingredient for creating the effect was . . . "Cling wrap," he admits. "Tiny confetti-size chips of plastic cling wrap were thrown into the process, which cause the chemicals to pull away from one another." The idea came to him when he was analyzing natural materials that had folds and cracks. "Nature always has the answer," he affirms.

PAGE 70: The Golden Egg that will give the Triwizard Tournament champions a vital clue to the second task—if they can find a way to open it. Concept art by Miraphora Mina for *Harry Potter and the Goblet of Fire*; OPPOSITE TOP: A film still shows the resplendent casket that encases the Goblet; OPPOSITE BOTTOM: A side view of the realized Goblet of Fire; BELOW: The four slips of paper submitted to the Goblet of Fire that bore each school's champion's name were spewed out digitally but caught in a physical form by Albus Dumbledore; RIGHT: A prop reference shot of the objective of the Triwizard Tournament: the Triwizard Cup.

SCHOOL TROPHIES

"What a charismatic quartet."

—Rita Skeeter, *Harry Potter and the Goblet of Fire*

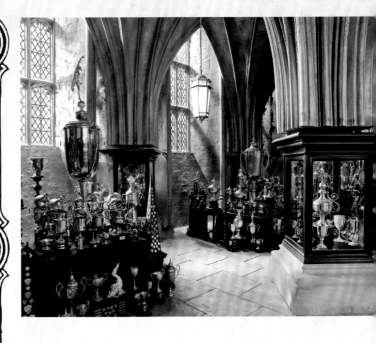

The Trophy Room at Hogwarts is seen briefly in *Harry Potter and the Goblet of Fire*; it's where the Triwizard Tournament champions gather after they are announced in the Great Hall. Filled with hundreds of trophies, the room might seem familiar: In *Harry Potter and the Order of the Phoenix*, it was transformed into the Room of Requirement, and in *Harry Potter and the Half-Blood Prince*, it was used as Horace Slughorn's office. The props department referred to the books for inspiration as they created originals and altered purchased trophies in a wizardly fashion. In addition to Quidditch trophies, there were Medals for Magical Merit, Awards for Special Services to Hogwarts, and other plaques and shields for Transfiguration, Chess, Potions, Bravery, and Effort. The prop makers inscribed these with names from the books as well as those of the film's crew members.

Trophies

Quidditch trophies — Roderick Plumpte
(small 4 individual Charlie Weasley
players) Gwenog Jones
 Alasdair Maddock

Medals of Magical — T. M. Riddle
Merit L. J. Evans
 (= Lily Potter)
 W. A. Weasley
 F. C. J. Longbottom
 J. E. Prewett

Awards for Special — T. M. Riddle
Services to Hogwarts M. G. McGonagall
(small burnished gold D. L. Boot
shield) R. J. H. King

also —
Transfiguration Trophy
Potions Cup
Chess trophy
Award for Effort — Oliver Wood

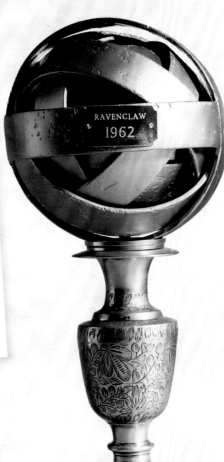

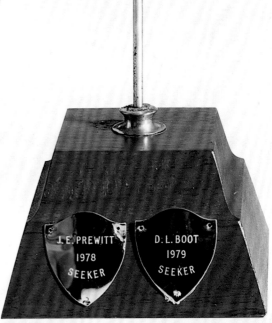

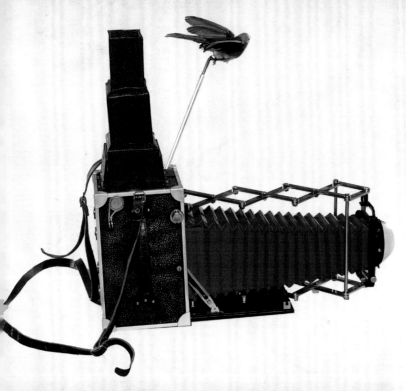

QUICK-QUOTES QUILL

"Don't mind if I use a Quick-Quotes Quill, do you?"
—Rita Skeeter, *Harry Potter and the Goblet of Fire*

The questionable investigative tactics of Rita Skeeter, reporter for the *Daily Prophet*, are very much in view when she interviews Harry Potter, the youngest Triwizard Tournament champion, in *Harry Potter and the Goblet of Fire*. Skeeter uses a Quick-Quotes Quill, which rewrites a subject's responses into sensationalist journalism. The animated nib is connected to an acid green–dyed feather that complements her outfit.

OPPOSITE: (clockwise from top left) A production reference shot of the trophy room; a trophy awarded to two Quidditch seekers and a victory trophy for Ravenclaw house; ABOVE: The camera used by the *Daily Prophet* photographer who accompanies Rita Skeeter during the first task of the Triwizard Tournament; BELOW: The Quick-Quotes Quill with Rita Skeeter's written notes; BELOW LEFT: Miranda Richardson (Rita Skeeter) on set inside of the champions' tent in *Harry Potter and the Goblet of Fire*.

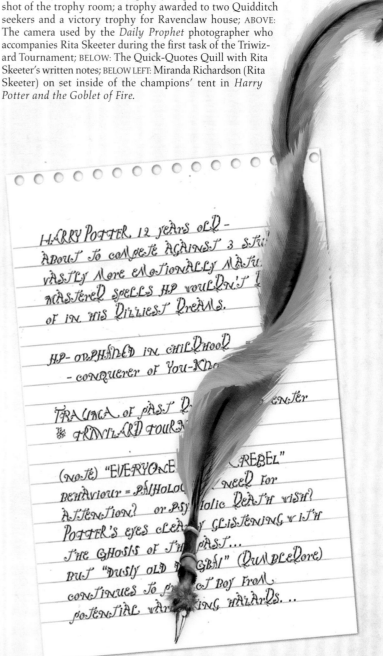

HARRY POTTER, 12 YEARS OLD –
ABOUT TO COMPETE AGAINST 3 STI...
VASTLY MORE EMOTIONALLY MATU...
MASTERED SPELLS HP WOULDN'T ...
OF IN HIS DIZZIEST DREAMS.

HP– ORPHANED IN CHILDHOOD
– CONQUERER OF YOU-KNO...

TRAUMA OF PAST D... ...NTER
& TRIWIZARD TOURN...

(NOTE) "EVERYONE ... REBEL"
BEHAVIOUR = PSYHOLOG... NEED FOR
ATTENTION? OR PSY... OLIC DEATH WISH?
POTTER'S EYES CLEA... GLISTENING WITH
THE GHOSTS OF THE PAST...
BUT "DUSTY OLD ...GBY" (DUMBLEDORE)
CONTINUES TO P... ...CT BOY FROM
POTENTIAL WA... ...KING HAZARDS...

THE GOLDEN EGG

"Come seek us where our voices sound, we cannot sing above the ground.
An hour long you'll have to look, to recover what we took."

—the merpeople's clue for the second task, *Harry Potter and the Goblet of Fire*

The first task of the Triwizard Tournament is to capture a golden egg being protected by a dragon. Once opened, the egg will reveal a clue to the second task. Designer Miraphora Mina first decided that the outside decoration of the egg would be quite formal: "It has an etching of a city—not a mythical, magical city, but maybe a historical place somewhere." Mina liked the idea of the prop's exterior appearing to be enameled (although it actually wasn't), and having alchemic symbols etched into it. In the book *Harry Potter and the Goblet of Fire*, the interior of the egg is described as a song. "So it needed to be something ethereal," says Mina. "Something where you couldn't quite work out whether the song is its content or if it's on the surface. So we imagined a crystal structure where things were possibly going on inside, but you couldn't easily work out what they were."

Another theme that Mina tried to incorporate in her designs for the films was the idea of discovery. For the golden egg, one of her areas of research was Fabergé eggs, created for the Imperial Russian family from the 1880s to the first decades of the twentieth century. These gold and silver eggs would open to reveal scenes created with jewels and enamel. "I think, to discover something, you need to work for it," Mina says. The mechanism to open it was a practical effect. "It's quite simple, really," she concedes. "I wanted something that would spring open automatically, as if you had the right code." Mina designed the device as a little owl's head that sits atop three wings, the number of which ties into the Triwizard Tournament. "And it's always interesting to have an uneven number," she adds, "so I knew it would break into three segments. Not like you were cracking an egg in half!" The device was hinged inside with a cantilevered arm so that the top layer of it would turn, lift, and release the three metal wings. The exterior of the egg was gold-plated. "We used gold plating quite a lot," says prop maker Pierre Bohanna, "because this prop and others have the reputation of being special. It's not cheap, but it's not *that*

expensive, and it works beautifully on film. It's got a quality that reflects light that you can't replicate with paint."

Once the top is turned, "it's as if you go down to another layer," says Mina. "I wanted there to be a contrast between the outer shell and the inside. It looks as though it's actually alive inside in a way." The bubbles within the egg are "not really bubbles in the sense of what bubbles are," Bohanna adds. The bubbles were created using small acrylic balls that became suspended in the resin solution used to make the core. "When any substance, like the resin we used, goes from a liquid state to a hard one," Bohanna continues, "it tends to shrink or expand. This particular product didn't stick to the plastic balls; it shrank away from them, and we got an incredibly convincing bubble effect." During the same process, pearlescent pigments were added that, in their own conversion from liquid to solid, "swirled" within the mix. "Our chief molder, Adrian Getley, was able to introduce the pigment at just the right time to catch it and allow it to create movement that looked like eddies and currents, and then stop before it traveled too deep as it set."

The egg was completely waterproof as it would need to be submerged during the many takes for the scene. It also weighed over ten pounds. "It would sink right to the bottom if you gave it half a chance," Bohanna admits. In order to keep the egg from tipping over when it was opened underwater, Daniel Radcliffe (Harry Potter) wore an invisible plastic clip around one hand that connected to a clip on the egg. This freed his fingers so that he could handle it without having to use both his hands.

OPPOSITE: Designer Miraphora Mina's concept art for *Harry Potter and the Goblet of Fire* displays an aerial view of the opened Golden Egg; ABOVE: A reference photo of the Golden Egg reveals the amazing bubbling effect created by the prop makers by suspending small acrylic spheres and pearlescent pigments within the resin mold.

LIFECASTS

*"Last night something was stolen from each of our champions. A treasure of sorts.
These four treasures, one for each champion, now lie on the bottom of the Black Lake."*
—Albus Dumbledore, *Harry Potter and the Goblet of Fire*

The second task of the Triwizard Tournament took place under the murky waters of the Black Lake, where the champions needed to rescue people dear to them who had been charmed into an enchanted sleep and were floating in the merpeople's village. "There was no way we were going to tie an actor to the bottom of a tank for three weeks of filming!" exclaims Nick Dudman, special makeup effects artist for the Harry Potter film series. And so lifecasts of the four actors were taken and used to create their submerged doubles.

Creating a lifecast of an actor for a movie is a technique that harkens back to the earliest days of filmmaking, and it is more commonplace today than it's ever been. Lifecasts are made when prosthetics need to be fashioned for complicated makeups or to create a face mask for the actor's stunt double. Today's needs include requiring a lifecast for animatronic or computer effects. "The reason for that is actually really simple," explains Dudman. "Quite often, we need to cyberscan someone, and when you're cyberscanning somebody with a laser, it's inevitable they'll move. They can't keep that still. If you scan and have a cup made, the copy is perfect. If you scan somebody's head, when you get it back from the scanning company, it's blurred. The detail is smudged on it, and it's because in the time the camera takes to go around or to slide down or whatever it's doing, there are tiny little movements. However, if we take a lifecast of somebody and scan that, it's absolutely nonmoving. So the quality of the scan the CG people obtain is ten times better."

The lifecasting process has evolved over the years, but the basic material—dental alginate—is still the main ingredient. First, a plastic cap is used to protect the actor's hair. Then the alginate, in powder form, is mixed with water. This turns into a rubbery consistency after three minutes. "Before it sets completely," Dudman explains, "you put it all over the whole head and shoulders, or the whole body, if that's what you need." Breathing holes are created as the alginate solidifies. Then the alginate is covered with a layer of plaster bandages that keeps the material in place until it dries. "When it's finished setting," he continues, "you cut it apart at a predetermined seam, take the actor out, reassemble the pieces, and fill it with plaster to make a perfect double. It's a very old-fashioned method, but it's still unsurpassed because plaster is the best material for giving you the data you need. It gives you all the skin texture down to a ridiculous level of detail—every single freckle, pore, and line." The plaster mold can then be used to create a double in whatever casting material is desired. Individual eyelashes and eyebrow hairs are punched in, as well as a full head of hair, and then the lifecast is painted with an amazing amount of detail. "If done properly," Dudman concludes, "they are incredibly accurate representations."

Lifecasts were made of the key cast members from the first film in the series, but what was unique about the Harry Potter films was that they needed to be redone at the start of *every* film, as the young actors were (literally) growing up. And lifecasts were an absolute necessity to

tell the story. When the victims of the Basilisk released from the chamber below Hogwarts in *Harry Potter and the Chamber of Secrets* are rendered immobile by the gaze of the serpent, they are petrified, essentially turned to stone, until an antidote can revive them. It would be unreasonable to expect the actors playing Colin Creevey, Justin Finch-Fletchley, Nearly Headless Nick, and Hermione Granger to lie or stand motionless over and over again during filming, and so lifecasts saved the day. (The petrified Mrs. Norris was an animatronic version of the cat.)

The same need arrived in the fourth film for the underwater scenes, but the doubles of Ron Weasley, Hermione Granger, Cho Chang, and Fleur Delacour's sister, Gabrielle, needed to show some movement. Animatronic dummies were made from lifecasts of the actors with a flotation tank inserted into them. The tank could have air pumped in and out in order to create the illusion of floating, and release bubbles from their mouths. Additionally, water was pumped into the bodies from outside the holding tank. This would transfer the water from one place to another within the figure, but because water shifts slowly, it created a gentle and natural movement.

Lifecasts were also used for characters who needed to be suspended in air: Katie Bell in *Harry Potter and the Half-Blood Prince* and Charity Burbage in *Harry Potter and the Deathly Hallows – Part 1*. Visual effects producer Emma Norton echoes Nick Dudman's

sentiments: "You can't hang an actress upside down for ten hours of filming every day!" These dummies were mechanized so that the bodies could writhe and their faces could reflect their pain. Two versions of a lifecast of Michael Gambon were created for *Harry Potter and the Half-Blood Prince*. It was intended that, after Dumbledore's fall from the tower, Hagrid would carry the deceased wizard across the Hogwarts grounds. However, because Hagrid is a half-giant, the Dumbledore lifecast needed to be produced a second time in a reduced version to keep the characters' scale in mind, and in the lightest weight possible, as Martin Bayfield, who played the full-scale Hagrid in long shots, was already carrying many pounds of costume and animatronics. Eventually, it was decided not to shoot this particular scene, but the knowledge gained from the task informed Dudman's crew when they created a supposedly deceased and definitely smaller scale Harry Potter to be carried by Hagrid in *Harry Potter and the Deathly Hallows – Part 2*.

OPPOSITE: Lifecasts in their early stages for *Harry Potter and the Half-Blood Prince*. Once the alginate is removed, the molds are covered with a fiberglass fabric for stability before being filled with plaster; LEFT: The lifecast of Hermione Granger for *Harry Potter and the Goblet of Fire* was fitted with a flotation tank inside that created the illusion of her floating in water and emitting air bubbles from her mouth; TOP: The second task required four students to be suspended underwater for many days of shooting: not something you would ask actors to do! ABOVE: Hagrid carries a supposedly dead Harry Potter into the Hogwarts courtyard in *Harry Potter and the Deathly Hallows – Part 2*.

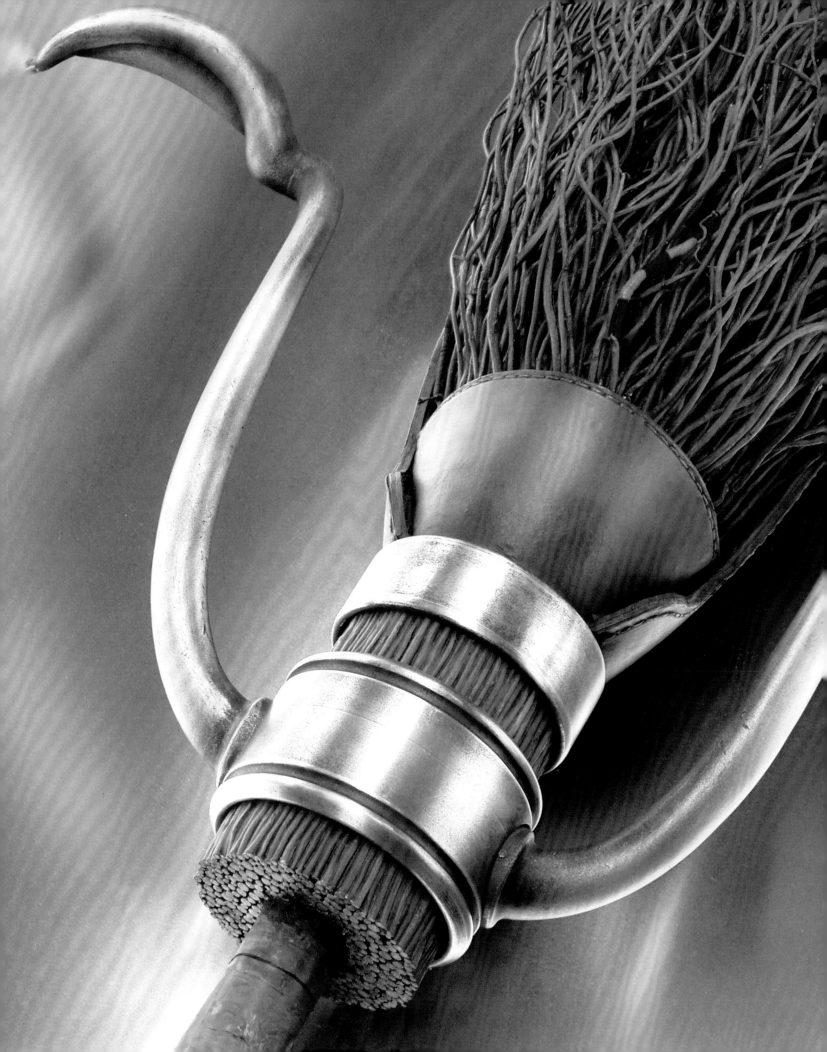

CHAPTER 4
BROOMS

"Look at it, the new Nimbus 2000!
It's the fastest model yet!"
—boy at Quality Quidditch Supplies, Diagon Alley,
Harry Potter and the Sorcerer's Stone

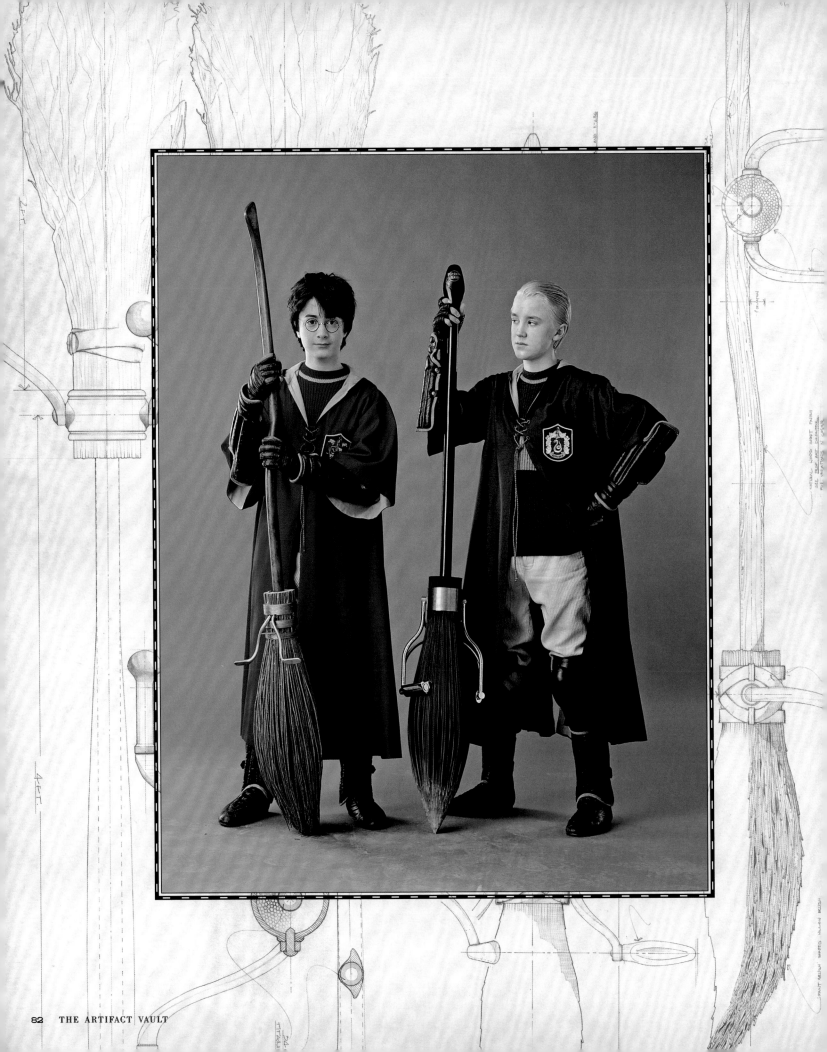

If there's one artifact ubiquitous to a story set in a wizarding universe, it would be flying brooms. For Harry Potter, learning to ride a broom is akin to passing a rite of passage in the wizarding community, and excelling at playing their most popular sport, Quidditch, endears him to them and them to him. But leave it to the concept artists, designers, and prop makers to deliver a new twist to an old angle.

The brooms used by the young wizards in their first flying lesson at Hogwarts in *Harry Potter and the Sorcerer's Stone* seem as old as the school itself. They are knobby, crooked, and scraggly. But it shouldn't matter what the broom looks like; it's all about the skill of the rider, and Harry demonstrates immediately what a talented flyer he is. As a storytelling element, Harry's gain and loss of brooms in the story is a way to develop his character and his relationships: When Professor McGonagall observes Harry's natural abilities in his first flying lesson in *Harry Potter and the Sorcerer's Stone*, and he becomes the new Seeker for Gryffindor's Quidditch team, it is she who provides Harry with the best broom of the time: the Nimbus 2000. Similarly, when he loses that broom during a game in *Harry Potter and the Prisoner of Azkaban*, due to his vulnerability to Dementors, it is Sirius Black who gifts him with a replacement—an even better broom. The Firebolt his godfather sends him is a clear symbol of the affection in their new relationship.

Both the Nimbus 2000 and the Firebolt showcase the fine art of broom-making, with their aerodynamic construction and neatly trimmed bristle heads. But "these weren't just props that the kids carry around," explains Pierre Bohanna. "They have to sit on them. They have to be mounted onto motion-control bases for special effects shots, and twisted and turned to imitate flying, so they had to be very thin and incredibly durable." To keep the brooms lightweight but strong, an aircraft-grade titanium center was used in their construction. This was covered by mahogany wood, and then birch branches were added for the bristle head. The better the broom, the sleeker the branches. In order to make broom-riding more comfortable, for the third film, *Harry Potter and the Prisoner of Azkaban*, foot pedals were added and bicycle seats, which were hidden by the player's robes, were attached to the brooms. (Also, padding was added to the rear part of the Quidditch uniform's

PAGE 80: A detail from the broom of Order of the Phoenix member Nymphadora Tonks; OPPOSITE: Daniel Radcliffe (Harry Potter) with a Nimbus 2000 and Tom Felton (Draco Malfoy) with a Nimbus 2001 show off their Quidditch brooms in a publicity still for *Harry Potter and the Chamber of Secrets*; OPPOSITE BACKGROUND: Blueprints for brooms used in *Harry Potter and the Half-Blood Prince* by Amanda Leggatt and Martin Foley; ABOVE: The Firebolt; BELOW: (left to right) Freddie Stroma (Cormac McLaggen), Daniel Radcliffe (Harry Potter), and Bonnie Wright (Ginny Weasley) await their "Action" cue as their brooms sit upon computerized rig arms in a specially prepared bluescreen room during the filming of *Half-Blood Prince*.

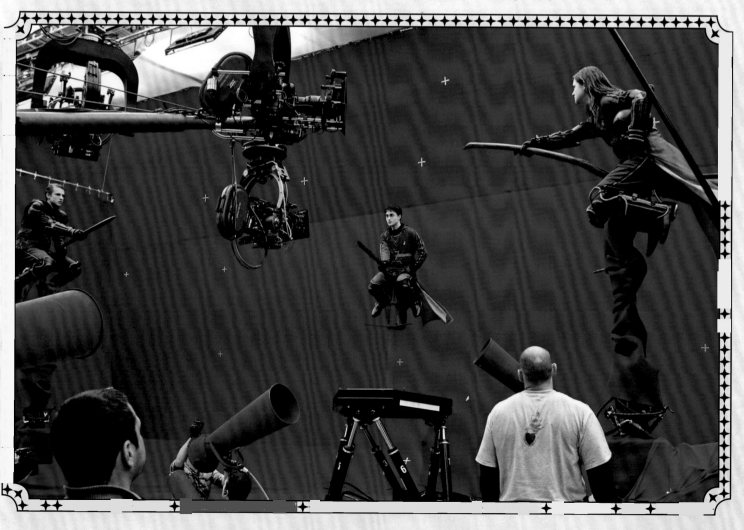

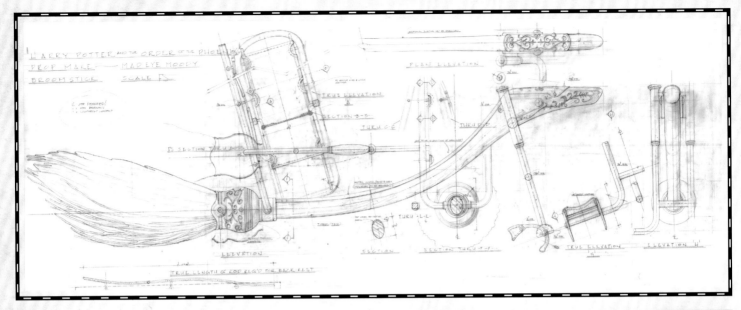

pants.) The bicycle seats on the brooms were specially molded. "Every actor came in," recalls visual effects supervisor John Richardson, "adopted the flying position on their own broom, and we literally molded their bottom to suit, and then fitted that on the broom. So everybody that went on a broomstick not only had their own broom, they also had their own molded seat."

The brooms created for the members of the titular Order in *Harry Potter and the Order of the Phoenix* were designed to match their character's personality. "If I remember this correctly," says concept artist Adam Brockbank, "I showed Stuart Craig a drawing of a kind of *Easy Rider* broomstick for Mad-Eye Moody, where he would sit on it with his legs forward, like a chopper." Craig refined the concept and the artwork was passed back and forth between them several times before the final version was agreed upon. "It was beautifully made, although you can't see much of it [in the film]. You can see by the way he sits in it that it's different from the others."

Brockbank worked on several other brooms, including Remus Lupin's, which reflects the poverty of his character in its unkempt and roughhewn appearance, and Nymphadora Tonks's broom, which in an early iteration sported ribbons and other adornments. The final broom for Tonks was constructed with differently colored sticks in its bristle head. Actress Natalia Tena loved its "manky" look. "I know everyone wanted to take their wands with them at the end of shooting," she recalls, "but I wanted my broomstick." Brockbank had previously designed Bulgarian Quidditch Seeker Viktor Krum's broom for *Harry Potter and the Goblet of Fire*. "We designed a special broomstick for Krum," explains Brockbank, "although Quidditch moves so quickly, you might not notice it. It was more streamlined than most, and quite flat on top with a spine underneath. The top and bottom were in different colors."

TOP: Blueprint of Alastor "Mad-Eye" Moody's broom; MIDDLE RIGHT: A close-up of a broom in the prop makers' workshop; RIGHT: Different views of Moody's broom by Adam Brockbank; OPPOSITE: (top to bottom) Visual development art of Nymphadora Tonks, Kingsley Shacklebolt, and Alastor "Mad-Eye" Moody in flight by Adam Brockbank for *Harry Potter of the Order of the Phoenix*.

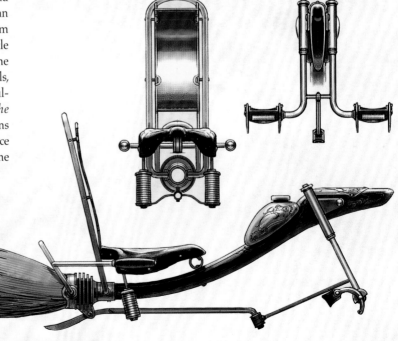

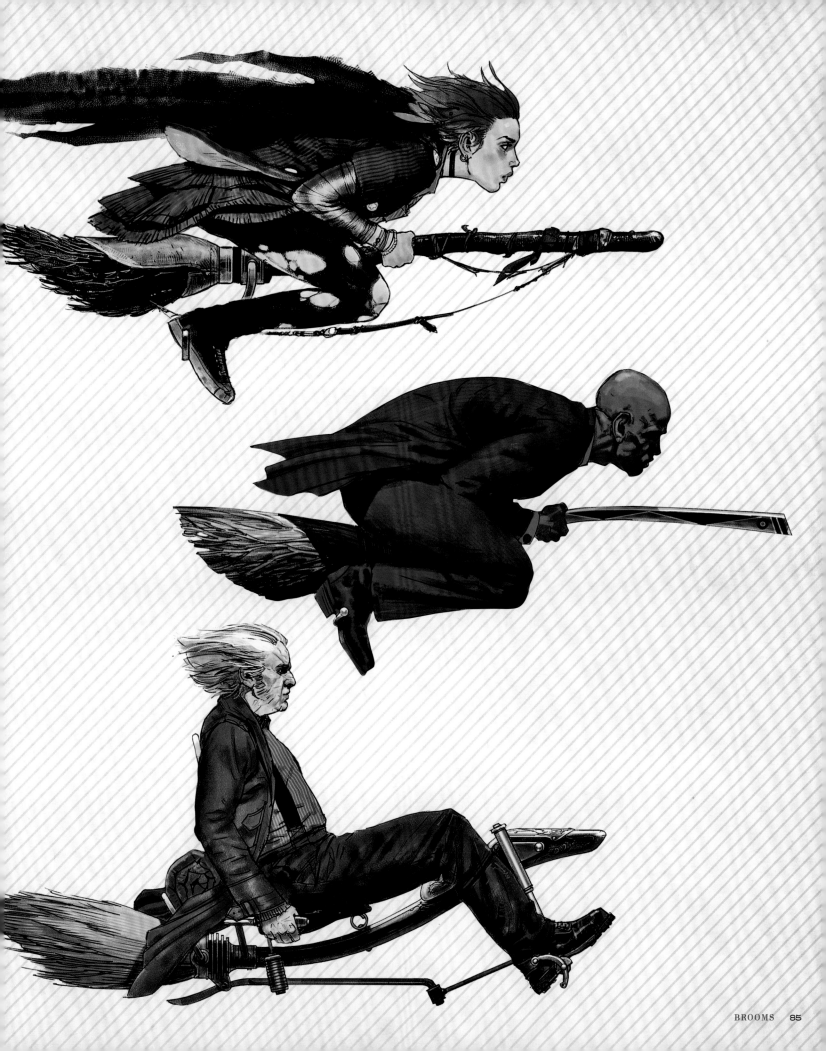

SHOT 4 | A

WIDE
TRACKING
SHOT.

TRAVEL WITH
RESCUE PARTY

SHOT-5 | A

HARRY
SWERVES TO
THE LEFT.

LOW ANGLE.
REVERSE ON WATER

TRAVEL BACK
AS WE
SEE HARRY

HE'S FREE
HE'S ENJOYING
HIMSELF

4-CONT | B

SHOT CONTINUED.

WE SEE
HARRY -
PULL OUT/SUBMERGE

HARRY SWINGS
OUT - NEARER
TO CAMERA.
CONTINUE TO
TRAVEL

4-CONT. | C

HARRY IN
F/G -
SWEEPS
PAST OBJECTS.

RIVER DRESSING

5-CONT. | B

23 JAN 2006
14 DEC 2005
22 NOV 2005

CONTINUE TO
TRAVEL BACK - ON
HARRY AS HE
WEAVES LEFT AND
RIGHT.

spells look as if they are burned/ branded into the wood
(possibly as part of the gold lettering process)

close up of spells
showing wood grain
beneath

metal has soft embossed
from underneath feel to it

Broomstick 4 detail showing treatment of wood

side view

top view

TOP: Members of the Order fly over the London landscape in *Harry Potter and the Order of the Phoenix* in art-work by Adam Brockbank; ABOVE: Concept artist Dermot Power's work offers possible textures and finishes for the Firebolt broom handle in *Harry Potter and the Prisoner of Azkaban,* including broom shafts debossed with spell symbols; OPPOSITE: A shot-by-shot storyboard sequence of Harry Potter and the members of the Order flying over the Thames River after he has been rescued from Privet Drive in *Order of the Phoenix.*

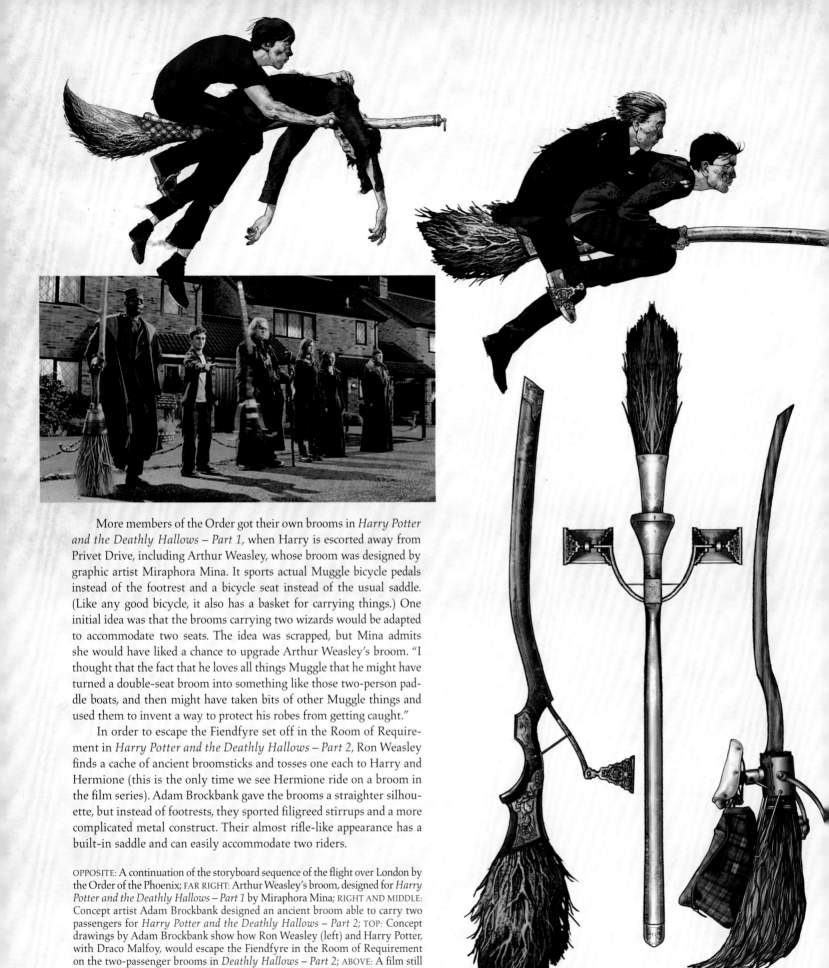

More members of the Order got their own brooms in *Harry Potter and the Deathly Hallows – Part 1*, when Harry is escorted away from Privet Drive, including Arthur Weasley, whose broom was designed by graphic artist Miraphora Mina. It sports actual Muggle bicycle pedals instead of the footrest and a bicycle seat instead of the usual saddle. (Like any good bicycle, it also has a basket for carrying things.) One initial idea was that the brooms carrying two wizards would be adapted to accommodate two seats. The idea was scrapped, but Mina admits she would have liked a chance to upgrade Arthur Weasley's broom. "I thought that the fact that he loves all things Muggle that he might have turned a double-seat broom into something like those two-person pad-dle boats, and then might have taken bits of other Muggle things and used them to invent a way to protect his robes from getting caught."

In order to escape the Fiendfyre set off in the Room of Require-ment in *Harry Potter and the Deathly Hallows – Part 2*, Ron Weasley finds a cache of ancient broomsticks and tosses one each to Harry and Hermione (this is the only time we see Hermione ride on a broom in the film series). Adam Brockbank gave the brooms a straighter silhou-ette, but instead of footrests, they sported filigreed stirrups and a more complicated metal construct. Their almost rifle-like appearance has a built-in saddle and can easily accommodate two riders.

OPPOSITE: A continuation of the storyboard sequence of the flight over London by the Order of the Phoenix; FAR RIGHT: Arthur Weasley's broom, designed for *Harry Potter and the Deathly Hallows – Part 1* by Miraphora Mina; RIGHT AND MIDDLE: Concept artist Adam Brockbank designed an ancient broom able to carry two passengers for *Harry Potter and the Deathly Hallows – Part 2*; TOP: Concept drawings by Adam Brockbank show how Ron Weasley (left) and Harry Potter, with Draco Malfoy, would escape the Fiendfyre in the Room of Requirement on the two-passenger brooms in *Deathly Hallows – Part 2*; ABOVE: A film still shows the Order of the Phoenix preparing to depart Privet Drive.

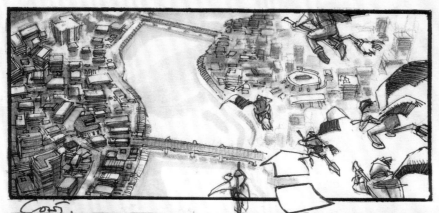

AS THE RESCUE
PARTY DROPS
INTO SHOT.

TRAVEL WITH THEM
AS THEY DIVE
TOWARD THE
RIVER.

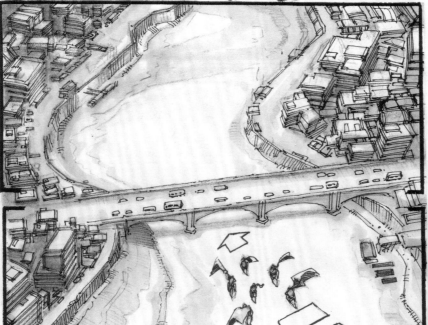

THE RESCUE
PARTY PULLS AWAY
FROM CAMERA.

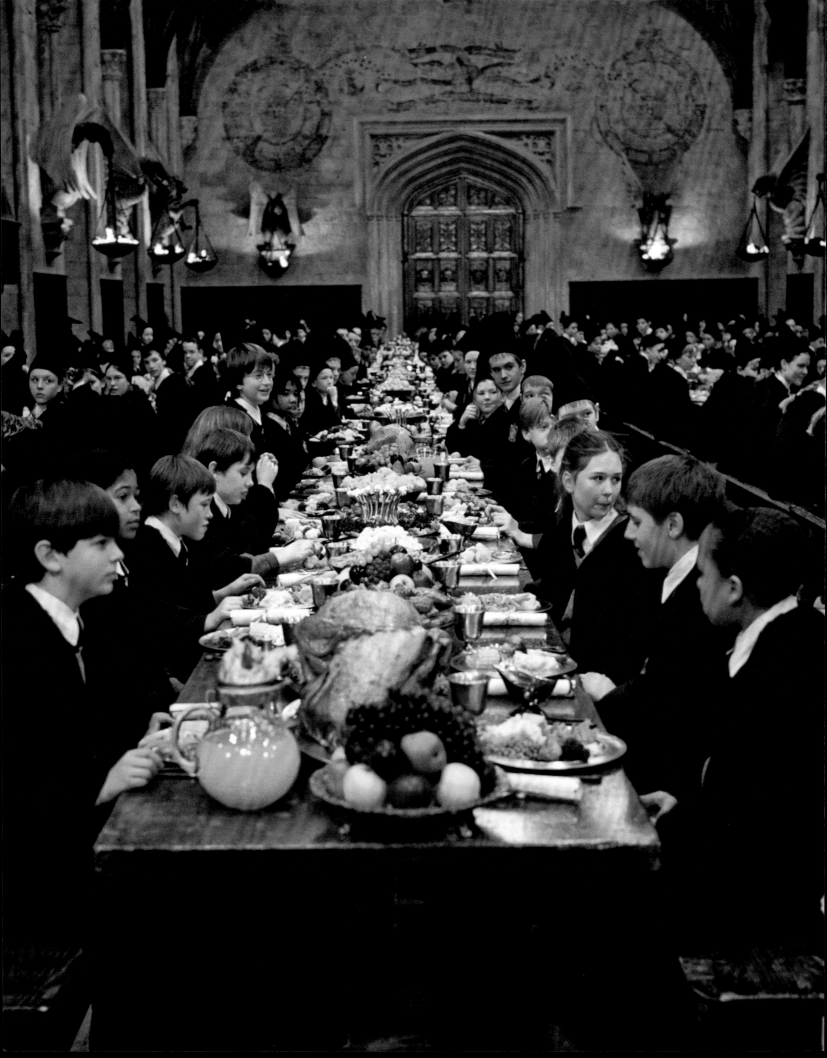

CHAPTER 5
FOOD AND DRINK

"Two pumpkin pasties, please."
—Cho Chang, *Harry Potter and the Goblet of Fire*

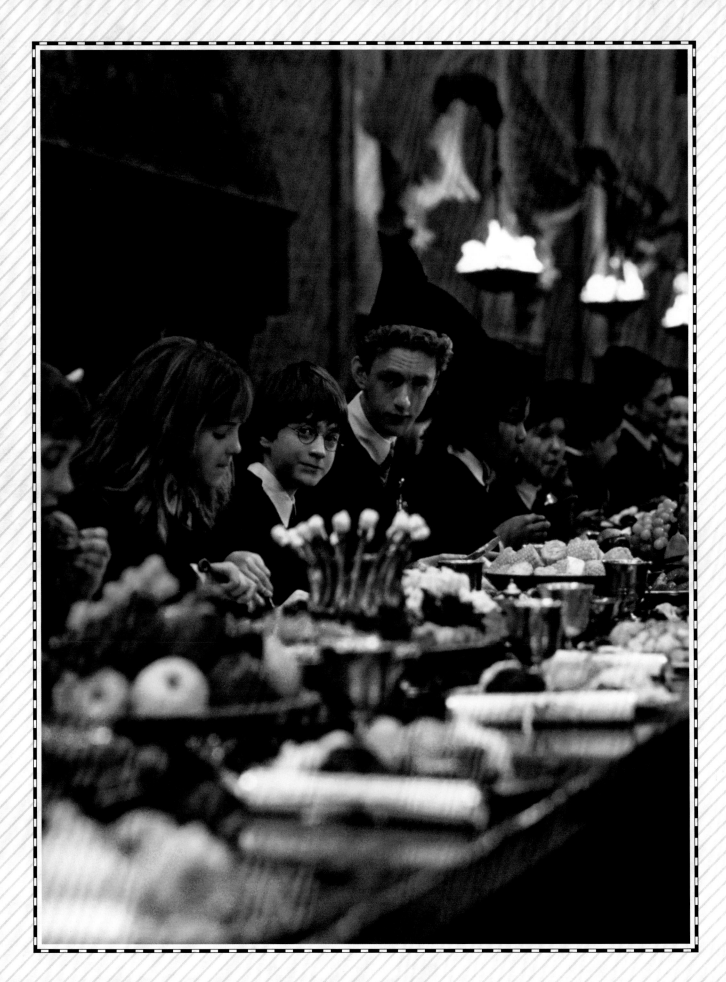

GREAT HALL FEASTS

"Let the feast begin!"

—Albus Dumbledore, *Harry Potter and the Sorcerer's Stone*

The feasts and sweets served in the Great Hall at mealtimes throughout the Harry Potter films were "catered" by the props department. "I remember that for the very first film, they had to make a choice," says prop maker Pierre Bohanna. "I think they had a five- or six-day shoot of the first Great Hall feast, which would include full turkeys, chicken drumsticks, ears of corn, mashed potatoes, etc." The choice was whether it was more cost effective to use real food or create replicas, but director Chris Columbus wanted to use real food. "No dummy stuff for him," adds Barry Wilkinson, property master for the film series. "So first we had to figure how we were going to feed four hundred and fifty kids. And you've got to change the food continually because you can't afford to let it go bad under the lights." Four mobile kitchens were placed around the set to accommodate this. Bohanna continues: "And after three days, it was horrible. No one was actually eating it, so the food sat there all day long. It was hard work to keep it warm and inviting, and the smell became prohibitive." Set decorator Stephenie McMillan concurs: "It became legendary how terrible it was."

This approach continued on the second film, although, "There wasn't a scene like that again with main course foods," explains Bohanna. "What tended to happen from then on was that whenever a feast was shown, it was usually the end of the meal, so we did a lot more puddings and things like that." The changes that came to the film series with the arrival of director Alfonso Cuarón on *Harry Potter and the Prisoner of Azkaban* included a switch to molded food replicas. Occasionally, actual food was still used; the profiterole cakes in *Harry Potter and the Order of the Phoenix* were made with real nuts and puff pastries, but the chocolate sauce that was drizzled on top was a secret recipe of the props department—and entirely inedible.

PAGE 90: Feasting in the Great Hall, *Harry Potter and the Sorcerer's Stone*. Four hundred students were fed on tables one hundred feet long; OPPOSITE: Harry Potter attends his first feast in the Great Hall after being sorted into Gryffindor house in *Harry Potter and the Sorcerer's Stone*. (Left to right) Neville Longbottom (Matthew Lewis), Hermione Granger, Harry Potter, Percy Weasley (Chris Rankin), Lee Jordan (Luke Youngblood); INSET AND ABOVE: A bottle of pumpkin juice, label designed by the graphics department.

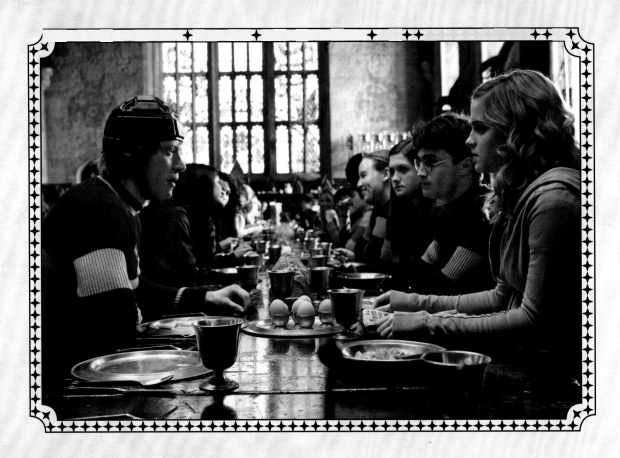

GREAT HALL BREAKFASTS

"If the contents are unsatisfactory, please return this product by owl."

—Statement on Pixie Puffs cereal box label, *Harry Potter and the Prisoner of Azkaban*

Even in the wizarding world, the most important meal of the day is breakfast. Served, as all meals are, in the Great Hall, racks of toast and round disks of butter are bracketed by large jugs of milk and juice that are poured out of a hog's head spout. Fruit preserve jars contain Crazyberry Jam, Forbidden Forest Blossom Honey, and Marmalade with Orange Bits, made by the Hogwarts house-elves, with best-before dates (June in Pisces) on the label. Not surprisingly, cereal is also part of the mix, with the choice of Cheeri Owls and Pixie Puffs as a glimpse into wizarding branding. The graphic designers offered boxes that included prizes, marketing slogans, and ingredient lists. Goodness knows how the students kept their teeth after eating Pixie Puffs (made by Honeydukes), which contains sugar, glucose fructose syrup, African honey, glucose syrup, molasses, magical niacin, iron, fiber, riboflavin, choco, and pixie dust.

ABOVE: Ron Weasley doesn't have much of an appetite for breakfast before his first Quidditch match as Gryffindor Keeper in *Harry Potter and the Half-Blood Prince*. Showing support across the table are Ginny Weasley, Harry Potter, and Hermione Granger; RIGHT: Front and back views of the Cheeri Owls wizarding cereal box (now with Skreet Oil); INSET: A hog's head–stoppered pitcher of orange juice; OPPOSITE: The Great Hall tables, set for a hearty and somewhat healthy breakfast in *Half-Blood Prince*.

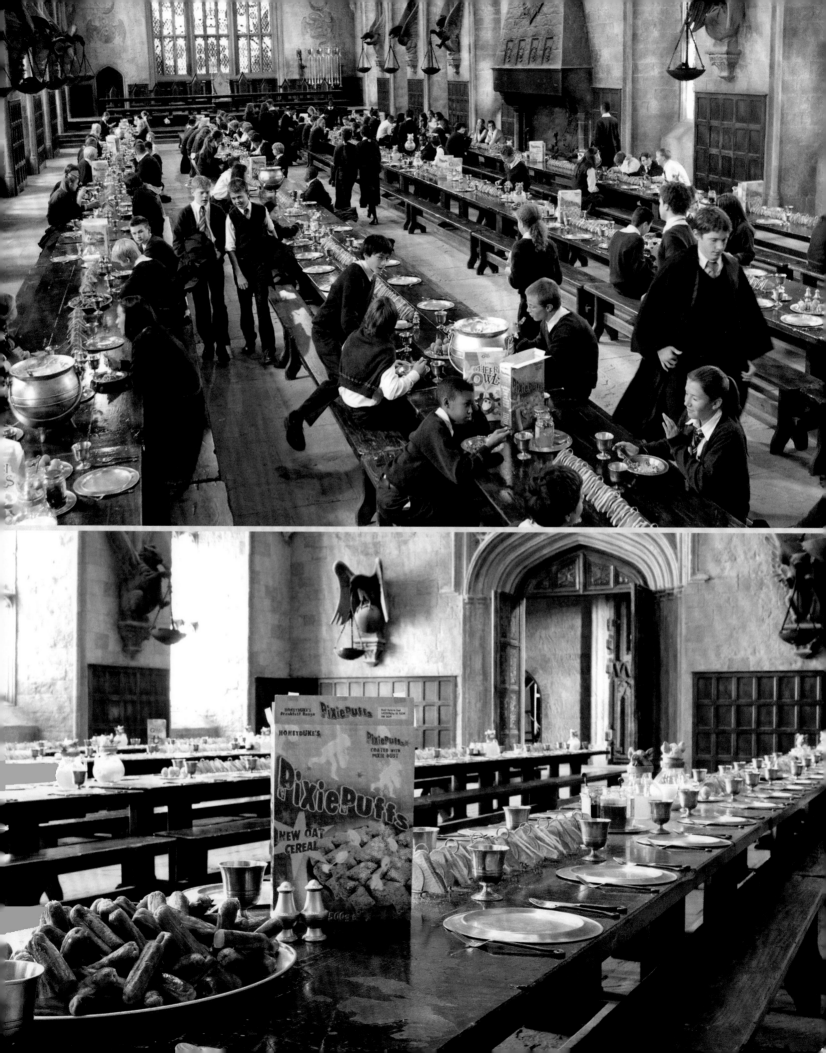

FOOD AND DRINK ESTABLISHMENTS

"Leaky Cauldron! Stay away from the pea soup!"

—shrunken head on the Knight Bus, *Harry Potter and the Prisoner of Azkaban*

Harry Potter's entrance to the wizarding world in *Harry Potter and the Sorcerer's Stone* is—literally—through the Leaky Cauldron, a pub where wizards can grab a Butterbeer or some pickled eel. It's also an inn, and Harry meets up with the Weasleys during his stay there in *Harry Potter and the Prisoner of Azkaban*. Later in the same film, he visits a tavern in Hogsmeade, the Three Broomsticks, which is also seen in *Harry Potter and the Order of the Phoenix* and *Harry Potter and the Half-Blood Prince*. These places are cozy and communal, and offer opportunities for clandestine talks or safe passages. In *Harry Potter and the Order of the Phoenix*, the nascent members of Dumbledore's Army meet in Hogsmeade at the Hog's Head, a slightly seedier pub that is discovered to be run by Albus Dumbledore's brother, Aberforth, in *Harry Potter and the Deathly Hallows – Part 2*.

Each place serves a selection of drinks, with bottles and barrels labeled by the graphics department, including the ubiquitous Butterbeer. There are several varieties of whiskeys, meads, and other beverages; many of the brands were created by the graphics team. The Three Broomsticks also offers bar food: Black Cat Potato Crisps and the house brand of Spellbinding Nuts.

TOP: The shape of the sign for Diagon Alley's Leaky Cauldron is as distinctive as its name; BELOW: Kegs of Butterbeer, pewter flasks, and a small bell that's rung to indicate last call at the bar; and OPPOSITE ABOVE: The tables are set for patrons of the Three Broomsticks in reference photos for *Harry Potter and the Order of the Phoenix*; OPPOSITE BELOW: Labels for some of the Three Broomsticks' offerings created by the graphics department.

*"Oh, the Three Broomsticks and I go way back.
Further than I'd care to admit. In fact,
I remember when it was simply One Broomstick!"*

—Horace Slughorn, *Harry Potter and the Half-Blood Prince*

FOOD AND DRINK AT THE BURROW

Not just crafty at knitting jumpers and scarves, Molly Weasley also makes homemade preserves, lovingly hand-labeled. Flavors include Magnificent Marmalade, Strawberry Jam, and Home Made Yummy Honey.

RIGHT: Labels for Molly Weasley's homemade jams were given the same craftsy feel by the graphics department as her ubiquitous knitting; ABOVE: A film still of the Christmas day spread at The Burrow from *Harry Potter and the Half-Blood Prince*, prior to the Death Eater attack; OPPOSITE RIGHT AND BOTTOM LEFT: Miraphora Mina and Eduardo Lima created the labels for choices available at the Luchino Caffe, visited by Harry, Ron, and Hermione in *Harry Potter and the Deathly Hallows – Part 1*; OPPOSITE TOP LEFT AND CENTER LEFT: Reference photos from the Luchino Caffe set.

FOOD AND DRINK IN THE MUGGLE WORLD

During their escape from Death Eaters who have crashed the wedding of Bill Weasley and Fleur Delacour in *Harry Potter and the Deathly Hallows – Part 1*, Harry Potter, Hermione Granger, and Ron Weasley seek shelter at the Luchino Caffe (named for Miraphora Mina's son). The graphic artists designed drink labels with a decidedly personal flavor, including Lima Lush, a citrus crush fizzy drink.

HOGWARTS EXPRESS TROLLEY CONFECTIONARIES

"Anything off the trolley, dears?"
"We'll take the lot."

—trolley witch and Harry Potter, *Harry Potter and the Sorcerer's Stone*

It is without a doubt that some of the most memorable props in the Harry Potter film series are the sweets. In *Harry Potter and the Sorcerer's Stone*, author J.K. Rowling delivered a trolley-full, which provided a bonding opportunity between future best friends Harry Potter and Ron Weasley on their first trip aboard the Hogwarts Express. The Famous Wizard card Harry gets with his Chocolate Frog is of Albus Dumbledore, but instead of the moving images seen in paintings and photographs in the wizarding world, the picture was made from the same foil material used to create a 3-D hologram.

RIGHT: Candies sold by the trolley witch on the Hogwarts Express in *Harry Potter and the Sorcerer's Stone* and *Harry Potter and the Goblet of Fire* were provided by Honeydukes, although this fact was not known until *Harry Potter and the Goblet of Fire*; OPPOSITE LEFT: Visual development art by Miraphora Mina of "Pick 'N' Trix" Honeydukes packaging, an originally flat container that expands to accommodate more and more sweets as they are added. BELOW, OPPOSITE BELOW, AND FOLLOWING PAGES: Hermione Granger's dentist parents would probably be appalled at the hundreds of sweets crafted for Honeydukes, supplied by the props department and labeled by the graphics department for *Harry Potter and the Prisoner of Azkaban*.

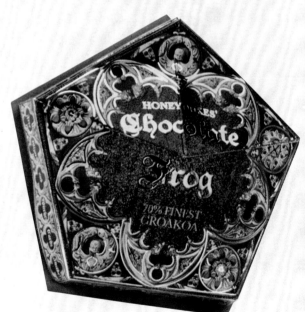

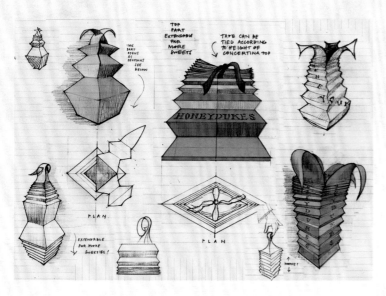

HONEYDUKES

"And Honeydukes is brilliant!"

—Ron Weasley, deleted scene, *Harry Potter and the Prisoner of Azkaban*

One of the highlights for third-year students on their first trip to Hogsmeade is a visit to Honeydukes: a shop filled with shelves and shelves of candies, cakes, lollipops, and chocolate treats. The props department churned out Skeleton Pops, Exploding Bonbons, Liquorice Wands, and Limas Crazy Blob Drops. Inspired by *Harry Potter and the Prisoner of Azkaban*'s Mexican director, Alfonso Cuarón, the prop makers added sugared skulls called *calaveras*, with their colorful Day of the Dead decorations. Before filming, the actors were informed that the candies had been coated with a lacquer finish in order to preserve it over several days of filming. But this wasn't actually true; it was just a ruse to lessen any pilfering or eating of the Honeydukes products.

Jelly Slugs

ZEBRA
HOOFS

CAULDRON
CAKES

PUMPKIN
PASTIES

EXPLOSIVE
FAIRY
DUST

POWDERED
PORCUPINE

HONEYDUKE

Shaved
Caterpillars
Suet Flavour

DRAGON
CLAWS

QUILBASH
1874 Quality Confectionary 2003
CAULDRON
AND
CAKES
Made in
Pakistan
454 g

Hocus Pocus Pops

EAT
ME

TRIWIZARD TOURNAMENT WELCOMING FEAST

*"This castle will not only be your home this year,
but home to some very special guests as well."*

—Albus Dumbledore, *Harry Potter and the Goblet of Fire*

We had feasts before," says set decorator Stephenie McMillan, "but we hadn't had a feast where we've seen this many desserts and puddings." The Welcome Feast for Beauxbatons Academy of Magic and Durmstrang Institute, the two schools visiting for the Triwizard Tournament in *Harry Potter and the Goblet of Fire*, is a chocoholic's dream. "I wanted this to have a different look than other feasts in the Great Hall, and I knew chocolate would be a good subject for a children's celebration," McMillan says. She also admits to an ulterior motive behind her decision: "I thought this would please the children, because they'd seen boring joints of turkey and roast beef too often. And it's fun to push things to extremes." McMillan designed the scene with three different colors in mind (it is the *Triwizard* Tournament, after all): white chocolate, milk chocolate, and dark chocolate. Many of the creations included all three colors in various ways, but after reviewing the overall tone, director Mike Newell asked McMillan to include some other colors, just to break up all the brown. "We had originally thought to have chocolate milkshakes, but we decided that was going a step too far," McMillan recalls, "so we used a delicate pink tint in the Hogwarts jugs, and put a few pink sweets in as well." Expanding the palette were the gold plates, cups, and cutlery with which McMillan had set the tables since the first film.

The vast array of desserts reflected both traditional and wizardly English treats. They also reflected the talents of the prop, art, and set dressing departments. Production designer Stuart Craig and McMillan first needed to review how the food would appear (not literally) on the tables. "We looked to see what shapes worked well together in giving it quite a lot of height," she says, "because once the children are sitting at the benches, they become something like a dark mass at the bottom of the room." To overcome this, many-tiered cakes, piles of profiteroles, and towers of ice cream paraded down the tables. Another decision that needed to be made was what would be actually baked or boiled and what would be a culinary illusion. "It's practicality that decides it, of course," explains McMillan. "Those things that definitely wouldn't melt could be real, and the things that definitely would couldn't be." So, as many of the treats were chocolate, many of the treats had to be made out of resin. McMillan felt that audiences would be hard-pressed to discern which was which: "I think you would find

ABOVE: The feast to welcome the Beauxbatons and Durmstrang schools for the Triwizard Tournament in *Harry Potter and the Goblet of Fire* was the first dessert menu the set design and prop makers' teams served for the Harry Potter films; OPPOSITE: Set designer Stephenie McMillan's color palette of milk, dark, and white chocolate for the feast was enhanced with a few pink accents and beautifully complemented the gold plates and cutlery used in the Hogwarts Great Hall.

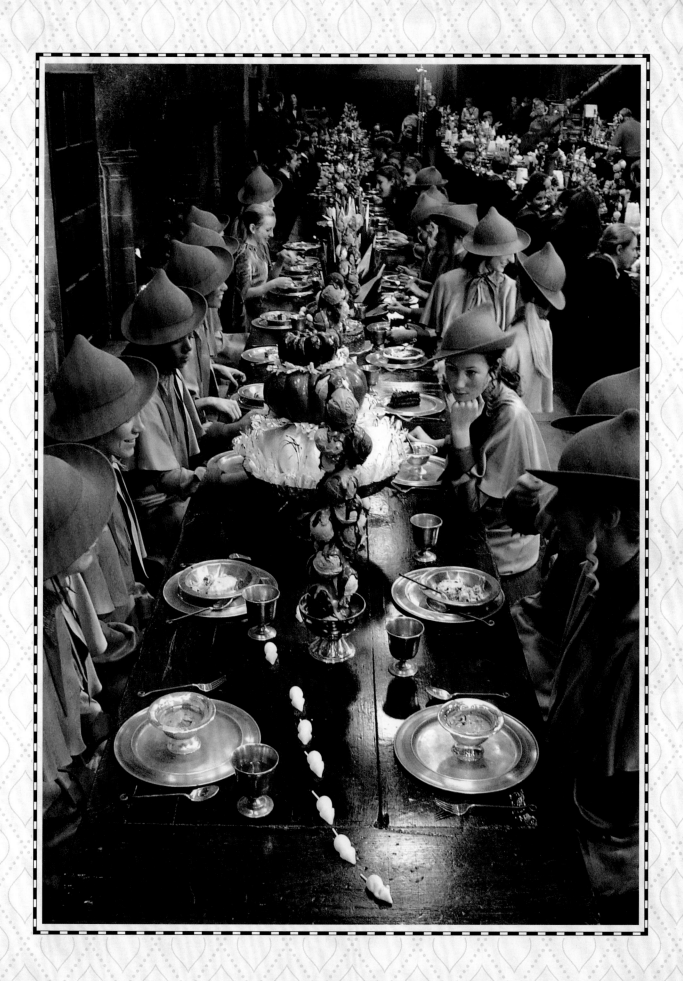

it very difficult to realize that the small chocolates on the dishes aren't edible, because Pierre Bohanna and his team have really perfected the art of food that looks realistic. I think you could easily be fooled by those, though they have real nuts on the top."

Among McMillan's favorite sweets are the "profiterole explosions." These were real profiteroles without the cream inside, drizzled with a faux chocolate sauce. Another was the tiny white (and a few odd pink) chocolate mice that ran along the tables. "We started with one thousand mice, to take into account the fact the children might eat some of them," she admits. Other desserts were also inspired by animals or nature. Chocolate frogs sit atop shiny frosted cakes. A rabbit in a top hat cake was molded from a real folding top hat (the rabbit was not made from a mold). "We started with sixteen of the top hats and really liked them," McMillan says, "so we ended up with sixty-four. We always have to think in huge multiples on Harry Potter. Never do one or two. It's always hundreds." A stacked pumpkin cake was molded from pumpkins that had been used as props in Hagrid's garden. Phoenix-adorned cakes sit at the top table. The original intention was to have cakes made to represent the four Hogwarts houses, but then the designers decided it might be simpler to have several cakes near Dumbledore that represented his phoenix, Fawkes.

One very striking concoction can be found in the towers of ice cream cones. "No-Melt Ice Cream!" McMillan says with a laugh. "We found a shape of cones we liked, made molds, and then let the props department have a ball with them. They're actually very heavy, but they add a bit more color into the room." Pierre Bohanna had already done a version of these for a feast in *Harry Potter and the Prisoner of Azkaban,* and so had perfected the technique—which is, sadly, completely inedible. "It's a combination of resins and powdered glass, a kind used for sandblasting," he explains, "so it's made of tiny little glass beads that give a wonderful iridescence. It sparkles, and it's got just the right texture of ice cream. There're loads of little tricks we develop and use. In order to replicate something, we'll buy a ton of it for research and think, how can we get this quality, this look? Of course, it takes lots of different ideas and lots of tries to get it to work." Once all the feast's foods were decided upon, designed, and created, the props department was tasked with making hundreds of them to serve the hundreds of people in the Great Hall. "We had giant wobbling chocolate trifles, blancmanges, steamed sponge puddings, which are not the prettiest things, and jelly custards, which Mike Newell requested," McMillan affirms. "And a magnificent ribbon cake that if you cut it, would have a most delicious, heavy, chocolaty filling made with rum inside. Well, I dreamed it would, anyway!"

THESE PAGES: More than a thousand white (and a few pink) mice wind around desserts of jelly custards, profiterole explosions, and chocolate rabbit in a top hat cakes on the Hogwarts tabletops. In order to provide varying heights of the desserts, tall towers of No-Melt Ice Cream—eighty of them—were placed in between the cakes and puddings, as well as varying levels of soft-serve No-Melt Ice Cream in cones.

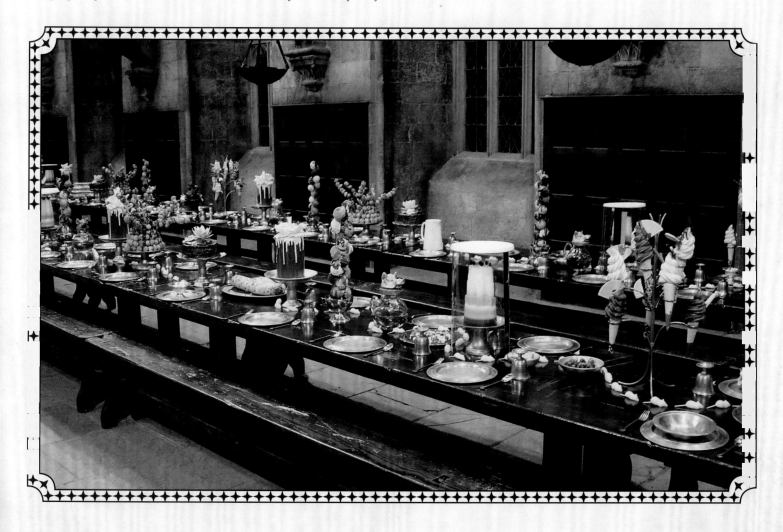

YULE BALL FEAST

"The Yule Ball has been a tradition of the Triwizard Tournament since its inception."

—Minerva McGonagall, *Harry Potter and the Goblet of Fire*

Set decorator Stephenie McMillan had two feasts to serve in *Harry Potter and the Goblet of Fire*; in addition to the welcome feast, she needed to provide the food served at the Triwizard Tournament's Yule Ball. Once again, she tried to find something new to serve. "For this one, I thought seafood would be good because, again, we hadn't seen it before. And it would look good on an icy base, which went with the theme of the room." Lessons had been learned from the real food used in the first Harry Potter films and so the majority of the food served was made of resin. To create the faux fish, McMillan and her team ransacked London's famous fish market, Billingsgate, for lobsters, crabs, prawns, and other shellfish. Some were used to create resin molds, but others were real. These were treated so they wouldn't go rancid under the studio lights, meaning no one could eat them, but no one could smell them either.

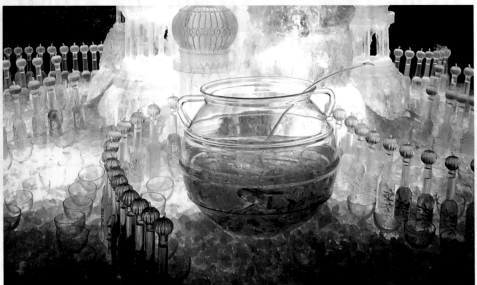

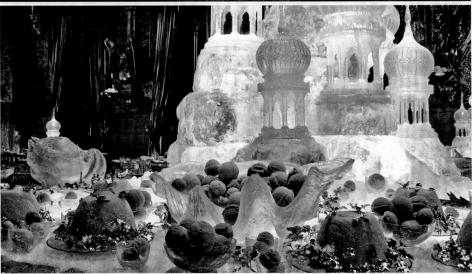

TOP AND ABOVE: The Yule Ball Feast in *Harry Potter and the Goblet of Fire*; BACKGROUND: Positioning and elevation notes for the tables' ice sculpture decorations; OPPOSITE: Resin-molded and a few real shellfish were placed atop tables of resin-molded ice in another new approach to a Hogwarts feast. The clear-cast ice sculpture, created by Pierre Bohanna and the props team, resembles the Royal Pavilion in Brighton

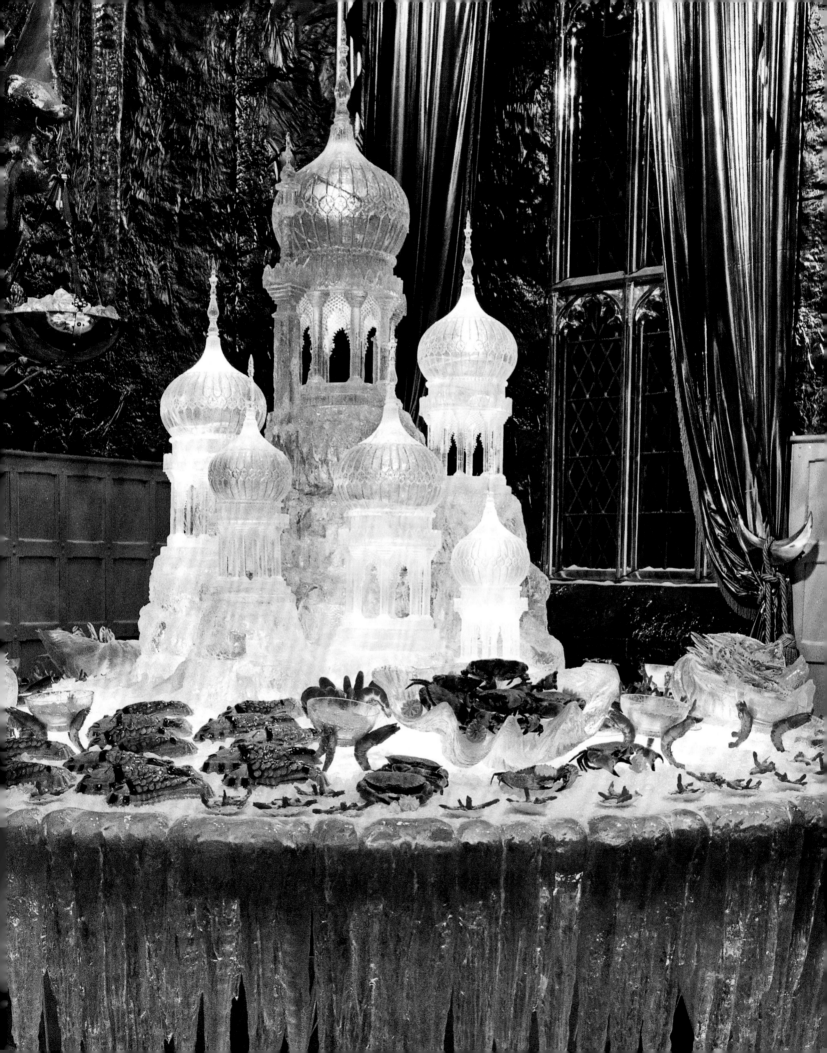

MAGICAL MUSIC

Two musical groups perform at the Yule Ball. Professor Filius Flitwick conducts a student orchestra at the start of the ball, accompanying the champions' dance with a waltz. The small ensemble plays white or translucent instruments, made of clear-cast resin, which match the icy theme of the Great Hall's decorations. The musicians who comprise the Hogwarts orchestra are members of the Aylesbury Music Centre Brass Band, ages eleven to nineteen. Later on, a wizard rock band takes over the entertainment. "We made all their instruments," Pierre Bohanna reveals. "A twelve-foot-high bagpipe and massive, colossal, clear cymbals. There was a keyboard, guitars, and a full set of drums. They didn't actually work, but they looked as if they did." The band performs onstage in front of a wall of large, chrome megaphones. "We wanted to create a sense of occasion with the band," says production designer Stuart Craig. "But of course, there's no electricity at Hogwarts, so everything is powered by steam!"

RIGHT: Icy music stands, made of the same clear-cast resin as the instruments, await the student orchestra. Lighting the resin was challenging because, "if you put white light on it," explains prop maker Pierre Bohanna, "it turns pink." Lighting gels gave it an ice-blue tone; ABOVE RIGHT: Professor Flitwick (Warwick Davis) introduces the wizard rock band that played at the Ball. Flitwick crowd-surfs during the concert, an idea Davis suggested that he thought no one would actually have him do! TOP: (left to right) Professor Flitwick; bassist Steve Mackey and front man Jarvis Cocker, both from the band Pulp; Jonny Greenwood, guitarist for Radiohead; and bagpiper Steven Claydon, who played in the band Add N to (X), rock out at the Yule Ball. Director Mike Newell wanted to re-create the dances of his own school years, which would start with formal dancing, "but at the end we'd all let our hair down and have enormous fun"; OPPOSITE TOP: Jonny Greenwood (right) plays a three-necked guitar, fitting for the Triwizard Tournament. Next to him, Steven Claydon tackles some pretty extreme bagpipes; OPPOSITE BOTTOM: The wizard band performed in front of a one hundred megaphone sound system. Scheduled toward the end of the movie shoot, the cast and crew were able to let lose during the scene's filming.

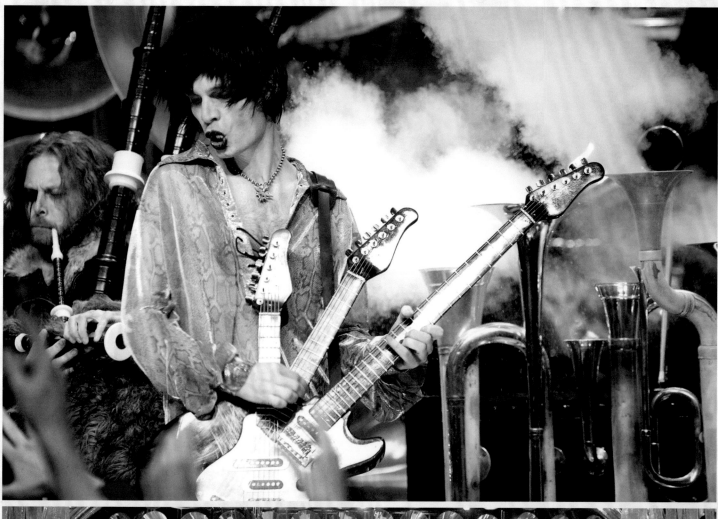
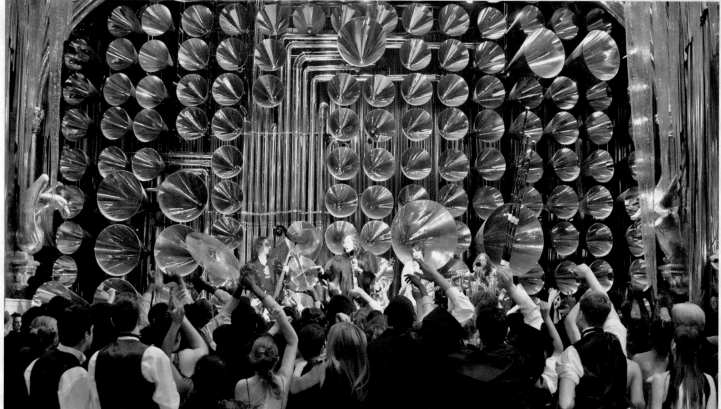

WEASLEY WEDDING

"Besides, you've still got the trace on you. We've still got the wedding."

—Ron Weasley, *Harry Potter and the Deathly Hallows – Part 1*

A bright, happy moment before the tumultuous events of *Harry Potter and the Deathly Hallows – Part 1* is the wedding of the Weasleys' eldest son, Bill, and the Beauxbatons Triwizard champion, Fleur Delacour. Within a huge marquee tent, guests danced, mingled, and feasted on plates of mouth-watering small confectionaries—petit fours, tiny éclairs, strawberries dipped in chocolate—almost all prepared out of silicon rubber. "We did have some real food on the tables for people to be seen eating," says Stephenie McMillan, "but not only did the rubber ones work for decoration, they were also necessary when the tent is destroyed and the guests are trying to escape." McMillan admits that it took several tries to get the right size of the little cakes. "Harry Potter usually has things larger than life, and we were first shown really big flans and huge fruit tarts. So I had to ask for another attempt." The home economist who prepared the edible items for the films came back with meringue swans. "Exquisite—and still too big," says McMillan. "I felt rather guilty saying, 'Well, it's not really quite what I had in mind." But it wasn't long before the props department was given the correct-size molds to create the small cakes McMillan had requested. *Four thousand* of them. The reception food was placed on three-tiered confectionary stands molded in breakaway Perspex from a glass version McMillan had found in an antiques shop.

The piece de la resistance of any wedding is the cake—and the Weasleys' was no exception. As the decorative theme of the wedding was French, as a nod to Fleur Delacour's family, "We decided the icing should look like French trellis arches, called *treillage*, found in eighteenth-century French gardens," says McMillan. The design, which encompasses latticework that surrounds four tiers separated by elaborate stands, was worked out on paper and then redrawn into a computer that produced templates to create the treillage. "Which saved us a lot of time with this process because we didn't have a lot of time to make it," recalls Bohanna. It wasn't that the treillage needed to be produced in a thin inedible material to keep the cast from sampling it, but because the weight of real icing would have been too heavy for the cake's proportions. "The actual cake component of it was a classic cake, albeit proportionately very stretched, because Stuart Craig wanted to make it very tall and slender."

Bohanna remembers that after the cake had been designed, Stephenie McMillan thought it might be a good idea if someone fell into the cake when the Death Eaters arrive and the wedding guests panic and run. "So suddenly we had to think about how to make it into a prop cake where, if someone fell into it, all the sponge and the cream would actually burst out. It seemed impossible because the fineness of the icing underneath each layer of cake is so light, it wouldn't actually be able to hold up under what might be more than twenty pounds for each tier." It might have *seemed* impossible, but not to the Harry Potter props team. "We did get it to work, making the cake essentially in foam, with very light foam tubes inside, filled with sponge cake and cream. And they actually shot a stunt guy falling through it, but decided against including it because it was too comical in a scene that needed to very dramatic and quite scary." However, Bohanna never thinks any task is wasted. "It's another thing we learned how to do, and so you never know when you'll need to do it again."

TOP: Hermione Granger's beaded handbag; ABOVE: A tiered confectionary stand made of breakaway material holds rubber éclairs, tarts, and meringue swans, all of which are safely destroyed when Death Eaters crash Bill Weasley and Fleur Delacour's wedding and the patrons run in fear; LEFT: The props department "catered" thousands of small petit fours, bonbons, and chocolates, all individually prepared so no two were alike; BACKGROUND: A blueprint by Julia Dehoff of the tabletop French-style glass candle holders. The stems were made of rubber and the funnels of breakaway glass; the "candles" were electric gelignite lights that actually lit the actors' faces; OPPOSITE LEFT: Draft work of the treillage cake by Emma Vane shows the proportions and placements of the very delicate icing design; OPPOSITE RIGHT: The finished cake, set with small candied fruits and a large warning not to try to take a taste!

SKETCH ELEVATION—SEE SEPERATE DWG FOR.
PLANS & ELEVATIONS OF CAKE COMPONENTS.

DETAIL 1
TIER 4
DWG F0931

PERFORATED BASKET OF ICING
TO HOLD FROSTED FRUIT.

PERFORATED ICING OF ICING.

DETAIL 3
TIER 3
DWG F0930

DETAIL 2
TIER 2
DWG F0929

DETAIL 1
TIER 1
DWG F0928

4¼"
TIER 4

6½"
TIER 3

4'-6 7/16"
O/A

1'-9 9/16"
TIER 2

1'-3½"
TIER 1

SKETCH ELEVATION

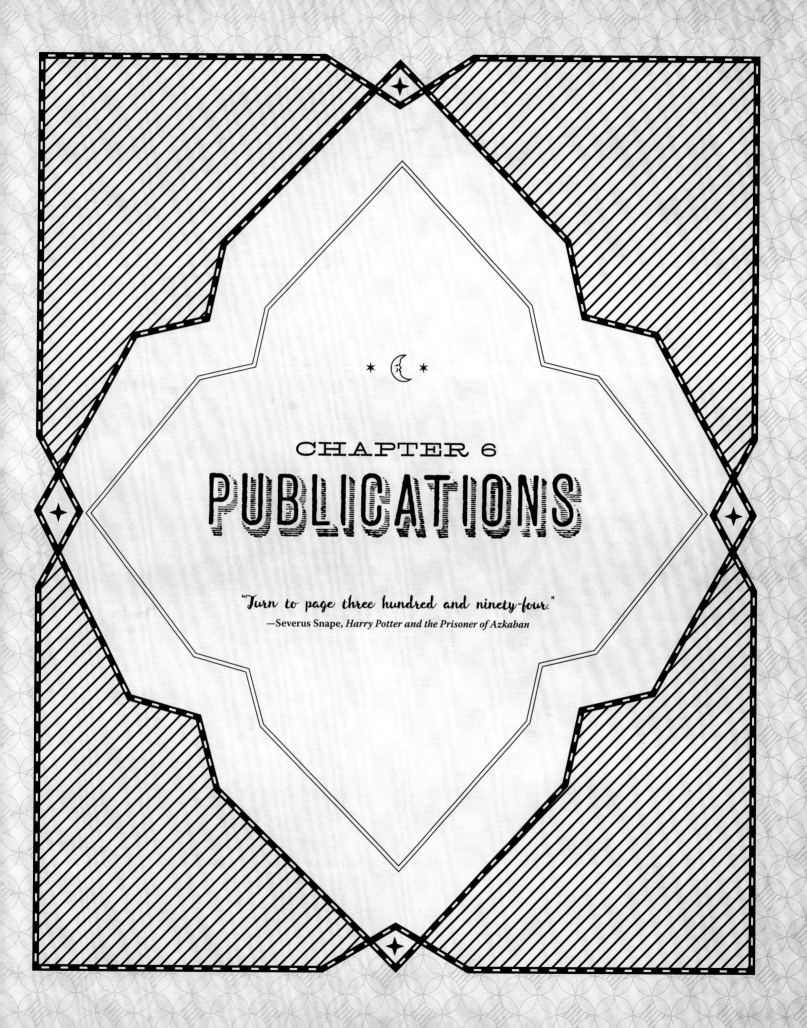

CHAPTER 6
PUBLICATIONS

"Turn to page three hundred and ninety-four."
—Severus Snape, *Harry Potter and the Prisoner of Azkaban*

"HE WHO MUST NOT BE NAMED RETURNS"

—headline in the *Daily Prophet*, *Harry Potter and the Order of the Phoenix*

It's a well-known visual effect in movies to see a whirling newspaper slow down to reveal a headline proclaiming information that is important to the audience. The newspapers and magazines in the Harry Potter films took this familiar convention and gave it its own unique spin, taking cinematic advantage of the moving images under the headlines of the wizarding world's media to advance the plot or recap necessary information. The *Daily Prophet* and *The Quibbler* were important storytelling devices, used to show the sway of public opinion as the Dark forces rose up and Harry Potter's supporters refused to be put down.

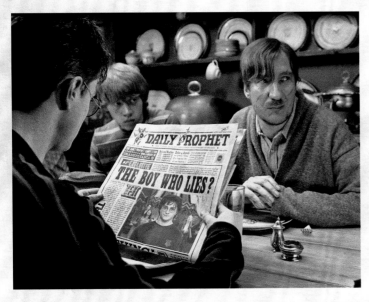

PAGE 114: The printing press used by Xenophilius Lovegood, editor of *The Quibbler*, damaged after the Lovegood house is destroyed by Death Eaters in *Harry Potter and the Deathly Hallows – Part 1*; ABOVE: Ron Weasley and Remus Lupin (David Thewlis) listen in at a meeting of the Order of the Phoenix in the kitchen of number twelve Grimmauld Place, as Harry Potter reads the latest edition of the *Daily Prophet*; RIGHT: Wizard publications include *The Quibbler*, published by Luna Lovegood's father, Xenophilius (this issue seen in *Harry Potter and the Deathly Hallows – Part 1* and *Harry Potter and the Deathly Hallows – Part 2*), and *Seeker Weekly*, a Quidditch aficionado magazine on Ron Weasley's bedside table in *Harry Potter and the Half-Blood Prince*; OPPOSITE: The *Daily Prophet* reports on the increasingly worrisome anti-Muggle incidents at the opening of *Harry Potter and the Deathly Hallows – Part 1*; FOLLOWING PAGES: Storyboards of the *Daily Prophet* drawn for *Harry Potter and the Order of the Phoenix* illustrate the complicated maneuvers through the paper's text and pictures that will be crafted digitally.

THE DAILY PROPHET

"Excuse me, little girl! This is for the Daily Prophet!"

—*Daily Prophet* photographer, *Harry Potter and the Chamber of Secrets*

Just as a hero stars in all the films in a series, sometimes so does a hero prop. A vital method of storytelling, and the wizarding world's primary printed news source, the *Daily Prophet* appeared in every Harry Potter film. It was known from the start that the newspaper would feature moving images within it, and so graphic designers Miraphora Mina and Eduardo Lima felt that the text should feel compatible with that. "We didn't know at first if the text might move as well," says Mina, "and that was probably one of the reasons that the pages have the text in spirals and shapes." For the first five films, the *Prophet*'s cover page often had text blocks in a design that reflected the story: In *Harry Potter and the Prisoner of Azkaban*, the headline announcing the Weasleys' grand-prize-winning trip to Egypt is in the form of a pyramid; Rita Skeeter's story about Harry Potter and the Triwizard Cup in *Harry Potter and the Goblet of Fire* is placed, literally, within the outline of the Cup. The newspaper's headline font, created by Mina, reflected the Gothic style production designer Stuart Craig had chosen for the film's architecture; other fonts were taken from old books, Victorian advertisements, and letter presses, but "we had to use an illegible font for the actual story copy," she adds. At first, the designers would place in a sketch for the moving images as a suggestion to the visual effects crew. "We'd send it in for approval," remembers Lima, "but the response would be, 'Well, that's good, but you know it's not the image we'll be using.'" So soon enough, Mina and Lima would simply write "MOVING PICTURE TO BE ADDED LATER" in big letters in the picture box for forthcoming issues. The final printed version of the paper would have green-screen material in the image box, of course.



③C. SHOT CONTINUES -

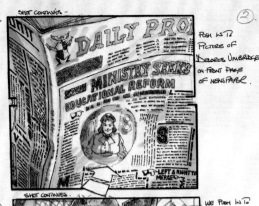

PUSH INTO PICTURE OF DELORES UMBRIDGE ON FRONT PAGE OF NEWSPAPER.

③D. SHOT CONTINUES.

WE PUSH INTO MOVING PHOTO OF UMBRIDGE - IN ONE OF THE CLASS ROOMS AT HOGWARTS.

③E. SHOT CONTINUES.

CAMERA STARTS TO ROTATE AROUND UMBRIDGE TO REVEAL.

③F. SHOT CONTINUES.

FROM OVER UMBRIDGE ONTO REPORTERS AND A PHOTOGRAPHER. CAMERA CONTINUES PULLING AWAY FLASH BULB'S BURST INTO LIFE.

07 FEB 2006
01 FEB 2006
31 JAN 2006

③G. SHOT CONTINUES.

③ CONTINUE TO PULL OUT OF DELORES UMBRIDGE GROUP.

WE SEE ABSTRACT GRAPHICS ON EDGE OF FRAME.

③H. SHOT CONTINUES.

A MAP OF THE U.K. NOW FORMS INFRONT OF CAMERA.

CONTINUE TO PULL BACK -

WE SEE CLOUD SYMBOLS MOVE IN 3D - ACROSS THE MAP. RAIN DROPS FALL ETC.

③I. SHOT CONTINUES.

CONTINUE TO PULL BACK TO REVEAL MORE OF THE GRAPHICS THAT WE REALIZE ARE PART OF THE DAILY PROPHET.

CAMERA CONTINUES TO PULL BACK.

07 FEB 2006
01 FEB 2006



③J. SHOT CONTINUES.

CAMERA CONTINUES TO PULL BACK.

MORE ABSTRACT IMAGES OF THE NEWSPAPERS GRAPHICS START TO STREAM PAST CAMERA.

③K. SHOT CONTINUES.

CAMERA TURNS THROUGH 180° STARTS TO PUSH INTO YET MORE GRAPHICS -

GRAPHICS RUSH INTO CAMERA / PAST CAMERA.

③L. SHOT CONTINUES.

REVEAL PICTURE OF MINISTER FUDGE -

CAMERA PUSHES INTO PICTURE PAST GRAPHICS.

③M. SHOT CONTINUES.

PUSH INTO PHOTO. THE SCENE IS IN THE MINISTRY OF MAGIC.

FUDGE IS SURROUNDED BY THE PRESS - HE PUSHES PAST CAMERA AS HE ANSWERS QUESTIONS. SHOT CONTINUES.

③N. SHOT CONTINUES.

CAMERA TRAVELS AROUND MINISTER FUDGE.

07 FEB 2006
01 FEB 2006

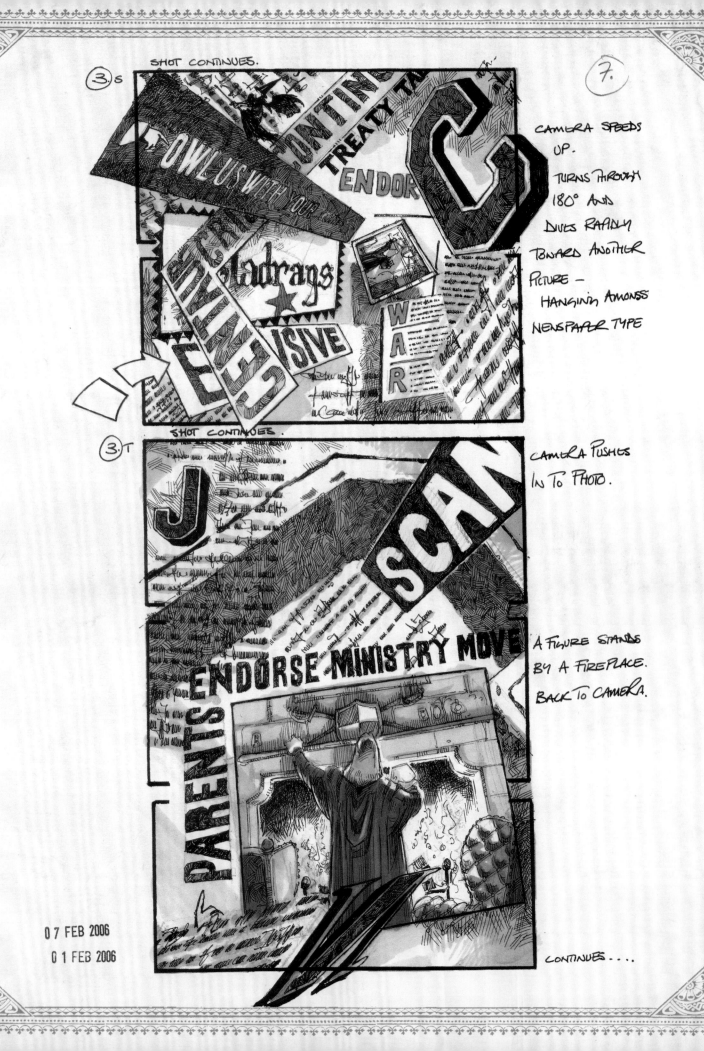

The DAILY PROPHET

★ THE WIZARD WORLD'S BEGUILING BROADSHEET OF CHOICE ★

10,000 GALLEONS ON POTTER'S HEAD SEE INSIDE FOR FULL DETAILS PG.3

NATIONAL WEATHER
SOUTH - SUNNY PERIOD - 2C
NORTH - CLOUDY & RAIN - 3C
EAST - SUNNY PERIOD - 5C
WEST - CLOUDY & RAIN - 3C

ZODIAC ★ ASPECTS
ta - ♍ LEO ☾ ♅ luna opp-
☿ in-♈ ★★★ com ☉ - ♃
o ♌ sizio- ♒ ne pi ✴ sces ⊞

FIRST-SECOND EDITION
№ 26/01/1968 - London - UK
TODAY ☿ in ARIES
Letters or vibes to the Editor should be sent only "by owl post" and with a clear mind to The Daily Prophet - UK

NEW HEADMASTER FOR HOGWARTS - SEVERUS SNAPE CONFIRMED

WIZARDING PARENT'S BACK DECISION

HARRY POTTER
UNDESIRABLE
№ 1

COMPULSORY I.D. CARDS - IMPOSED BY THICKNESSE

AURORS

▬ e. limus **4** ▬ SPORTS **3** ▬ security **17** ▬ MINISTRY AFFAIRS **20** ▬ potions **19**

POTTER LIES LOW

DECOMMISSIONED - WANDS CONFISCATED

Since the *Daily Prophet* is, well, a daily publication, Mina assumed that the paper would look new, but the filmmakers didn't want white pages, and the paper was given an off-white tint. Their choice of dye was, again, coffee, which added a slight scent to the prop. The pages would be put on the floor to dry, and any wrinkles would be ironed out.

While the headline and specific stories would be dictated by the scripts, Mina and Lima were given a free hand (subject to the filmmakers' approval) with other stories, regular features, and advertisements. Like most newspapers, the *Prophet* offers crossword puzzles (with Escher-like designs that question what is across and what is down), contests (WIN A TRIP TO TRANSYLVANIA), letters to the editor (to be sent by owl post only), horoscopes, classifieds, and advice columns. As for other headlines that were needed to fill out the pages, "We had to come up with these," says Lima, "and we had a lot of fun doing it." "But we're not writers so we pulled ideas from our friends and coworkers," adds Mina. "One of our friends was a ginger, so she featured quite prominently in the issues. She goes to Azkaban for illegal henna (GINGER WITCH SURVIVES HENNA EXPLOSION), then she comes out, but gets arrested again (HOOLIGAN GINGER WITCH ARRESTED IN MUGGLE FOOTBALL MATCH)." Frequently, the names of their fellow graphic artists were used in the ads. "And, of course, we always tried to put our names in it," Lima confirms. M. Mina and E. Lima were the final contestants in a wizarding dueling final, and a mashup of their names became a Dark Arts protection course for the Spellbound Minulimus Method. Lima, among others, also posed for pictures in the ads; one of his is for another course in scuba spells, and he is decked out in full gear. "It's not just us," Lima concedes. "My mum's a writer for the *Prophet*."

The graphics team estimates that there were forty original editions of the *Daily Prophet* created throughout the film series, although the interiors were often repeated, as they would not be seen on camera. "Sometimes we needed thirty copies, and sometimes we needed two hundred," says Mina. Once an issue was approved, it needed to be recreated quickly. "The work was heavy-duty," she continues, "but with our team, I felt like we had elves."

Once the Ministry begins to take control of the newspaper, starting in *Harry Potter and the Order of the Phoenix*, the style and personality of the paper changed. "We discussed it with [director] David Yates," recalls Mina, "and he wanted it to have a dogmatic feel; that nobody had a say anymore, that it was all coming from the Ministry, so this was a big influence on the look." The graphics team was inspired by Russian Constructivism propaganda posters, and so the aesthetic took on a totalitarian tone with bold Soviet-era letters. "The design is always underpinned by the story," Mina explains. The height of the paper was reduced and Yates also asked for everything to be printed on the horizontal. "We also looked at newspapers from the 1940s," she continues. "When something was really important, they would fill the whole page with one story." As the style of newspaper changed, so did the design of its title. But Mina and Lima did enhance the "P" of *Daily Prophet* in gold foil because, as Mina explains, "With such a heavy font, the gold was really just to keep it still, absurdly, magical."

OPPOSITE: A special issue of the *Daily Prophet* was distributed as the Ministry of Magic takes increasing control over the newspaper in *Harry Potter and the Deathly Hallows – Part 1*; RIGHT: The style and personality of the *Daily Prophet* changed drastically from the embellished, free-form style seen in *Harry Potter and the Chamber of Secrets* (top) to the unadorned, block-style distributed in *Harry Potter and the Order of the Phoenix* and *Harry Potter and the Deathly Hallows – Part 1* (bottom); FOLLOWING PAGES: Advertisers in the *Daily Prophet* feature an acne medication, the Minulimus Method protection course of study, and the Fambus Station Wagon from the Nimbus broom company.

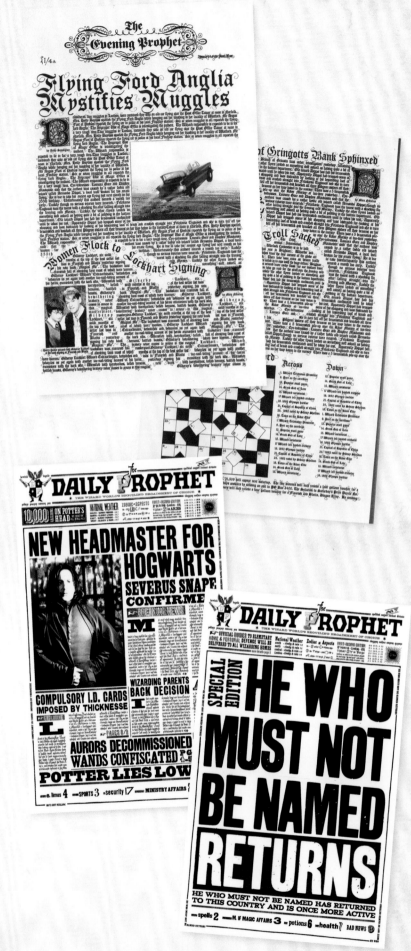

IS YOUR OWL READY?

FOR THE NATIONAL **S.M.S**➤

SECRET MESSAGING ★★★ SERVICE

DOES YOUR OWL STAND OUT FROM THE REST?

GRADE **1** BIRDS URGENTLY REQUIRED

.M.S➤ IS YOUR OWL WORTHY?
RECRUITMENT MEETING AT: WOODSIDE ARBORETUM ON: 17/##✠

ALWAYS BE: ON GUARD

DON'T RISK BEING UNPREPARED
THE ENEMY CAN STRIKE AT ANY TIME

PREPARATION IS THE BEST PROTECTION

WARNING!

DEATH EATERS ARE AMONG US!

HELP US TO HELP YOU!

YOUR INFORMATION IS VITAL

INFORM IMMEDIATELY
THE MAGICAL LAW ENFORCEMENT SQUAD
OF ANY SUSPICIOUS BEHAVIOUR

with the new range of potions from *Witch Watchers*

EAT AS MUCH AS YOU WANT

GRINGOTTS
SAVINGS FREE OF HEXING TAX OF UP TO 3,000 GALLEONS EACH TAX YEAR
START SAVING FROM JUST ONE SICKLE !

JUNIOR WIZARD SAVINGS ACCOUNTS
The value of investments may go down as well as up and the child may not get back the full amount of any additional contributions.

IS YOUR FAMILY HEIR BROOM OUT OF DATE?
NOT ENOUGH BROOMS IN THE FAMILY GARAGE?

WE HAVE THE SOLUTION

It's no quiet! It's no sound!

A REMARKABLE NEW BROOM JOINS
THE NIMBUS FAMILY OF FINE BROOMS
REACH NEW HEIGHTS IN THIS NEW NIMBUS STATION WAGON...

IT'S THE SMARTEST BROOM WHEREVER YOU GO!

NIMBUS STATION WAGON

STAMP OUT THE ENEMY

BE AWARE OF DEATH EATERS
REPORT TO THE MINISTRY IF YOU SPOT ANY SUSPICIOUS WIZARDS

MINISTRY OF MAGIC
WIZARDING PUBLIC AWARENESS
NOTICE No. M89h-z

Practitioners of Dark Arts using New "Rune-Sign Language"
to Bamboozle Bonafide Witches & Warlocks!

REFER TO MANUAL M89h-z FOR CODE-BREAKING INFORMATION

BE VIGILANT!

★★★ SERVICES REQUIRED ★★★

YOUR MINISTRY NEEDS YOU

JOIN THE MINISTRY'S ONLY
OFFICIAL ATTACK SQUAD
DON'T FALL VICTIM!
SIGN UP NOW

WARNING: MUST BE OF ADULT WIZARDING STATUS SIGN UP

DEFENSIVE SPELLS ⊕
(ADVANCED) TRAINING

INTENSIVE COURSE EXPERT TRAINERS!
MASTER DEFENSIVE WAND SKILLS IN JUST ONE WEEK!

ENROLL NOW
WARNING: MUST BE 18 + TO APPLY

100% MINISTRY APPROVED
No. 1 4+ PROTECTION

COUNTER CURSE

PROTECT AGAINST THE DARK ARTS

Get FREE enchantments

for a limited time only

WATCH YOUR BACK

COVERT DEATH EATERS ARE OMNIPRESENT

REPORT ANY SUSPICIOUS ACTIVITY
FORTHWITH TO THE AUROR OFFICE
AT THE MINISTRY OF MAGIC

WAND SERVICING
-NOTHING IS MORE *VITAL* IN THESE DARK TIMES!-

A. WEBB SERVICING LTD.
EPHRAIM LANE, H. HEATH
EST. **1728**

ENDORSED BY THE M.O.W

MINISTRY OF WANDS

WAND SERVICING • MOW TESTS
REPAIRS • RECOVERY SERVICE

YOUR WAND IS YOUR LIFE!

COLLECTION & DELIVERY SERVICE AVAILABLE

THE QUIBBLER

"Quibbler? Quibbler?"

—Luna Lovegood, *Harry Potter and the Half-Blood Prince*

dited by Xenophilius Lovegood, *The Quibbler* is "The Wizarding World's Alternative Voice," to quote their masthead. First seen in *Harry Potter and the Order of the Phoenix, The Quibbler* was printed on newsprint paper to give it more of a tabloid rag feel, although among its articles about revealing ancient rune secrets or rumors of goblins cooked in pies, it clearly prints truths about what the Ministry's up to and offers unqualified support to Harry Potter. Just as with the *Daily Prophet*, Miraphora Mina and Eduardo Lima were charged with adding text to supplement the headlines required by the scripts. In addition to her appearance in the *Prophet*, the ginger witch is similarly reported on in *The Quibbler* (GINGER WITCH ARRESTED IN CAXAMBU WITH FAKE HENNA). Mina's and Lima's names are used individually (THE LEAD SINGER OF THE HOBGOBLINS AND MINA LIMA ARE THE SAME PERSON!) or in mashups (MY WEEK WITHOUT RUNES BY EUDAPHORA MERGUS). Regular features include interviews and classifieds, a column called "Revelations," and a weekly query about the Muggle world (BARCODES: WHAT'S THE POINT?). The text font used is not so much illegible as unintelligible. Called "Greek text," it's commonly used in the publishing industry to lay out a book's body text in the design before the author turns in the manuscript.

A special edition was created for *Harry Potter and the Half-Blood Prince* to feature Spectrespecs, which Luna Lovegood is wearing when she spots an injured Harry under his Invisibility Cloak (it was the Wrackspurts around his head that gave him away). The cover was printed on heavier paper, and the outline of the Spectrespecs was perforated for their removal.

Harry Potter, Ron Weasley, and Hermione Granger get a chance to see where *The Quibbler* is printed when they visit Xenophilius in *Harry Potter and the Deathly Hallows – Part 1*. Five thousand copies of the current issue were printed to pile around his circular house. Additionally, large, vintage wooden typesetting characters were strewn around the room, loaned to Stephenie McMillan from a print museum located in a small town near the Leavesden Studios, and a mechanized printing press was installed. "Maybe only a quarter of his house was living quarters," Stuart Craig explains. "So the special effects team created a press based on an American version from the 1800s, and put the paper on a conveyor belt system. We thought it would be fun to have rollers rushing across the ceiling and up and down the walls." Craig asserts it was "more dynamic, more fun, and more to blow up in the end."

ABOVE AND OPPOSITE: Issues of *The Quibbler*, published by Xenophilius Lovegood, Luna's father. What had originally been more of a tabloid rag, with articles about moon frogs and yeti tracking, *The Quibbler* became an alternative voice against the Ministry of Magic and a staunch supporter of Harry Potter; ABOVE MIDDLE: One of the most popular issues of *The Quibbler* included removable Spectrespecs for spotting wrackspurts, sported by Luna Lovegood (Evanna Lynch); BELOW: A storyboard of Luna Lovegood on the Hogwarts Express distributing that edition of *The Quibbler* in *Harry Potter and the Half-Blood Prince*; FOLLOWING PAGES: Interior pages of *The Quibbler* offered games, spell instructions, and personal stories, including one written by a familiar-sounding Eduaphora Mergus.

THE LEAD SINGER OF "THE HOBGOBLINS" & MINA LIMA ARE THE SAME PERSON!

5

ntesque aliqu tincidunt mole auctor klli pulima an sagittis dolor ligula. Su spe Phasellus ulv Proin eu arcu. Nam Curabitur facilisis co metus. Phasellus acc massa in lorem.Fusc vel diam suscipit nor Sed dolor. Nla augue interdum quis, solltu m, feugiat vitae, erat felis, dictki a et, feugikiat qui esent luctus element Phasellus pulvinar n quam. Aliquam ultri

asellus accumsan m.Fusce egetl suscipit nonumiy. lor. Nla augue pede, interdum quis, solitudinali quam, feugiat vitae, tortor. Sed erat felis, dictkium ve vida et, feugikiat quis, nisi

metus. Phasellus accumsan massa in lorem.Fusce egetl vel dian gue pede, interdum f ed erat quam, kium ve esent lu quis, nisi entumqu Phasellus pulvinar niksi e quam. Aliquam ultricesse

8

EXCLUSIVE

SPELL STEPS OF THE WEEK:

WAKEFIELD'S SAMBATA

1

2

3

4

owl us with your comments!

cilisi. In vel leo fauci luctus. Etiam imentum, nulla sedrl semper, sapien turkp us diam, vel laoreet magna eget massa. SI disse semper nibh ve vehicula rutrum. Pel que congue tincidunt ris. Proin est quam, diet vel, dignissim n vel. sem. Etiam dio. Proin tvu sa a leuismodm lesu massa nulla c diam, at aliquam mkil us massa in mi. Sed eget re Mhasellus pulvinar nis i quam. Aliquam ultricil sem vel dolor. Cura ur in tellus it am sumife rm um . Integeir rdi rdum magni ulla In vel augue Nunc vit co faucibusleo facilisis luctus. Etia imentum, nulla sed semper, sapien tur diam, vel laoreet sa na eget massa. Sus

THE QUIBBLER

WRACKSPURTS

UNFUSS THE MYSTERY

DR. SHAMAN REPORTS

2

vallis. Phasellur ulvel yelit' Proin eu arcu. Nam atorci. Curabitur facilisis commol metus. Phasellus accuma massa in lorem.Fusce eg vel diam suscipit nonu Sed dolor. Nla augue p terdum quis, solltud am, feugiat vitae, to ed erat felis, dictkiu vida et, feugikiat quis, esent luctus elementum Phasellus pulvinar niksi quam. Aliquam ultricesse m vel dolor. Curabitur in tellus sit amet ipsum ferm entum posuere. Integer im perdiet interdum illmagna Nulla facilisi. In vel augue Nunc vitae leo faucibusleo facilisis luctus. Etiam imentum, nulla sedrhoncu

Proin eu arcu. Nam atorci. Curabitur facilisis commol etus. Phasellus accumsan ssa in lorem.Fusce egetl diam suscipit nonumiy. dolor. Nla augue pede, dum quis, solltudinali feugiat vitae, tortor. et, feugikiat quis, nisi t luctus elementumqu asellus pulvinar niksi e am. Aliquam ultricesse vel dolor. Curabitur in tellus sit amet ipsum ferm entum posuere. Integer im perdiet interdum illmagna Nulla facilisi. In vel augue Nunc vitae leo faucibusleo cilisis luctus. Etiam cond tum, nulla sedrhoncu apien turkpis cur vel laoreet sapien

9 GINGER WITCH ARRESTED IN CAXAMBU WITH FAKE HENNA

assa nulla congu diam, at aliquam mkiletus massa in mi. Sed eget lore Mhasellus pulvinar nisi et quam. Aliquam ultricil ies sem vel dolor. Curabitiour

massa in mi. Sed eget lore Mhasellus pulvinar nisi et quam. Aliquam ultricil ies sem vel dolor. Curabitiour in tellus sit amet ipsumife rmentum posuere. Integeir imperdiet interdum magni Nulla facilisi. In vel augue Nunc vitae leo faucibusleo facilisis luctus. Etiam cond imentum, nulla sed rhonci semper, sapien turpis cursi diam, vel laoreet sapienma na eget massa. Suspendisse

NEXT WEEK

MUGGLE WORLD

BARCODE WHAT'S THE POINT?

‖‖‖‖‖‖‖‖‖‖
42000 06200

by a Ministry Insider

GAMES

1

2

3

Check this week's answer by sending us an owl

CORNELIUS "GOBLIN-CRUSHER" FUDGE

POWER + GOLD = FUDGE

NEXT WEEK

GOBLINS COOKED IN PIES!

by a Ministry Insider

BOOKS

*"Do you think Neville Longbottom, the witless wonder,
could have provided you with gillyweed if I hadn't have
given him the book that led him straight to it?"*

—Barty Crouch Jr., disguised as Alastor "Mad-Eye" Moody, *Harry Potter and the Goblet of Fire*

In addition to the textbooks necessary for Hogwarts classes such as Potions, Defense Against the Dark Arts, and Charms, books were created for Hagrid's hut and Dumbledore's office, for the Hogwarts library (regular and restricted sections), for Neville Longbottom in order to help Harry Potter in *Harry Potter and the Goblet of Fire*, for Hermione Granger to take on their journey in *Harry Potter and the Deathly Hallows – Part 1*, and for author Bathilda Bagshot's house. Books were seen close up, being held by students, and in the distance, so the use or view of the book on camera determined their material and construction. Many of the shelved books in Dumbledore's office were London phone books rebound in faux covers and sprinkled with dust. Some shelves in the Hogwarts library were filled with books in the same way, but there were also books that needed to fly up to their places, for example, in *Harry Potter and the Half-Blood Prince*. Stephenie McMillan's team made these out of a lightweight material. Their "flight" was created by having crew members wearing green-screen gloves reach through the stacks to grasp the books that Emma Watson (Hermione Granger) would hold up. The piles of books in the library and the curved stacks in Flourish and Blotts that seemed to defy gravity were created by the prop makers, who would insert a curved metal bar through a hole drilled in the books, like stringing beads, to create the effect.

TOP: Harry Potter and Remus Lupin talk over several stacks of bound books after the professor resigns from Hogwarts at the end of the events of *Harry Potter and the Prisoner of Azkaban*; ABOVE LEFT: A tacky book stack, *The Life & Lies of Albus Dumbledore*, from *Harry Potter and the Deathly Hallows – Part 1*; OPPOSITE: The precariously stacked books of Flourish and Blotts bookstore in a reference photo for *Harry Potter and the Chamber of Secrets*; RIGHT: The books that "floated" from Hermione Granger's hand to the shelves of the Hogwarts library in *Harry Potter and the Half-Blood Prince* were caught by crew members.

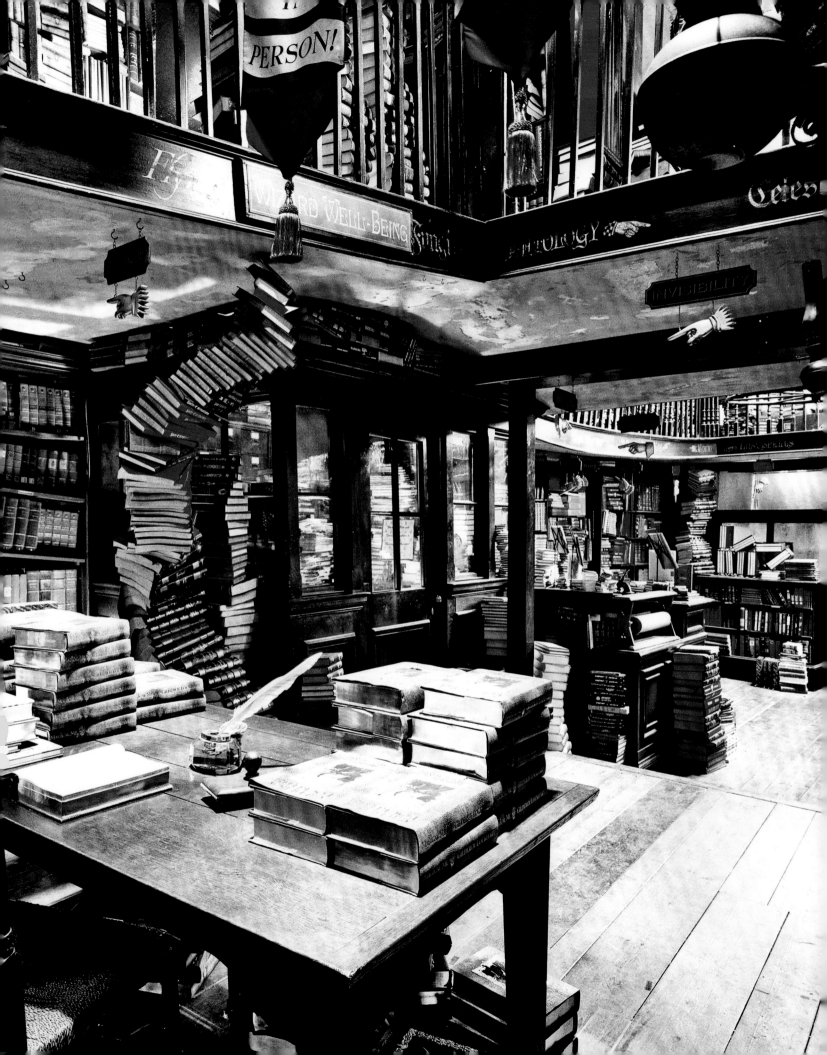

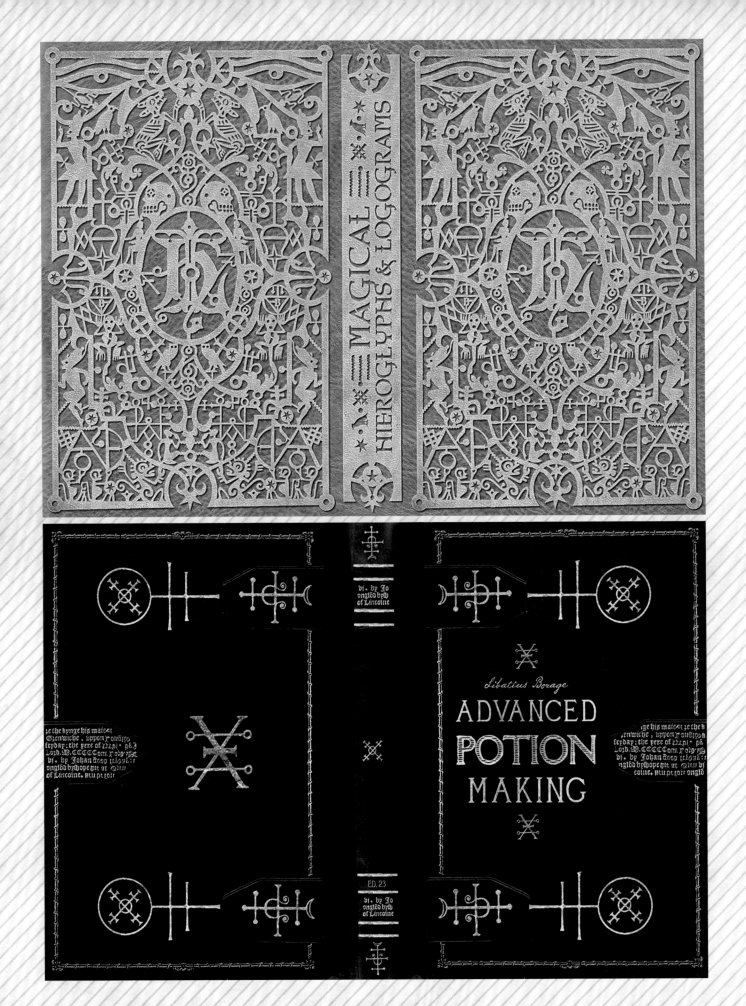

TEXTBOOKS

"Honestly, don't you two read?"

—Hermione Granger, *Harry Potter and the Sorcerer's Stone*

TOP LEFT TO RIGHT: Rubeus Hagrid's copy of *Dragon Breeding for Pleasure and Profit* and the first-years' textbook for Professor McGonagall's Transfiguration class, both from *Harry Potter and the Sorcerer's Stone*, textbook for third-year Defense Against the Dark Arts students, *Harry Potter and the Prisoner of Azkaban;* ABOVE: A Defense Against the Dark Arts textbook and a student notebook created for *Harry Potter and the Goblet of Fire;* OPPOSITE TOP: The exquisite cut-out cover of one of the twenty books Hermione takes with her in *Harry Potter and the Deathly Hallows – Part 1;* OPPOSITE BOTTOM: Perhaps the first edition of *Advanced Potion-Making*, crafted with a leather cover debossed with gold symbols.

Before the start of each school term, Hogwarts students would receive a letter listing what books they would need for the subjects assigned to them for the year. Along with writing the text for the pages within, the graphics department created the title treatments and the design and binding of the books. "We worked very closely with bookbinders and learned traditional techniques and processes," says Miraphora Mina. "It was a wonderful experience to engage with other craftsmen because we wanted to push the boundaries of what you would normally expect in a book binding, and learn how to make covers out of metal and silk and gold leaf."

Miraphora Mina and Eduardo Lima collected a considerable amount of old books that they used as reference for both for the binding and its contents in addition to being able to observe how a book aged; for example, where it broke with daily or yearly use. Once the team, which included their assistant, Lauren Wakefield, decided upon a final design, different-sized editions of the book would be created, again depending upon their time in front of the camera. "There are those books at regular size that the students use," explains Lima, "but when they need to be read close-up on camera, we'll do a bigger version, from twenty-five to fifty percent bigger, especially when you need to read the handwriting, as was the case with the *Advanced Potion-Making* book."

Every book was filled with about twenty pages of text on its subject, written by the members of graphics department, and these pages would be repeated and bound until they reached the size of the book they wanted. A minimum of copies, usually eight, would be created for each book that was handled by a main character. The

schoolbooks in general would be printed for classes of twenty to thirty students, plus several extras, in case the book was destroyed in a stunt or was accidentally ruined during shooting. Author's names that didn't come from the original novels came from friends, family, or members of the graphics department: *Olde and Forgotten Bewitchments and Charms* is by E. Limus (Eduardo Lima), *Ancient Runes Made Easy* is by Laurenzoo (Lauren Wakefield), and *New Theory of Numerology* is by Lukos Karzos (Miraphora Mina's son). With so many books needed for Flourish and Blotts, new titles were created with a wizardly bent (*A Fully Illustrated History of the Flying Carpet* and *Wanderings of a Tree Through the Alps*), and a few seemed to parallel books from the Muggle world (*Wizards Are from Neptune . . . Witches Are from Saturn*). Familiar names showed up for the publishers: Luca Books, Winickus Press (for graphic artist Ruth Winick), and MinaLima Books.

In *Harry Potter and the Deathly Hallows – Part 1*, Hermione Granger brought many books with her on their journey seeking out the Horcruxes that she thought would be helpful. In addition to any books that had already been mentioned that would be useful, such as *Moste Potente Potions*, which Hermione used to create Polyjuice Potion, Mina and Lima added others to her cache to total about twenty books, carried in a small beaded bag touched with the Undetectable Extension Charm. This was an occasion when the artists tried to get into the character's skin. "It was a really nice opportunity to think, well, which ones would she have taken on her trip?" asks Mina. "There was a line in the script that described her bag. She shakes it, and there is this terrible noise of stacked books falling over. Sadly, you don't get to see all of them in the film."

TOP: *The Standard Book of Spells* for first years, *Harry Potter and the Sorcerer's Stone*; ABOVE: The Runes Dictionary Hermione Granger brings with her in *Harry Potter and the Deathly Hallows – Part 1*; OPPOSITE TOP: *Fantastic Beasts and Where to Find Them*, required for first years, *Sorcerer's Stone*; OPPOSITE BOTTOM: Bathilda Bagshot's *A History of Magic*. Versions of this book are seen throughout the film series but this one features the author's image, played by actress Hazel Douglas in *Deathly Hallows – Part 1*; FOLLOWING PAGES: The array of books seen throughout the Harry Potter series included not only school subjects but topics from sports to psychology to social interaction.

BATHILDA BAGSHOT

A HISTORY OF MAGIC

BATHILDA
BAGSHOT

A HISTORY OF MAGIC

A
HISTORY
OF
MAGIC

BATHILDA
BAGSHOT

12ND
EDITION

BATHILDA BAGSHOT

BATHILDA BAGSHOT EMBARKED ON THE JOURNEY OF
MAGICAL KNOWLEDGE DECADES AGO. SHE HAS ALWAYS BEEN
FASCINATED BY THE MYSTERIES AND CURIOSITIES OF
THE WIZARDING WORLD. A HISTORY OF MAGIC EXAMINES
SIGNIFICANT MOMENTS AND FACTS THEREIN, FROM THE
BEGINNING OF TIME TO THE 19TH CENTURY, MAKING THIS BOOK
AN ESSENTIAL PIECE OF WIZARDING-LITERATURE.

M.L
Books
MINALIMA PRINTERS LTD.

M.L
Books.

Q.U.A.B.B.L.E.
QUIDDITCH teams of ENGLAND & IRELAND
Miro Limus

★ An EXTRAORDINARY visual record of the ART of QUIDDITCH ★

M·E·R·G·E

Q.U.A.B.B.L.E.
QUIDDITCH teams of ENGLAND & IRELAND
Miro Limus

REVISED EDITION
with a new foreword by

QUIDDITCH ENGLAND & IRELAND · QUIDDITCH teams of ENGLAND & IRELAND

M·E·R·G·E

ABCD EFGH IJKL MNOP STUV XYZ

A USEFUL GUIDE TO GRAMMATICA

merge publication

GRAMMATICA

GRAMMATICA

ABCD EFGH IJKL MNOP STUV XYZ

M. CARNHH

Laurenzoo's
ANCIENT RUNES MADE EASY

The essential RUNE reference for everyday use

- Over 754.097 outstandingly definitions and alternatives for 21.000 runes & symbols
- Easy-to-use arrangement
- Most useful alternative words/runes given fist and highlighted
- Helpful advice on Rune origins
- Coverage of new runes
- Includes a Rune reference supplement

NEW · Rune Pronunciation Help.

THE MOST HELPFUL PAPERBACK AVAILABLE

merge publications

Laurenzoo's
The Ultimate RUNEfinder
ANCIENT RUNES MADE EASY

merge

Laurenzoo's
ANCIENT RUNES MADE EASY
The Ultimate RUNEfinder

merge publications

A Chudley Cannons Official Merchandise

A COLLECTORS' EDITION
FLYING WITH THE CANNONS
Julius Debotte

A COMMEMORATIVE BOOK EXALTING THE CHUDLEY CANNONS GLORIOUS PAST, PRESENT & FUTURE. WITH AN INTRODUCTION BY THE FAMOUS BEATER JOEY JENKINS AND POETICALLY WRITTEN AND BEAUTIFULLY ILLUSTRATED BY JULIUS DEBOTT MAKING THIS AN ESSENTIAL BOOK FOR EVERY CHUDLEY CANNONS FAN.

A Chudley Cannons Official Merchandise

FLYING WITH THE CANNONS

FLYING WITH THE CANNONS

A CONSECUTIVE BOOK EXALTING THE CHUDLEY CANNONS GLORIOUS PAST, PRESENT & FUTURE

Written by Julius

nam it th ashes of the Platter, a is an Oven, which I shoul e Jew had not painted it, togeth nable, wherein consists a great part of the se as it were the belly, or the wombe, containing the true na heat to animate our young King. If this fire be not measured anically, saith Cabd the Persian son of Jasichus; if th a sword, saith Pythagoras; if thou fire nd makest it feel the heat of the , and burn his flowers befo w, making them cc inted for t nfentio

M.L Books
MINERVA ECHIBA LTD

BATHILDA BAGSHOT

The DECLINE of PAGAN Magic

M.L Books

The DECLINE OF PAGAN Magic
BY BATHILDA BAGSHOT

HOW TO TAME TIGERS
Professor Vindicus Veridis

LUCABOOKS

Prof. Garius Tomkink

HOGWARTS
A HISTORY

12 simple ways to make you THE MASTER OF APPROACH AND CHARM YOUR WAY!

THE NUMBER ONE BESTSELLER!

- WAND CONTROL
- FRESH HALITOSIS
- LOVE POTION COCKTAILS
- SPELLS STRENGTH
- LATIN SPELLS AND MANTRAS

.... AND MANY MORE TIPS AND TRICKS TO MAKE YOUR LOVE LIFE OUT OF THIS WORLD...

HOW TO WOO WITCHES
MAURICIUS CARNEIRUS

- 5 MILLION WIZARDS HAVE TRIED & TESTED!
- BESTSELLER IN OVER 34 COUNTRIES!
- A WORLDWIDE PHENOMENUM!

TRY IT NOW!!!
guaranteed satisfaction or your money back
- 289295

merge

Printed and Bound in Caxambu
No part of this publication may be reproduced or used in any form, or by any means without the prior permission of the publisher.

HOW TO WOO WITCHES
MAURICIUS CARNEIRUS

merge

Irsis Pius

WIZARDS ARE FROM NEPTUNE...

WITCHES ARE FROM SATURN

bla blab
blabla bla
bla blablablblab
blabla bla blablaa
blbalblab blablalba
lblblab blablabla
blabl blablablabla
blablabl abla
bla blabl abl

and

blabalabla bal abl
balablabalablbla
ablabla balabl
blabla ablablbalablba
blablab balabl
blablabal balbal
blablabla
blablabla
fullstop

ISWN

JUCABOOKS
INCYBOOKS

9 781551 668703

...WITCHES ARE FROM SATURN

Irsis Pius

WIZARDS ARE FROM NEPTUNE

NUMEROLOGY

£45∂
890
15345
90

NU ME RO LO GY

£4
3756
890

USE-UL UIDE o UME-OLO-Y

merge
publications

merge
publications

L. WAKEFIELD

UNFOGGING the FUTURE

UNFOGGING the FUTURE

Cassandra Vablatsky

LE CONSPIRACY TH E MUGGLE CON SPIRACY

THE MUGGLE CONSPIRACY

THE MUGGLE CONSPIRACY THE MUGGLE CO

Sinistra Lowe

Phyllida Spore's

1000
Magical Herbs & Fungi

MAGICAL ME AND GILDEROY LOCKHART'S BOOKS

"When young Harry stepped into Flourish and Blotts this morning to purchase my autobiography, Magical Me—which, incidentally, is currently celebrating its twenty-seventh week atop the Daily Prophet's Bestseller List—he had no idea that he would, in fact, be leaving with my entire collected works…free of charge!"

—Gilderoy Lockhart, *Harry Potter and the Chamber of Secrets*

The design of Gilderoy Lockhart's published autobiographical adventures seen in *Harry Potter and the Chamber of Secrets* was a departure from the brief the graphic artists had received about books for the first film. Word came down to them from J.K. Rowling that the author wanted them to look like the hackneyed books of poor quality you pick up at an airport, at least ones that had been created for mass appeal. Miraphora Mina admits she panicked a bit when she heard this. "I thought, how can we possibly fit something like that into the world we've created that's Victorian and Gothic and very rich in an historical sense?"

When Mina thought deeper about the possibilities, she realized that Lockhart himself was the key to the design. "We knew he was a fake, so we used fake skins on the covers to give the impression that he was trying too hard to be what he was," she explains. "We thought that lent itself perfectly to covers that are trying to imitate the look of snakeskin or lizard skin and that would also connect with his journeys into the wild. So these became suitably tacky and horrible. I felt it was much better that we went down this route rather than just look for shiny, bright colors. These also had a nostalgic feel, but it was still superficial and shallow."

Even the paper chosen for the book came under consideration. "Initially, we chose a thin stock, so you could almost see through it, because that would seem very cheap," explains Lima. "And the producers liked it, but after putting together a sample, we realized it would be a nightmare to print and shoot, so we needed to use a thicker paper." Because each student in his Defense Against the Dark Arts class needed to purchase the entire set of Lockhart's books, multiple copies needed to be created.

The main feature of Lockhart's book covers is a portrait of the man himself. Miraphora Mina and Eduardo Lima came up with a list of suggested environments that could serve as the pictures' backgrounds, and just like filming the moving portraits, a small set was built, costumes fabricated, and the scene shot. "That was really fun," Mina admits, "because it was a step out from the traditional look of everything." Two versions of each book were created. "We had green-screen material on the book for the bookshop and for when he's signing the books," she explains. "But also had multiple versions of a completely finished book." For the books that wouldn't be seen so closely on camera (i.e., for the kids in the back of his DADA class), the static version of the cover was used.

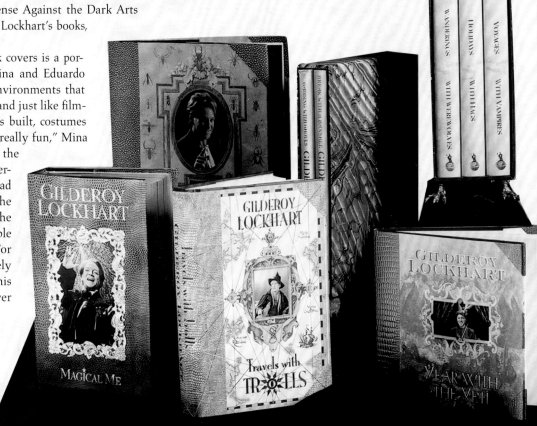

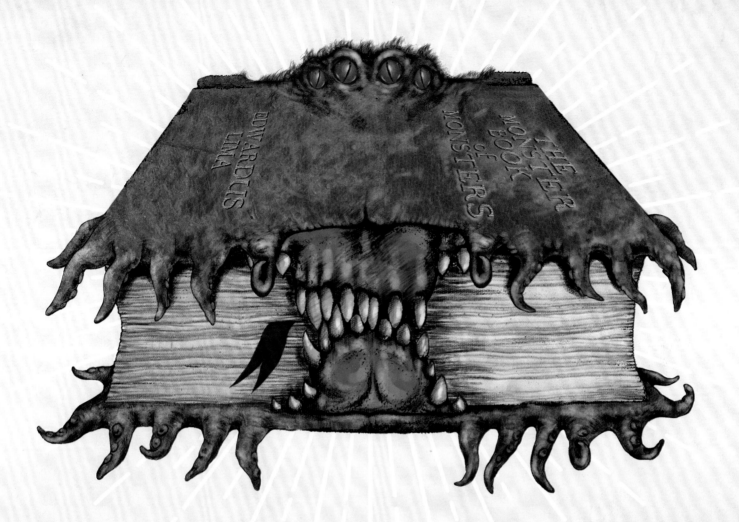

THE MONSTER BOOK
OF MONSTERS

*"Gather 'round. Find yerself a spot. That's it.
Now, firs' thing yeh'll want ter do is open yer books."
"And exactly how do we do that?"
"Crikey. Didn' yeh know? All yeh've got ter do is stroke 'em."*
—Rubeus Hagrid and Draco Malfoy, *Harry Potter and the Prisoner of Azkaban*

Many concepts were suggested for *The Monster Book of Monsters*, the book Hagrid assigns in *Harry Potter and the Prisoner of Azkaban* when he becomes the Care of Magical Creatures professor, including versions with a tail or clawed feet, and even one with a book spine that was made up of, well, spines. Common elements were eyes (in various numbers), sharp, snaggly teeth, and fur. Lots of fur. The monster book's "face" traveled from a portrait to a landscape direction, which would obviously work better by having the opening of the book be where the mouth was placed. Eyes moved from the middle to near the spine to back to the middle (and four of them was the decided number). Miraphora Mina's design offered the ingenious use of the book's ribbon as its tongue. Mina designed the title's typeface and placed the author's name on the cover: Edwardus Limus.

Though the graphics department was usually tasked with creating text to fill a book's pages, in this case, visuals were required, and so some familiar monsters were featured in the entries (goblins, trolls, and Cornish pixies) as well as some unfamiliar monsters created by concept artist Rob Bliss, who offered plant creatures, four-limbed snakes, and something that resembled a cross between a troll and a chicken. Sharp eyes will have noticed that on the Marauder's Map design used for the end credits of *Harry Potter and the Prisoner of Azkaban*, one room is a "Book of Monster's Repair Workshop."

OPPOSITE: The questionably biographical works by Gilderoy Lockhart created for *Harry Potter and the Chamber of Secrets*; ABOVE: Visual development artwork of *The Monster Book of Monsters* by Miraphora Mina with the eyes set on the book's spine, as seen in *Harry Potter and the Prisoner of Azkaban*.

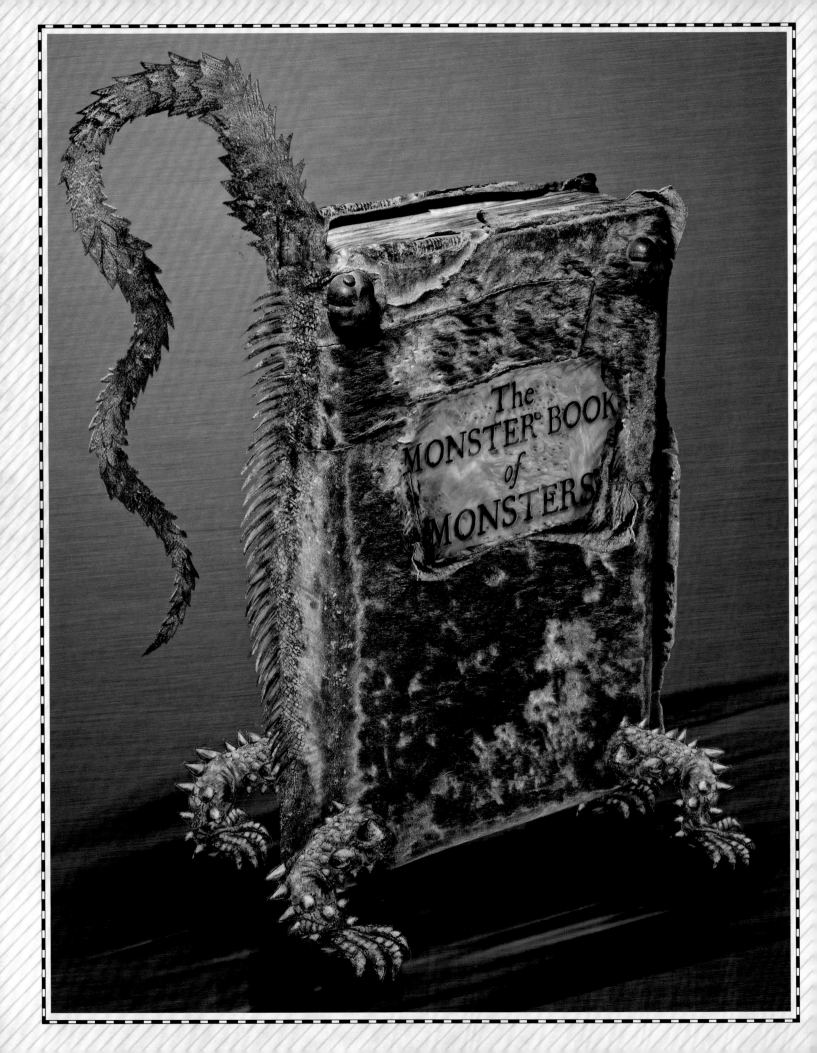

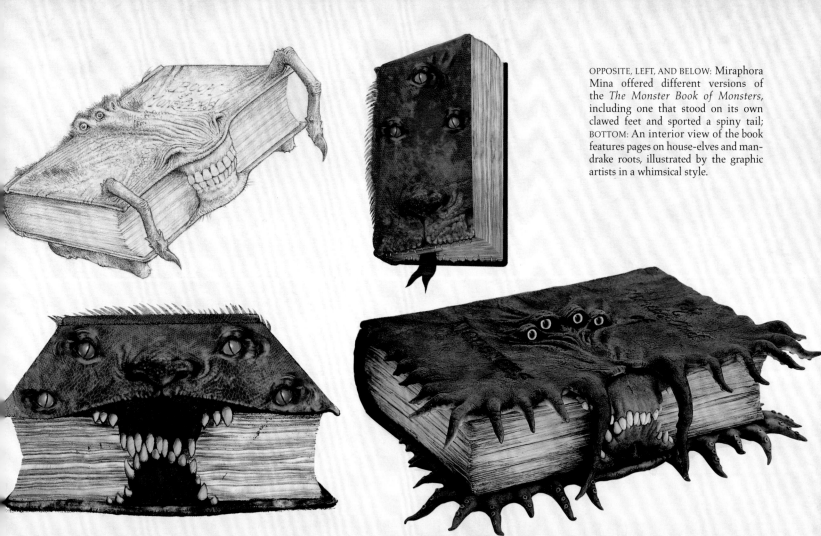

OPPOSITE, LEFT, AND BELOW: Miraphora Mina offered different versions of the *The Monster Book of Monsters,* including one that stood on its own clawed feet and sported a spiny tail; BOTTOM: An interior view of the book features pages on house-elves and mandrake roots, illustrated by the graphic artists in a whimsical style.

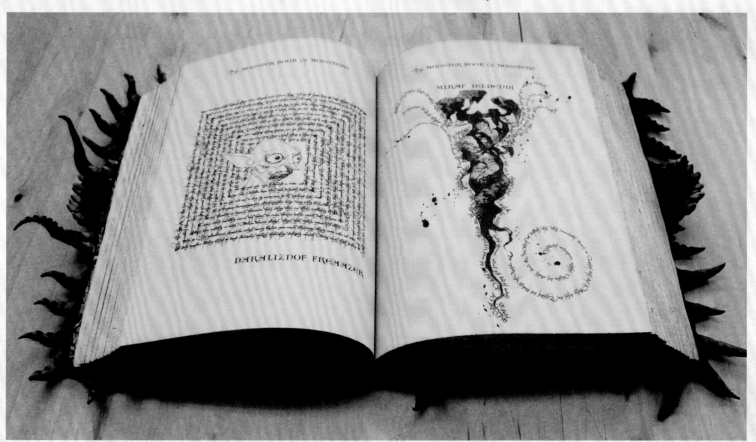

CHAPTER NINETEEN
RUDIMENTARY HOCUS POCUS for
UNSTINKING SINISTER SOCKS

There are some fundamental and distinguishing
factors which will help you to determine
SINISTER from HUNKYDORY.

"But how can I tell?" I hear you say...

1. In the first instance one must examine the
presentation of the said Article and make a
swift assessment ... black or white? Dark or
Light? Pungent or Perfumed?

Tip? COLOUR can reveal the inner Darkness
or Light.
Dear Student....Remember the Golden O.A.P.
rule from Chapter Seven?
Observe, Assess, Prescribe...

68a

1. FAVOURED POSITIONS FOR A
LEFT-HANDED HEX-BREAKER

1. 2. 3.

4. 5. 6.

The HEX ZAPPER wards off and destroys
negative energies then attracts positive ones.

68b

DARK ARTS DEFENSE:
BASICS FOR BEGINNERS

*"From now on, you will be following a carefully structured,
Ministry-approved course of defense magic."*

—Dolores Umbridge, *Harry Potter and the Order of the Phoenix*

The new Defense Against the Dark Arts professor in *Harry Potter and the Order of the Phoenix*, Dolores Umbridge, comes with her own idea of how to teach Defense Against the Dark Arts, which is to say they should be taught in theory, and not in a practical application. The book she has selected for the curriculum is decidedly juvenile in appearance. "In terms of choice of design," explains Miraphora Mina, "it was absolutely meant to be putting them down to the primary school level. And that needed to be quickly shown on-screen." Mina was inspired by both the design and construction of textbooks from the 1940s and 1950s. The book is bulky, with a glued-on cloth spine and a printed front and back cover. The illustration on the front goes against the elaborate, intricate designs seen on other textbooks. "They're children playing wizards," she says, "looking at a picture of themselves reading the book with a cover of them looking at a picture of themselves reading the book, in an endless spiral." The graphic team chose a thick paper for the interior pages, because they felt that would give the effect of the book not having much content in it.

RIGHT: Dolores Umbridge assigned a puerile, uninformative version of the Dark Arts Defense textbook when she taught the class in *Harry Potter and the Order of the Phoenix*; TOP: Interior pages of the book were illustrated with dull images and contained mind-numbing content created by the graphics department; OPPOSITE LEFT: The well-worn second edition of *Advanced Potion-Making* that Harry Potter ends up with in *Harry Potter and the Half-Blood Prince*; OPPOSITE RIGHT: Notes written in the endpapers of the Half-Blood Prince's copy of *Advanced Potion-Making* were digitally duplicated for multiple sizes of the book seen on-screen.

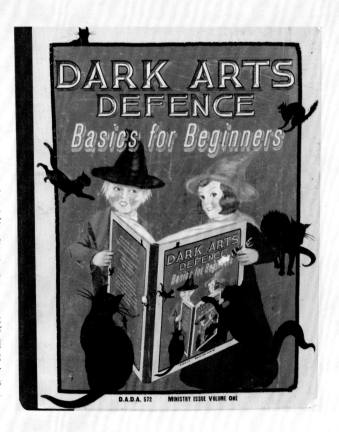

D.A.D.A. 672 MINISTRY ISSUE VOLUME ONE

ADVANCED POTION-MAKING

"Crush with blade—releases juice better."

—written in Harry Potter's textbook by the Half-Blood Prince, *Harry Potter and the Half-Blood Prince*

It is Harry Potter's soaring successes in Potions class that bring him opportunities to bond with (and interrogate) Horace Slughorn, a former Potions master who has been brought back so Dumbledore can confirm if he told Tom Riddle, his student, about Horcruxes. The reason for Harry's success? A copy of *Advanced Potion-Making* marked up by the mysterious and talented Half-Blood Prince. At the year's start, neither Harry nor Ron Weasley expect to be taking Potions, but Professor McGonagall dashes these expectations, and they head to class. Neither has a copy of the required textbook, but Professor Slughorn informs them there are extras in the back cupboard. Of the two, one is new, and one shabby and soiled. Diving into the cupboard, Ron comes up the winner with the newer one, and Harry is left with the used version. But Harry's dilemma is pivotal to the story.

"In this case," explains Miraphora Mina, "we had only a few seconds on-screen to show to the audience why they both want *this* book and neither of them want *that* book, because they don't know *that* book has all the secrets and knowledge that Harry needed for the story to evolve. You've got to remember how it was as a child," she continues. "'I want the shiny one. I'm not going to have that crappy, dirty one.' We had to design a new version and old version that had to be quickly identifiable as the same book, but different editions." The older edition of *Advanced Potion-Making* is worn, with a Victorian feel in its lettering and graphic of a smoking cauldron. The more recent edition is smaller, has simple, clean lines, and though it still sports cauldrons, they're more stylized and contemporary (if 1950s can be considered more contemporary).

Harry's edition of *Advanced Potion-Making* has notes scribbled in the margins and around the text by the previous owner, handwritten by Mina. "I was [in charge of] Severus Snape's handwriting, so I had to imagine how Snape would write. Probably he wouldn't have it all tidy and in the same direction, with lots of thinking and scrubbing out." As there were differently sized versions of the book for filming close-ups and middle shots, Mina's notes on the "hero" copy were scanned in and added to the pages digitally before the versions were printed.

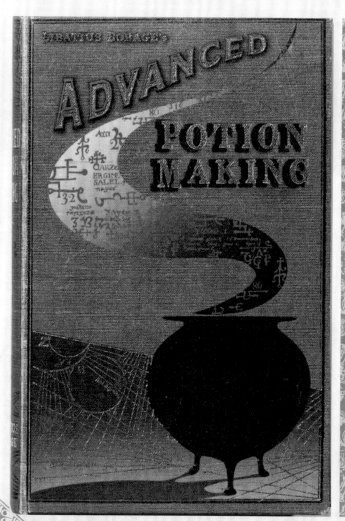

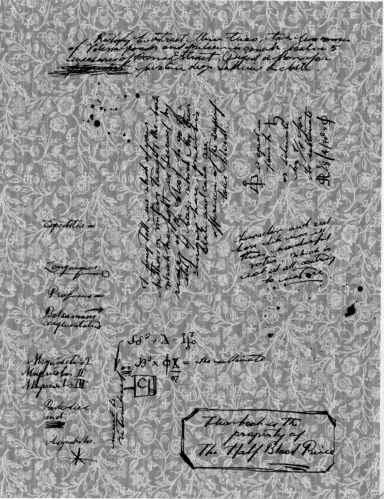

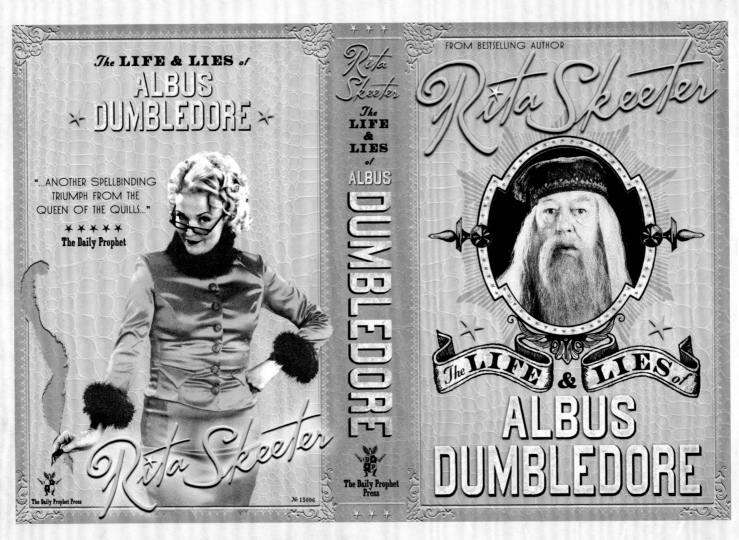

THE LIFE & LIES OF ALBUS DUMBLEDORE

"I'm told he's been thoroughly unriddled by Rita Skeeter in 800 pages, no less."

—Muriel Weasley, *Harry Potter and the Deathly Hallows – Part 1*

Similar to Gilderoy Lockhart's books, tabloid reporter Rita Skeeter's tell-all biography of Albus Dumbledore seen in *Harry Potter and the Deathly Hallows – Part 1* also needed to be trashy and cheap. Again, Miraphora Mina and Eduardo Lima were "absolutely stunned," says Mina, "because, in this world, how could we print something so artificial? But we already knew how gaudy and salacious the character was. She's sensational, so with the design of this book we chose to do that by using really artificial colors, techniques, and finishes." The front cover's graphic burst and spine border is in an acid green color that matches the outfit Skeeter is wearing on the back (her first costume in *Harry Potter and the Goblet of Fire*). Really thin paper was used for interior for this, one of the few paperback books seen in the film series.

TOP: The eye-popping cover of Rita Skeeter's tell-all book about Albus Dumbledore. Information in the book helped Hermione Granger learn about the Dumbledore family in *Harry Potter and the Deathly Hallows – Part 1*; RIGHT: Albus Dumbledore's letter to Gellert Grindelwald, which is reproduced in *Life & Lies*.

THE TALES OF BEEDLE THE BARD

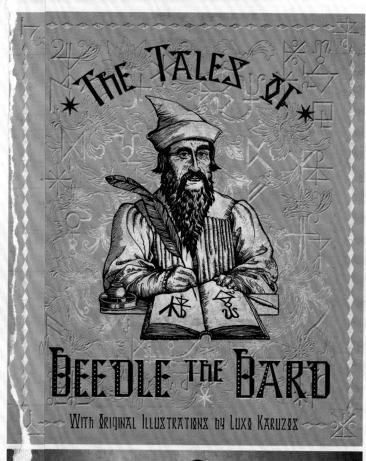

"To Hermione Jean Granger, I leave my copy of The Tales of Beedle the Bard, in the hope that she finds it entertaining and instructive."

—Rufus Scrimgeour, reading from the Last Will and Testament of Albus Dumbledore, *Harry Potter and the Deathly Hallows – Part 1*

The stories written by Beedle the Bard are the wizarding world's equivalent of the Grimm brothers' or Hans Christian Andersen's fairy tales. It is crucial for Hermione Granger to receive Dumbledore's copy of *The Tales of Beedle the Bard* in order to understand the history and portent of the Deathly Hallows and to become familiar with *The Tale of the Three Brothers*, a story about three wizard brothers whose efforts to outwit death result in the creation of the Hallows—the Elder Wand, the Resurrection Stone, and the Cloak of Invisibility.

Miraphora Mina and Eduardo Lima knew that the design of this book needed to show that though it was a children's book, within it there was more gravity to the stories. The small book contains delicate laser-cut illustrations resembling a fine lace that front each story. The artist of these "original illustrations" is listed as Luxo Karuzos, another variation on Mina's son's name. It was the director's intention to zoom in on the illustration before the Three Brothers tale and through that segue to the animated telling of the story, but this idea was not implemented for the film's final cut.

Throughout their work on the films, Mina and Lima would show key props to the filmmakers, including an unfinished copy of this book, for approval. When J.K. Rowling was on set one day during the shooting of *Harry Potter and the Deathly Hallows – Part 1*, producer David Heyman took her over specifically to show her *The Tales of Beedle the Bard*. "She looked at it and said, 'Oh, I have to have one,'" remembers Lima. "And we said, 'It's not ready yet, you need to wait until we finish the book.' She said okay and gave me back the book. Not two seconds later, she came back and said, 'I'm really sorry, but I need to take one now,' and she gave me a massive big hug. We were like, 'What?' But she's so lovely, we couldn't refuse!"

TOP: "Color key," reference art created for the lighting and animation teams, by sequence supervisor Dale Newton depicts the brothers creating the bridge across the river in the *The Tale of the Three Brothers* sequence in *Harry Potter and the Deathly Hallows – Part 1*; MIDDLE: Albus Dumbledore's copy of *The Tales of Beedle the Bard*, bequeathed to Hermione Granger, provides a vital clue in the pursuit of the Deathly Hallows. Cover design by Miraphora Mina and Eduardo Lima; LEFT: Color key art by animation director Ben Hibon shows Death departing with the second brother.

"HARRY POTTER UNDESIRABLE No. 1"

—cover page of the *Daily Prophet*, *Harry Potter and the Deathly Hallows – Part 1*

The Ministry of Magic is the governing arm of the wizarding world in Britain that, overall, establishes and enforces magical law, overseen by the Minister for Magic. Headed by Cornelius Fudge during Harry Potter's first five years at Hogwarts, the Ministry went back and forth between repudiating, discrediting, and then reluctantly admitting that Lord Voldemort had returned. The events in *Harry Potter and the Order of the Phoenix* made it apparent that the Dark forces were reassembling, and their rise to power inevitably led to a takeover of the Ministry, in *Harry Potter and the Deathly Hallows – Part 1*. As the tenor of the Ministry changed with the involvement of the Death Eaters and other personnel with unquestioning loyalty to Lord Voldemort, the look and feel of the inescapable paperwork and publications associated with any bureaucracy changed to a much more somber and repressive tone.

ABOVE: Bureaucratic administrations yield much bureaucratic paperwork. The graphic and prop departments provided notebooks and folders for Ministry of Magic workers to carry it in, *Harry Potter and the Order of the Phoenix*; OPPOSITE, CLOCKWISE FROM TOP LEFT: Ministry of Magic flying memos and a visitor badge created for *Harry Potter and the Order of the Phoenix*; Arthur Weasley's Muggle-Born Registration Commission Registration Form, found by Harry Potter in Dolores Umbridge's office at the Ministry of Magic, *Harry Potter and the Deathly Hallows – Part 1*; Letter to Arthur Weasley from Mafalda Hopkirk, stating the charges and time of the disciplinary hearing for Harry's violation of the Decree for Reasonable Restriction of Underage Sorcery, *Harry Potter and the Order of the Phoenix*; Official Ministry of Magic stamps; Letter to Harry Potter regarding his breaking the Decree for Reasonable Restriction of Underage Sorcery, *Harry Potter and the Order of the Phoenix*.

⋆ MINISTRY OF MAGIC ⋆
VISITOR
No. 10201
This pass is issued subject to the Ministry of Magic Health and Safety Regulations (345-B & 346-B) and should be returned to reception before leaving the premises.
This badge must be displayed at all times

Dear Mr Potter,

The Ministry has received intelligence that at twenty three minutes past six this evening you performed the Patronus Charm in the presence of a Muggle.

As a clear violation of the Decree for the Reasonable Restriction of Underage Sorcery, you are hereby expelled from Hogwarts School of Witchcraft & Wizardry.

Hoping that you are well,

Mafalda Hopkirk

London ◐ in Scorpio

MINISTRY PARAPHERNALIA

"Hoping that you are well,
Mafalda Hopkirk, Ministry of Magic."

—letter to Harry Potter, *Harry Potter and the Order of the Phoenix*

Harry's first visit to the Ministry of Magic in the films was in *Harry Potter and the Order of the Phoenix*, when he is brought in for a disciplinary hearing for performing underage magic (vanquishing two Dementors with a Patronus). Ministry paperwork created by the graphics department included visitor badges, official stamps, flying memos, and various correspondences.

Ref. No. 3966-IO8-HJP

Dear Mr. Weasley,

Due to the current circumstances we are informing you as guardian for Harry James Potter, that the Disciplinary Hearing for the offences stated below will now take place on 12th of August at 8am in the Courtroom IO at the Ministry of Magic.

The charges against the accused are:

• The accused in full awareness of the illegality of his actions produce a Patronus Charm in the presence of a Muggle,

• The accused used magic outside the school while under the age of seventeen.

Hoping that you are well.

Mafalda Hopkirk
Commander-in-Chief
Improper Use of Magic Office

In Accordance with
Ministry for Magical
Missives Guidelines 892X

Ref. No. 3966-IO8-HJP

Ministerial Code of
Confidential Communications
Conduct 572 B

DEPARTMENT OF LAW ENFORCEMENT IMPORTANT GUIDELINES - 123JX-45 - Decree No. 1567kllo-000094 9833-ipG M. of MAGIC

As referred to in Decree No. 18I9I6-78 of I924, Decree No. 2345093 of I925, Decree No. 34568-Ok06-984 of I927, Decree No. 5679:009-89 of I930, Decree No. 98746-00098-0 of I932, Decree No. 5673:erf-lins of I933, Decree No. 4Slghyt6-78x of I935, Decree No. 568I-kji-lo9 of I936, Decree No. isaye 9839 iw0-99 of I938, ...

Mr. A. Weasley
The Burrow
Ottery St. Catchpole

Ref. No. 3966-IO8-HJP

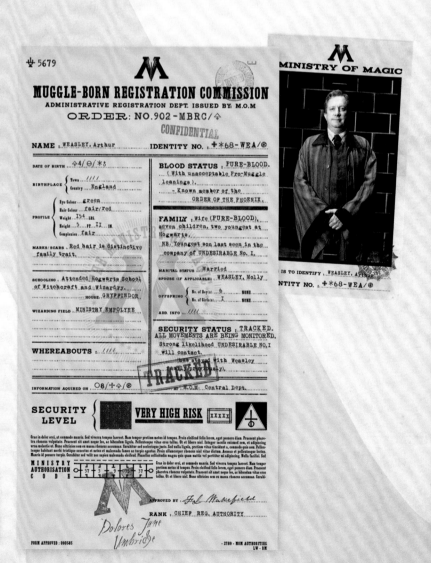

⚕ 5679

M

MUGGLE-BORN REGISTRATION COMMISSION
ADMINISTRATIVE REGISTRATION DEPT. ISSUED BY M.O.M
ORDER: NO. 902-MBRC/⊕
CONFIDENTIAL

NAME : WEASLEY, Arthur **IDENTITY NO.** : ⁂68-WEA/⊕

DATE OF BIRTH : ⊶/⊖/⁎3

BIRTHPLACE : Town : ‖‖‖ / Country : England

PROFILE : Eye Colour : green / Hair Colour : fair/Red / Weight : 154 lbs / Height : 2 FT. II IN. / Complexion : fair

MARKS/SCARS : Red hair is distinctive family trait

SCHOOLING : Attended Hogwarts School of Witchcraft and Wizardry. HOUSE : GRYFFINDOR

WIZARDING FIELD : MINISTRY EMPLOYEE

WHEREABOUTS : ‖‖‖

INFORMATION AQUIRED ON : 08/⊕/⁎

BLOOD STATUS : PURE-BLOOD.
(With unacceptable Pro-Muggle leanings).
- Known member of the ORDER OF THE PHOENIX.

FAMILY : Wife (PURE-BLOOD), seven children, two youngest at Hogwarts.
NB. Youngest son last seen in the company of UNDESIRABLE No. I.

MARITAL STATUS : Married

SPOUSE (IF APPLICABLE) : WEASLEY, Molly

OFFSPRING : No. of Boys : 5 ... NONE / No. of Girls : I ... NONE

ADD. INFO : ‖‖‖

SECURITY STATUS : TRACKED.
ALL MOVEMENTS ARE BEING MONITORED. Strong likelihood UNDESIRABLE No.I will contact.

TRACKED

.. M.O.M. Central Dept.

SECURITY LEVEL | **VERY HIGH RISK** XXXX

MINISTRY AUTHORISATION CODE

APPROVED BY

RANK : CHIEF REG. AUTHORITY

Dolores Jane Umbridge

FORM APPROVED : 090585

- 2700 - MOM AUTHORITIES LW- SM

MINISTRY OF MAGIC

IS TO IDENTIFY : WEASLEY, Arthur
IDENTITY NO. : ⁂68-WEA/⊕

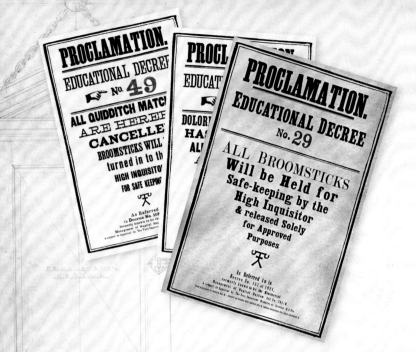

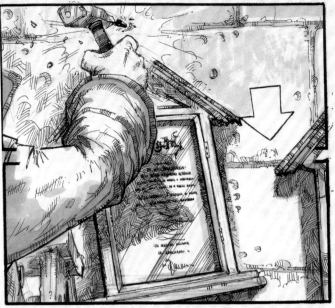

EDUCATIONAL DECREES

"Educational Decree No. 23: Dolores Jane Umbridge has been appointed to the post of Hogwarts High Inquisitor."

—proclamation sign, *Harry Potter and the Order of the Phoenix*

Educational Decrees were laws created by the Ministry of Magic, seemingly to improve discipline and assign punishments for student transgressions at Hogwarts, and enacted by Dolores Umbridge during her tenure as Defense Against the Dark Arts professor in *Harry Potter and the Order of the Phoenix*. These proclamations were the Ministry's attempt to wrest control of the school from Dumbledore. They are, as the bottom of the Decree declares, "subject to approval by the Very Important Members of Section M.I. Trx." And in a clever imitation of government-speak, the last line on the Educational Decrees, hidden by the frames, reads: "Blah blah blah bl Ahbla Blah . . . Bla Blah blabish."

TOP LEFT: Dolores Umbridge, in her capacity as the Ministry-appointed High Inquisitor, created more than a hundred Educational Decrees intended to undermine and control the Hogwarts students in *Harry Potter and the Order of the Phoenix*; LEFT: Draft work by Gary Jopling of the Educational Decrees placed around the doors to the Great Hall; ABOVE: Storyboards illustrate caretaker Argus Filch hammering yet another proclamation into the stone wall; OPPOSITE TOP: Cover of the Ministry Identity Card booklet; OPPOSITE MIDDLE AND BOTTOM: Identity cards for Mafalda Hopkirk (Sophie Thompson) and Reg Cattermole (Steffan Rhodri).

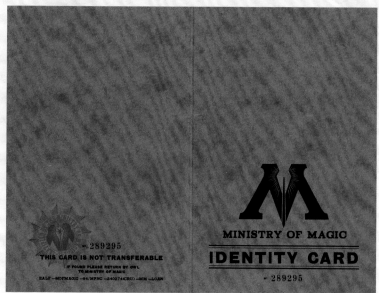

MINISTRY OF MAGIC IDENTITY CARDS

"In case you're interested, I'm Reg Cattermole,
Magical Maintenance Department."

—Ron Weasley, *Harry Potter and the Deathly Hallows – Part 1*

Identity cards were created for *Harry Potter and the Deathly Hallows – Part 1*, which Harry, Ron, and Hermione use to infiltrate the Ministry when they use Polyjuice Potion to become three Ministry workers. The IDs were produced in moving and non-moving image forms, with green-screen paper in place of the static photograph.

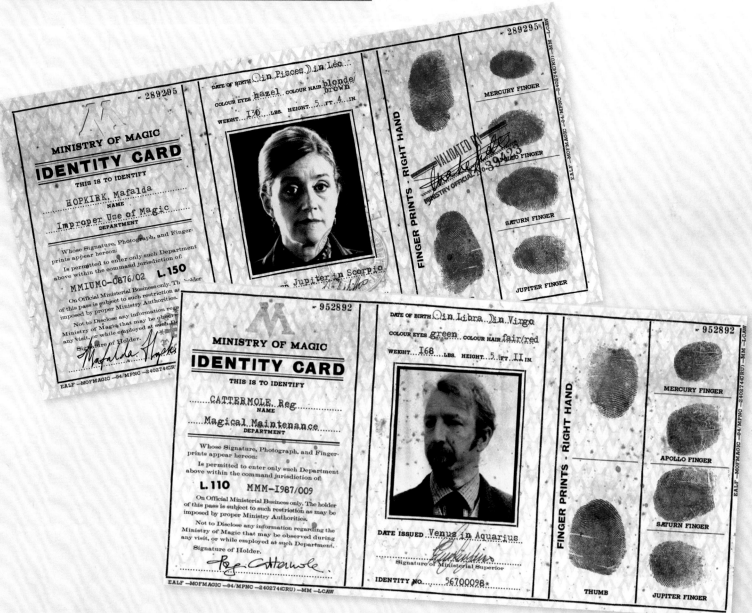

MUGGLE-BORN REGISTRATION COMMISSION

"I'm half-blood! My father, my father was a wizard!"

—scared man, *Harry Potter and the Deathly Hallows – Part 1*

Dolores Umbridge had many jobs in her work for the Ministry, but perhaps none so heinous as being Head of the Muggle-Born Registration Commission, which registered and persecuted non-pureblood wizards during the events of *Harry Potter and the Deathly Hallows – Part 1* and *Part 2*. It is to Harry's disgust, as he riffles through Umbridge's desk, that he sees registration forms for the members of the Order of the Phoenix, the photos of deceased members having been crossed out with a large red X.

BELOW: The graphics department created form after form for the inquisitions held by the Muggle-Born Registration Commission—these, for Mary Cattermole, were reviewed by Dolores Umbridge, *Harry Potter and the Deathly Hallows – Part 1*; RIGHT: Harry Potter discovers the forms for his friends and loved ones in Dolores Umbridge's desk; OPPOSITE: The graphics used on Mudblood propaganda items in *Harry Potter and the Deathly Hallows – Part 1* echoed the blocky, spare style of the Cold War Soviet Union era.

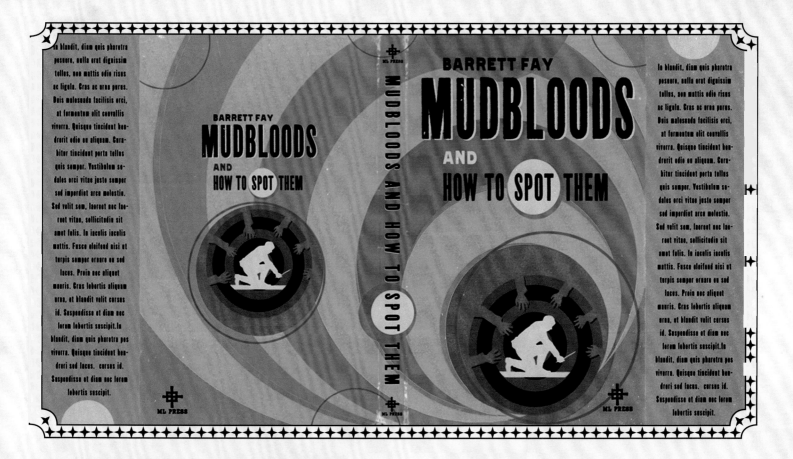

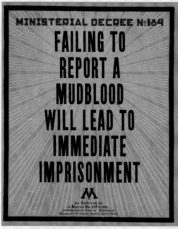

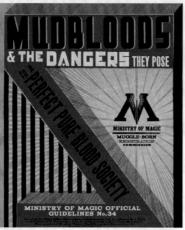

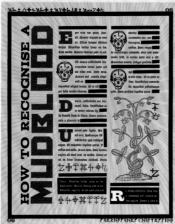

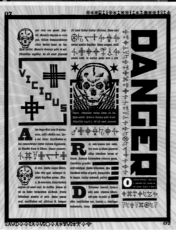

MUDBLOOD PROPAGANDA

"Let's get back to work please. Calm down."
—wizard in the Muggle-Born Registration Commission office,
Harry Potter and the Deathly Hallows – Part 1

Umbridge's office also distributed anti-Muggle literature such as *Mudbloods and How to Spot Them* in *Harry Potter and the Deathly Hallows – Part 1*. Director David Yates suggested that Miraphora Mina and Eduardo Lima look at Soviet propaganda of the post–World War I era, which used primary colors and bold lettering on posters and in pamphlets to be eye-catching and to incite heightened emotions. This style was a total antithesis to the Gothic and Victorian familiarity of Hogwarts and the wizarding community.

WANTED POSTERS

"Remember: Negligence costs lives."

—printed on Lucius Malfoy's CAUGHT poster, *Harry Potter and the Deathly Hallows – Part 1*

The graphics department had to satisfy both sides of the battle between good and Dark forces throughout the Harry Potter films. Wanted posters were first created for Sirius Black in *Harry Potter and the Prisoner of Azkaban*, where the symbols on his booking slate loosely translate to "more or less human." Eduardo Lima admits that even though some of their work was for a somber subject, "One of the most enjoyable aspects of working on the films was being given the freedom to add your own little touches. On Sirius's wanted poster, for example, we asked for information to be delivered by owl."

A decidedly darker tone was applied in *Harry Potter and the Deathly Hallows – Part 1*, where Public Safety Notices warning of threats from Death Eaters changed to posters for the capture of Undesirable No. 1—Harry Potter—distributed by the Ministry. Eduardo Lima and Miraphora Mina "damaged" the posters to show evidence of them being exposed to rough weather conditions or simple hooliganism where they hung in Diagon Alley.

RIGHT AND BELOW MIDDLE: The wanted poster for Sirius Black, posted throughout the wizarding world in *Harry Potter and the Prisoner of Azkaban*, was created in two versions: a "flat" version containing a still photo and text, and another with a green screen in place of the photo so that moving footage of actor Gary Oldman could be composited in during post-production; BELOW LEFT, RIGHT, AND OPPOSITE: These posters were pasted on walls in Diagon Alley and Hogsmeade in *Harry Potter and the Deathly Hallows – Part 1* and *Harry Potter and the Deathly Hallows – Part 2*.

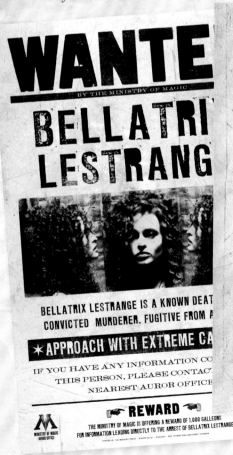

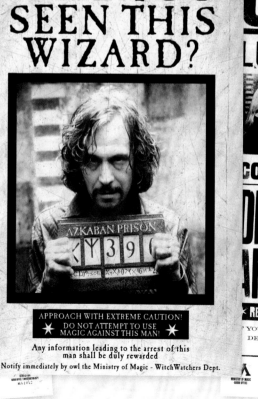

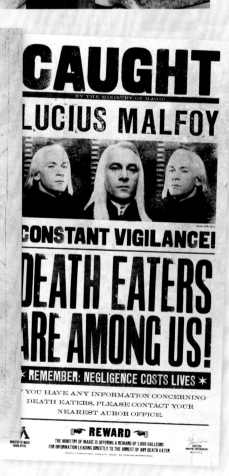

WANTED

BY THE MINISTRY OF MAGIC

FENRIR GREYBACK

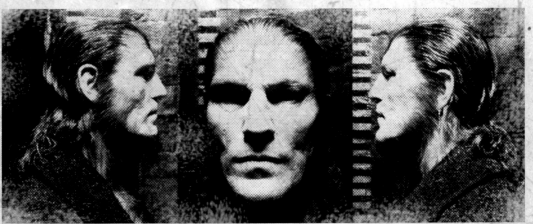

*Azkaban Id/No. 51922

FENRIR GREYBACK IS A SAVAGE WEREWOLF.
CONVICTED MURDERER. SUSPECTED DEATH EATER.

★ APPROACH WITH EXTREME CAUTION! ★

IF YOU HAVE ANY INFORMATION CONCERNING
THIS PERSON, PLEASE CONTACT YOUR
NEAREST AUROR OFFICE.

MINISTRY OF MAGIC
-AUROR OFFICE-

 REWARD

THE MINISTRY OF MAGIC IS OFFERING A REWARD OF 1.000 GALLEONS
FOR INFORMATION LEADING DIRECTLY TO THE ARREST OF FENRIR GREYBACK.

DIRECTOR
AUROR OFFICE / INVESTIGATION DEPT.
No. 61042

PRINTED BY THE MINISTRY PRESS - DIAGON ALLEY - ENGLAND - REG.120990/00E.LIMA/00987-000MOM

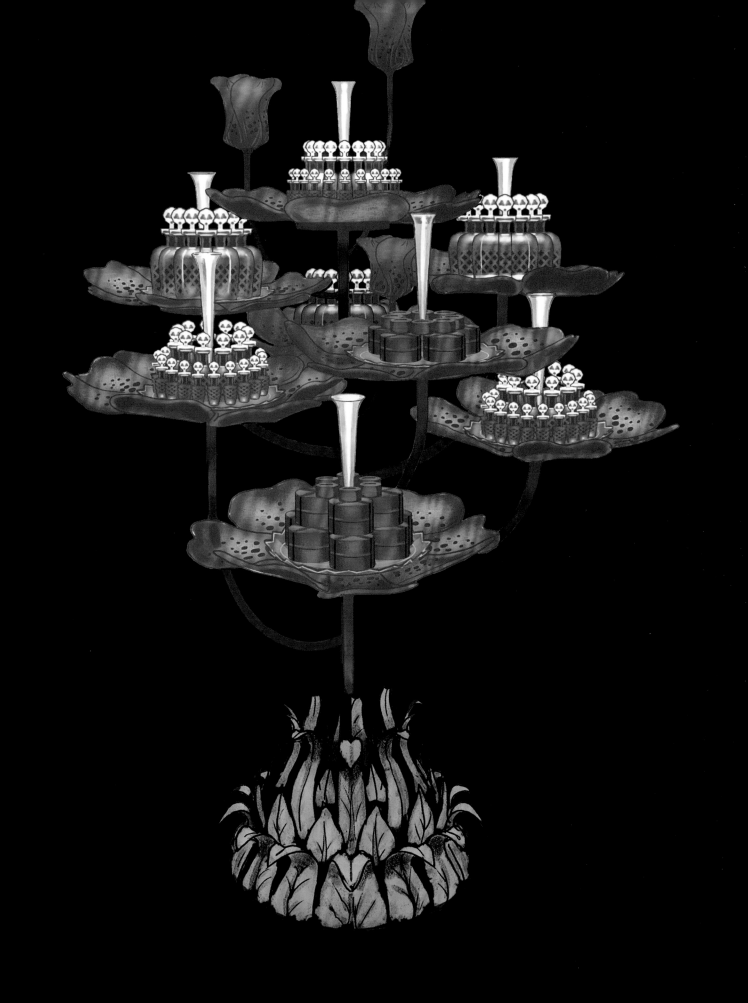

CHAPTER 7

WEASLEYS' WIZARD WHEEZES

"Step up! Step up! We've got
Fainting Fancies, Nosebleed
Nougat, and just in time for
school, Puking Pastilles!"

—Fred and George Weasley,
*Harry Potter and the
Half-Blood Prince*

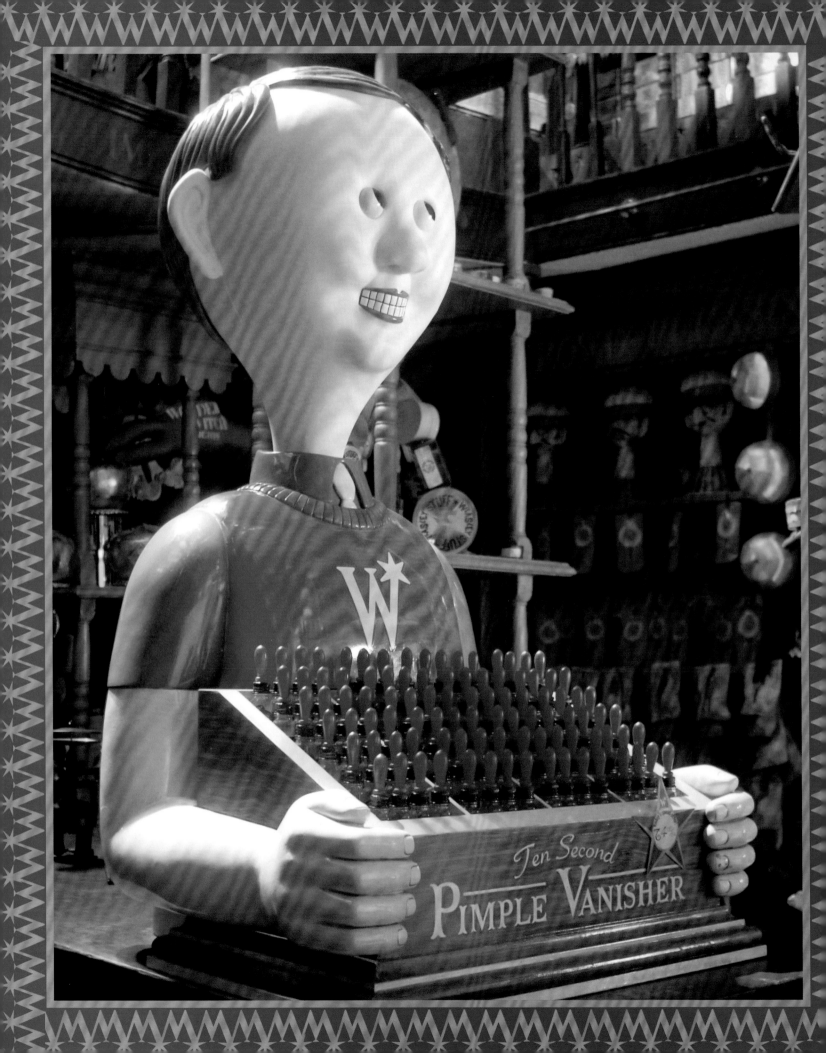

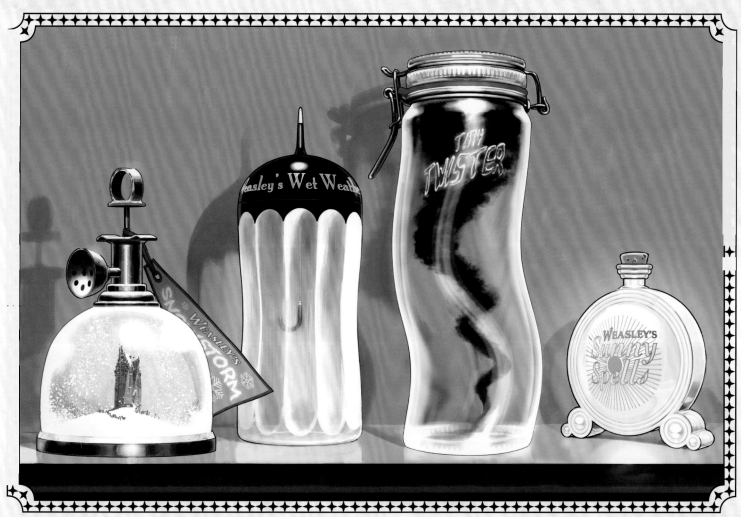

Ever the entrepreneurs, the Weasley twins turned their small foray into commerce while at Hogwarts into a successful business and brand at Weasleys' Wizard Wheezes, established in Diagon Alley in *Harry Potter and the Half-Blood Prince*, offering a wealth of practical jokes, class-evading skiving snacks, love potions, and many other whimsical and inventive magical products.

"This was really a designer's dream," says Miraphora Mina. "To be told you have to design every single package for a four-story shop of magical jokes owned by two teenagers who probably don't have much of a design sense. We had to throw away all our ideas of good design and use clashing colors and dreadful printing techniques." Even so, the first product designs that Miraphora Mina and Eduardo Lima turned in to production designer Stuart Craig were considered too pretty and delicate. "Stuart said to us, 'Please, can you make this more vulgar?'" recalls Mina. "So we looked at a lot of packaging for fireworks and firecrackers because they're really cheap and disposable, and the printing is always amiss." They selected paper that was of a substandard quality and never worried if something was poorly printed. "It was strange," Mina admits. "It was like drawing with your left hand when you're trained to use the right."

To add a variety of textures, and so that not all the packaging was made out of paper, Mina and Lima went to souvenir shops to purchase small tins and other interesting items. "We would look at them and say, what's good about this? That? Okay. Then we'd cover the rest of it with our graphics." Every product that could be was taken from the

books, and then the concept and graphic artists came up with ideas for the rest. In order to fill the shelves, the size of the graphics department was almost tripled (from three to eight) in order to accommodate creating a lot of product in not a lot of time. "We had about one hundred and forty different product designs," says Lima, "and they required manufacturing runs from two hundred to four thousand." The total number of items in Weasleys' Wizard Wheezes is estimated at forty thousand. All were made in-house and all for less than two minutes of screen time.

Packaged within the visually attention-grabbing boxes and bottles were many toys or jokes that came from the books, some of which had already been seen in earlier films, and others that would make a later debut. As the Weasley twins always seemed to have something in development, it is gratifying to see Extendable Ears, first used in

PAGE 152: Concept art of a Wonder Witch display by Adam Brockbank for *Harry Potter and the Half-Blood Prince*; OPPOSITE: The Ten Second Pimple Vanisher in its unblemished state; TOP: The containers for the Weather in a Bottle product line, visualized by Adam Brockbank, resemble their contents: A tiny tornado swirls in a twisted twister jar, an umbrella tops the Wet Weather bottle, and the snowstorm bottle, containing a small Shrieking Shack, evokes a snow globe; RIGHT: Early concept art for the Puking Pastilles dispenser; FOLLOWING PAGES: Packaging and logos designed by the graphics department headed by Miraphora Mina and Eduardo Lima. No color was too garish, no lettering too appalling.

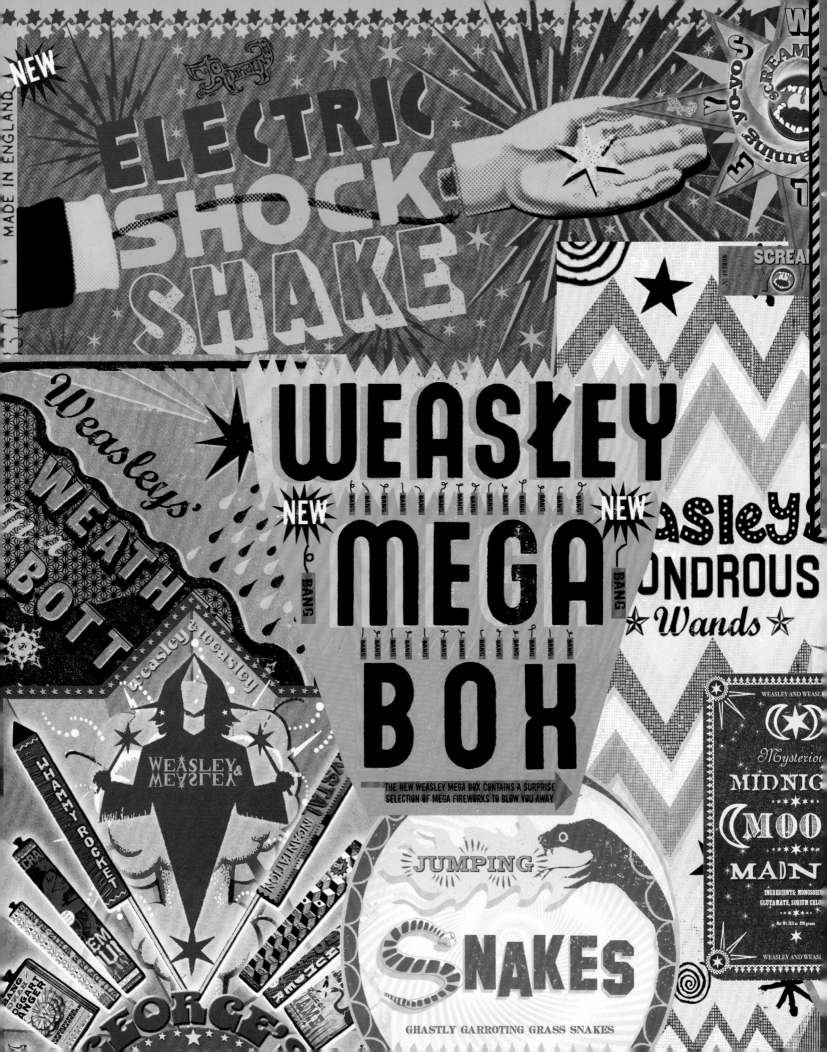

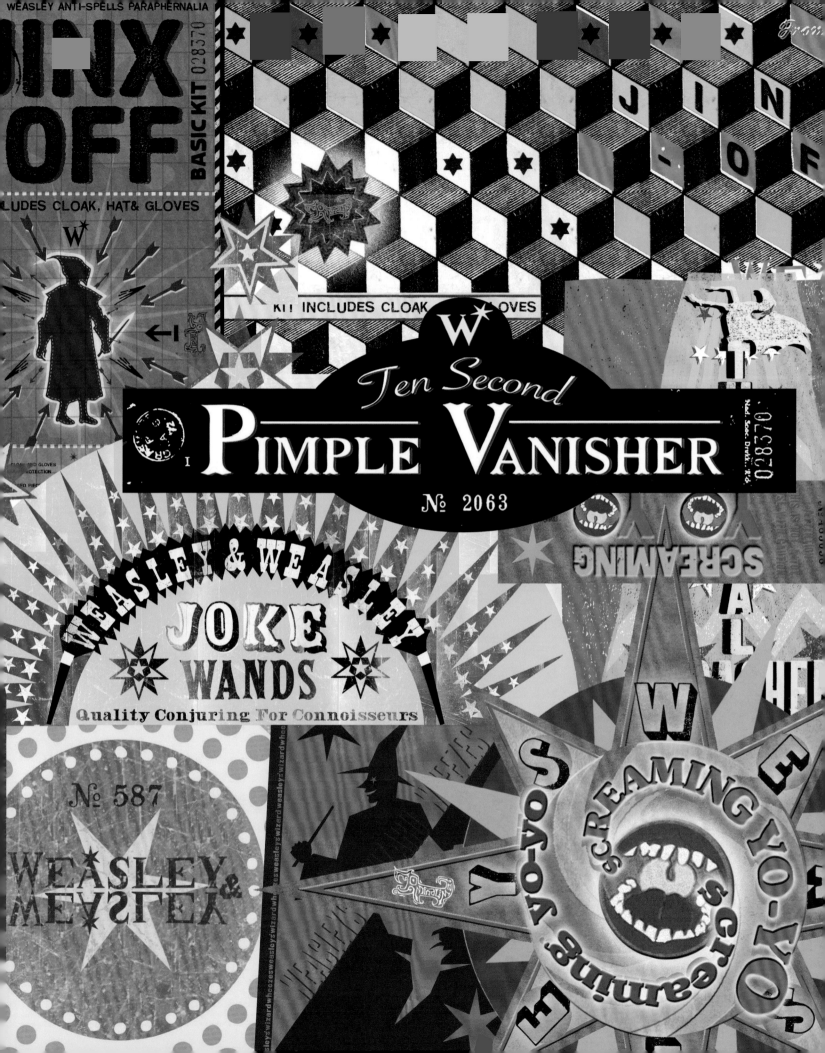

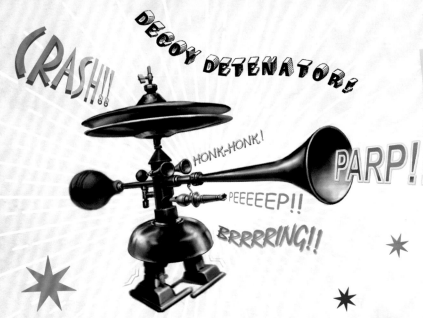

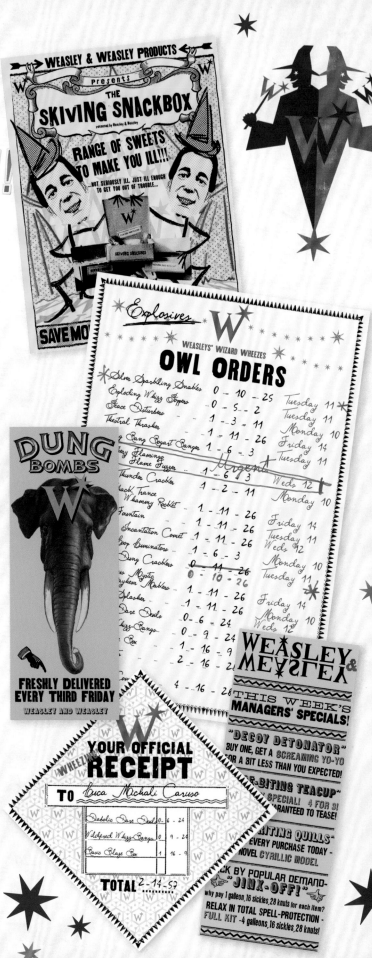

Harry Potter and the Order of the Phoenix, on the shelves, as well as the Skiving Snackbox, featuring Nosebleed Nougats, Fever Fudge, and Fainting Fancies. The Dark Mark, from *Harry Potter and the Goblet of Fire*, was offered in a tasty edible form, an obvious slight to the Dark forces, as was a tin toy of Dolores Umbridge riding a unicycle on a tightrope (muttering "I will have order!"). The distracting Decoy Detonator used by Harry Potter in *Harry Potter and the Deathly Hallows – Part 1* must have come from the Weasleys' store. The twins even offered a toy version of their father's Flying Ford Anglia car, the Aviatomobile.

"There were many layers of hero props in the store," says props art director Hattie Storey. "We ended up making *too* many hero props; there wasn't possibly enough time to feature them all in that scene, it was quite a short scene. But as we didn't know which ones the director would feature, we just kind of did everything." Storey was aware, though, that fans would probably watch the movie and this scene in particular more than once, and, "in a film like this, it's really nice if you can spot new things upon each viewing." This echoes the words of James Phelps (Fred Weasley): "The set for Weasleys' Wizard Wheezes had so much detail in it that you could stay in there for days and not see it all."

At the same time that the Weasleys' Wizard Wheezes catalog was being created, the concept artists were coming up with ideas for the big displays that would inhabit the store. "Many are described in the book," says Adam Brockbank, "but, really, what do they look like?" One of these was the Puking Pastilles display, a confectionary that was part of the Weasleys' original Skiving Snackbox. The style that Miraphora Mina and Eduardo Lima had chosen for the graphics harkened back to the cheap plastic and tin toys of the 1950s, and so Brockbank built upon that, referencing his memories of the crudely designed charity donation boxes that sat outside shops in Britain in the 1950s, often of children and animals. "And we knew we wanted it to be kind of funny and kind of disgusting at the same time," he says. "So it became this slightly badly sculpted kid throwing up into a bucket, but it's actually not vomit, it's a stream of Puking Pastilles, so you would just put your cup under it, fill it up, and go pay for it."

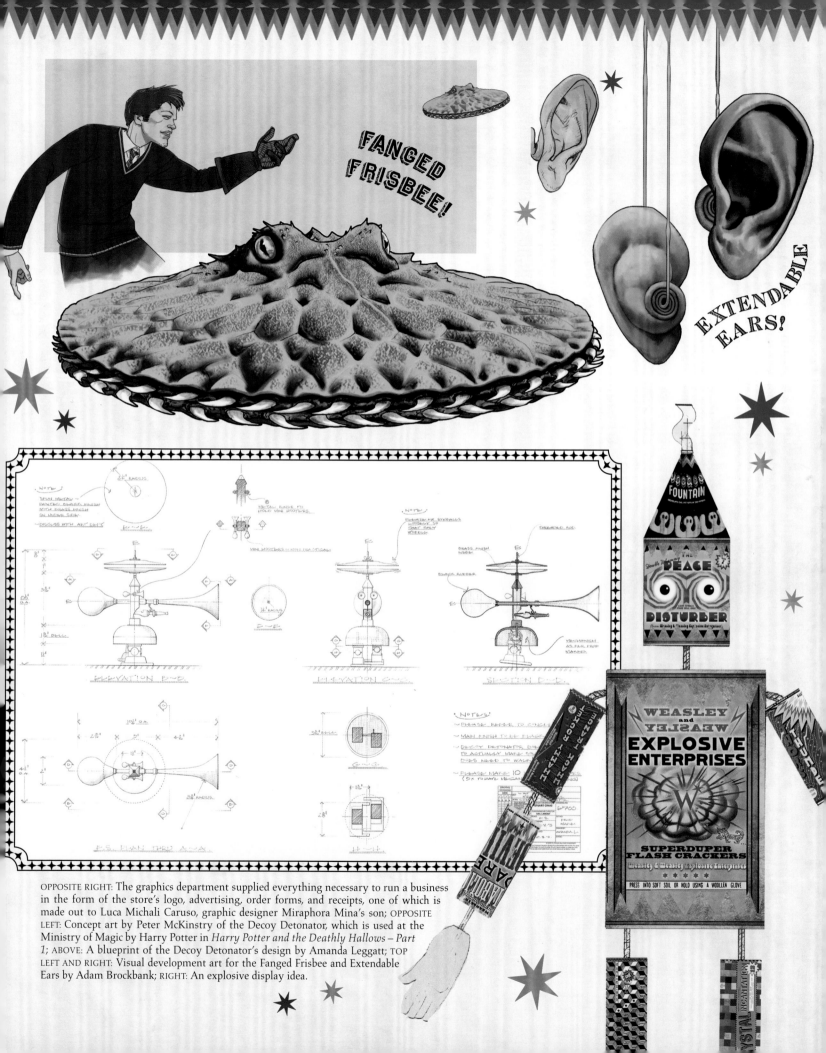

FANGED FRISBEE!

EXTENDABLE EARS!

OPPOSITE RIGHT: The graphics department supplied everything necessary to run a business in the form of the store's logo, advertising, order forms, and receipts, one of which is made out to Luca Michali Caruso, graphic designer Miraphora Mina's son; OPPOSITE LEFT: Concept art by Peter McKinstry of the Decoy Detonator, which is used at the Ministry of Magic by Harry Potter in *Harry Potter and the Deathly Hallows – Part 1*; ABOVE: A blueprint of the Decoy Detonator's design by Amanda Leggatt; TOP LEFT AND RIGHT: Visual development art for the Fanged Frisbee and Extendable Ears by Adam Brockbank; RIGHT: An explosive display idea.

WEASLEY and WEASLEY
EXPLOSIVE ENTERPRISES

SUPERDUPER FLASH CRACKERS

PRESS INTO SOFT SOIL OR HOLD USING A WOOLLEN GLOVE

Once approved, Pierre Bohanna and his team fashioned a six-foot-tall green-faced schoolgirl who pukes the thousands of green-and-purple silicon pastilles needed to revolve in a never-ending circle of sick that was, as Hattie Storey describes it, "brought to life in sickening detail." Another prop was the Ten Second Pimple Vanisher. "So we thought, 'Well, let's have this head where the pimples pop out and then disappear again,'" Brockbank continues. "And Pierre made something that did that, with rolling eyes and a wobbling head." One of the biggest displays is outside the store: a twenty-foot-tall figure of one of the Weasley twins replicating a ubiquitous Muggle magic act: Tipping his hat reveals a rabbit that alternately disappears, then reappears. "We hoped to achieve an environment that was utterly irresistible to a small wizard child," says Miraphora Mina, "while also momentarily stepping out of the familiar visual style of the Hogwarts world."

BELOW: Visual development art by Adam Brockbank for the Ten Second Pimple Vanisher, which had remote-controlled devices inside its head to cause pimples to appear and disappear; RIGHT, FAR RIGHT, AND BOTTOM RIGHT: The garish Puking Pastilles dispenser gushed a constant stream of circulating candies; OPPOSITE TOP: Visual development art of the Screaming Yo-Yo by Adam Brockbank; OPPOSITE BELOW: (left to right) Products in Weasleys' Wizard Wheezes include a nose-biting teacup and an edible jellied version of the Dark Mark. Brockbank's concept art of the Dark Mark indicates the thickness and construction of the candy.

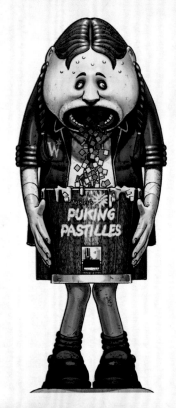

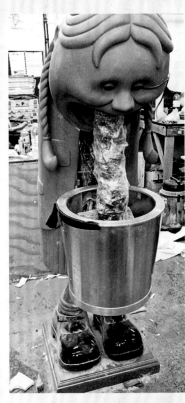

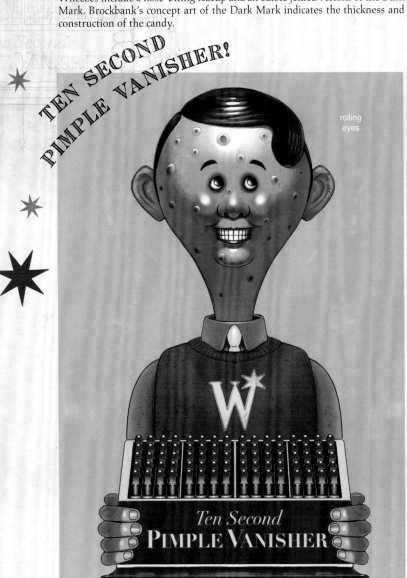

TEN SECOND PIMPLE VANISHER!

rolling eyes

Ten Second
PIMPLE VANISHER

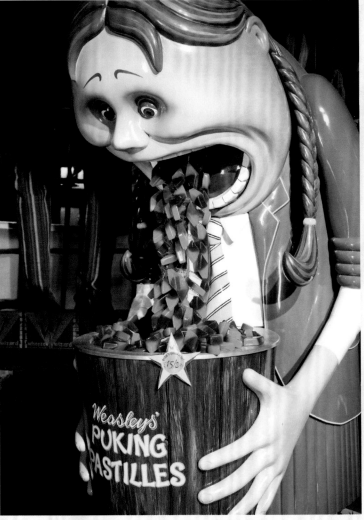

Weasleys' PUKING PASTILLES

porcelain teeth and gums

painted rubber lips draw back

vibrating rubber tongue

SCREAMING YO-YO

EDIBLE DARK MARK

TRICKS

STICKY TRAINERS

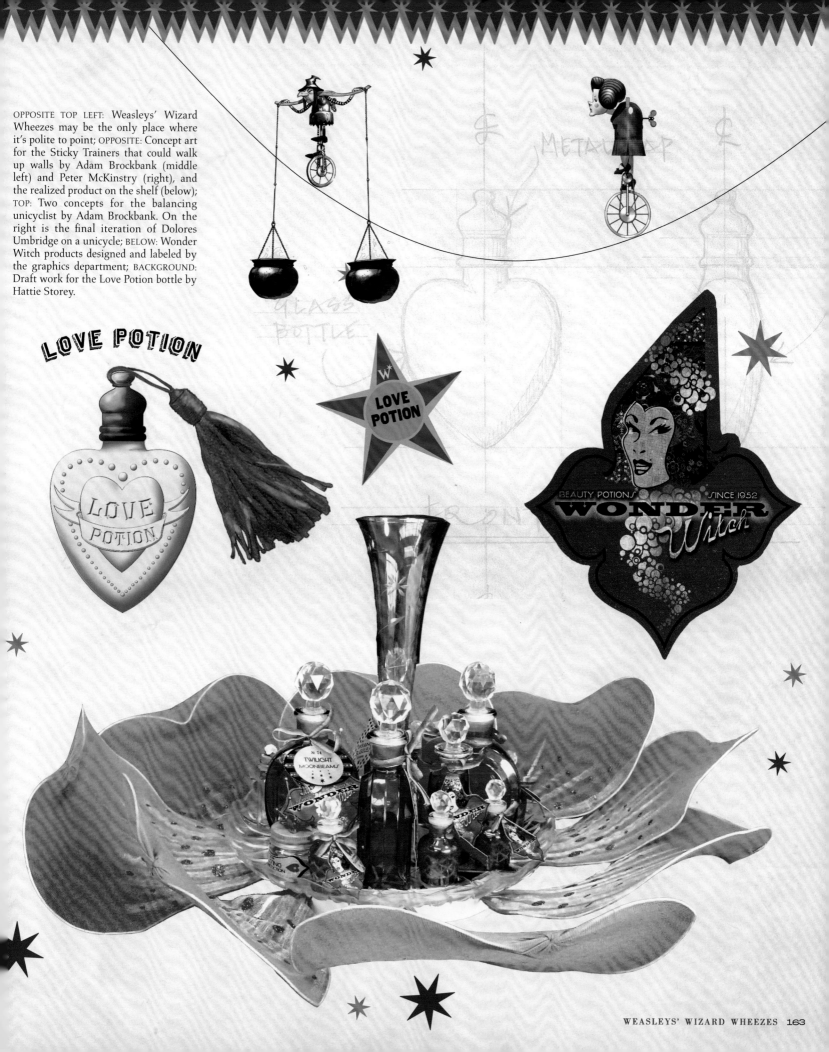

OPPOSITE TOP LEFT: Weasleys' Wizard Wheezes may be the only place where it's polite to point; OPPOSITE: Concept art for the Sticky Trainers that could walk up walls by Adam Brockbank (middle left) and Peter McKinstry (right), and the realized product on the shelf (below); TOP: Two concepts for the balancing unicyclist by Adam Brockbank. On the right is the final iteration of Dolores Umbridge on a unicycle; BELOW: Wonder Witch products designed and labeled by the graphics department; BACKGROUND: Draft work for the Love Potion bottle by Hattie Storey.

LOVE POTION

LOVE POTION

LOVE POTION

WONDER Witch
BEAUTY POTIONS SINCE 1952

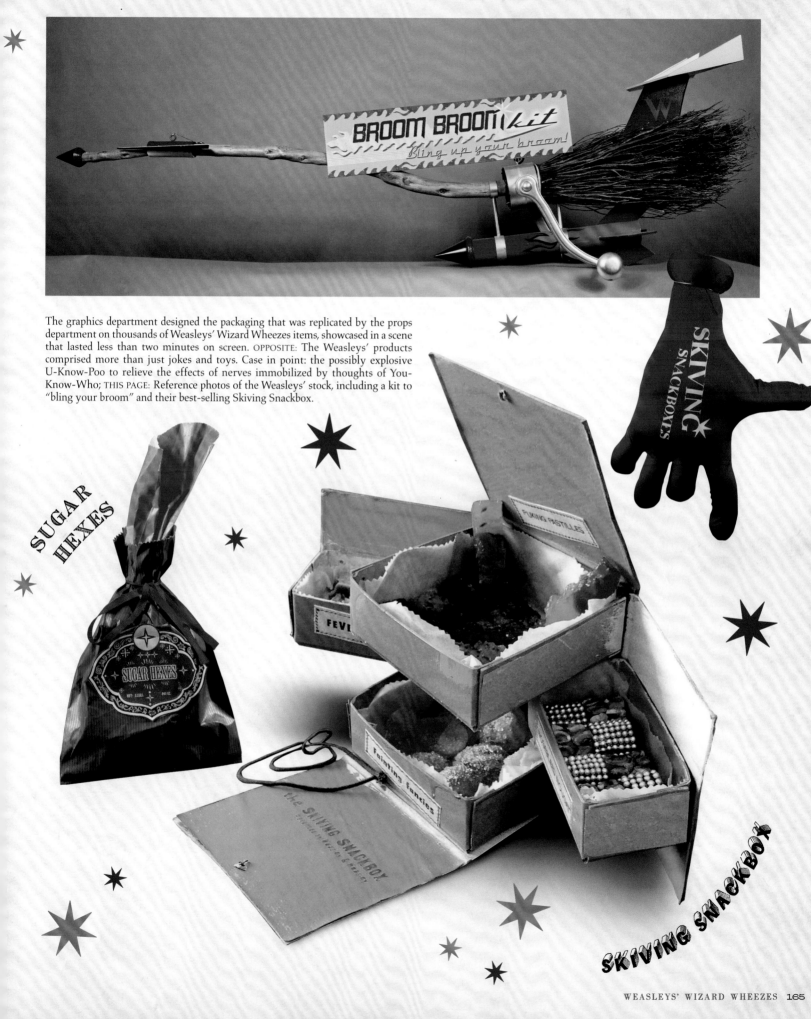

BROOM BROOM *kit*

Bling up your broom!

The graphics department designed the packaging that was replicated by the props department on thousands of Weasleys' Wizard Wheezes items, showcased in a scene that lasted less than two minutes on screen. OPPOSITE: The Weasleys' products comprised more than just jokes and toys. Case in point: the possibly explosive U-Know-Poo to relieve the effects of nerves immobilized by thoughts of You-Know-Who; THIS PAGE: Reference photos of the Weasleys' stock, including a kit to "bling your broom" and their best-selling Skiving Snackbox.

SKIVING SNACKBOXES

SUGAR HEXES

SUGAR HEXES

PUKING PASTILLES

FEVE

Fainting fancies

the SKIVING SNACKBOX

SKIVING SNACKBOX

CHAPTER 8

WIZARD INVENTIONS

*"If there's anyone untrustworthy around,
it's meant to light up and spin.
I thought, you know, it can't hurt."*

—Ron Weasley, deleted scene, *Harry Potter
and the Prisoner of Azkaban*

THE DELUMINATOR

"First, to Ronald Bilius Weasley, I leave my Deluminator, a device of my own making, in the hope that—when things seem most dark—it will show him the light."

—Rufus Scrimgeour, reading from the Last Will and Testament of Albus Dumbledore, *Harry Potter and the Deathly Hallows – Part 1*

Audiences of *Harry Potter and the Sorcerer's Stone* had no idea that the small item Albus Dumbledore used to darken the street lamps on Privet Drive would have more significance than just being a *really cool* magical tool. When activated, the "Put-Outer," as it was originally called, draws in light, and can then reverse the process to release the illumination it has captured. After Dumbledore's death, the device, now called the Deluminator, reappears in *Harry Potter and the Deathly Hallows – Part 1* as a bequest to Ron Weasley, and is used effectively when Harry, Hermione, and Ron are attacked by Death Eaters in Luchino Caffe after their escape to the Muggle world. However, its most important function is its ability to act as a homing device. After Ron leaves his friends following an argument, he hears Hermione's voice coming from the Deluminator. When he clicks it on, a tiny ball of light appears, then enters his chest, and Ron knows this will lead him back to Harry and Hermione. If Ron did not have this, he wouldn't be reunited with his friends and find the Sword of Gryffindor, which destroys the Horcrux locket.

A purely mechanical device, the Deluminator has small caps on both ends. One of the caps flips up and back when a switch on the side is moved, then a small piece shoots up from within a cylinder. Another even smaller cap rises up and off the first piece before revealing the device that takes in or releases light. The piece used in *Harry Potter and the Deathly Hallows – Part 1* is not the same one from *Harry Potter and the Sorcerer's Stone*. "We remade it," says Pierre Bohanna, "because Dumbledore gives it to Ron, and we thought Dumbledore might have updated it." The first Put-Outer had a small light that would arise and illuminate it. The Deluminator Ron receives eliminated the light and was produced in a smaller size. Both versions were covered in malachite, a semiprecious stone that was machined onsite.

PAGE 166: Concept art of the Wizard Wireless by Andrew Williamson for *Harry Potter and the Order of the Phoenix*; ABOVE: Albus Dumbledore (Richard Harris) uses his "Put-Outer" to dim the lights on Privet Drive as he awaits the arrival of the infant Harry Potter in *Harry Potter and the Sorcerer's Stone*; TOP: The final look of the now-named Deluminator for *Harry Potter and the Deathly Hallows – Part 1*; OPPOSITE: Early visual art by Peter McKinstry (top) and a blueprint by Hattie Storey (bottom) for *Harry Potter and the Deathly Hallows – Part 1* explore the redesign and new mechanics of the Deluminator.

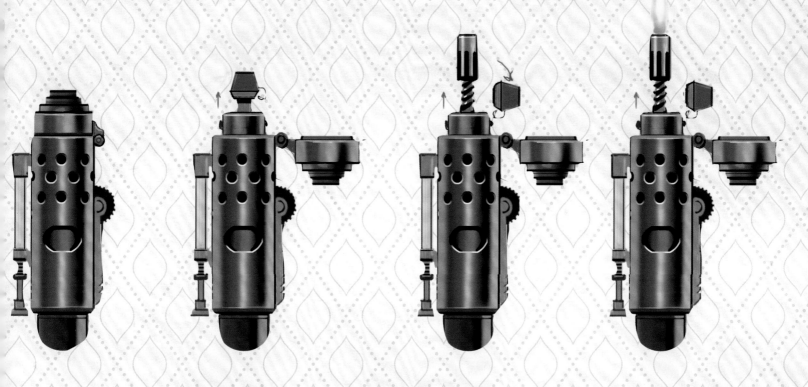

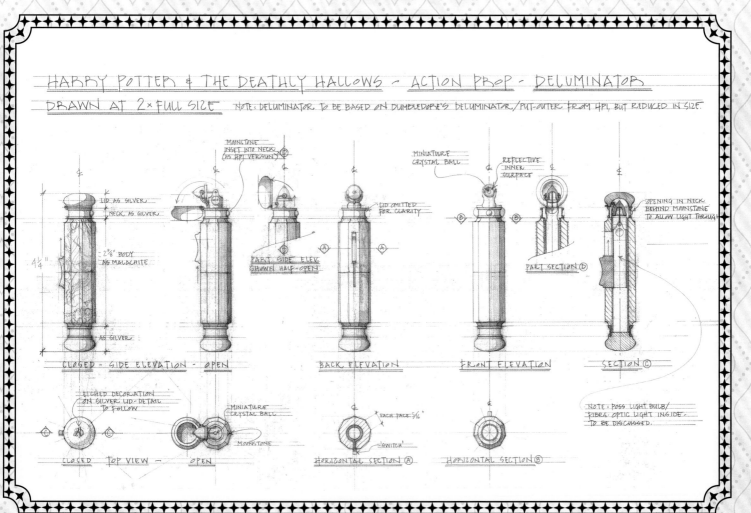

HARRY POTTER & THE DEATHLY HALLOWS - ACTION PROP - DELUMINATOR

DRAWN AT 2 × FULL SIZE NOTE: DELUMINATOR TO BE BASED ON DUMBLEDORE'S DELUMINATOR/PUT-OUTER FROM HP1, BUT REDUCED IN SIZE.

MOONSTONE
INSET INTO NECK
(AS HP1 VERSION)

MINIATURE
CRYSTAL BALL

REFLECTIVE
INNER
SURFACE

LID AS SILVER

NECK AS SILVER

LID OMITTED
FOR CLARITY

OPENING IN NECK
BEHIND MOONSTONE
TO ALLOW LIGHT THROUGH

2³⁄₈" BODY
AS MALACHITE

PART SIDE ELEV.
SHOWN HALF-OPEN

PART SECTION Ⓓ

AS SILVER

CLOSED - SIDE ELEVATION - OPEN BACK ELEVATION FRONT ELEVATION SECTION Ⓒ

ETCHED DECORATION
ON SILVER LID - DETAIL
TO FOLLOW

MINIATURE
CRYSTAL BALL

NOTE: POSS LIGHT BULB/
FIBRE-OPTIC LIGHT INSIDE -
TO BE DISCUSSED.

MOONSTONE

EACH FACE 5⁄16"

SWITCH

CLOSED TOP VIEW - OPEN HORIZONTAL SECTION Ⓐ HORIZONTAL SECTION Ⓑ

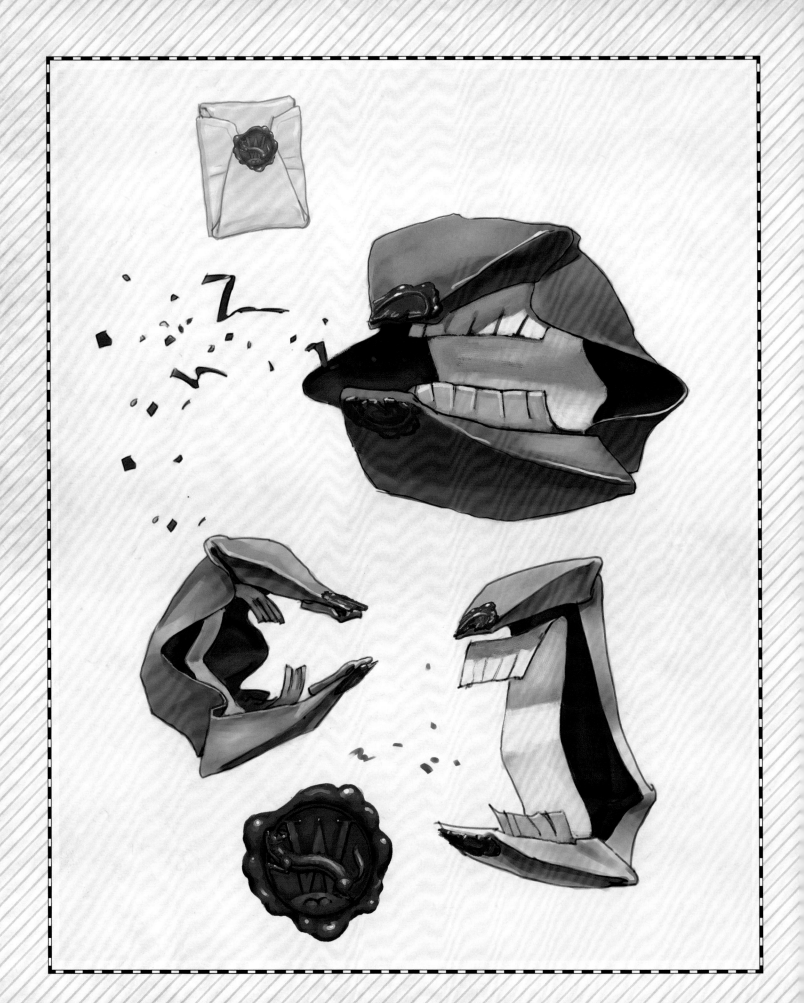

THE HOWLER

"Go on, Ron. I ignored one from my Gran once...it was horrible."

—Neville Longbottom, *Harry Potter and the Chamber of Secrets*

A Howler is a magical letter that conveys its contents in the voice of its sender, and the contents are usually unpleasant and heated. Ron Weasley receives a Howler from his mother, Molly, in *Harry Potter and the Chamber of Secrets*, after he has taken a joyride in his father's enchanted car in order to get him and Harry Potter to Hogwarts. "But instead of just having an envelope with a face on it," explains designer Miraphora Mina, "it tells its own story." Mina was inspired by the Japanese art of folding paper, origami. "There were so many things that lent themselves to that. The ribbon that encircles the letter could turn into a tongue, for example. The white paper inside would turn into teeth within the red mouth." Mina inscribed Molly Weasley's tirade on a piece of paper that was incorporated into the digital construction. In order to ensure that the Howler was actually saying what it was saying, phonetic shapes that mimicked a real mouth reciting the dialogue were designed as reference.

OPPOSITE: Visual development art by Adam Brockbank for *Harry Potter and the Chamber of Secrets* portrays the Howler in its various stages, from the envelope imprinted with a Weasley wax seal to full admonishment, spewing its furious paper-confetti outrage; ABOVE LEFT: Ron Weasley cringes at the wrath of his mother; MIDDLE LEFT: The final sealed envelope and address label; BELOW: A 3-D mock-up of the Howler shows the placement of the letter within, next to the handwritten version. Notice how the writing changes for the nicer words; INSETS: Phonetic shapes were developed to animate the Howler's mouth movements. These are for EE, CH, F, and A sounds (top to bottom).

Ronald Weasley
Hogwarts School
of
Witchcraft &
Wizardry

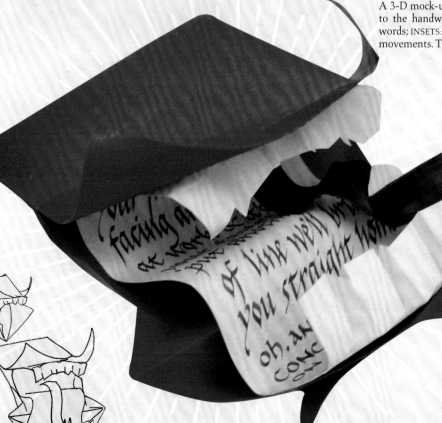

Ronald Weasley! How dare you steal that car! I am absolutely disgusted! Your father's now facing an enquiry at work & it's all your fault! If you put another toe out of line we'll bring you straight home! oh. and GINNY DEAR. CONGRATULATIONS ON MAKING GRYFFINDOR. YOUR FATHER AND I ARE SO PROUD.

CLOCKS AT THE BURROW

"It's not much, but it's home."

—Ron Weasley, *Harry Potter and the Chamber of Secrets*

The first time Harry Potter sees the inside of a wizard family's house is when he is brought to The Burrow, residence of the Weasleys, in *Harry Potter and the Chamber of Secrets*. The home is filled with magical artifacts in motion, including clocks that tell something other than time. To the left of the kitchen's entrance is a clock with chore reminders made of wood that can be interchanged on its face. This clock, designed by concept artist Cyrille Nomberg, features hanging pendulums in the shape of owls. Tasks include "De-gnome the Garden," "Do Your Homework," Make Tea," and "Make More Tea."

Farther inside the house is a colorfully painted grandfather clock that allows the members of the family to know where the others are (and if they're in mortal peril of some sort). The hands on this vintage clock were made from scissor handles with green-screen material in the handholds that was replaced in post-production with film of the actors. After this clock was destroyed in the attack on The Burrow by Death Eaters in *Harry Potter and the Half-Blood Prince*, it was replaced by a similar style in a plain brown wood, faced with Nomberg's original concept art from *Harry Potter and the Chamber of Secrets*.

TOP: An early concept of the Weasley kitchen clock by Adam Brockbank for *Harry Potter and the Chamber of Secrets* with friendly reminders for family chores, which uses the wizard's wand as the clock hand; RIGHT: The first iteration of the Weasley living room clock, which seems to be a little too tall for the room, showed the whereabouts of Molly's husband and children; OPPOSITE BOTTOM LEFT: Cyrille Nomberg's concept art for the kitchen clock had wooden interchangeable reminders; OPPOSITE TOP AND MIDDLE RIGHT: Nomberg's design was used for the final Weasley kitchen clock seen in *Harry Potter and the Chamber of Secrets*; OPPOSITE MIDDLE RIGHT: After The Burrow was set on fire by Death Eaters in *Harry Potter and the Half-Blood Prince*, a new living room clock was needed. Concept art by an unidentified artist echoes the location-finding aspect of the original clock; OPPOSITE BOTTOM RIGHT: In a remnant saved from the old clock to the new, a witch who looks suspiciously like Molly Weasley flies over a painted version of The Burrow.

clock 2

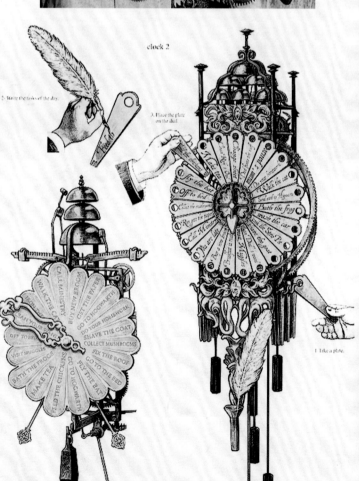

2. Write the tasks of the day.

Finish

3. Place the plate on the dial.

1. Take a plate.

SELF-KNITTING NEEDLES

"I think it's brilliant!"

—Harry Potter, *Harry Potter and the Chamber of Secrets*

The costume designer for *Harry Potter and the Sorcerer's Stone*, Judianna Makovsky, established the Weasley flair for fashion early on with a look that was homemade and craftsy, with a decidedly ginger-complementary palette. In the books, it's written that Molly Weasley loved knitting, and so *Harry Potter and the Chamber of Secrets* costume designer Lindy Hemming continued Makovsky's brief of adorning the family's clothes with woolen embellishments. The prop makers picked up the cue and created a magical knitting machine (working on Molly's next creation) that delights Harry on his first visit to The Burrow. The machine is a simple practical effect: Hidden by the wall of wool is a device that holds up the piece and moves the knitting needles back and forth. The mother of one of the crew members was filmed as reference, knitting for several hours so that the action would look realistic.

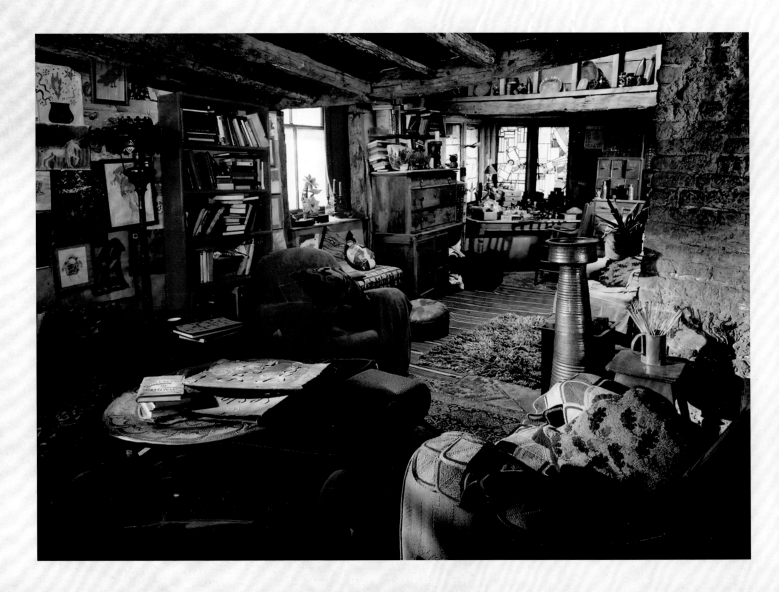

SLIDE PROJECTOR

"Suffice it to say, your professor finds himself incapable of teaching at the present time."

—Severus Snape, *Harry Potter and the Prisoner of Azkaban*

In *Harry Potter and the Prisoner of Azkaban*, while substituting for Professor Lupin in his Defense Against the Dark Arts class, Professor Snape uses a projector to show slides on the history of the werewolf. Production designer Stuart Craig went much earlier than the technological level of 1950s. The nineteenth-century projector Snape uses resembles the magic lanterns of the seventeenth century, using mirrors, glass slides, and a magical power source.

OPPOSITE TOP: Molly Weasley's hands-free magical knitting needles; and OPPOSITE BOTTOM: The results of her efforts, seen draped over furniture in The Burrow (and also seen draped over her children and their friends), *Harry Potter and the Chamber of Secrets*; TOP: Professor Snape uses a slide projector when he substitutes for an ailing Professor Lupin in *Harry Potter and the Prisoner of Azkaban*. The slide on screen in this set reference shot (notice—no students) seems to be a werewolf version of Leonardo da Vinci's Vitruvian Man; RIGHT: Concept art by Dermot Power of Severus Snape operating the "magic" lantern.

SNEAKOSCOPE

"I got you something wicked at Dervish and Banges."
—Ron Weasley, deleted scene, *Harry Potter and the Prisoner of Azkaban*

At Hogwarts, third-year students are allowed to visit the nearby town of Hogsmeade, given they have permission from a parent or guardian. Without permission, Harry Potter cannot join his friends on their first excursion. In a scene that was filmed but left out of the final cut of the movie, Ron hands him the small Dark detector he purchased for Harry at Dervish and Banges in order to cheer him up. The Sneakoscope, which looks like a top, would light up, spin, and whistle if Dark or devious magic was happening near the holder. Concept artist Dermot Power explored various styles and shapes for the Sneakoscope, and even included a description of the way the prop would work and a suggestion of what materials might be used by the prop makers.

OPPOSITE: Visual development artist Dermot Power rendered more than a dozen possible iterations for the Sneakoscope that was deleted from the final screen version of *Harry Potter and the Prisoner of Azkaban*, some of which are featured here. The Sneakoscope was imagined with metallic or colorful finishes and could alert its owner of Dark forces nearby by lighting up, whistling, or spinning like a top; RIGHT: Power even offered a detailed version of how one Sneakoscope would operate; BELOW: The final Sneakoscope, sold at Weasleys' Wizard Wheezes in *Harry Potter and the Half-Blood Prince*, with packaging designed by the graphics department.

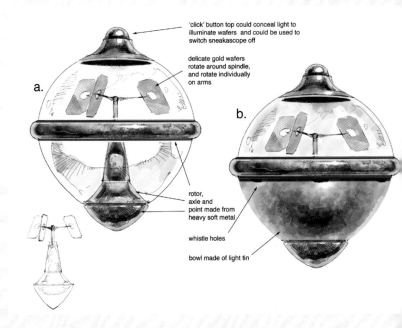

'click' button top could conceal light to illuminate wafers and could be used to switch sneakoscope off

delicate gold wafers rotate around spindle, and rotate individually on arms

a.

b.

rotor, axle and point made from heavy soft metal

whistle holes

bowl made of light tin

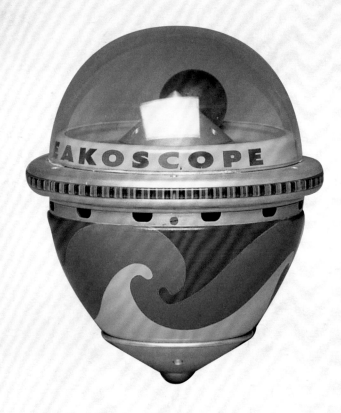

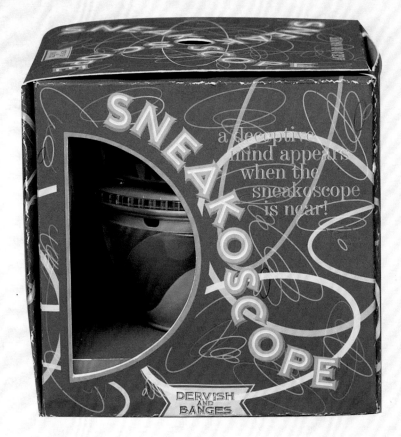

a deceptive mind appears when the sneakoscope is near!

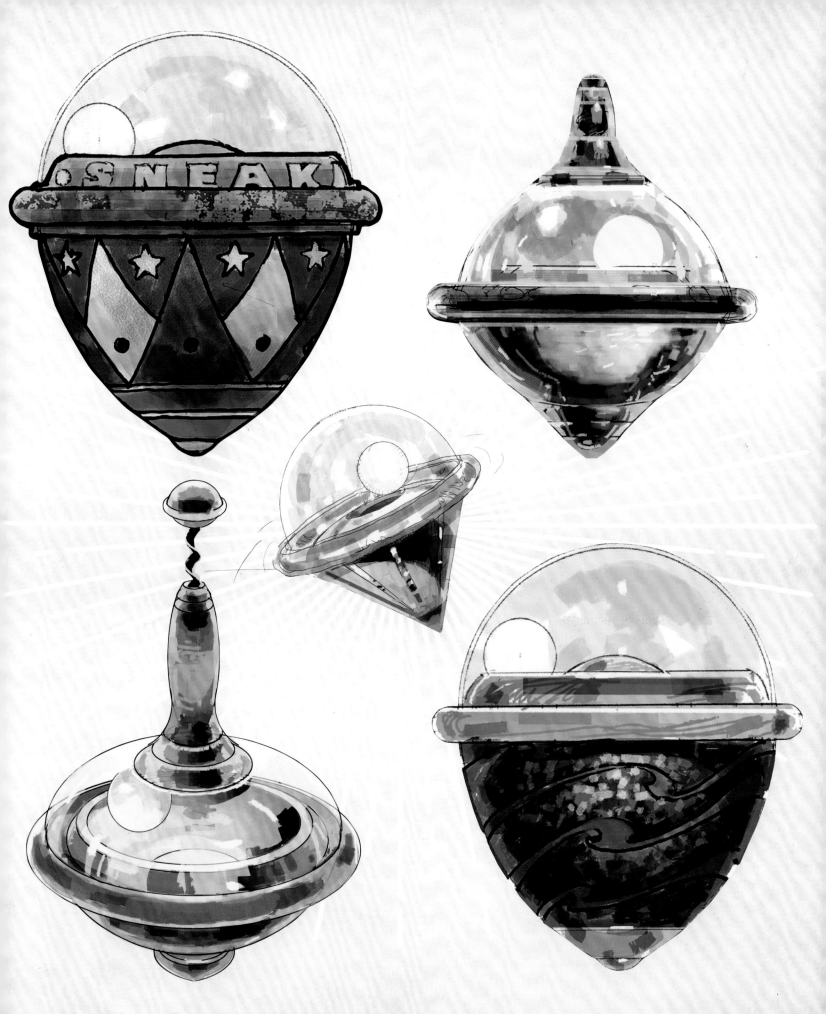

UNDERWATER VIEWING SCOPE

"What's the matter with him?"
"I don't know, I can't see him!"

—Seamus Finnigan and Dean Thomas, *Harry Potter and the Goblet of Fire*

For the second task of the Triwizard Tournament, an underwater viewing device was conceived that would allow viewers to watch the progress of the four champions as they attempted to free their friends in the Black Lake. A set of flexible tubes that disappear under the waterline are visible on the left side of the tower platform, the only portion of the viewing scope that was realized.

OMNIOCULARS

"Blimey, Dad, how far up are we?"

—Ron Weasley, *Harry Potter and the Goblet of Fire*

In order to get a closer view of the action at the 422nd Quidditch World Cup final match in *Harry Potter and the Goblet of Fire* from their location on the topmost tier of the stadium, Ron Weasley used a pair of Omnioculars.

TOP AND ABOVE: Visual development art by Paul Catling of a tentacled scope for viewing the four Triwizard champions in their second task under the waters of the Black Lake in *Harry Potter and the Goblet of Fire*; RIGHT: Catling also created concept art for the Omnioculars Ron Weasley wears at the Quidditch World Cup match at the opening of *Harry Potter and the Goblet of Fire*; OPPOSITE TOP LEFT: A storyboard image for *Harry Potter and the Order of the Phoenix* shows a floor polisher at work in the Ministry of Magic; OPPOSITE TOP RIGHT: Concept art by Adam Brockbank of the machine, with a clue as to how it is operated; OPPOSITE BOTTOM: Brockbank also illustrated a Ministry of Magic security measure in the form of a wand checker for witches and wizards entering the building.

MINISTRY TECH

Concept artists explore many possibilities as they develop ideas to enrich an environment. For the Ministry of Magic's Atrium, which Harry Potter and Arthur Weasley pass through on their way to Harry's trial in *Harry Potter and the Order of the Phoenix*, artist Adam Brockbank brainstormed different aspects of the business of running the Ministry. Security was considered, with a wand-checking machine that would be set at the entrance. Maintenance was addressed in a floor-polishing machine that one presumes is powered by the house-elf inside. Sadly, neither piece made it on-screen.

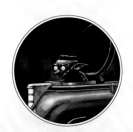

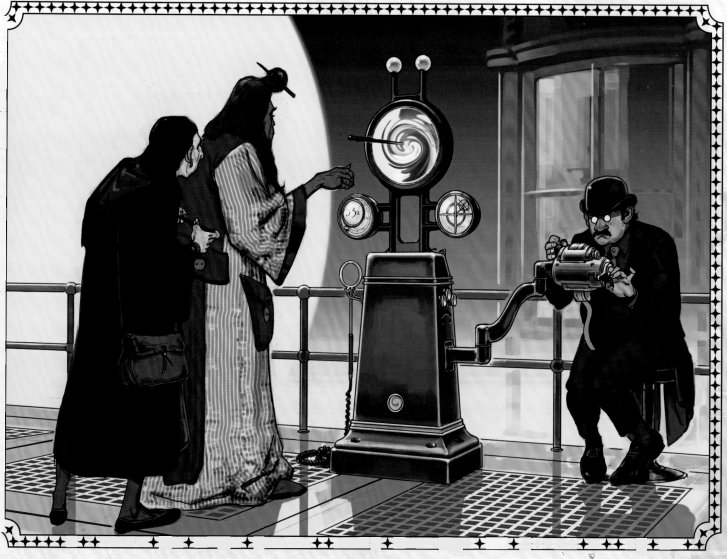

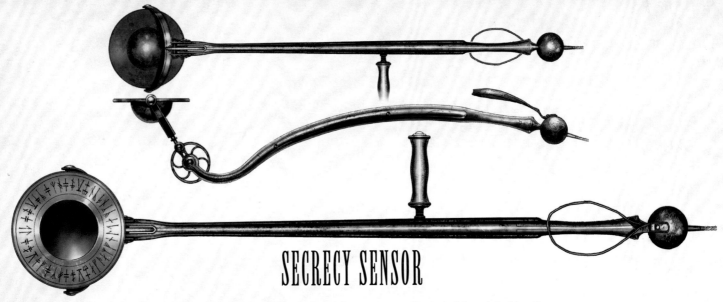

SECRECY SENSOR

"It's all right, Mr. Filch. I can vouch for Mr. Malfoy."

—Severus Snape, *Harry Potter and the Half-Blood Prince*

When the news that Lord Voldemort has returned reverberates throughout the wizarding community, Hogwarts implements measures to ensure the security of the students and professors. Upon their arrival at the school in *Harry Potter and the Half-Blood Prince*, everyone and everything must pass the inspection of a Secrecy Sensor wielded by Argus Filch. Devices and inventions in the wizarding world often resemble something familiar from the Muggle world. In this case, the Dark detector seems to find security breaches the same way a metal detector scans for treasure.

ABOVE: Concept art by Adam Brockbank of an assortment of possible Secrecy Sensors for *Harry Potter and the Half-Blood Prince*; BELOW: A Brockbank visualization of this Dark detector being used by Argus Filch at the Hogwarts gates is seamlessly transferred onto the screen, with David Bradley in the role of the Hogwarts caretaker; OPPOSITE TOP: Visual development art by Andrew Williamson of the Wizarding Wireless Network that broadcasts a Ministry announcement in *Harry Potter and the Order of the Phoenix*; OPPOSITE BELOW: A blueprint of the Wizarding Wireless Network's inner workings.

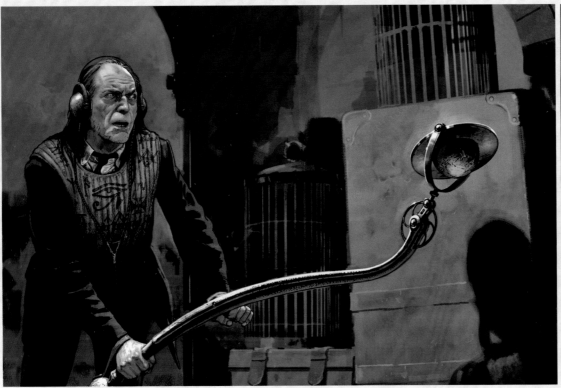

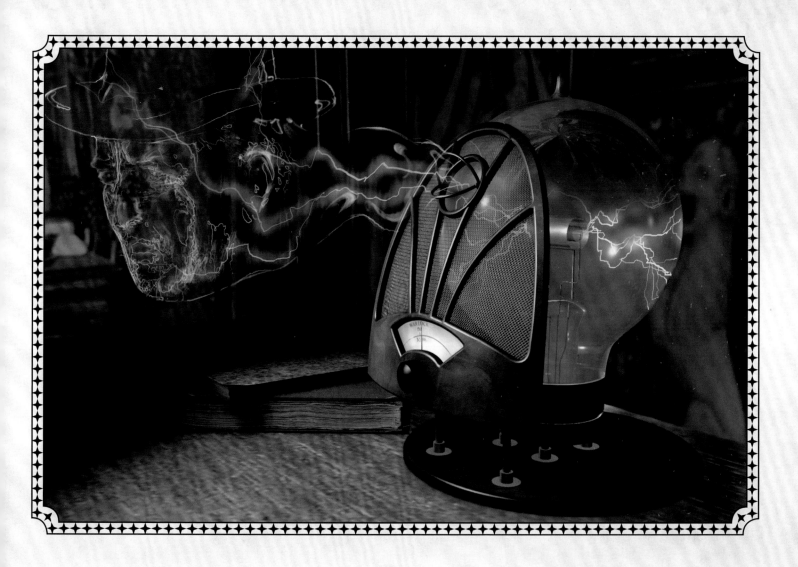

WIZARD WIRELESS

"We have a new weather report:
Lightning has struck. I repeat,
lightning has struck..."

—Nigel Wolpert, *Harry Potter and the Deathly Hallows – Part 2*

Wireless communication devices were used in two of the Harry Potter films. In *Harry Potter and the Order of the Phoenix*, Harry, Ron, and Hermione listen to the Minister for Magic continue to deny the return of Lord Voldemort while they are in the Gryffindor common room. And in *Harry Potter and the Deathly Hallows – Part 2*, Neville Longbottom, concealed in the Room of Requirement, tells another member of Dumbledore's Army, Nigel, to send a coded message to the members of the Order of the Phoenix to let them know that Harry is at Hogwarts.

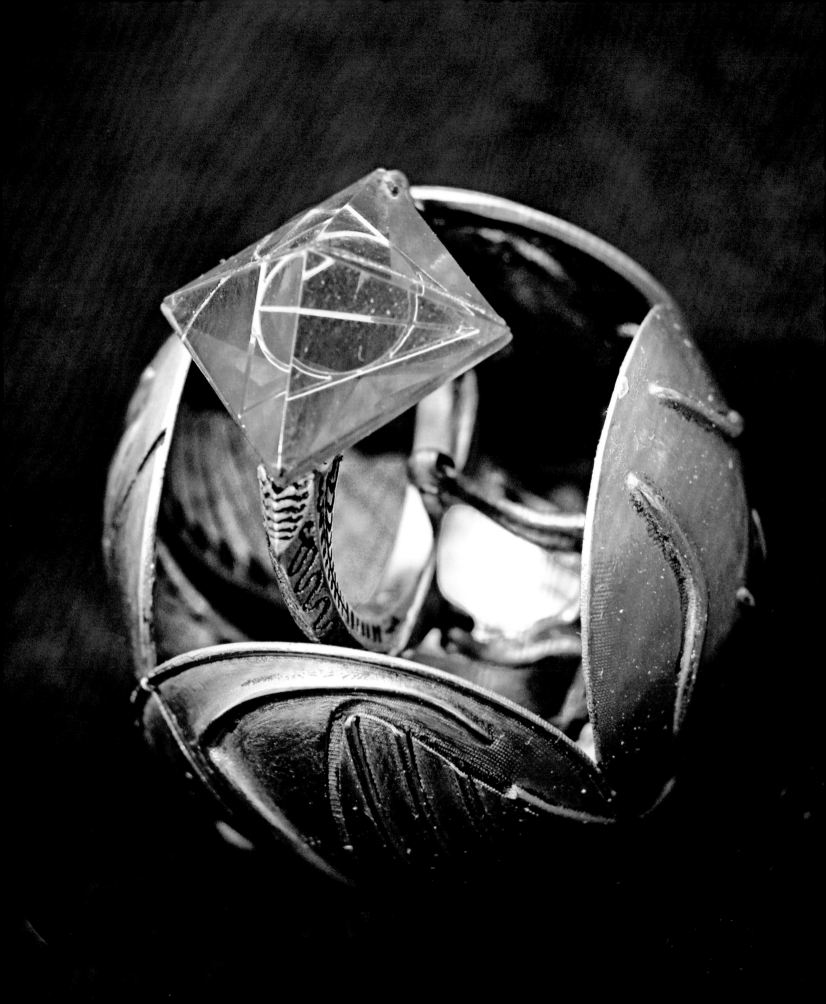

CHAPTER 9
HORCRUXES AND HALLOWS

"But magic ...especially Dark magic ...leaves traces."

—Albus Dumbledore, *Harry Potter and the Half-Blood Prince*

LORD VOLDEMORT'S HORCRUXES

"But if you could find them all....
If you did destroy each Horcrux..."
"One destroys Voldemort."

—Harry Potter and Albus Dumbledore, *Harry Potter and the Half-Blood Prince*

In an effort to gain immortality, the young Lord Voldemort, then called Tom Riddle, coerced his Potions master, Horace Slughorn, into explaining what a Horcrux was—a way to protect one's body by concealing a part of his soul in an object or a living thing—and how to generate one. Lord Voldemort has created seven Horcruxes that Harry Potter must find, which, once destroyed, will allow him to vanquish Lord Voldemort. The plot rests on these articles, which are, in their simplest forms, a cup, a ring, a book, a snake, a tiara, a necklace, and a boy who lived. Their designs needed to be exceptional and memorable, as these are perhaps the most consequential artifacts in the Harry Potter films.

PAGE 182: Both a Horcrux and a Deathly Hallow, the Resurrection Stone in Marvolo Gaunt's ring emerges at the conclusion of *Harry Potter and the Deathly Hallows – Part 2* from the first Golden Snitch Harry Potter caught playing Quidditch; RIGHT: Harry Potter's notebook, showing notes important to his search for Horcruxes; BELOW: A props reference shot for *Harry Potter and the Half-Blood Prince* of the first two destroyed Horcruxes, Tom Riddle's diary and Marvolo Gaunt's ring, as they sit atop Albus Dumbledore's desk; OPPOSITE: Additional views of Tom Riddle's destroyed Horcrux diary, impaled by a Basilisk tooth in *Harry Potter and the Chamber of Secrets*.

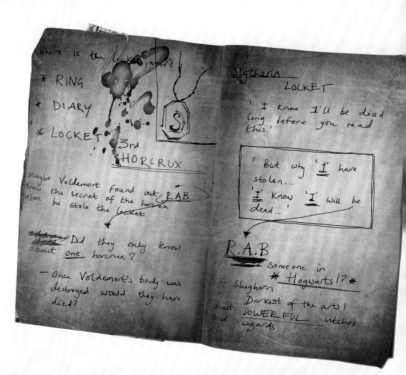

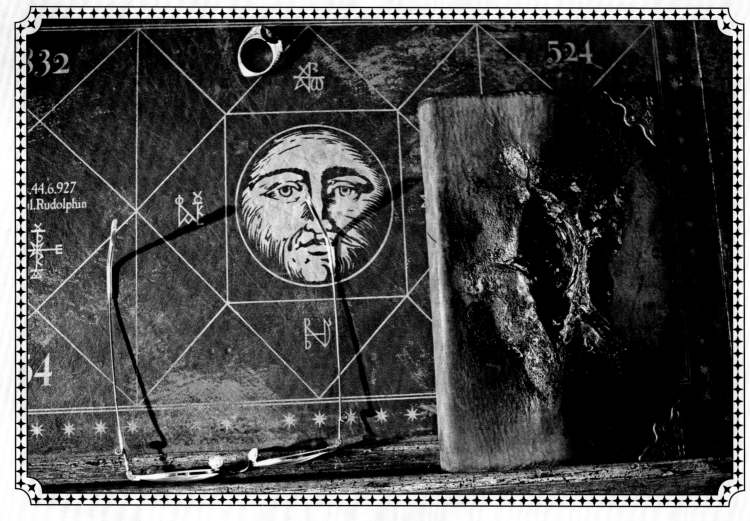

TOM RIDDLE'S DIARY

"I knew it wouldn't be safe to open the Chamber again while I was still at school. So I decided to leave behind a diary, preserving my sixteen-year-old self in its pages, so that one day I would be able to lead another to finish Salazar Slytherin's noble work."

—Tom Marvolo Riddle (Lord Voldemort), *Harry Potter and the Chamber of Secrets*

When creating a hero prop (or in this case, perhaps it should be called a "villain" prop), the prop makers needed to evaluate how its condition might change through the events of the movie story. Tom Riddle's diary starts in fairly good condition when Lucius Malfoy secretly adds it to Ginny Weasley's school supplies in *Harry Potter and the Chamber of Secrets*. Its black leather cover exhibits only a few scuffs and scratches that were created by a method called "breaking down," wherein the prop makers pound, stain, rip, or scrape up an object. Later in the film, the diary is damaged by water, and then destroyed by the venom from a Basilisk.

The last diary prop was outfitted with a tube that pumped out black fluid in a practical effect when Harry pierces it with the snake's fang. The fangs on the Basilisk that Harry encountered in the Chamber were constructed from different materials suited to their purpose. "Stunts and close-ups present different requirements," explains Pierre Bohanna. "The Basilisk fang used to destroy Tom Riddle's notebook is a rubberized one designed not to hurt if you accidentally stab yourself with it." The fangs inside the Basilisk's mouth were more solid where they were embedded but still flexible and rubbery at the pointed end for safety. The fangs were also broken down to give them the appearance of years of wear and tear. Hermione Granger and Ron Weasley return to the Chamber in *Harry Potter and the Deathly Hallows – Part 2* to gather another fang, used to destroy both the cup and diadem Horcruxes.

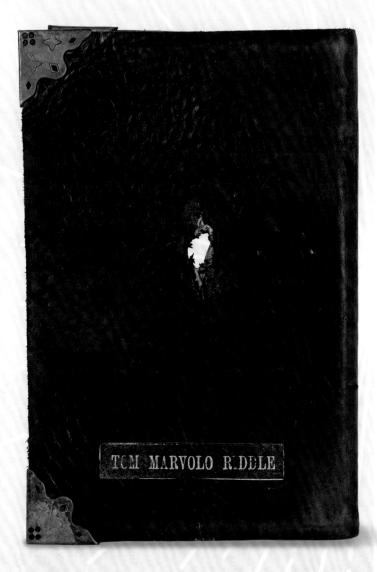

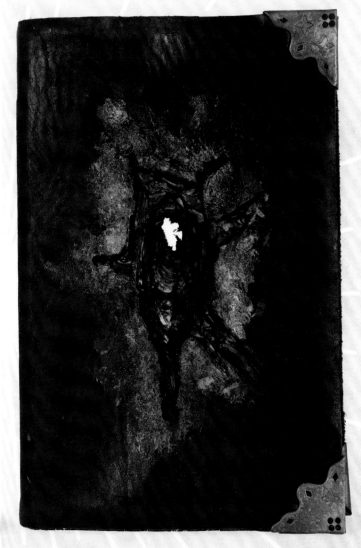

MARVOLO GAUNT'S RING

"They could be anything. The most commonplace of objects. A ring, for example ..."

—Albus Dumbledore, *Harry Potter and the Half-Blood Prince*

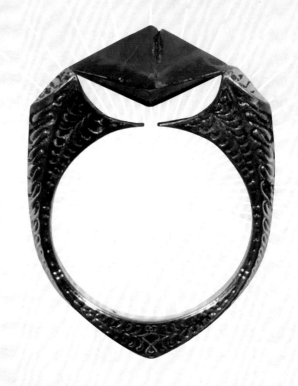

Dumbledore reveals to Harry how Lord Voldemort has taken objects familiar to him and turned them into Horcruxes, seen in *Harry Potter and the Half-Blood Prince*. The Headmaster reminds him of the diary Harry destroyed and shows him another: a gold ring topped with a black stone. This ring, which belonged to Tom Riddle's grandfather, is seen in the Pensieve flashbacks as Tom persuades Professor Slughorn to reveal the method of making these Dark objects. While the ring is seen only fleetingly, it impacts the story greatly as Dumbledore explains that a Horcrux leaves a trace of Dark magic upon it, which will enable Harry to find the remaining ones. The final look of the ring was created by Miraphora Mina, who designed and crafted many of the jewelry props in the film series. The ring's design showcases an obvious Slytherin connection as two stylized snake heads meet to hold the gem in their jaws. Sadly, although Dumbledore succeeds in destroying this Horcrux with the Sword of Gryffindor, it eventually costs him his life.

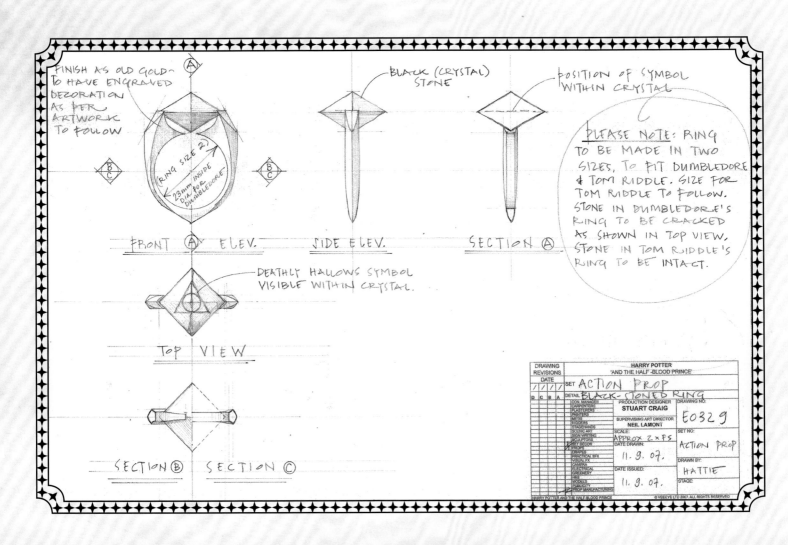

FINISH AS OLD GOLD - TO HAVE ENGRAVED DECORATION AS PER ARTWORK TO FOLLOW

BLACK (CRYSTAL) STONE

POSITION OF SYMBOL WITHIN CRYSTAL

(RING SIZE 2)

23mm INSIDE DIAL FOR DUMBLEDORE

FRONT (A) ELEV. SIDE ELEV. SECTION (A)

PLEASE NOTE: RING TO BE MADE IN TWO SIZES, TO FIT DUMBLEDORE & TOM RIDDLE. SIZE FOR TOM RIDDLE TO FOLLOW. STONE IN DUMBLEDORE'S RING TO BE CRACKED AS SHOWN IN TOP VIEW. STONE IN TOM RIDDLE'S RING TO BE INTACT.

DEATHLY HALLOWS SYMBOL VISIBLE WITHIN CRYSTAL.

TOP VIEW

SECTION (B) SECTION (C)

DRAWING REVISIONS				HARRY POTTER 'AND THE HALF-BLOOD PRINCE'		
DATE				SET ACTION PROP		DRAWING NO:
/ / / /				DETAIL BLACK-STONED RING		
D	C	B	A	PRODUCTION DESIGNER STUART CRAIG		E0329
				SUPERVISING ART DIRECTOR NEIL LAMONT		
				SCALE: APPROX 2 × FS		SET NO: ACTION PROP
				DATE DRAWN: 11.9.07.		
				DATE ISSUED: 11.9.07.		DRAWN BY: HATTIE
						STAGE:

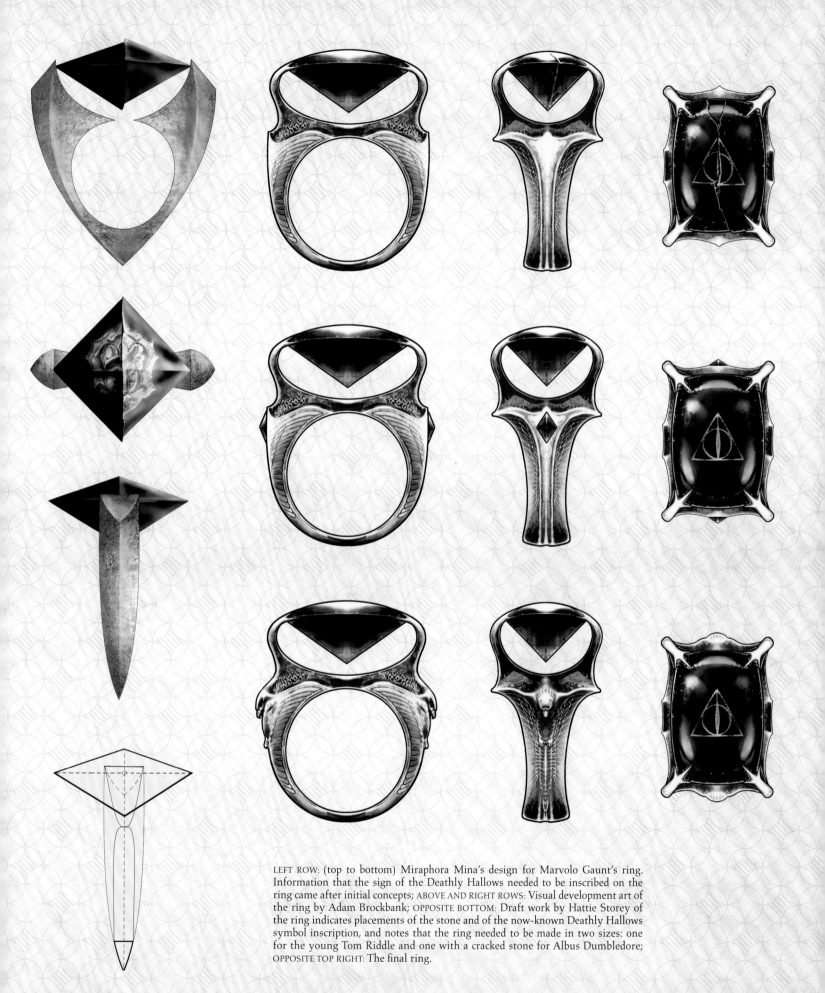

LEFT ROW: (top to bottom) Miraphora Mina's design for Marvolo Gaunt's ring. Information that the sign of the Deathly Hallows needed to be inscribed on the ring came after initial concepts; ABOVE AND RIGHT ROWS: Visual development art of the ring by Adam Brockbank; OPPOSITE BOTTOM: Draft work by Hattie Storey of the ring indicates placements of the stone and of the now-known Deathly Hallows symbol inscription, and notes that the ring needed to be made in two sizes: one for the young Tom Riddle and one with a cracked stone for Albus Dumbledore; OPPOSITE TOP RIGHT: The final ring.

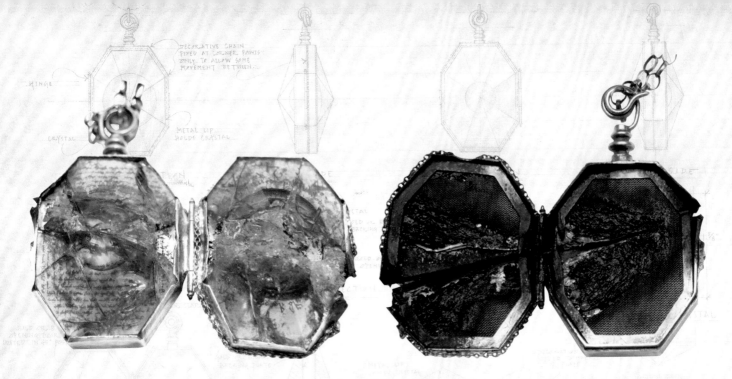

SALAZAR SLYTHERIN'S LOCKET

*"I know I will be dead long before you read this....
I have stolen the real Horcrux and intend to destroy it."*

—Harry Potter reading R.A.B.'s note, *Harry Potter and the Deathly Hallows – Part 1*

Unknown to Dumbledore and Harry when they seek the locket Horcrux in *Harry Potter and the Half-Blood Prince*, there are actually two lockets: one that had belonged to Salazar Slytherin and was passed down to Voldemort, which the Dark Lord turned into a Horcrux and secreted in a crystal cave, and a locket that Sirius Black's brother, Regulus, left as a replacement when he stole the real locket Horcrux. "This was a case of not knowing that the locket wasn't a real locket when we started designing it," says art director Hattie Storey. So two lockets, one refined and one less so, needed to be created. "The locket was a challenge," says Miraphora Mina, "because it was full of evil, but it also needed to have a beauty to it; to be something appealing and something historical."

The real Slytherin locket was based on an eighteenth century piece of jewelry from Spain that Mina saw in a museum, and who loved the idea that the crystal on the front was faceted, "so it was almost like, as there were lots of different sides, you didn't quite know which bit of it was going to open." As described in the book, the locket was adorned with a jeweled "S" on the front created from diamond-cut green stones. Mina surrounded this with astrological symbols, specifically the aspect notations used for horoscopes that refer to the relative angles of planets to each other. There is also an inscription inside the ring and another, longer inscription on its faceted back.

"The locket was a treat to conjure up," Mina states. "I was allowed to play with every detail on that locket, so even the loop that goes onto the chain is a little snake wound around it. The great thing on Harry Potter was that all these things were manufactured on-site, so discussions could take place with the prop maker about the right materials to use, and that would perhaps necessitate an alteration of the design a little bit." When it came time for Ron Weasley to destroy the Horcrux with the Sword of Gryffindor in *Harry Potter and the Deathly Hallows – Part 1*, duplicates needed to be made. "The original brief was that we'd only need two or three," recalls Pierre Bohanna. "It ended up being forty."

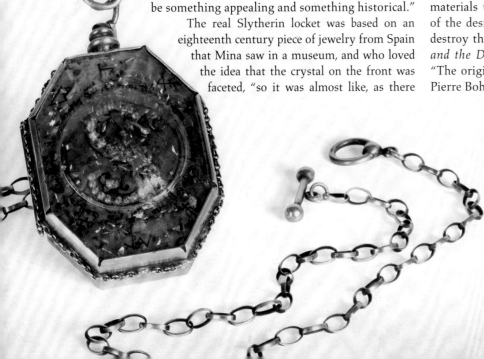

LEFT: The fake locket, a much cruder version of the real one, housed a tiny piece of parchment that Miraphora Mina inscribed in her facet as a graphic designer; TOP: Salazar Slytherin's locket after Ron Weasley destroys it with the Sword of Gryffindor in *Harry Potter and the Deathly Hallows – Part 1*; BACKGROUND: Draft work of the locket by Hattie Storey shows views of the artifact from every angle; OPPOSITE: (top to bottom) Storyboard art showing the progression of the locket from its retrieval in the Horcrux cave to the discovery that it is not the real locket in *Harry Potter and the Half-Blood Prince* to art and still photography showing the real locket's destruction in *Harry Potter and the Deathly Hallows – Part 1*; OPPOSITE RIGHT: Concept art of different suggestions for the "S" design by Miraphora Mina.

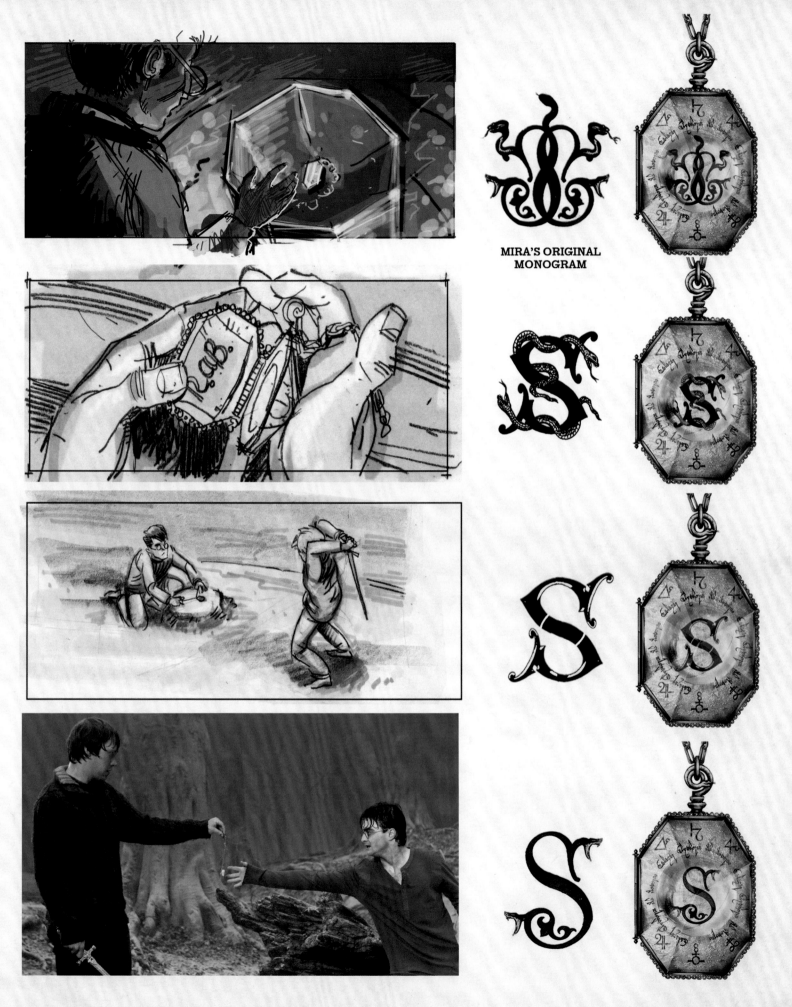

MIRA'S ORIGINAL
MONOGRAM

CUT

Harry's POV.
Dumbledore fills ladle and raises it....

TILT UP ...

Flare circles round out of shot
..see digram.

45a

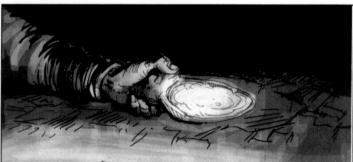

Cont'd

with ladle as it rises...

45b

Cont'd over

Cont'd

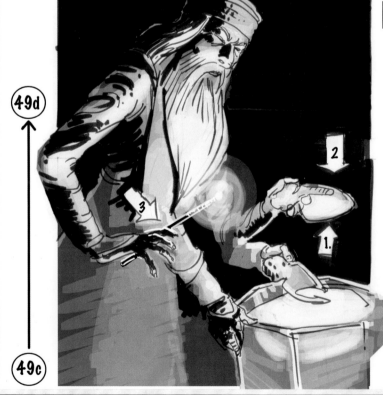

Harry's POV.

1. Dumbledore fills and raises third cup of liquid.

2. he nearly drops cup.

3 .Grabs hold of the side of the basin.

Flare circles round out of shot
..see digram.

49d

49c

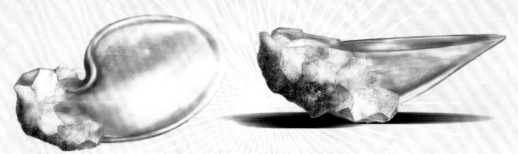

HORCRUX CAVE
CRYSTAL GOBLET

*"It is your job, Harry, to make sure I keep drinking this potion even
if you have to force it down my throat. Understood?"*

—Albus Dumbledore, *Harry Potter and the Half-Blood Prince*

One of the first props the designers started on for *Harry Potter and the Half-Blood Prince* was the crystal scoop Harry would use to drain the poisonous water from the basin that held the fake Horcrux locket. "We had originally envisioned a metal cup attached by a chain to the crystal basin for Dumbledore to drink from," says Hattie Storey. "But then we felt that it had to be something that looked as though it could be found in the cave, where there wasn't anything but crystal, and that it would appear semi-manmade. It was obviously found or created on the spot by Lord Voldemort for the purpose of drinking the potion." During her design research, Miraphora Mina came upon an ancient carved jade

scoop from China with a sheep's head holder that influenced the organic, crystalline shell-shaped prop. "It was one of those times," Storey concludes, "that once you find the solution, it seems as if it just couldn't have been anything else." However, this was easier said than done. It took sixty prototypes before the final piece was approved to be molded and cast.

ABOVE: Concept art by Miraphora Mina of the crystal goblet used in *Harry Potter and the Half-Blood Prince*; BELOW: Harry Potter helps Albus Dumbledore drink the basin's potion in order to retrieve the Horcrux locket in visual development art by Adam Brockbank; OPPOSITE: Storyboard art of the scene adds detail of how the ladle will scoop up the water.

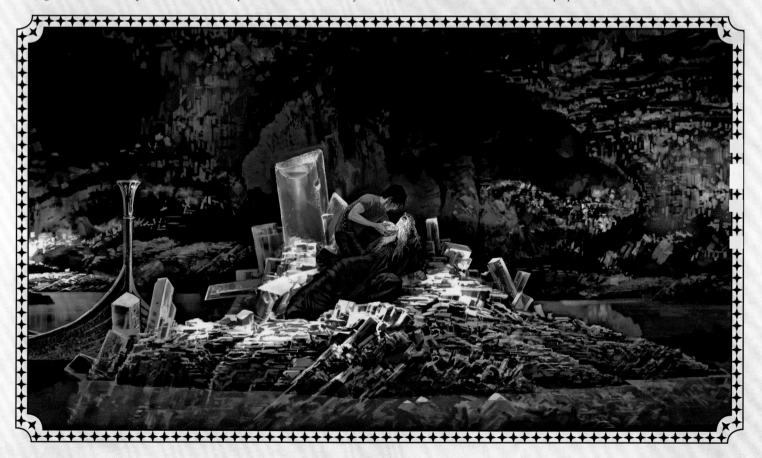

HELGA HUFFLEPUFF'S CUP/LESTRANGE GRINGOTTS VAULT

"Are you thinking there's a Horcrux in Bellatrix's vault?"

—Hermione Granger, *Harry Potter and the Deathly Hallows – Part 2*

"A ny prop, but especially one that has significance to the story, goes through a long design process," explains Pierre Bohanna. "At least half a dozen designs go in front of the director and producers for approval." The Hufflepuff cup is a case in point: Originally presented to be twice its size, the filmmakers asked if it could be made smaller. Did this influence Miraphora Mina's design? "At the time, book seven hadn't come out, so all we knew was that we just needed a badger on it," she explains. "It was meant to be very modest. It didn't have that kind of magisterial thing that the others did. I can't say whether it would have affected the design if we had known that it was going to need to multiply into thousands and thousands!"

Mina's influences included gold goblets and thistle-shaped medieval cups. First, a full-size mold of the design was crafted, with a bas-relief of the Hufflepuff badger upon it. Then the prop makers used a method of metalcraft where, in this case, a thin layer of pewter was beaten onto it. Finally, the pewter was painted gold by Pierre Bohanna. The cup was commissioned for *Harry Potter and the Half-Blood Prince* to be placed in the Room of Requirement, but it wasn't really seen until *Harry Potter and the Deathly Hallows – Part 2*, when Harry, Ron, and Hermione invade Bellatrix Lestrange's vault at Gringotts. Due to a spell on the vault's contents, any object touched will multiply and multiply and multiply . . . "We used the analogy of a children's ball pit," explains Hattie Storey, "where you have to wade through all those plastic balls. It's a bit like that, but with treasure and gold."

In order to create the amount needed, Pierre Bohanna used an injection-molding machine that needed to run on a twenty-four-hour schedule. "We had six different objects that that we made soft rubber copies of," Storey continues, "so in the end we had literally filled twenty cubic meters of that vault." In order to reach the real Horcrux cup at the topmost corner of the vault, Daniel Radcliffe (Harry Potter) leapt upward onto a series of rising platforms hidden beneath the thousands of props. The real cup is destroyed by Hermione Granger in the Chamber of Secrets.

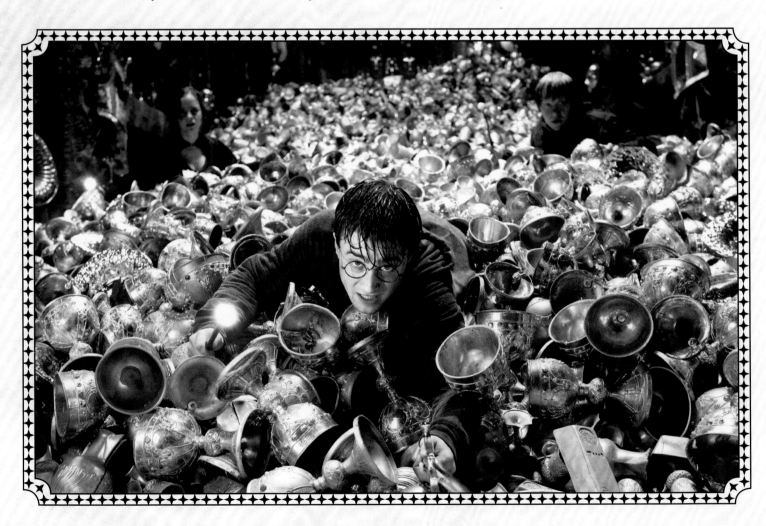

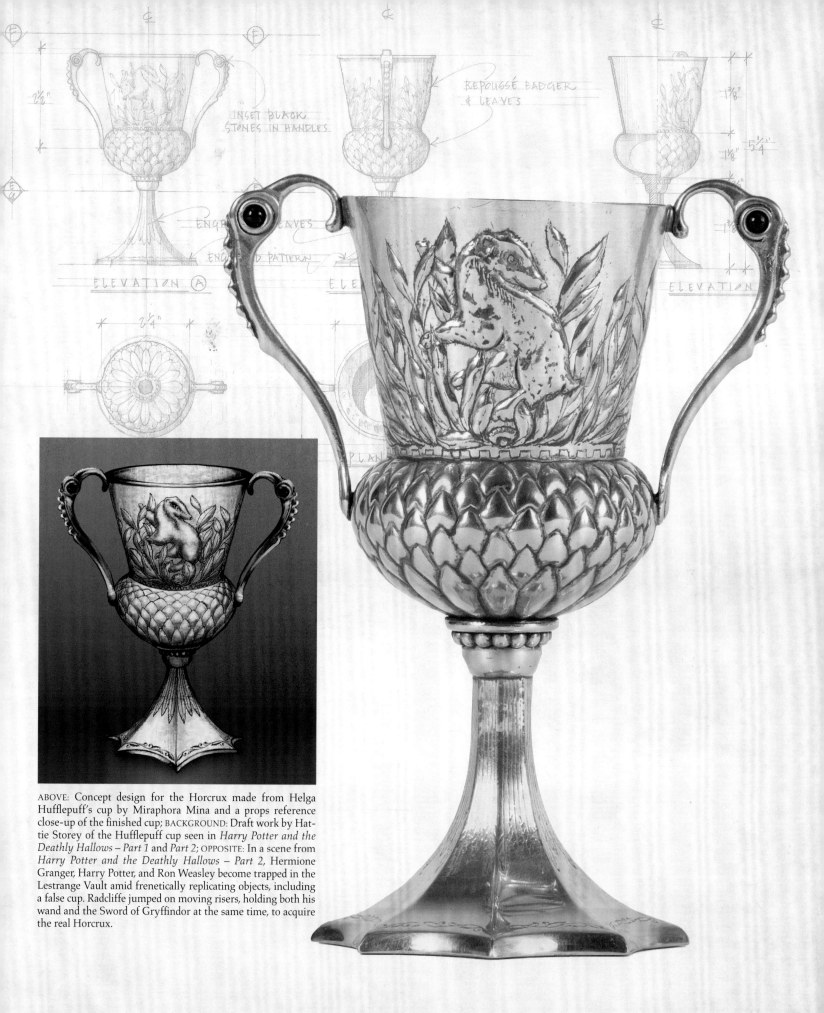

ABOVE: Concept design for the Horcrux made from Helga Hufflepuff's cup by Miraphora Mina and a props reference close-up of the finished cup; BACKGROUND: Draft work by Hattie Storey of the Hufflepuff cup seen in *Harry Potter and the Deathly Hallows – Part 1* and *Part 2*; OPPOSITE: In a scene from *Harry Potter and the Deathly Hallows – Part 2*, Hermione Granger, Harry Potter, and Ron Weasley become trapped in the Lestrange Vault amid frenetically replicating objects, including a false cup. Radcliffe jumped on moving risers, holding both his wand and the Sword of Gryffindor at the same time, to acquire the real Horcrux.

REPOUSSÉ BADGER & LEAVES

INSET BLACK STONES IN HANDLES

ENGRA... ...EAVES

ENC...D PATTERN

ELEVATION A

ELE... ELEVATION

PLAN

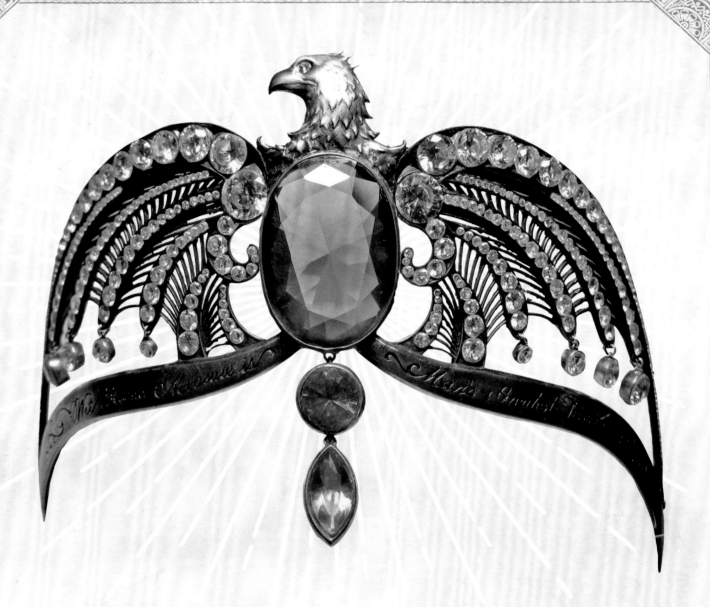

ROWENA RAVENCLAW'S DIADEM

"Excuse me. Could someone tell me what a bloody diadem is?"
—Ron Weasley, *Harry Potter and the Deathly Hallows – Part 2*

The diadem of Hogwarts House founder Rowena Ravenclaw also went through several redesigns before its final iteration. "It was scripted to be in *Harry Potter and the Half-Blood Prince*, and we did make one," recalls Hattie Storey, "but it was never seen. Then we redesigned it for *Harry Potter and the Deathly Hallows – Part 2*. Now it's so different I'm glad it wasn't established in the sixth film." There are, as with Salazar Slytherin's locket, actually two versions of the diadem (which Cho Chang informs Ron is "*. . . kind of crown. You know, like a tiara.*").

In the book *Harry Potter and the Half-Blood Prince*, Xenophilius Lovegood (a Ravenclaw, as is his daughter, Luna) believes he is in the possession of the diadem. Sharp eyes will spot a double-eagle tiara resting atop a bust of Rowena Ravenclaw when Harry, Hermione, and Ron visit Lovegood looking for information in *Harry Potter and the Deathly Hallows – Part 1*. But the real Horcrux is at Hogwarts, in the Room of Requirement. Clearly, the Ravenclaw diadem needed to include an image of the Ravenclaw eagle. It is a success of design that the diadem is actually shaped by the wings of a singular eagle. The wings are outlined in clear white gems, and the eagle's body and hanging "tail feathers" are made of three multifaceted light blue stones. The diadem is destroyed by Harry with the same Basilisk tooth used to destroy the Hufflepuff cup, and then kicked into a blazing Fiendfyre by Ron.

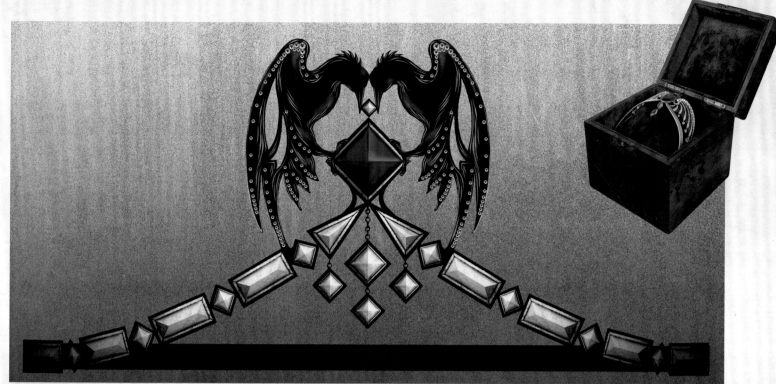

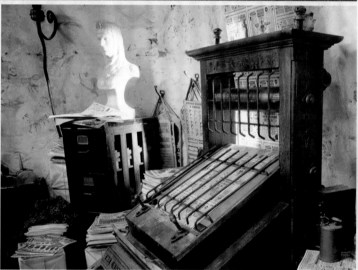

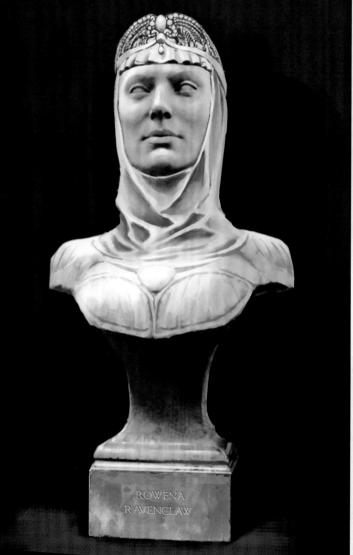

OPPOSITE: Rowena Ravenclaw's diadem incorporates the Ravenclaw house's eagle and her maxim, "Wit beyond measure is man's greatest treasure," inscribed along the bottom of the eagle's wings, in its design; TOP: An early concept of the Ravenclaw diadem painted by Miraphora Mina for *Harry Potter and the Half-Blood Prince*; BELOW: The diadem was created but not used in the movie; LEFT: Concept art by Adam Brockbank of a bust of Rowena Ravenclaw wearing a diadem (similar to but not the real one) seen in the Lovegood House; ABOVE: The fake diadem is fairly easy to spot in a set reference photo for *Harry Potter and the Deathly Hallows – Part 1*.

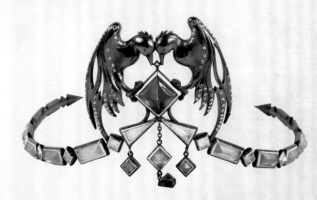

NAGINI

"It's the snake. She's the last one. The last Horcrux."

—Harry Potter, *Harry Potter and the Deathly Hallows – Part 2*

Fearsome and faithful to Lord Voldemort, Nagini is the only fully computer-generated Horcrux. For her first two appearances, in *Harry Potter and the Goblet of Fire* and *Harry Potter and the Order of the Phoenix*, Nagini's design was a fusion of Burmese python and anaconda, both of which come up shorter than this snake's twenty-foot length. Though the intention was always for Nagini to be a digital construct, the creature shop fabricated a fully painted maquette (model) of the snake at her full size, which was then cyberscanned for the computer animators.

Nagini's role was increased in *Harry Potter and the Deathly Hallows – Part 1* and *Part 2*, and, it was "very important that we create a very believable, scary character," explains Tim Burke, visual effects supervisor. "Nagini is a servant to Voldemort, but also a very evil crea-

ture in her own right. I felt that when we'd last seen her, she wasn't quite a real snake. In the past she never had a large role, but in this film she was going to have a lot of chances to scare the kids." Burke convinced his team that the best inspiration for the revamp would be a real snake, so he brought a professional snake wrangler into Leavesden Studios to let them observe a real python.

In addition to the animators filming and sketching the snake, one of the digital artists created all the textures of Nagini's scales by hand from still shots of the python. This allowed CGI to capture the iridescence and reflective quality of snakeskin as well as truer, more vibrant colors. Viper- and cobra-like movements were added for additional creepiness, her eyes were given the depth of a viper's, and her fangs were sharpened.

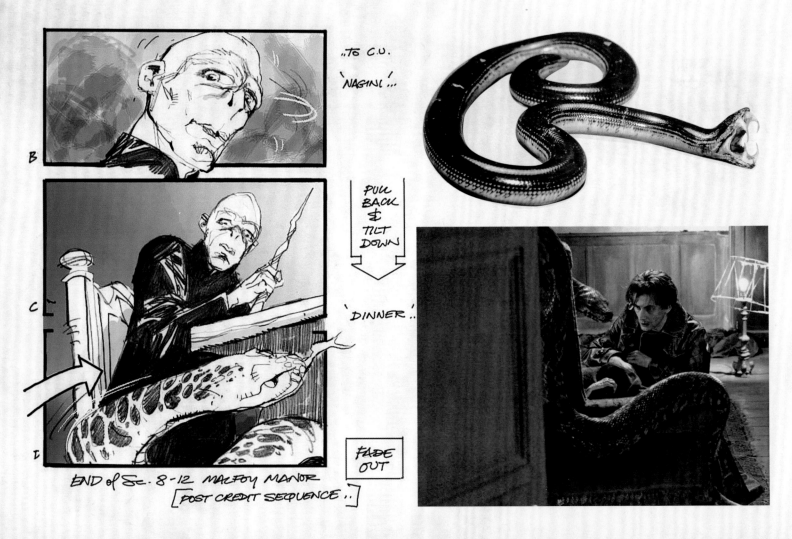

GODRIC GRYFFINDOR

SWORD OF GRYFFINDOR

*"It would take a true Gryffindor
to pull that out of the Hat."*

—**Albus Dumbledore**, *Harry Potter and the Chamber of Secrets*

Any mention of Horcruxes can't go without a nod to the Sword of Gryffindor, which destroys the ring, the locket, and the snake. Harry Potter first encounters the sword in *Harry Potter and the Chamber of Secrets* when he pulls it out of the Sorting Hat and uses it to kill the Basilisk. Goblin-made, the Sword is able to absorb qualities that strengthen it; in this case the serpent's venom, which is one of the few ways to destroy a Horcrux. We see a flashback of Dumbledore using the Sword to destroy the ring Horcrux in *Harry Potter and the Half-Blood Prince*, and then Neville Longbottom also pulls it from the Hat, in *Harry Potter and the Deathly Hallows – Part 2*, and kills Nagini with it. The prop makers purchased a real sword at an auction for reference and researched medieval swords for inspiration. The Sword is set with ruby cabochons, the color of Gryffindor house, and has a small inset picture on the top of its blade presumably of Godric Gryffindor.

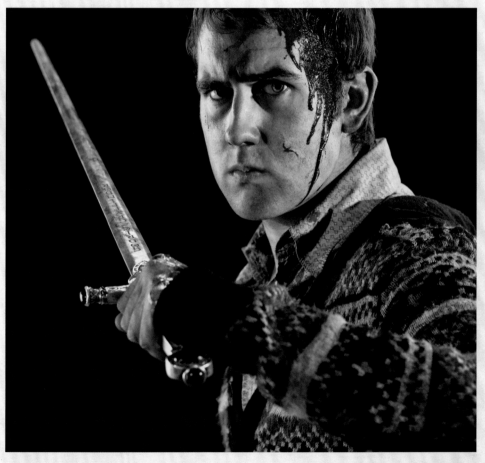

OPPOSITE ABOVE RIGHT: Nagini in her python/anaconda mashup by visual development artist Paul Catling for *Harry Potter and the Goblet of Fire*; OPPOSITE TOP: Nagini was tried with more boa constrictor characteristics in another possibility by Catling; OPPOSITE BOTTOM RIGHT: Barty Crouch Jr. (David Tennant) and Nagini watch over the barely corporeal form of Voldemort in *Harry Potter and the Goblet of Fire*; OPPOSITE LEFT: Storyboard art for *Harry Potter and the Deathly Hallows – Part 1* of Voldemort offering Nagini a meal (of Professor Charity Burbage); LEFT: A true "hero" artifact: the Sword of Gryffindor; ABOVE: Neville Longbottom (Matthew Lewis) poses with the Sword of Gryffindor in a publicity still.

"What do you know about the Deathly Hallows?"
"It is rumored there are three: the Elder Wand, the Cloak of Invisibility that hides you from your enemies, and the Resurrection Stone to bring back loved ones from the dead. Together they make one the Master of Death. But few truly believe that such objects exist..."

—Harry Potter and Garrick Ollivander, *Harry Potter and the Deathly Hallows – Part 2*

In addition to the Horcruxes, Harry Potter is made aware of three more articles that need to be accounted for: the Deathly Hallows, which will make Lord Voldemort invincible. The discovery of what these are and who possesses them is stunning, as they have been visibly part of the story all along, and associated with Harry, Dumbledore, and the young Voldemort. Harry first learns of the Deathly Hallows when he sees a curious necklace worn by Xenophilius Lovegood at Bill Weasley's wedding in *Harry Potter and the Deathly Hallows – Part 1*. The three artifacts the stylized necklace represents are believed by some to hold the key to becoming the Master of Death. Harry's suspicion is that Lord Volde-mort has assumed the legend is true and is making efforts to acquire them. The Dark Lord steals the first—the Elder Wand—from Dumbledore's crypt in the epilogue of *Harry Potter and the Half-Blood Prince*. Harry unknowingly already possesses one—the Cloak of Invisibility—and inherits the third—the Resurrection Stone—from Dumbledore.

INSET: Development artwork by Miraphora Mina of the necklace Xenophilius Lovegood wears in *Harry Potter and the Deathly Hallows – Part 1*; BELOW: Hermione Granger, Ron Weasley, and Harry Potter watch as Lovegood sketches out the symbol for the Deathly Hallows in a scene from the film; OPPOSITE: Storyboard art of the same scene.

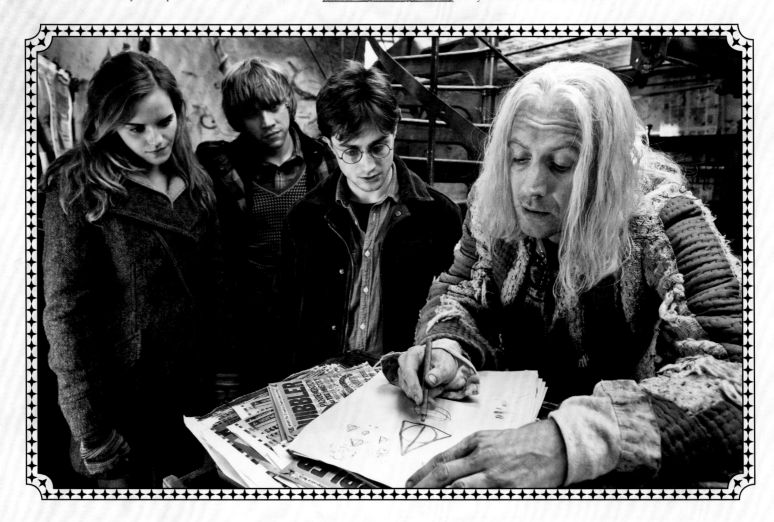

A

Wider as the group try to follow what Lovegood is saying.

Page ◯

CUT TO

B

Angle on Lovegood.

Lovegood: The Resurrection
Stone

Lovegood draws something on
paper o/s

CUT TO

C

Closer on the Three as they
listen intently.

CUT TO

D

... then he encloses both
in a TRIANGLE.

Lovegood: The Cloak Of
Invisability. Together.....
they make the Deathly Hallows.
Together ...they make one
master of Death.

CUT TO

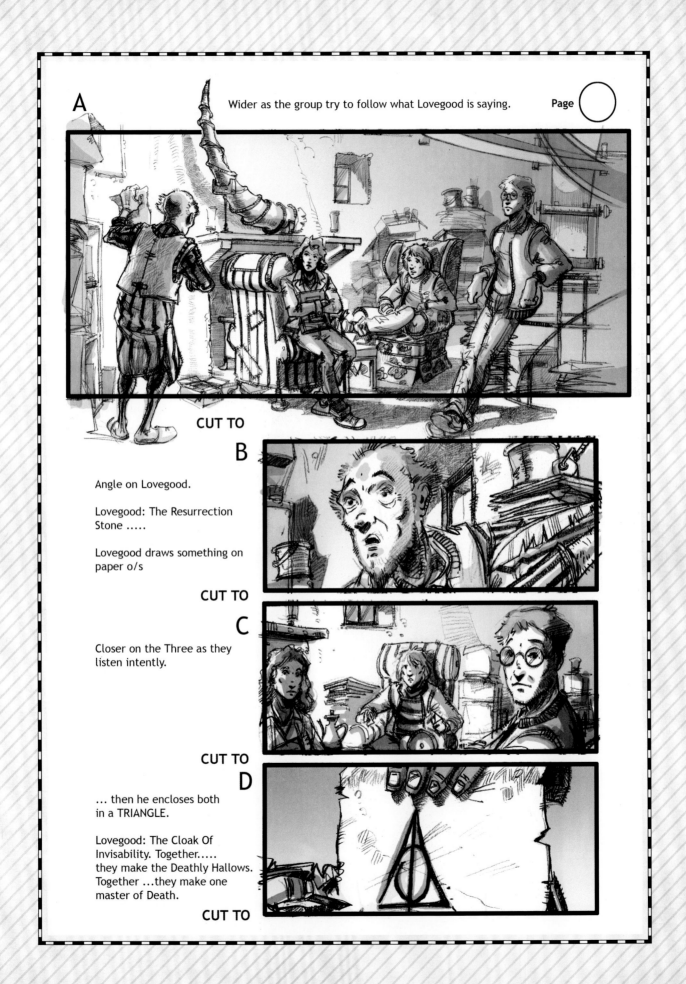

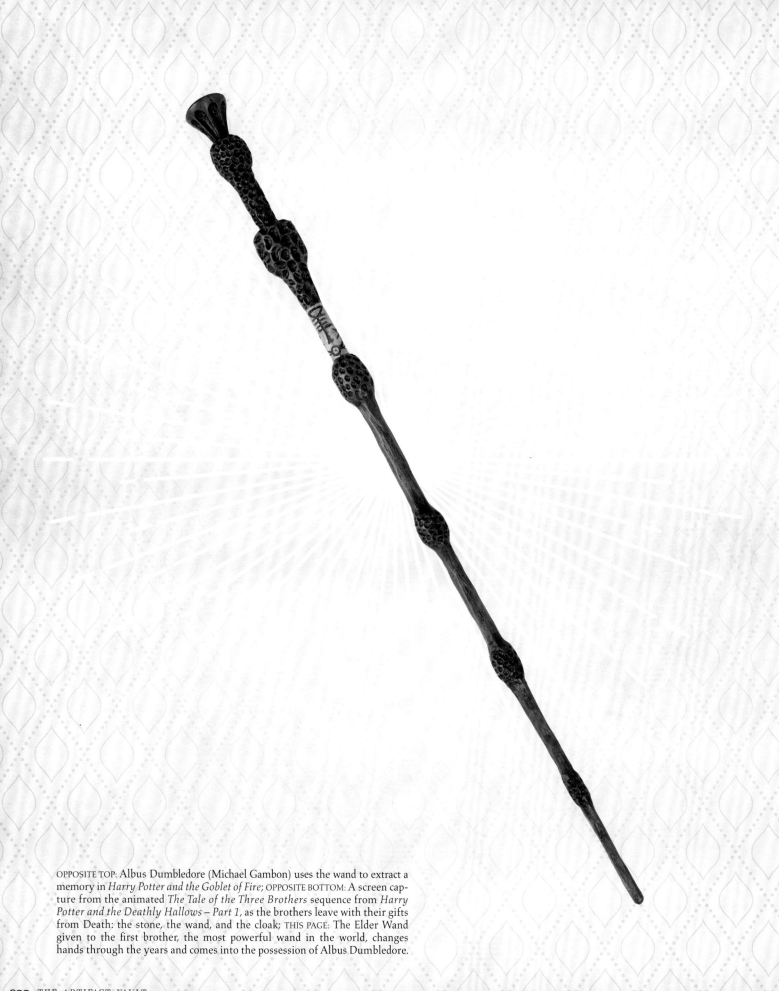

OPPOSITE TOP: Albus Dumbledore (Michael Gambon) uses the wand to extract a memory in *Harry Potter and the Goblet of Fire*; OPPOSITE BOTTOM: A screen capture from the animated *The Tale of the Three Brothers* sequence from *Harry Potter and the Deathly Hallows – Part 1*, as the brothers leave with their gifts from Death: the stone, the wand, and the cloak; THIS PAGE: The Elder Wand given to the first brother, the most powerful wand in the world, changes hands through the years and comes into the possession of Albus Dumbledore.

ELDER WAND

*"The oldest asked for a wand more powerful than any in existence.
So Death fashioned one from an elder tree that stood nearby."*

—**Hermione Granger, reading from** *The Tales of Beedle the Bard, Harry Potter and the Deathly Hallows – Part 1*

The first samples of wands shown to author J.K. Rowling for *Harry Potter and the Sorcerer's Stone* were crafted in myriad styles, from a gilded Baroque design, to one with roots that had crystals tied on the end, to simple, straightforward, turned wood wands. The latter were the ones Rowling chose. The prop makers produced them in the wood of the wand if they had been mentioned in the book, or if not, a high quality wood. "We tried to find interesting pieces of precious woods," Pierre Bohanna explains, "but we didn't want a plain silhouette, so we chose wood that might have burrs or knots or interesting textures to create a unique shape to it." Once the wand was approved, it was molded in resin or urethane, as wood would have broken too easily during use.

The Elder Wand benefitted from this philosophy of shape. Albus Dumbledore's wand was fashioned from English oak and inlaid with a bone-looking material inscribed with runes. "What makes it very recognizable," says Bohanna, "is that not only is it one of the thinnest wands, it has these wonderful outcroppings of nodules on it, every two or three inches." The prop makers had no idea that Dumbledore's wand would turn out to be one of the Deathly Hallows and perhaps the most powerful wand ever. "It's easy to recognize from a distance," Bohanna explains. "And should be, as obviously it's the biggest gun on the set, so to speak. As far as wands are concerned, it's the one to beat all others."

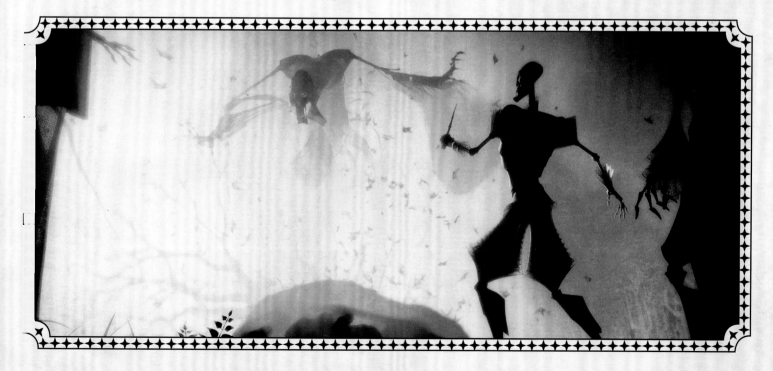

INVISIBILITY CLOAK

"Finally Death turned to the third brother. A humble man, he asked for something that would allow him to go forth from that place without being followed. And so it was that Death reluctantly handed over his own Cloak of Invisibility."

—Hermione Granger, reading from *The Tales of Beedle the Bard, Harry Potter and the Deathly Hallows – Part 1*

Harry Potter receives an Invisibility Cloak in *Harry Potter and the Sorcerer's Stone* at Christmas, the first holiday at which he has ever received worthwhile presents. A mysterious note accompanies the package informing him that his father, James Potter, left the cloak in the possession of the gift-giver, but it is time it was returned to Harry. Harry uses the cloak throughout the film series (with the exception of *Harry Potter and the Order of the Phoenix*), but it isn't until *Harry Potter and the Deathly Hallows – Part 2* that he discovers its origin and the consequence of it being part of the Deathly Hallows.

The cloak was created by the costume department, under the direction of Judianna Makovsky. The thick velvet material was dyed and imprinted with Celtic, runic, and astrological symbols. Several cloaks were created with this fabric for different uses. When Daniel Radcliffe (Harry Potter) puts on the cloak to make himself invisible, it is a version lined with green-screen material. Radcliffe would subtly flip the cloak around before placing it over him so that the green fabric would be right side up. Another version was lined with the same dyed material on both sides when it would be held or used over a full-body green-screen suit for complete invisibility.

ABOVE: A screen capture from *Harry Potter and the Deathly Hallows – Part 1*. The brothers have received their gifts from Death, who awaits his opportunity to take them back; RIGHT: Color key art by Dale Newton of Death, who cuts a piece of his own covering to make the cloak; OPPOSITE TOP: Harry Potter holds up the Invisibility Cloak, a Christmas present from Albus Dumbledore, in a scene from *Harry Potter and the Sorcerer's Stone*; OPPOSITE BELOW: Production shot of Daniel Radcliffe with the cloak flipped to its green-screen side.

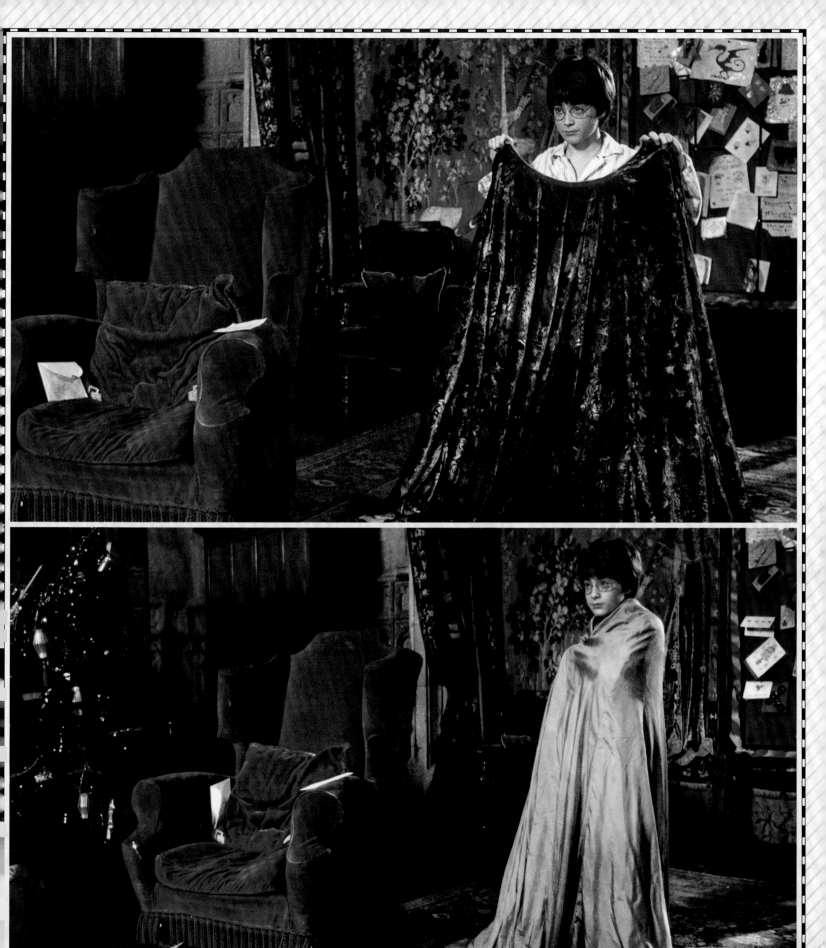

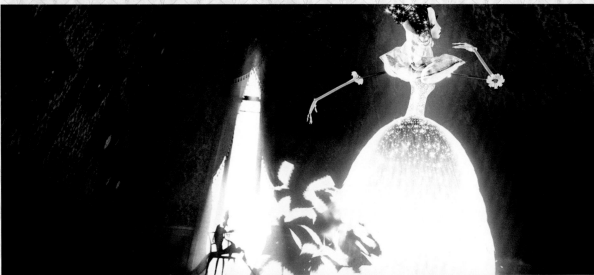

RESURRECTION STONE

"The second brother decided he wanted to humiliate Death even further and asked for the power to recall loved ones from the grave. So Death plucked a stone from the river and offered it to him."

—Hermione Granger, reading from *The Tales of Beedle the Bard, Harry Potter and the Deathly Hallows – Part 1*

OPPOSITE: Visual development artwork for the animated *The Tale of the Three Brothers* sequence from *Harry Potter and the Deathly Hallows — Part 1*; TOP: A screen capture of the second brother receiving the Stone from Death in *Harry Potter and the Deathly Hallows – Part 1*; ABOVE LEFT: The inscription on the Golden Snitch is finally understood by Harry Potter near the end of the events in *Harry Potter and the Deathly Hallows – Part 2*. When the Snitch does open, it reveals the Resurrection Stone, which Harry uses to speak to loved ones who have passed away: his parents, James and Lily; his godfather, Sirius Black; and his teacher, Remus Lupin; BELOW: Visual development art imagines the mechanism used to open the Golden Snitch.

The Resurrection Stone is the only artifact that is both a Deathly Hallow and a Horcrux. The Stone is first seen in *Harry Potter and the Half-Blood Prince* in a cracked, ruined form, having been destroyed as a Horcrux with the Sword of Gryffindor by Albus Dumbledore, at the eventual cost of his own life. The Stone returns in *Harry Potter and the Deathly Hallows – Part 2*, when it is discovered to be inside Dumbledore's bequest to Harry: the first Golden Snitch he ever caught.

The Stone is another example of the filmmakers starting to create a prop for one film before the book that would become the next film was published, or the significance of the prop would increase. "We were as much in the dark as everyone else when we first started designing the Stone for the ring Dumbledore had in the sixth film," recalls Hattie Storey. Not only did they not know that it would turn out to be the Resurrection Stone, they didn't know what the symbolic design for the Deathly Hallows was, which needed to be etched onto the Stone. But then, fortunately, the seventh book, *Harry Potter and the Deathly Hallows – Part 1*, came out. "I read through it in a real hurry at first," Storey continues, "and what we learned changed our ideas for the Stone."

The Stone is seen for the last time in *Harry Potter and the Deathly Hallows – Part 2* when Harry touches the Golden Snitch to his lips. It does, as it says, "*. . . open at the close.*" A practical mechanism moves one curve of the Golden Snitch inside another curve at the same time as it pushes the Stone upward, which then becomes its digital double to float in the air.

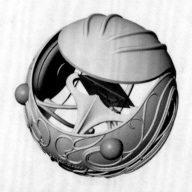
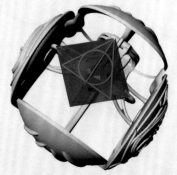

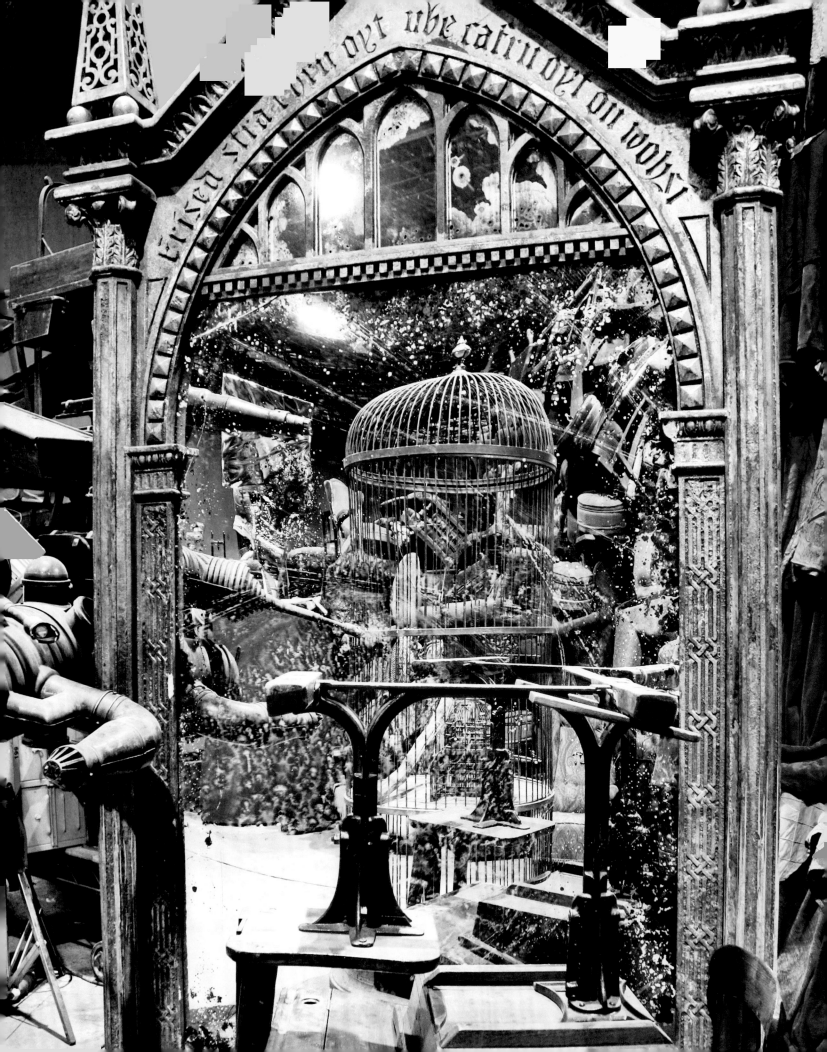

CONCLUSION

Many recognizable props found their way to the Room of Requirement throughout series, and they all eventually ended up in one of the five large warehouses necessary to store everything. Barry Wilkinson, property master for the films, praises the artists and craftspeople involved over the years. "Since the first film, the standards have stayed the same. Every set we're proud of because they're just brilliant."

OPPOSITE: The Mirror of Erised reflects the many artifacts piled high in a production reference shot of the Room of Requirement in *Harry Potter and the Deathly Hallows – Part 2*; ABOVE: Visual development artwork of paper swallows by Adam Brockbank, to be used in *Harry Potter and the Order of the Phoenix* when Parvati Patil sends an origami bird flying across the Defense Against the Dark Arts classroom; LEFT: Draco's drawing, folded to create a paper crane in *Harry Potter and the Prisoner of Azkaban*. Eolan Power, son of concept artist Dermot Power, drew the prop; BELOW: Visual development artwork for the cages which house the birds used by Draco Malfoy to test the Vanishing Cabinet, *Harry Potter and the Half-Blood Prince*.

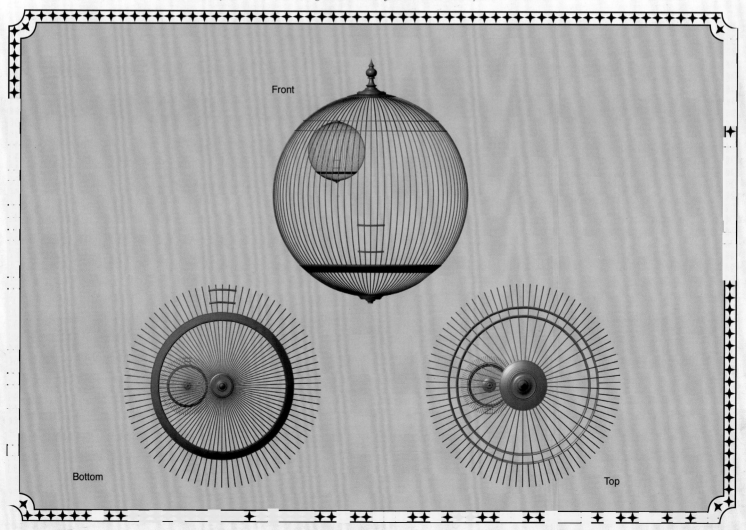

Front

Bottom

Top

HarperCollins books may be purchased for educational, business, or sales promotional use. For information please e-mail the Special Markets Department at SPsales@harpercollins.com.

First published in the United States and Canada in 2016 by:
Harper Design
An Imprint of HarperCollins*Publishers*
Tel: (212) 207-7000
Fax: (855) 746-6023
harperdesign@harpercollins.com
www.hc.com

Distributed throughout the United States and Canada by
HaperCollinsPublishers
195 Broadway
New York, NY 10007

Library of Congress Control Number: 2016930801

ISBN 978-0-06-247421-6

Produced by

INSIGHT EDITIONS
PO Box 3088
San Rafael, CA 94912
www.insighteditions.com

PUBLISHER: Raoul Goff
ART DIRECTOR: Chrissy Kwasnik
COVER DESIGN: Jon Glick
INTERIOR DESIGN: Jenelle Wagner
EXECUTIVE EDITOR: Vanessa Lopez
PROJECT EDITOR: Greg Solano
PRODUCTION EDITOR: Rachel Anderson
EDITORIAL ASSISTANT: Warren Buchanan
PRODUCTION MANAGER: Blake Mitchum
JUNIOR PRODUCTION MANAGER: Alix Nicholaeff
PRODUCTION COORDINATOR: Leeana Diaz

Insight Editions would like to thank Victoria Selover, Elaine Piechowski, Melanie Swartz, Kevin Morris, Ashley Bol, George Valdiviez, Jamie Gary, Kat Maher, and Claire Houghton-Price.

 REPLANTED PAPER

Insight Editions, in association with Roots of Peace, will plant two trees for each tree used in the manufacturing of this book. Roots of Peace is an internationally renowned humanitarian organization dedicated to eradicating land mines worldwide and converting war-torn lands into productive farms and wildlife habitats. Roots of Peace will plant two million fruit and nut trees in Afghanistan and provide farmers there with the skills and support necessary for sustainable land use.

Manufactured in China by Insight Editions

16 17 18 19 20 / 10 9 8 7 6 5 4 3 2 1

PAGE 2: The Golden Snitch.
PAGE 3: This illustration accompanied the Polyjuice Potion recipe in *Moste Potente Potions, Harry Potter and the Chamber of Secrets.*
THIS PAGE: Hufflepuff- and Gryffindor-supporting fan paraphernalia, created for *Harry Potter and the Sorcerer's Stone.*